OLYMPIA

OLYMPIA

PARIS IN THE AGE
OF MANET

OTTO FRIEDRICH

HarperCollins*Publishers*

HarperCollins books may be purchased for educational, business, or sales promotional use. For information, please call or write: Special Markets Department, HarperCollins Publishers, Inc., 10 East 53rd Street, New York, NY 10022. Telephone: (212) 207-7528; Fax: (212) 207-7222.

FIRST EDITION

Designed by Fritz Metsch

Library of Congress Cataloging-in-Publication Data

Friedrich, Otto, 1929–
 Olympia: Paris in the age of Manet / by Otto Friedrich.—1st ed.
 p. cm.
 Includes bibliographical references and index.
 ISBN 0-06-016318-6 (cloth)
 1. Art—Political aspects—France—Paris. 2. Art, French—France—Paris. 3. Art, Modern—19th century—France—Paris. 4. Art and state—France—Paris. 5. Manet, Edouard, 1832–1883—Criticism and interpretation. 6. France—Politics and government—1852–1870.
 I. Title.
 N6847.F75 1992
 701'.03—dc20 91-50443

92 93 94 95 96 MAC/HC 10 9 8 7 6 5 4 3 2 1

To Priscilla

I am a born enemy of texts that explain drawings, and drawings that explain texts.... The explanation of one artistic form by another is a monstrosity. You won't find in all the museums of the world a good picture that needs a commentary. Look at exhibition catalogues. The longer the entry, the worse the painting.

—GUSTAVE FLAUBERT, *Letters*

Degas stopped to look at each canvas, and presently gave a little exclamation of disgust. "To think," he remarked, "that not one of these fellows had ever gone so far as to ask himself what art is all about!"

"Well, what is it all about?" countered the critic.

"I have spent my whole life trying to find out. If I knew, I should have done something about it long ago."

—AMBROISE VOLLARD,
Recollections of a Picture Dealer

CONTENTS

Illustrations follow page 76

PREFACE

More than forty years ago, when I was young and foolish in Paris, I dreamed of becoming a professional pianist and of writing a book about Chopin, whose portrait by Delacroix hung on my wall, as it still does. A few years later, when I had gradually come to accept the fact that I would never be a professional pianist, I discovered Stendhal, and so my imagined book on Chopin gradually changed into an imagined book on Chopin's Paris, which would naturally include Stendhal, as well as Delacroix and Liszt and George Sand. A book about the city that Walter Benjamin once called "the capital of the nineteenth century."

I lived in Paris for several years, writing bad novels. I even got married in Paris, at the imposing Mairie of the Sixth Arrondissement on the Place Saint-Sulpice, and my first son was born in Paris. I worked for the United Press there, producing stories about the early days of an obscure war being fought by French troops in Indo-China, but I never wrote my book about the Paris of Chopin.

About ten years ago, I went to New York's City Center to enjoy one of the later operas by Rossini, *The Count d'Ory*. And then thought no more about it. Just a few days later, however, I happened to be driving home from a long and unpleasant session at the dentist's office when the car radio suddenly began playing *The Count d'Ory*. An omen. I suddenly remembered (though I had never actually forgotten) the bizarre story of Rossini's artistic paralysis. How he had begun writing operas at fourteen,

achieved his first production at La Scala at twenty, wrote both *Tancred* and *The Italian in Algiers* at twenty-one, became, in fact, the most prolific and successful composer in Europe, and then, after conquering Paris with *William Tell* at the age of thirty-seven, stopped forever, never wrote another opera, spent forty years just growing fatter.

So why not go to Paris, and write my book about the capital of the nineteenth century not in terms of such familiar figures as Chopin and Stendhal but in terms of Rossini's forty-year effort to avoid writing another opera? It seemed an engaging idea. I could still include Stendhal, who wrote in 1824 the first major biography of Rossini, but also all the other interesting people whom Rossini met (Wagner, for example) or did not meet (Empress Eugénie), just as Tom Stoppard had written a brilliant play, *Travesties,* about how James Joyce, Lenin, and Tristan Tzara never met when they all lived in the Zurich of 1917.

So I went back to Paris in the spring of 1980 to look for Rossini. I could not find any trace of him. At the house where he had lived on the Chaussée d'Antin, there was no plaque to mark his passing. Of the house that the city authorities had given to him in Passy, there was no sign. In the archives at the opera house, there stood busts of Gluck and Meyerbeer but no relics of the composer of *William Tell.*

What I found instead, on a sunny wall at the far end of a long corridor in the Jeu de Paume museum, was Manet's *Olympia.* Ostensibly a *demi-mondaine,* she seemed to me a goddess. I was overwhelmed by her beauty, and began wondering who had served as the model, and I forgot Rossini just as thoroughly as Paris had forgotten him. The question now was how to write that long-imagined book about nineteenth-century Paris in terms of the young woman who had posed for *Olympia.*

Her name was Victorine Meurent, and I duly learned, over the next few years, that others had pursued the same idea and worked hard to learn everything that could be learned about her—her emergence out of nowhere, her brief celebrity, her mysterious trip to America, her efforts to become a painter herself. But Victorine was a girl of the streets, and history suffers from class prejudice. The working classes produce relatively few letters and journals and memoirs, and what does get produced generally does not get preserved. Manet preserved Victorine in her eternal youth and beauty, but so little is known about her life that she can provide no more than a chapter or two in a book about something else.

About Manet himself? He too kept no journals and wrote few letters,

and his life was rather uneventful, but there was something interesting about the network of women surrounding him. He lived virtually all of his life with his mother, and when he finally married—in the same year he met Victorine Meurent—he married his music teacher, a rather heavy woman somewhat older than he, and he adopted and painted but never acknowledged the boy who was apparently their illegitimate son. Then as a kind of contrast to Victorine, the earthy model whom he liked to dress up in various disguises, there was his deep friendship with his gifted fellow painter Berthe Morisot. They both loved and admired each other, but since they could not marry, she joined the family by marrying his younger brother. The one irritant in this intense relationship was Éva Gonzalès, Manet's only pupil. In this web of women all emotionally tied to Manet—mother, wife, model, colleague, pupil—there must surely be a way of finally creating a portrait of nineteenth-century Paris.

Then Ronald Reagan got elected President and began tearing apart much of what had been achieved in this country in the past generation. Another of my old ideas had been to ghostwrite the memoirs of Rita Hayworth, the queen of the Hollywood of my boyhood. Alzheimer's disease reached her before I did, and so I decided that only a kind of social history of Hollywood in the 1940s could simultaneously expose the origins of Ronald Reagan and commemorate the beauty of Rita Hayworth (and Ingrid Bergman as well). And since I wanted to publish this while Reagan was still vegetating in the White House, Olympia had to wait for me to write *City of Nets: A Portrait of Hollywood in the 1940's.*

When I once again returned to Olympia, the estate of Glenn Gould wanted to know whether I was interested in writing a biography of the Canadian pianist. Once again, Olympia had to wait, as did Berthe Morisot, Manet, Rossini, and all the others. They were all infinitely patient, of course, but time keeps changing things. The French authorities decided to move Manet's paintings from the Jeu de Paume to the new Musée d'Orsay on the other side of the Seine, and Olympia's position then was rather different from what it had been. I had to go back to Paris and look at her once more. This is something that I now do every time I go back to Paris, and I go back there as often as I can. My Paris is still the nineteenth-century Paris, where, before the women of Manet's circle were born, Chopin played his mazurkas.

I should perhaps add a word of warning. The history of a culture does not proceed in a linear way, nor does this book. Chronology is generally a

convenience but no more than that. Nana flourished under the Napoleonic empire, for example, even though she was not captured on canvas or paper until long after the empire had collapsed. Similarly, we must not be too concerned that some of our characters never actually met. Although Manet never even set eyes on the Empress Eugénie, for example, it was partly because of her that he found himself standing guard in an artillery unit on the walls of Paris. So how can we omit Wagner from Manet's Paris when Manet's wife played his music to the dying Baudelaire?

Finally, I want to acknowledge that my work on Manet benefited greatly from sojourns at the Fondation Karolyi in Vence, France, and the Rockefeller Foundation's Villa Serbelloni in Bellagio, Italy. I also want to thank Herbert Cahoon, curator of autograph manuscripts at the Pierpont Morgan Library, New York, for letting me study the various Manet papers in the Morgan collection.

LOCUST VALLEY, N.Y., 1991

OLYMPIA

OLYMPIA

It seems that I must do a nude. All right,
I'm going to do them a nude...
—*ÉDOUARD MANET*

The public nakedness of a beautiful woman sometimes becomes a question of politics—politics meaning not just who won the last election but how the relations among people are organized, which actions or emotions are permitted under which unspoken and frequently changing rules. When Édouard Manet presented to the world of 1865 the masterpiece that he called *Olympia,* the first reaction of the Parisian press and public was one of hostility, even outrage, along with a certain amount of nervous laughter. To some extent, though in different ways, those same reactions still persist today.

We do not know exactly what the name Olympia means. Manet provided no explanation except by quoting a few lines of florid poetry by a friend named Zacharie Astruc, who actually wrote a much longer poem after first seeing the picture:

> *Quand, lasse de rêver, Olympia s'éveille,*
> *Le printemps entre au bras du doux messager noir;*
> *C'est l'esclave, à la nuit amoureuse pareille,*
> *Qui vient fleurir le jour délicieux à voir:*
> *L'auguste jeune fille en qui la flamme veille.* °

°No translation can make this sound admirable, but one published version reads: "When, tired of dreaming, Olympia awakens, / Spring enters on the arm of the mild black messenger; / She is the slave who, like the amorous night, / Comes to adorn with flowers the day delightful to behold: / The august young woman in whom ardour is ever wakeful."

Astruc's outpouring in turn may derive from an unproduced play that he wrote at about this time, *The Dialogue of the Foolish Virgins and the Wise Virgins.* One of the former is named Olympia, and she declares at one point: "Our dearest possession, is it not freedom? Free, sovereign, that must be our fate. The man who will marry me will satisfy my wishes large and small; I swear it, or I'll no longer be Olympia." Or the name may simply have come from the heroine of a highly successful new opera, *Herculanum,* by Félicien David, which had its premiere in 1859. This heroine was a Babylonian Queen Olympia, who considered it her destiny to halt the spread of Christianity. "When Satan says,/Here is the punishment!" she sings in her final scene, "Olympia responds:/Well, then! I defy it!"

Manet's Olympia speaks for herself without a word. She floats on the thick white pillows of her bed, wearing only one pink orchid in her coppery hair, a thin black ribbon bow-tied around her neck, a wide bracelet on her right wrist, and a blue slipper dangling from one of her casually crossed feet. As the observing eye roams over her body, it can hardly help pausing to admire her ripe breasts and belly, but the hand that stretches with apparent modesty across the thighs draws the roaming eye irresistibly downward. Yet when one has savored the sensuous body, it is the face that remains haunting, not just for its sturdy beauty but for its strangely enigmatic expression. Olympia gazes squarely back at every admirer with a look of casual indifference, of recognition, of sadness, of courageous defiance.

The strangest thing about the uproar that greeted Olympia's first appearance at the official Salon of 1865 was that most of the people who looked at her literally couldn't see her. This was partly a technical matter. Because they were accustomed to seeing elaborate gradations between light and dark, and because Manet suppressed virtually all such gradations, the critics could not see Olympia as a three-dimensional figure at all, only as a crude arrangement of flat patterns, or, as Gustave Courbet put it, "a queen of spades emerging from her bath." Even more striking, though, were the critics' repeated assertions that this beautiful creature was ugly. "A female gorilla, a rubber grotesque," said Amadée Canteloube in *Le Grand Journal.* Manet "has made himself the apostle of the ugly and the repulsive," said Felix Jahyer in his handbook on the Salon. "People crowd around M. Manet's rancid *Olympia*

as though they were at the morgue," Paul Saint-Victor wrote in *La Presse*. "When art descends as low as this, it does not even deserve a note of censure."

Such outbursts remain mysterious, since French connoisseurs of beauty had been accustomed to admiring nude figures ever since Gislebertus of Autun carved his exquisite Eve in the early twelfth century. In terms of structure and design, *Olympia* very closely resembles a scarcely less voluptuous Renaissance nude painted by Titian and known as the *Venus of Urbino*, but Olympia is not Venus, nor Eve either (except in her essential nature, her *raison d'être*). Although Parisian critics and spectators were accustomed to admiring Madonnas who had been born in the streets of Montmartre, and nude nymphs and goddesses of every variety, Manet's *Olympia* was virtually the first painting that made no pretense at such disguises. Everything about her proclaims that she is a contemporary Parisian. She has often been patronizingly described as a *demimondaine* awaiting some new client, but though Manet may well have intended her as such—and Olympia was a popular *nom de guerre* among such women—there is no real evidence for it. She could just as easily be a bourgeois bride awakening on her wedding day, or, for that matter, the Empress of France—or perhaps a modern Venus after all. But the most important thing is that she is simply herself, and as you coolly appraise her, she is coolly appraising you.

The image is so powerful that it has often mesmerized other painters. Gaugin made himself a copy of *Olympia*. So did Degas and Fantin-Latour. So did Cézanne, more than once, but Cézanne felt some inner need to degrade the beautiful Olympia, eliminating the ambiguity in Manet's work by introducing a top-hatted admirer into the bedchamber. Modern parodies are even more compulsively insulting. Picasso introduced not one client but two, both naked and not particularly interested in their hostess. Jean Dubuffet's bloated and knife-smeared *Olympia* of 1950 hardly represented a female figure at all. Larry Rivers, a prisoner of contemporary ideology, insisted on negrifying his version of 1970 and entitling it *I Like Olympia in Black Face*.

Olympia, the supposed *demimondaine* whose body is supposedly for sale, has never actually been bought by anyone. When the Prussians threatened to besiege Paris in 1870, this was one of a dozen paintings that Manet removed to a neighbor's storage cellar for safekeeping. After

he retrieved it in 1872, he set a price of 20,000 francs on it (roughly $10,000),* but that was a price nobody wanted to pay. So *Olympia* remained in his atelier for the rest of his life.

Today, of course, *Olympia* is priceless, one of France's great national treasures, and so she enjoys the ambiguous honor of symbolizing what French officials believe that citizens should think of themselves. When the authorities rearranged their collections just after World War II and assembled some 500 Impressionist and Post-Impressionist paintings in the Jeu de Paume museum on the Place de la Concorde, Olympia finally came to reign as a kind of goddess. Her portrait hung high on a wall at the far end of a long corridor, so that as one approached, it kept growing larger and larger. By now, almost everyone who came here already knew *Olympia* from a thousand reproductions in a thousand volumes of art history—remember that, as André Malraux told us in *The Voices of Silence,* the camera has enabled us to know much more of the world's art than Manet ever knew, or Rembrandt or Michelangelo, but much of what we know is wrong. The reproductions are always just a few inches high, whereas the actual *Olympia* is quite large, about seventy-five inches by forty-one, and that size makes her overwhelmingly real, not a figurine but a woman. Some visitors in those postwar days still reacted, like their forefathers, with a nervous laugh (what *is* it about Olympia's beauty that is so provoking?), but most simply stood admiring and enjoying her. Since one had to look upward, one almost inevitably became awed, hypnotized, transfixed.

Triumphs, too, are transient. And when the French authorities decided a few years ago to rearrange their treasures yet again, Olympia was taken down from her place of honor in the Jeu de Paume and assigned to a completely new museum of nineteenth-century art being created out of the skeleton of an old railroad station on the south bank of the Seine, the Gare d'Orsay. The gyrations of politics have brought a new generation of women to positions of power in the world of art— Gae Aulenti designed the spectacular interior of the Musée d'Orsay and

*Trying to convert Parisian prices of the nineteenth century into contemporary dollars is a hazardous venture. John Rewald's authoritative *History of Impressionism* calculates (in a 1987 printing of its 1973 fourth revised edition) that one franc "of the period" (the early 1870s) was worth the equivalent of two and one-half of today's francs, or about fifty cents. Bear in mind, though, that the value of today's francs and dollars changes frequently, and so does their meaning in terms of what they could buy. Rewald and others estimate an 1870 workman's average daily pay at five francs whereas no modern workman is likely to accept a daily wage of $2.50.

Françoise Cachin became its director—and they naturally had their own views of figures like Olympia.

One can see the difference before one even enters the Musée d'Orsay; one can feel an unusual sense of irony and parody. Over here to the left of the entry stands a gigantic rhinoceros, originally created for one of those great industrial expositions so dear to the nineteenth century, but over there at the right-hand edge of the plaza stands a far more imposing set of guardians, six huge bronze women supposedly representing the six continents, all created by such half-forgotten sculptors as Eugène Delaplanche and Alexandre Falguière for the Paris Exposition of 1878. With the guileless innocence of imperialist prejudice, five of the six statues are majestically bare-breasted women of color (North America is represented by an Indian) while the figure of Europe alone is chastely outfitted in armor.

The same ironies exist inside. The great central gallery, where once the railroad lines flowed out toward Orléans and the South, is now dominated not by the masterpieces of Manet or Degas but by a series of statues of the kind that used to be commissioned for public gardens, or, for that matter, railroad stations. The only painting in this entire central gallery is that famous quasi-erotic panorama by Manet's teacher, Thomas Couture, *The Romans of the Decadence.* The nearby statues include such curiosities as a Sappho by James Pradier, Hebe asleep under the protection of a huge eagle, a series of bacchantes, and, perhaps most remarkable of all, *Eve After the Sin,* by that same Eugène Delaplanche who created the monolithic statue of Africa out in the plaza. Disconsolate in her guilt and shame, this marble Eve holds her head in her hands while the serpent coils affectionately around her feet.

Only by venturing through a nearby doorway into an almost subterranean chamber, where the only light is electric light, can one rediscover *Olympia,* demoted and demythologized. In the new world of feminist professionalism, a naked woman lying on a bed can no longer have a place of honor. So *Olympia* hangs in a corner, next to Manet's portrait of Émile Zola. She is just one of thirteen Manet paintings in this rather auxiliary room, all thirteen hung at the same height, all treated as exactly the same, the divine Olympia exactly the same as a still-life of a fish. Seen so close, at eye level, she now seems almost shabby. There are lots of small cracks streaking across her right breast and across her right thigh. Even the picture frame seems unaccountably chipped, with bits of

red underpaint showing through the gold. Yet that ironic expression on her face remains as haunting as ever. Although she has been demoted, she knows nothing of the self-conscious shame of that Eve out on the other side of the doorway in the grand gallery.

Olympia remains above all such things, of course, above politics past and present. In painting her portrait, Manet was exploring all kinds of ideas, symbolic imaginings, structural plans, but he was also looking at a beautiful young Parisian woman lying naked on a bed, infinitely desirable, and nobody can look at her without wondering who she really was. Where did she come from? What was she like? What did she think of the man who was looking at her and painting her and making her immortal, and of all the others who would look at her, over that painter's shoulder, in all the years to come?

One day in 1862, according to a legend that is quite possibly untrue, Manet was strolling near the Palais de Justice, on the Île de la Cité, when he caught sight of a remarkable looking girl, young, sturdy, vibrant, full of life and spirit. What struck him most, according to one of Manet's friends and earliest biographers, Théodore Duret, was "her original look and her determined manner." He accosted her, told her that he was an artist, and that he wanted to paint her. Manet at thirty was an impressive figure, tall, blond-bearded, elegantly dressed. *"Ce riant, ce blond Manet,"* as Théodore de Banville later wrote,

> *De qui la grâce émanait*
> *Gai, subtil, charmant en somme,*
> *Sous sa barbe d'Apollon*
> *Eut de la nuque au talon*
> *Un bel air de gentilhomme.* °

The girl, being a Parisian who knew the ways of the streets, probably did not put much faith in this stranger's tale of being a painter, but she found him engaging, attractive, and so she accepted his invitation. Her name was Victorine (or Victorine-Louise) Meurent (or Meurend or Meu-

° "This laughing, this blond Manet / From whom there shone forth grace, / Gay, subtle, altogether charming, / Under his Appollonian beard, / Had from head to toe / The fine air of a gentleman."

rand), and she was about eighteen. Scholarly investigators have devoted a good deal of effort to discovering the details of her youth and upbringing but with relatively little success. History does not preserve many documents concerning lower-class girls. She was born, it has been stated, on February 18, 1844 (so she and Manet were both Aquarians, for whatever that may tell us), to Jean-Louis-Étienne Meurent and his wife, Louise-Thérèse, who lived at 39 Rue de la Folie-Méricourt, above the Brasserie du Prince Eugène. Her father was an engraver, one of her uncles a sculptor. Of her schooling, whatever it was, nothing is known.

Victorine Meurent had artistic talents and ambitions, of an uncertain kind. She played the guitar. She liked to draw (in due time, she would take up painting with rather surprising results), but at this age her main relationship to the world of art was as a model. In the records of the atelier of Thomas Couture, there are several listings between December of 1861 and January of 1863 that say: "*Mod* [meaning *model*] Louise Meurand *[sic]* 25 [francs]."

Couture was an eminently successful painter of fashionable historical epics. He won a medal at the 1847 Salon for his enormous rendition of Roman decadence. Victorine Meurent's appearance as a model in his atelier is notable primarily because one of Couture's most refractory students was the young Manet, who had worked in this studio for six rebellious years, from 1850 to 1856. One of Manet's main arguments with Couture, in fact, involved the role of models. Instead of impersonating classical nudes, Manet wanted the models to pose naturally, even, if necessary, fully clothed. Couture rebuked him by making the remarkable accusation that he would never be more than "the Daumier of your time." Manet was not offended, but he saw little hope of agreement. "I don't know why I'm here," he said, according to his fellow pupil and lifelong friend Antonin Proust. "Everything we see around us is ridiculous. The light is false. The shadows are false. When I come to the studio, it seems to me that I'm entering a tomb."

Manet nonetheless learned much of his craft in Couture's atelier. But when he tried to impress the older master by inviting him to his own studio to see one of his first major paintings of Parisian life, *The Absinthe Drinker* (1859), Couture's reaction was shattering, and prophetic. "An absinthe drinker!" he exclaimed. "And they paint abominations like that! My poor friend, you are the absinthe drinker. It is you who have lost your moral faculty."

Manet had left Couture's atelier before Victorine Meurent's first recorded appearance there, so that was probably not their meeting place either. The first real evidence of any encounter is an undated entry in one of Manet's notebooks: "Louise Meuran [sic], Rue Maître-Albert, 17." The homonymic misspelling of Victorine's name may mean that Manet had asked her for her name and written down what her answer sounded like; it may mean simply that her answer did not seem very important. According to yet another theory, Manet went to the Place Maubert to check on the engravings done by Victorine's father, and so he inevitably met the engraver's handsome daughter. The workshop's address, 17 Rue Maître-Albert, was then a wooden boardinghouse, divided into about twenty-five furnished rooms. Not long afterwards, it was torn down to become a hotel.

We have no way of knowing exactly what Manet saw in Victorine. He saw a very attractive girl, of course, but Paris is full of those. More important, Manet was not essentially interested in painting Victorine herself but rather Victorine as a model of other people. This may mean that he saw in her an inherent gift of physical mimicry, an actress's ability to become anyone she chose. Or it may mean that Manet simply selected her to represent whatever he wanted her to be, either that he could see her in any role he chose for her, or that he didn't really care what she looked like, that she represented to his eye no more than what a mannequin represents to a couturier. That she was, in other words, everybody and nobody.

The only time that he ever painted her to look like herself was probably the first picture he did of her. The exact sequence of his early works is not certain, but *Portrait of Victorine Meurent* dates from 1862, the year they met. It is a small and fairly simple picture of a handsome young woman in a white blouse, her red hair parted in the middle and bound across the top by a blue ribbon and bow. Around her neck, she wears the thin black ribbon that will later adorn the neck of Olympia. Art historians attach intense importance to details of this sort. "Here he is manifestly enchanted with the contrast between blue ribbon and tawny hair, to be echoed in such sketches as the *Study for 'Le déjeuner sur l'herbe'* and the *Olympia* watercolor," according to the authoritative catalogue by Françoise Cachin, Charles S. Moffett, and Juliet Wilson Bareau for the Metropolitan Museum's great Manet exhibition of 1983. It quotes Jacques-Emile Blanche to similar effect: "How often does the

chance meeting of a painter and a model influence decisively the character of his works! I consider a head of Victorine Meurand [sic], wearing a blue ribbon in her hair, as the keynote of the characteristic combinations of colours on Manet's palette...."

A less professional observer might be more impressed by two characteristics of Victorine herself. One is that this lively girl of about eighteen looks a mature thirty, as though Manet already saw her as she would become.° The other is that she is serious, grave, perhaps even anxious, certainly thoughtful, as though she too saw what she would become. Manet may have given her the portrait as a present, regarding it as no more than a kind of study, and she, when her later troubles came, may have sold it, for it first appeared in public as the property of a Glasgow shipbuilder at the end of the century. It eventually ended in the hands of a Boston merchant, who donated it to the Boston Museum of Fine Arts, where it hangs today.

Having finished the experiment of painting Victorine as herself, Manet dressed her up in the most extravagant costume, as a matador, not a woman who has costumed herself as a matador for some elaborate party but a real matador brandishing a real sword and cape in a real bull ring. This was a time of intense interest in all things Spanish, for Maria Eugenia Ignacia Augustina de Montijo had been the empress of France for the past ten years. All things Spanish were accordingly in vogue, from the drama of Carmen by the Empress's friend Prosper Mérimée to a performance by such touring Spanish dancers as Lola de Valence, who posed for Manet in 1862. Indeed, Manet's first painting to be acclaimed by an honorable mention at the Salon of 1861 was *The Spanish Singer.*

Beyond fashion, though, a young French artist could hardly help being impressed by the great Spanish painters in whatever form he discovered them, as when Manet first met Edgar Degas copying Velázquez's *Infanta Margarita* directly onto a copperplate in the Louvre in 1859. Manet was so overwhelmed by the Spanish masters that it became commonplace to accuse him of being derivative, even a plagiarist. "The word 'imitation' is unfair," Manet's friend Charles Baudelaire

°There is some question about Victorine's generally accepted age. Beatrice Farwell reports in *Manet and the Nude* that she has discovered in the Bibliothèque Nationale some pictures made by a photographer named Quinet in 1852 and 1853, "representing a model in...various degrees of undress who is almost certainly Manet's Victorine...." If so, Dr. Farwell estimates her age in these photographs as "at least 17, perhaps 20, making her 27 to 30 in 1862–3."

finally wrote to one such critic, Théophile Thoré. "Manet has never seen a Goya; Manet has never seen a Greco.... This seems unbelievable to you, but it's true. I have myself admired, in amazement, these mysterious coincidences.... People have told him so much about his imitations of Goya that now he is trying to see some Goyas. It is true that he has seen Velázquez, I know not where. You don't believe what I tell you? You doubt that such surprising mathematical parallels can be found in nature? Very well!"[*]

There is nothing realistically Spanish, of course, in *Mlle V...in the Costume of an Espada*. Manet kept a number of theatrical costumes in his atelier, but he may have simply rented this "suit of lights" for the occasion. Even then, though, Victorine wears a head scarf under her black toreador's hat and a rather absurd pair of brown slippers on her feet. If anything could be more unrealistic than such a patchwork costume, it was the idea of Mlle. V. appearing in a bull ring in the first place. But it is not a real bull ring after all. To the exasperation of Manet's contemporaries, he portrayed the bull being stabbed by a picador in the middle distance as an image completely out of proportion to the rest of the scene, far smaller than some figures standing against the bull ring wall at the back of the picture.

A number of Manet's contemporaries were genuinely convinced that he was technically unable to paint correctly, and some modern critics still share that view. One of them, John Richardson, has said of this particular picture that Manet's "sense of scale has let him down so badly that the bullfighting scene makes an annoying hole in the decorative schema," and more generally that Manet's sense of scale suffered "a further habitual weakness (due possibly to some defects in the artist's vision)." In the age of Pollock and De Kooning, critics can find some explanation for any artist's vagaries, and since Manet's figure of the picador seems an obvious copy from Goya's *Tauromaquia,* the relative sizes of Victorine and her associates can hardly be taken too literally. "Where a history painter of the time would have used these costumes in some plausible context..." Beatrice Farwell has written, "Manet in 1862 used them to present quite frankly his perfectly recognizable and named

[*]Rewald, in *The History of Impressionism,* challenges this frequently quoted statement by declaring that Baudelaire "pretended" that Manet had never seen a Goya. He adds, without any corroborating evidence: "It seems certain that the painter did see at the Louvre Louis Philippe's rich 'Spanish Museum' (he was 16 years old when it was dismantled after the revolution of 1848)."

female model in a scene painted so as to leave no doubt in the viewer's mind of the total artificiality of its construction."

"There is only one true thing: instantly paint what you see," Manet once said to his friend and schoolmate Antonin Proust. "When you've got it, you've got it. When you haven't, begin again." But what is it that you see, and how do you see it? One evening during that first year of his acquaintance with Victorine, Manet was walking along the Boulevard Malesherbes with Proust when he saw a young singer emerging from a shabby café with a guitar slung over her shoulder. Once again, as with Victorine, he saw something that struck his fancy, and so he accosted her and introduced himself as a painter and asked her to pose for him. (Were these various encounters inspired purely by an artist's fascination with women randomly glimpsed in the street, or was Manet essentially trying literally or figuratively to proposition them? There is no certain answer, but despite the legends of *la vie de bohème,* much of the evidence suggests that Manet was rather reticent and inhibited toward women.) The important thing is that when the café singer laughed and declined Manet's invitation to pose (what could have bothered her?), the painter seems to have been quite indifferent. "If she won't pose," he said, "I've got Victorine."

So Victorine became *The Street Singer,* a somewhat enigmatic figure of the night, in a billowing brown dress, enigmatic partly because her thickly browed eyes seem to be staring vacantly into space. "The eyebrows have been moved from their horizontal position to a vertical one parallel to the nose, like two dark commas," the influential critic Paul Mantz somewhat exaggeratedly complained in *La Gazette des Beaux Arts.* "There is nothing more there than the shattering discord of chalky tones with black ones. The effect is pallid, harsh, ominous." Enigmatic, too, because Manet has chosen to encumber his singer's left arm not only with her large guitar but with a paper packet full of cherries, some of which her right hand holds up in front of her mouth. So Victorine in this new disguise is almost entirely hidden, her face behind her hand, her body in the flowing dress.

And then Manet almost inevitably decided to take all her clothes off. He was out strolling with Proust, according to a sometimes disputed account in Proust's *Édouard Manet, Souvenirs,* when the idea first came to him, or when he first formulated it. "We were at Argenteuil one Sunday, watching the white barques ply the Seine…" Proust wrote. "Some

women were bathing. Manet's eye was fixed on the flesh of the women leaving the water. 'It seems,' he said to me, 'that I must do a nude. All right, I'm going to do them a nude. When we were at the studio, I copied Giorgione's women, the women with the musicians. That's a dark picture. The background has retreated. I want to do it over, and do it in the transparency of the atmosphere, with figures like those that we see over there. I'll take a beating, but let them say what they want.' "

The young Manet was a very reluctant radical. He yearned to conform, yearned for the approval of authority. It is easy enough to see why when one contemplates one of his earliest paintings, the *Portrait of M. and Mme. Auguste Manet* (1860). There they sit, infinitely forbidding, all in black, neither one looking at the son who is portraying them. Auguste Manet, then sixty-three, with a stubbly gray beard and a deep frown, his right hand clenched on the arm of his chair, was chief of staff at the Ministry of Justice, then a judge at the Court of the Seine. His wife, Eugénie, the daughter of a diplomat, was fifteen years younger but looks almost equally wintry and withered.

Being a lawyer, the father expected to make his oldest son, born on January 23, 1832, study law. When the ordinarily docile son protested that he wanted to be an artist, the father relented only so far as to declare that the son did not have to become a lawyer but did have to choose some serious profession. On an odd impulse, the son announced that he would like to join the navy. The surprised father agreed to his enrollment in a school for naval cadets. The son liked the sea but understood little of mathematics or science, and he ignominiously failed the examinations that were supposed to lead to a naval commission. The French navy was reasonably understanding, however, and it had a policy of encouraging the aspirations of any youth who shipped out to gain some practical experience in the merchant marine. At sixteen, young Manet signed on board the *Le Havre et Guadeloupe* and headed out on a six-month voyage to Rio de Janeiro. He spent much of his time at sea in sketching, and the indulgent captain contributed to his artistic education only by asking him to repaint the red skins on a supply of Dutch cheeses that showed signs of going bad. When Manet returned to Paris, he had learned so little seamanship that he once again failed the naval exams.

Judge Manet finally acquiesced in his son going to study art at the atelier of Thomas Couture. This does not mean that Manet emerged into a life of bohemian revelry. He continued to live at home, and his parents supported him well into adulthood. And when he found a girl, it was the plump Dutch piano teacher who had begun coming to the Manet apartment in 1849 to give music lessons to the fledgling painter and his two younger brothers. Her name was Suzanne Leenhoff, and she was eighteen, more than a year older than Manet. In 1852, when she was twenty-one, she gave birth to an illegitimate son whom she named Léon. On his birth certificate, she claimed that his natural father was someone called Koëlla, but a century of art scholarship has failed to uncover any evidence of who this Koëlla was, or whether he ever existed.°

Only after old Judge Manet's death in 1863—apparently of an illness deriving from syphilis—did Manet marry Suzanne Leenhoff. His friends had hardly known of her existence. "Manet has just given me the most unexpected piece of news," Baudelaire wrote to a newspaper editor that October. "He is leaving tonight for Holland, from where he will bring back his *wife*. It would seem that he has some excuse, for it appears his wife is beautiful, kind, and a very good musician. So many ornaments combined in the person of a single female are monstrous, are they not?"

Manet's father apparently never knew of the affair that had been going on for more than ten years, and he would not have approved. Thus an attempt to marry might have jeopardized Manet's inheritance. His mother knew, though, and whether she approved or not, she wanted the relationship legalized. Indeed, she told Manet that she would give the couple a wedding present of 10,000 francs, to add to the 9,000 francs and the share in family real estate that Manet had inherited on the death of his father. Suzanne Manet pretended for years that her son was actually her younger brother, but Manet eventually adopted him—the date is uncertain because the Paris city records were burned during the sup-

°A fanciful scholar named Harry Rand (*Manet's Contemplation at the Gare Saint-Lazare*) has discovered two Spanish painters named Coello, whom Manet "must have been aware of," but he adds that "there is no pertinent reason to suppose" that Manet would have named his son after them. He also discounts another theory, offered by Steven Kovács, that Manet was recalling his ocean voyage, and Koëlla "was suggested by *goëland,* the French word for seagull," because the bird "might come to symbolize for Manet ... an unbounded freedom." Rand's own theory: "Separated into two sounds, pronounced 'co-ella,' we recognize the Spanish pronoun for 'her.'... Thus, the name ... literally means 'with her.' Léon's first name could easily be a contraction of Suzanne's maiden name of Leenhoff, and his middle name, Édouard, is reasonably self-explanatory."

pression of the Paris Commune in 1871—adopted him and painted him over and over (in *The Balcony,* in *Soap Bubbles,* in *The Luncheon,* in *Interior at Arcachon*), and yet never acknowledged that the boy was his son. This was not a man who yielded up his secrets easily.

Hungry for official approval, Manet yearned to win medals for his paintings at the Salon, to earn the praise of powerful newspapers like *Le Temps* and *Le Figaro,* to receive commissions for portraits of the rich and the aristocratic. So when he finally decided that the Parisian artistic establishment wanted him to paint a nude, he not only drew his inspiration from Giorgione's *Concert champêtre* (now attributed to Titian) but took his central composition from a group of three figures in Raphael's *Judgment of Paris* (then fairly well known in a popular engraving by Marcantonio Raimondi). Once he had invoked these Renaissance masters, however, Manet proceeded to create a scene characteristically modern, characteristically scandalous, characteristically his own. "A commonplace woman of the demimonde, as naked as can be, shamelessly lolls between two dandies dressed to the teeth," according to one hostile critic, Louis Étienne. "These latter look like schoolboys on a holiday, perpetrating an outrage to play the man.... This is a young man's practical joke, a shameful open sore not worth exhibiting."

There are indeed elements of a private joke here. Of the two young men in what Manet originally called *La partie carrée,*° the lounging and gesticulating figure on the right is Manet's brother Eugène, or perhaps his brother Gustave, or possibly a combination of the two (both of them posed for the part); the reflective figure on the left is more recognizably the Dutch sculptor Ferdinand Leenhoff, the brother of Manet's mistress. The voluptuous girl often described as a demimondaine is, of course, Victorine Meurent. Her body, when Manet finally shows it to us, is one that would have pleased Rubens. Her breasts are full, her thighs thick, her stomach round, and Manet the realist cruelly insisted on painting a horizontal crease across that warm midriff. When one has admired her figure, though, what remains in the mind is once again that haunting expression on her face, quizzical, bold, challenging. It remains unclear why anyone should be scandalized by her nakedness, any more than by Giorgione's equally naked and equally robust flute players. The shock apparently came from the fact that her male companions were so

°Literally, "the party squared," meaning a party for two men and two women.

completely and contemporaneously dressed, which changed Victorine from a "nude" into a pretty girl without any clothes on.

There is a fourth figure in the background, a demurely robed female emerging from a stream, who has never been identified but may also have been posed by Victorine in another one of her many manifestations. In her honor, Manet somewhat ironically called the painting *The Bath* when he formally submitted it to the jurors for the Salon of 1863. (The painting is now famous under the title *Le déjeuner sur l'herbe,* of course, even though the figures in the foreground are not actually picnicking on the fruits and pastries spread out in a beautiful still-life at Victorine's side.) The jurors were not impressed. They rejected Manet's masterpiece as unworthy of public exhibition.

It is a little difficult now to appreciate the importance of the Salon in the Paris art world of the mid-nineteenth century, but it was supreme. There were very few art dealers or galleries then, and the annual Salon represented the only road to both public and private commissions. It had been created under King Louis XIV in 1663 as part of the decree establishing the Royal Academy of Painting and Sculpture. Originally, only members of the Academy itself could exhibit their pictures, but the Revolution changed all that. The National Assembly announced in 1791 that the Salon would be open to everyone, but that a government committee would decide which works deserved to be shown. Predictably enough, this official jury system caused endless troubles, and each attempt at reform, under monarchy and republic alike, brought new kinds of troubles. The royal jurors were inevitably conservative in both politics and taste, and during the supposedly bourgeois monarchy of Louis-Philippe they disgraced themselves by barring pictures by Delacroix, Courbet, Corot, Millet, and Théodore Rousseau. After the revolution of 1848, the authorities of the Second Republic abolished the jury and proclaimed a Salon open to everyone. That provoked a stampede. The number of exhibitors, which had risen even during the jury years from 258 in 1791 to 3,182 in 1831, now soared to more than 5,000. The next year, the exhibitors themselves elected the jury, and the year after that the government demanded the right to name some jurors, and so on.

With the triumph of Napoleon III in the coup d'état of 1851, the imperial government once again named the jury, and the jury once again began excluding anything unconventional. In 1863, when Manet submitted *Le déjeuner sur l'herbe* (as well as *Mlle. V...in the Costume of an*

Espada and *Young Man in the Costume of a Majo*), the jurors established a record of sorts by rejecting more than 4,000 paintings. This was not purely reactionary blindness, of course. A number of the submissions were amateurish daubings. But the painters rejected that year included not only Manet but Pissarro, Whistler, Fantin-Latour, Braquemond, and Cézanne. The young artists who gathered every evening at the Café de Bade on the Boulevard des Italiens began talking of public protest. A petition circulated. *Le Courrier Artistique* spoke of the need for "a sweetening of the rigors of the regulations." The petitioners chose Manet and Gustave Doré to carry their protest to the Ministry of Fine Arts.

The Emperor Napoleon III may have been unworthy of his grand title, but he was no fool in matters of imagery and publicity. Accompanied only by one aide-de-camp, he casually extended his daily stroll from the gardens of the Tuileries to the new Palace of Industry. There, less than two weeks before the official opening of the Salon on May 1, he asked the attendants to show him some of the rejected paintings as well as some of the accepted ones. Checking with gloved hands through dozens of stacked canvases, he could find very little to choose between them. Back at the Tuileries, he summoned the officials responsible for the arts, notably Count Alfred-Émilien de Nieuwerkerke, a sculptor of sorts who owed his impressive title as superintendent of fine arts and director-general of museums to the fact that he was the lover of the emperor's cousin, Princess Mathilde. The emperor proposed that the jury reconsider and modify its verdicts, but he was told that this would compel the jury to resign, thus weakening official authority in the arts. Then he had a much better idea. "Numerous complaints have reached the Emperor on the subject of works of art which have been refused by the jury…" said the surprising announcement in *Le Moniteur* of April 24. "His Majesty, wishing to let the public judge the legitimacy of these complaints, has decided that the rejected works of art are to be exhibited in another part of the Palace of Industry.…"

Thus was created the celebrated Salon des Refusés, which has acquired an acutely symbolic significance in the annals of art, an importance perhaps greater than the artistic merit of the paintings on exhibit. "Henceforth," as Pierre Schneider has written, "the body artistic split into the 'academics' and the 'independents.' The experiment of the

Salon des Refusés was never to be forgotten by the revolutionary artists of later years. In 1863 the École's° undisputed authority ended and the avant-garde was born." If, as is often said, Manet was the first modern painter, it was here that he first showed himself as such, here in this strange scene of Victorine Meurent and her friends picnicking in the sun-dappled woods. And if most critics were blind, the best young painters saw the uniqueness of Manet almost immediately. "Manet was as important to us as Cimabue and Giotto were to the Italian Renaissance," said Renoir. And Gauguin: "Painting begins with Manet."

This question of Manet's modernity remains a little ambiguous, particularly in a time when Mark Rothko and David Smith are considered virtually old masters. In Manet's own time, in his youth, the two great contemporaries who seemed to divide all of painting between them were Ingres and Delacroix, Ingres the classicist and Delacroix the Romantic, Ingres the master of line and Delacroix the master of color. Manet and Proust timorously called on Delacroix, ostensibly to ask permission to copy his *Dante and Virgil in Hell* in the Louvre, but Delacroix, who later reciprocated Manet's admiration, was already a historic figure. Manet was exploring a modernity that he did not fully understand as such; he considered it simply painting what he saw.

Manet's modernity is partly a matter of technique, of his foreshortened perspective, his habit of leaving many pictures looking unfinished, his hard edges, possibly derived from the new craze for photography, his innovations in creating paintings that are implicitly about the act of painting. But his modernity also lies in his insistence on what was then modern subject matter, not the traditional Roman warriors or biblical events but cafés, street scenes, the contemporary Parisian life. This was not all of Parisian life, to be sure—there are very few workers in Manet's vision, very few miners or seamstresses (or indeed peasants, like the figures in Courbet). Manet's Paris, even in his portraits of bohemia, was essentially the Paris of the newly triumphant bourgeoisie, which not only recognized Manet as a member but which took an increasing interest in seeing pictures of itself, at play and on display.

This was, nonetheless, a very insecure bourgeoisie. It had emerged out of several revolutions, and everywhere it looked, it saw menace, both

°The official École des Beaux Arts.

above and below, and also within itself. Manet knew all that from experience, and his Parisians often display anxiety in the midst of their entertainments, the anxiety of competition and alienation. His characters often avoid looking at each other, seem almost not to know each other, seem angry with each other. *"Il faut être de son temps,"* Manet often said. One must belong to one's time. It is this attitude, and this understanding of the anxieties of modern times, that makes Manet seem so modern. Indeed, if the term post-modern means anything, Manet could almost be called post-modern.

And yet he was deeply conservative, deeply traditional. He saw the naked figure of Victorine Meurent in terms of Giorgione and Raphael. And Velázquez, always Velázquez. In quoting and echoing the masters of the Renaissance, in ways that most of his contemporaries never noticed, Manet was asserting not his modernism but his classicism; yet it was a classicism that insisted that the great traditions must continue, that modernism was not a break with the past but an evolution of the past. When he repainted Giorgione or Velázquez, he was reconceiving and rethinking their visions.

Manet's young and younger contemporaries recognized all this almost by instinct, and so they regarded him as their leader and hero. Manet wanted none of that. He enjoyed the companionships of the café life, but he worked alone. That too was very modern, as recognized by Baudelaire in his prescient proclamation on "the heroism of modern life" in his review of the Salon of 1845. "Everybody paints better and better, something that strikes us as desolating—but of invention, of ideas, of temperament, there is no more than before," Baudelaire wrote. "To the wind that will blow tomorrow, nobody is lending an ear, and yet the heroism of modern life surrounds us and presses us.... The true painter is he who will know how to seize on the epic side of actual life, to make us see and understand how grand and poetic we are in our neckties and our polished boots."

We do not know for certain whether Manet ever read that declaration—it appeared when he was just thirteen—but the two men met in about 1859 and became friends. They shared a fascination with everything Spanish and often went together to see the Spanish dancers who performed at the Hippodrome in 1862. Baudelaire never wrote at any length about Manet's early works, which he admired, but Manet made half a dozen attempts to etch the haunted face of the poet, first in pro-

file under the towering hat of a devoted *flâneur,* or boulevardier, then in a full-face portrait based on a photograph by the eccentric known as Nadar. No less important, Manet painted in 1862 the only portrait ever done of Baudelaire's Creole mistress, Jeanne Duval, who by then was past forty, partly paralyzed, and grimly bitter. Manet, as was his way, painted all those "modern" details exactly as he saw them, and Baudelaire was hardly overjoyed. The picture, probably offered to Baudelaire and probably declined, remained in Manet's atelier until his death.

Now the emperor had provided a handsome theatre for all of the rejected painters at the Salon des Refusés. "It was all very well set out," as Émile Zola later wrote in his novel *L'Oeuvre (The Masterpiece),* "the setting quite as luxurious as that provided for the accepted pictures: tall, antique tapestry hangings in the doorways, exhibition panels covered with green serge, red velvet cushions on the benches, white cotton screens stretched under the skylights, and, at the first glance down the long succession of rooms, it looked very much like the official Salon, with the same gold frames, the same patches of color for the pictures. But what was not immediately obvious was the predominant liveliness of the atmosphere, the feeling of youth and brightness. The crowd, already dense, was growing every minute, for visitors were flocking away from the official Salon, goaded by curiosity, eager to judge the judges...."

An astonishing total of 7,000 Parisians crowded the Salon des Refusés during the first few hours of opening day, May 15, 1863. But despite Zola's "feeling of youth and brightness," most accounts of the affair indicate that the crowds came not to admire the rejected but to gape and laugh and jeer. Or so said the newspapers of the day, which are not necessarily the most reliable witnesses to artistic events in nineteenth-century Paris.° "This exhibition, at once sad and grotesque, is one of the oddest you could see," Maxime du Camp wrote in the influential *Revue des Deux Mondes.* "It offers abundant proof of what we knew already, that the jury always displays an unbelievable leniency. Save for one or two questionable exceptions there is not a painting which deserves the honor of the official galleries.... There is even something cruel about this exhibition: people laugh as they do at a farce. As a

°"Poor twentieth century..." Edmond de Goncourt wrote in his journal in 1885, after reading *Le Figaro*'s account of one of his own receptions, which the writer told him had to be written before it happened because of early deadlines, "if it tries to get information about the nineteenth century from the newspapers!"

matter of fact, it is a continual parody, a parody of drawing, of color, of composition. These, then, are the unrecognized geniuses and their productions!"

The Emperor Napoleon came, together with the Empress Eugénie, to inspect the results of his magnanimity. The imperial couple paused for several minutes before Manet's *Déjeuner sur l'herbe*. The emperor thoughtfully stroked his mustache while his courtiers waited and watched for some sign of the imperial judgment. The emperor made a silent gesture that was said to be a shrug of dismissal; some accounts say that he pronounced the picture "immodest"; the empress was later reported to have judged it obscene. The emperor privately bought for himself, however, Alexandre Cabanel's *Birth of Venus,* in which the voluptuous blond goddess lies dozing on a bed of ocean waves while a heavenly chorus of cherubs announces her arrival. The press and public took their cues from the imperial verdict. The sycophantic Théophile Gautier, who had once preached the independence of art for art's sake, now managed to devote twelve articles to the official Salon (in which he described Cabanel's *Birth of Venus* as "of an extreme charm") without even mentioning the Salon des Refusés.

Not everyone was so indifferent. Zacharie Astruc, the would-be poet who was soon to baptize *Olympia,* wrote a passionate defense of his friend: "One must have the strength of two to stand up under the storm of fools who pour in here by the thousands to jeer to the limit, with stupid smiles on their lips.... Manet, one of the greatest personalities of our time, is its *éclat,* its inspiration, its pungent savor, its astonishment." But the prevailing opinion was that Manet was just showing off, trying to provoke a scandal. "There has been a lot of excitement about this young man..." wrote Jules Castagnary. "But then what? Is this drawing? Is this painting?... Not one detail has attained its exact and final form.... I see boneless fingers and heads without skulls.... What else do I see? The artist's lack of conviction and sincerity."

What Manet was actually doing during much of this uproar was painting something far more shocking and far more wonderful, Victorine as the mysterious Olympia. There is no way of knowing now exactly what Manet had in mind; Olympia is both a woman and an icon, both a woman and a design, both a woman and an idea. Manet made many pre-

liminary studies, and Olympia looks quite different in every one of them. The first version, which may have been no more than a sketch of an impulse, shows a rather anonymous-looking brunette lying on her side— but with a wide-eyed black cat perched nearby. The first actual study that is recognizably Victorine, done in red chalk, is only recognizably her body; the egg-smooth face has no features whatever. Then there is a watercolor in which Victorine's hair flows loose over her shoulder, and she looks much thinner and younger, rather like a discontented coed. There is a woodblock, too, and two etchings, all done after the painting, as though Manet could never be satisfied with this figure.

As with *Le Déjeuner sur l'herbe,* he seems to have planned to invoke a Renaissance painting and then to modernize it almost to the point of parody. His main source this time was Titian's *Venus of Urbino,* which he had copied in the Uffizi Gallery when he visited Florence in 1853. She, too, lies voluptuous on a white couch, with her left hand across her thigh, but the tone is entirely different. Though apparently modeled by a well-known courtesan, she gazes demurely past the viewer toward some spot in the middle distance. Other contrasts between *Olympia* and Titian's *Venus* are even more striking. In the background, for example, two of Venus's servants busy themselves with domestic duties, apparently packing or unpacking a bridal chest, whereas Olympia's black maid brings in a huge bouquet as an apparent invitation to further action. At Venus's feet, a little lap dog dozes in quiet comfort, very different from the yellow-eyed black cat that arches its back for Olympia. And then there is Venus's guardian hand. "If the latter's hand, lying relaxed over her sex, subtly draws attention to that region, it also conceals it in the manner of the classical Venus Pudica," as Theodore Reff writes with scholarly delicacy in *Manet: Olympia,* "whereas Olympia's hand, its fingers more firmly pressed against her thigh and tensely splayed, conveys at once a greater inhibition and a more deliberate provocativeness."

Some have suggested the influence not of Titian so much as of Goya, and it is true that the cool and appraising eye of the celebrated *Naked Maja* more closely resembles the spirit of Olympia, but the pose and the design are quite different. Indeed, when one attempts a survey of reclining nudes, they all have certain elements in common, but any search for sources and influences is little more than a historical guessing game. The young Manet had also copied in the Louvre Titian's *Jupiter*

and Antiope, for example, in which the voluptuous maiden, with her left hand in the traditional position, awaits with interest the advancing god. And he quite probably knew Velázquez's "Rokeby Venus," and certainly Courbet's *Reclining Nude*, painted just a year before *Olympia*. In the Salon of 1863, from which *Le Déjeuner sur l'herbe* had been excluded, the jury accepted not only Cabanel's *Birth of Venus* but two other versions of that legendary scene as well.

Manet's apparent quotations, his repeated reminders that a painting is being painted, have enthralled the critics and scholars of this burnt-out age, which cherishes such things, which dotes on citation and pastiche and parody. "Manet's deliberate allusions to older art..." as Reff writes, "is one of the reasons that his art of that period seems modern, seems in fact to mark the real beginning of modern art." Though Manet may have thought that he was exhibiting his works to a sophisticated Parisian audience, however, virtually none of his contemporaries recognized any of his allusions to the masterpieces of the past. It was not until 1897 that a critic first saw any connection between *Olympia* and the Titian *Venus* upon which it had been so artfully modeled. All that these contemporaries saw, to the extent that they saw anything, was something scandalous.

Did they also see a boast, or, depending on one's point of view, a confession? In other words, is *Olympia*—and, to a somewhat lesser extent, *Le Déjeuner sur l'herbe*—evidence of a love affair between Manet and Victorine Meurent? There is no documentary proof of any kind, no letters or journals to corroborate the supposition. This does not, of course, deter a biographer like Henri Perruchot, who writes suggestively that "Victorine satisfied not only the painter in Manet, but also the man. There was soon a good deal of gossip concerning their relationship. Suzanne probably never heard it, but in any case she was much too placid by nature to be alarmed by a fancy of this kind." Such suggestions all derive, however, from one's own preconceptions. If one assumes that all men and women fornicate whenever the opportunity arises, if one assumes that the French are particularly self-indulgent in these matters, that artists think of little else, and that models are by definition available to anyone who asks, then the relationship of Manet and Victorine seems self-evident. If, on the other hand, one remembers that the French bourgeoisie of the nineteenth century was ridden with taboos and repressions, that Manet seems to have been quite inhibited,

that he lived under the watchful eye of his mother, and that he had just recently become married, then the implications are not so clear.

Let it also be recorded here that Manet was, in the words of a contemporary journalist named Paul Alexis, "one of the five or six men of present-day Parisian society who still knows how to talk to a woman. The rest of us, feverish analysts, desperately ambitious or dreamily hypochondriacal, are too bitter, too distracted, too deep in our obsessions: our forced gallantries make us resemble bears dancing the polka; we may pretend to have velvet paws, but our claws, suddenly appearing, frighten and scandalize; our imagination fails to caress like the fans of our partners. Édouard Manet is a happy exception."

The essential evidence, though, is in the painting itself. It is easy to argue that Manet painted Victorine with such passionate admiration for her body that he must have known it. But such an argument, too, simply reflects preconceptions. Why must he? The passionate admiration is undeniable, but why is it inevitable that it was ever consummated? And then there is the ambiguous expression on Olympia's face. What looks independent and defiant if she is, as generally supposed, a demimondaine getting ready to open for business, looks rather different if one starts wondering whether she has been making love with the man who is painting her picture. "Yes, she did—that's what gives her that confidence, that strength," says a contemporary New Yorker who has modeled in similar circumstances. "That look that says—well, how can I put it?—that she knows her adversary."

Perhaps, but that whole approach derives from yet another preconception, that the expression on Olympia's face was truly the expression on Victorine's face, when we know very well that Manet could and did paint Victorine to look however he wanted her to look. She may, at the very moment when he added the most sensuous touch to her lips, have been staring vacantly into space and wondering what to buy for dinner. Manet did realize, when it was all done, that he had painted not only something extraordinary but something revelatory, confessional, something that told—perhaps because he was not sure exactly what it did tell—more than he wanted told. And so he put it away, did not submit it to the jury for the Salon of 1864, took it out again, retouched it a bit, put it away again, showed it to a friend or two, thought about it, then finally offered it to the Salon of 1865 and found himself in the center of a maelstrom.

The uproar about *Olympia* seemed so extreme, in what was after all the age of the can-can and the imperial demimonde, of *Madame Bovary* and *Nana,* that some observers tried to suggest outside influences as an explanation. "Rowdies, specially recruited to come and scoff at the 'Olympia,' laughed, screamed and threatened; sticks and umbrellas were brandished before this awakening beauty," wrote Manet's first biographer, Edmond Bazire, just a year after the painter's death. "The scoffers formed bands which even the army was unable to disperse. The terrified authorities were obliged to protect the picture with two uniformed guards. Even that wasn't enough...."

While it has never been established that anyone really recruited people to threaten *Olympia,* the authorities did become so nervous about disorders that they decided to rehang the picture high up against the ceiling, where it would be safe from flailing umbrellas and thrown objects (and also from admiring observation). "At an immeasurable height," as Bazire put it, "where it defied at one and the same time the fury and glances of the crowd."

The press, of course, reported all this with glee. "An epidemic of crazy laughter prevails...in front of the canvases by Manet," Ernest Fillonneau wrote in *Le Moniteur.* And Felix Jahyer, in his pamphlet on the Salon: "Such indecency! It seems to me that *Olympia* could have been hung at a height out of range of the eye.... I should hope that the derision of serious people would disgust him with this manner so contrary to art." And Ernest Chesneau in *Le Constitutionnel:* "He succeeds in provoking almost scandalous laughter, which causes the Salon visitors to crowd around this ludicrous creature called *Olympia.*" And Jules Claretie in *L'Artiste:* "We find him [Manet] again this year with two dreadful canvases, challenges hurled at the public, mockeries or parodies, how can one tell? Yes, mockeries. What is this Odalisque with a yellow stomach, a base model picked up I know not where, who represents Olympia? What Olympia? A courtesan no doubt."

And finally the magisterial denunciation by Gautier: "In many persons' opinion, it would be enough to pass by and laugh; that is a mistake. Manet is not of no account; he has a school, he has admirers and even enthusiasts; his influence extends further than you think. Manet has the distinction of being a danger. But the danger is now past. *Olympia* can be understood from no point of view, even if you take it for what it is, a puny model stretched out on a sheet. The color of the

flesh is dirty, the modeling nonexistent. The shadows are indicated by more or less large smears of blacking.... Here there is nothing, we are sorry to say, but the desire to attract attention at any price."

It is possible that all this criticism missed Manet's point entirely. The distinguished art historian E. H. Gombrich likes to tell of a scene in which a woman visiting Matisse's atelier complained that "surely the arm of this woman is much too long," and Matisse replied: "Madame, you are quite mistaken. This is not a woman, this is a picture." Émile Zola was to make much the same judgment on Manet's *Olympia* and the absurd uproar that surrounded its first appearance. "Tell them aloud, then, *cher maître,* that a painting is for you a mere pretext for analysis," he wrote. "You needed a nude woman, and you chose Olympia, the first to come along; you needed clear and luminous tones, and you introduced a bouquet; you needed black tones, and you placed in a corner a Negress and a cat. What does all that mean? You hardly know, and neither do I."

It is also quite possible, of course, that Zola, like so many formalist critics, is overintellectualizing a largely unintellectual process, that *Olympia* is no more a "pretext for analysis" than it is what Sir Kenneth Clark called a magnificent study of white on white. Perhaps one might come closer to the true origins of artistic impulses by recalling one of E. E. Cummings's slightly self-conscious disputations: "Mr youse needn't be so spry/concernin questions arty/each has his tastes but as for i/i likes a certain party/gimme the he-man's solid bliss/for youse ideas i'll match youse/a pretty girl who naked is/is worth a million statues."

In any case, Manet was deeply wounded by the storm of criticism, and he had little recourse. "I could wish you were here," he wrote to Baudelaire, who was off in Brussels at the height of the controversy. "Insults pour down on me like hail. I should so much like to have your opinion of my paintings, for all this outcry irritates me, and it is evident that someone or other is at fault." But Baudelaire already knew something of how prophets are treated. The imperial authorities had prosecuted his masterpiece, *Les Fleurs du Mal* (1857), on the charge that some of his verses were an offense against public morality. He had been convicted and fined 300 francs (which was reduced to 50 francs only after Baudelaire appealed to Empress Eugénie for clemency). The judge ruled that six of his verses "inevitably lead to the arousal of the senses by crude and indecent realism," and so they were suppressed in the revised edition of 1861, a ban that was not lifted until 1949. Afflicted now by

alcohol and opium, Baudelaire was already in the grip of the illness that would paralyze and kill him within two years, in 1867, and so he received Manet's complaint with all the sympathy of a stone.

"I must speak to you of yourself," he wrote. "What you demand is really stupid. *They make fun of you; the jokes aggravate you; no one knows how to do you justice, etc. etc.* Do you think you are the first man put in this predicament? Are you a greater genius than Chateaubriand or Wagner? [Note how artfully he cites Chateaubriand rather than the obvious choice: himself.] Yet they certainly were made fun of. They didn't die of it. And not to give you too much cause for pride, I will tell you that these men are examples, each in his own field and in a very rich world, whereas you are only the first in an art in a state of decadence." Having delivered that stern lecture, Baudelaire was characteristically more sympathetic in writing about Manet to someone else, a mutual friend: "When you see Manet, tell him this: that torment—whether it be great or small—that mockery, that insults, that injustice are excellent things, and that he would be ungrateful if he were not thankful for injustice. I know well that he will have some difficulty understanding my theory; painters always want immediate success. But really, Manet has such brilliant and facile ability that it would be unfortunate if he became discouraged. He will never be able to fill completely the gaps in his temperament. But he has a *temperament,* that's the important thing...."

By that summer, Manet was sick to death of the whole controversy, sick of the whole Parisian art world. He went to the seacoast at Boulogne in search of peace, as he often did, and when he did not find it there, he suddenly decided to make his first pilgrimage to the land of Velázquez and Goya. He invited as traveling companions the fashionable Belgian painter Albert Stevens, who had become the lover of Victorine Meurent shortly after she posed for *Olympia,*° and the novelist Jules Champfleury, but when both of them delayed, he set off by himself "to receive the advice of 'Master Velázquez.'" To Burgos he went, then to Valladolid and Madrid. Like a true Parisian, he found Spain hot and dirty, and the food dreadful, but he did finally reach the Prado and see

°Kathleen Adler has even suggested that *Olympia* might have been Manet's sardonic response to Stevens's now-lost *Palm Sunday,* a great success at the Salon of 1863. *Palm Sunday* shows an amply dressed young woman, possibly modeled by Victorine Meurent, respectfully attaching sprigs of boxwood to portraits of her parents. An image of the Virgin Mary watches over the woman's nearby bed, and a white cat plays at her feet.

Velázquez as he can only be seen in Spain. "Velázquez alone makes the journey worthwhile..." he wrote to Fantin-Latour. "He is the painters' painter."

But nothing seemed to change in Manet's professional life. The following spring, he submitted to the Salon jury two completely uncontroversial new pictures, a darkly Velázquezian portrait of the actor Philibert Rouvière playing Hamlet and the famous red-capped boy known as *The Fifer* (which, according to one analyst, was actually modeled by Victorine, though Manet's unacknowledged son, Léon, is a far more likely candidate). Both were summarily rejected. But at that point, there clambered into Manet's life a bumptious young man who was to become the most passionate defender of both Olympia and of Manet himself.

Émile Zola, then twenty-six, later described himself in *L'Oeuvre* as "very dark, with a round determined face, a square nose, gentle eyes and an energetic expression." The Goncourt brothers were, as always, more cruel and probably more accurate in describing the man who claimed to be their disciple: "The wreck of a Normalian student, thick-set and sickly looking at the same time...a pale and waxy complexion.... A being difficult to grasp, profound, confused, suffering, full of anxiety, disturbed, ambiguous." Zola had indeed flunked out of a Parisian *lycée*, where he was supposed to prepare for a career as an engineer, and so he had to take a lowly job as a customs clerk, then found a place in the packing department of the publishing house of Hachette, then talked his way into the advertising department, then got his first novel published, and then, on the eve of being fired, began writing letters offering his services to various newspapers. One of these was *L'Événement,* founded by Victor Hugo in 1848, to which Zola offered short book reviews because "today's public wants brief notices, liking the news nicely served out in little dishes." He was hired.

Clearly a scrambler, industrious, indefatigable, a passionate believer in what he called the man of action, and correspondingly contemptuous of what he considered weakness and mediocrity, Zola knew little about art. But he had been a friend and schoolmate in Aix-en-Provence of a youth named Paul Cézanne. Cézanne probably accompanied him to the Salon as early as 1861 (when Zola was still only twenty-one, Cézanne twenty-two), probably pointed out Manet's portrait of his parents, as well as *The Spanish Singer,* probably took him to the Salon des Refusés, probably told him, articulated for him, what the younger generation of

painters could see in *Le Déjeuner sur l'herbe*. Zola was acutely attuned to the ambitions of the young, to the possibilities of the future. In the official rejections of Manet, he saw a wonderful opportunity for himself. And if he was something less than an authority on art, he already showed considerable skill in describing what he saw. Of the Manets that had been shown at the Salon, he wrote: "Quite simply they burst open the wall."

Like the brilliant journalist that he was, Zola not only identified the painter of the future but wangled an introduction, went to interview Manet in his studio, looked through all the rejected paintings, and then began writing. "We laugh at M. Manet, and our sons will go into ecstasies in front of his canvases," he declared. "I do not intend to set myself up as a rival Nostradamus, but I am prepared to prophesy that this change of opinion will take place in the very near future." And then: "It appears that I am the first to praise Manet without reservations. This is because I care little for all those boudoir paintings, those colored images, those miserable canvases where I find nothing alive.... I am so sure that Manet will be one of the masters of tomorrow that if I had any money, I should be sure of making a good bargain if I bought all his canvases today. In fifty years, they will sell for fifteen or twenty times more, when certain 40,000 franc paintings won't be worth forty francs...."

He was, of course, spectacularly accurate. *Le Déjeuner sur l'herbe*, for example, could not be sold at all until 1878, when Manet unloaded it on the singer Jean-Baptiste Fauré for 2,600 francs; the gallery of Durand-Ruel acquired it in 1898 for 20,000 francs, promptly sold it to the collector Étienne Moreau-Nélaton for 55,000 francs, and Moreau-Nélaton eventually donated his entire collection to the Louvre, where all pricing stops. A preliminary sketch of this painting, which Manet sold or more likely gave to a family friend, Commandant Hippolyte LeJosne, resurfaced long after the Commandant's death when his family sold it to the Société Druet in 1924 for 250,000 francs, and Druet sold it four years later to Samuel Courtauld of London for 1.2 million. All Zola had predicted sixty years earlier was that in fifty years every Manet painting would increase in value by forty times, not millions.

But the prices were only symbolic. Zola wanted above all to be "the first to praise Manet without reservations," and he was determined to praise not only the painter and the body of his work but each of the paintings that had been rejected and ridiculed. *"Le Déjeuner sur l'herbe*

is Manet's greatest painting, the one in which he has realized the dream of every painter," he wrote, and then, despite a certain hyperbolic redundancy, he became even more emphatic in his enthusiasm for what he proclaimed to be Manet's masterpiece, *Olympia.* "I said masterpiece, and I will not retract the word," Zola wrote. "I maintain that this canvas is truly the painter's flesh and blood. It is all his and his alone. It will endure as the characteristic expression of his talent, as the highest mark of his power."

Zola went on to provide detailed analyses of these works, and of the newly created and newly rejected *Fifer,* but what rings through the years is that unmistakable tone of unerring prophecy ("Hats off, gentlemen, a genius!" Robert Schumann had once written of the unknown young Chopin). Prophets are often wrong, of course, and pseudo-prophets even more often, but one senses that Zola, for all his conniving opportunism, saw and felt in Manet what Herman Melville had said of his own encounter with Hawthorne: "One shock of recognition." "People may laugh at the panegyrist as they laugh at the painter," Zola wrote. "One day we shall both have our revenge. There is one eternal truth that upholds me as a critic: it is that genius alone survives and dominates the centuries. It is impossible—impossible, do you understand?—that Manet will not have his day of triumph and crush the timid mediocrities who surround him."

Manet, who was considerably more elegant than Zola, had no great desire to crush timid mediocrities. Revenge was not his style; he had work to do. But after several years of mindless attacks, he could hardly help feeling some gratitude toward this noisy enthusiast. "I don't know where to find you," he wrote on the day Zola's article appeared in *L'Événement,* "to shake your hand and tell you how proud and happy I am to be championed by a man of your talent. What a fine article. A thousand thanks."

This was the third in a series of articles that Zola planned to write on the Parisian art scene, but these first installments stirred up such a storm of objections that his editor, mindful of the stiff fines and jail terms that the imperial authorities regularly imposed on troublesome newspapers, ordered him to bring his series to a halt. Zola realized, however, that he had found a splendid subject for his argumentative talents. He went and interviewed Manet some more, then expanded his original article and republished it the following January in *La Revue du XIXe Siècle.* "What a

famous New Year's present you've given me," Manet promptly wrote him, "in your remarkable article, which is very gratifying. It comes in good time...."

It came in good time because Manet was again being rejected by the Salon, and so he was planning a major exhibition at his own expense. It would of course include both *Le Déjeuner sur l'herbe* and *Olympia.* Zola promptly proposed that his article serve as a catalogue. Manet at first agreed—"I confess I should be only too pleased to see your pamphlet about myself on sale at my show"—but some scruple intervened. "My dear friend," he wrote, "upon sober reflection, I believe it would be in bad taste and would unnecessarily dissipate our strength to reissue and sell such a perfect eulogy of myself at my own show." Zola, to whom the concept of good taste was almost unknown, repolished his observations on Manet and republished them anyway as a pamphlet timed to coincide with Manet's exhibition. Then he published them once again in his book of art criticisms, *My Salon* (1879).

Manet repaid him with far more than letters of thanks. He painted his portrait: a watchful, wary Zola, sitting at his cluttered desk but rather formal in his black jacket and gray-striped trousers. And since Zola was incapable of not writing about anything that happened to him, he acutely described the drudgery of posing for Manet and thus inadvertently left us an account of what may have gone through the mind of Victorine Meurent during those long hours when she played the part of Olympia. "In the numbness that overtakes motionless limbs, in the fatigue of gazing open-eyed in full light, the same thoughts would always drift through my mind, with a soft, deep murmur," he wrote to Théodore Duret. "The nonsense abroad in the streets, the lies of some and the inanities of others, all that human noise which flows, worthless as foul water, was far, far away.... At times, in the half-sleep of posing, I would watch the artist, standing before the canvas, face tense, eye clear, absorbed in his task. He had forgotten me, he didn't know I was there, he was copying me as he would have copied any human animal, with an attention, an artistic awareness, the like of which I have never seen...."

In all this somberness, there is one little joke. To the fashionable Japanese pictures on the walls of Zola's study, Manet added one small sketch of a beautiful girl lying naked on a white pillow and being offered a bouquet of flowers by her black servant. It is, of course, Victorine Meurent as *Olympia,* but just as all the preliminary sketches of her kept

coming out differently, so this one is slightly different too. Only here is she looking not directly out at the viewer but slantingly toward one side, toward Zola sitting at his desk. Could there have been any higher compliment?

Conversely, the French authorities paid *Olympia* their highest compliment (a negative compliment being the highest of which French officialdom is capable) when the definitive Manet exhibition of 1983 was being organized to commemorate the hundredth anniversary of the painter's death. They agreed to send just about anything in the Jeu de Paume on loan to the Metropolitan Museum in New York, just about anything, but not Victorine Meurent picnicking on the grass and not Victorine lying on her pillows with that flower in her hair and that mysterious look in her eyes. No insurance could be high enough, no security precautions intense enough, to permit those two images ever to leave their native France.

· 2 ·

EMPRESS EUGÉNIE

How ignoble men are!
—PRINCESS MATHILDE

Men are worth nothing at all.
—EMPRESS EUGÉNIE

Manet never painted the most powerful woman in France, the Empress Eugénie, who had disapproved of *Le Déjeuner sur l'herbe,* and so the great tradition of Spanish royal portraits failed to reappear under the empire of Napoleon III. There was no sequel to Velázquez's Isabella of Bourbon or Mariana of Austria, or to Goya's relentless portraits of Charles IV and his queen. Instead of some subtle masterpiece by Manet, we have only the conventional handiwork of Franz Xavier Winterhalter, who generally portrayed the empress and her ladies in waiting as waxworks dolls.

This is in many ways a pity, for Eugénie was considered a great beauty. "She possessed a singularly striking face, oval in contour, and remarkable for the purity of its lines," according to the rather effusive memoirs of Dr. Thomas W. Evans, the courtly Philadelphia dentist whose mastery of the anesthetic powers of nitrous oxide had made him a court favorite from Paris to St. Petersburg. Dr. Evans's praises extended to Eugénie's complexion, which was "brilliant, light, clear"; to her eyes, "peculiarly soft and liquid, shielded by long lashes"; to her hair, "of a most beautiful chestnut color"; to her figure, "above the average in height and almost perfect in its proportions—the waist round and the neck and shoulders admirably formed"; and, of course, her mouth, "a small, delicate mouth that disclosed when she smiled teeth that were like pearls."

The occasion for this rhapsody was Eugénie's marriage to the Emperor

Napoleon III, on January 30, 1853, which was quite the finest thing of its kind and time. The master designer Eugène Viollet-le-Duc, who was in the process of renovating the Cathedral of Notre Dame, redecorated the whole building for the wedding ceremony, hanging brightly colored streamers from the roof, an ermine-lined velvet canopy above the altar, and so on. Fifteen thousand candles. An orchestra of 500 musicians to play Daniel Auber's fanfares. Napoleon's wedding present to his bride was a pearl-and-sapphire pendant that contained a fragment of the True Cross, once sent by Harun al-Rashid to Charlemagne. The city of Paris tried to give her a 600,000-franc set of diamonds, but Eugénie grandly declined and asked the city authorities to donate the money to the poor.

"I nearly fainted before entering the *Grande Salle* where we signed," she wrote to her older sister Paca about the previous day's civil ceremony. "I cannot express all that I suffered.... I was paler than the jasmine which I wore on my heart...." By the next day, though, when she rode through Paris in the gilded imperial coach, her hair alight with diamonds and orange blossoms, she was fully in command. Evans's account: "When the archbishop said to her: 'Madame—you declare, recognize, and swear before God, and before the Holy Church, that you take now for your husband and legal spouse the Emperor Napoleon III, here present,' she responded in a clear, sweet voice, '*Oui, Monsieur.*'"

Who could have guessed that only five years earlier the beautiful Eugénie had been thrashing around in agony, having just swallowed a poison that she had concocted from matchstick heads because the Spanish marquis who she thought was in love with her was actually pursuing her older sister? Who, for that matter, could have guessed that only seven years earlier the imperial bridegroom had been imprisoned for life in the dank fortress of Ham, or that he kept as his mistress there a laundress named Alexandrine Vergeot who bore him two illegitimate sons? In creating grand-opera roles for themselves, Napoleon and Eugénie also created an operatic empire as a stage set on which they could play those roles, on which the most impressive effects could all be achieved with fireworks and mirrors.

Despite the imperial title that Napoleon had formally bestowed on himself two months before his marriage, it had not been easy for him to find an empress. The most distinguished European families recalled only too well how his tempestuous uncle had shattered the monarchical traditions of the entire continent, and they still knew the Bonapartes as a

squalling family of rather unimpressive Corsican lineage. If the first Napoleon had asserted his imperial claims by force of arms, that force brought little honor to the titles he handed out to his relatives. His younger brother Louis, whom Napoleon made king of Holland in 1806 (until he drove him from his throne and annexed his "kingdom" in 1810), was a man of dark and paranoiac temperament, and afflicted by scrofula and gonorrhea as well. He never wanted to marry the gifted and giddy blonde whom Napoleon chose for him, the emperor's own stepdaughter, Hortense de Beauharnais. Louis managed to consider himself the father of Hortense's first two sons, but the king and queen were thoroughly separated in the summer of 1807, when she became pregnant again during a prolonged outing in the Pyrenees with a retinue of attendant lords and ladies.

There were some who thought that the father of the child Hortense bore the following spring was Napoleon himself, but modern scholarship attributes their intimacy to a later period. And though others think the father may have been a Dutch admiral named Verhuell, or perhaps a Dutch chamberlain named Bylandt, or perhaps a French magistrate named Descazes—Hortense was really very attractive, and not very hard to please—the likeliest candidate seems to have been another admirer, René de Villeneuve, who did accompany her into the Pyrenees. In any case, Louis Bonaparte repeatedly declined any responsibility for Hortense's third son, Charles Louis Napoleon, the future emperor. He even once wrote to Pope Gregory XVI, after the youth became briefly involved in an abortive insurrection against Gregory's rule of the papal states: "As for the [one] who usurps my name, you are aware, Holy Father, that he, thank heaven, is nothing to me. It is my misfortune to be married to a Messalina who breeds."

Even by the nineteenth century's somewhat debased standards of aristocracy, an implicitly illegitimate third son of a deposed younger brother to a fallen ex-emperor could hardly seem a very desirable matrimonial match, and so Louis Napoleon spent much of his youth in idle romantic adventures, but within the Bonaparte family dynastic ambitions still flourished. To ex-Queen Hortense, who now called herself the Duchess of Saint-Leu and lived in exile in the Swiss château of Arenenberg, the most appropriate wife for her youngest son was Princess Mathilde, the handsome and vaguely intellectual daughter of yet another Napoleonic younger brother, Jerome, sometime king of Westphalia.

Mathilde was a rather innocent fifteen and Napoleon a rather debauched twenty-eight when Hortense invited the girl to Arenenberg to be courted and seduced. Though Napoleon and Mathilde never really fell in love, they liked each other, and felt attracted, and naturally wondered whether this might not be a reasonably happy union. "We played charades and innocent little games," Mathilde later recalled. "We kissed each other as often as we could, sometimes furtively, when we could escape the vigilance of my good [chaperone]."

They considered themselves engaged, and so did their parents, but such things required elaborate financial negotiations, and Jerome Bonaparte was in no hurry to sell his daughter. While these negotiations dragged on, an extraordinary event occurred. Napoleon, all dressed up in military costume, appeared with a handful of followers at an artillery barracks in Strasbourg, at dawn of an October day in 1836, and announced that the nation was up in arms, and that a new Napoleon was marching to Paris to overthrow King Louis Philippe, of the House of Orléans. It was not to be. An obstinate colonel not only placed the would-be emperor under arrest but contemptuously knocked off his hat and tore off his epaulettes. The police then bundled the inept usurper onto a ship and sent him into exile, with a purse of 15,000 francs, in darkest America. Ex-King Jerome, who had been hoping to receive a royal pension, was horrified by Napoleon's folly. He notified him that any marriage to his daughter Mathilde was now unthinkable.

Napoleon's imperial ambitions were generally considered absurd. When Hortense's imminent death by cancer inspired her exiled son to make a furtive return to Europe, he ended as a *revenant* in the not-quite-respectable salons of London, an aging but amusing adventurer whose clothes and mustaches were not quite right and who spent a lot of time and money in pursuing women who also were not quite right. Somehow, though, he managed to borrow 20,000 pounds, to rent and outfit an excursion steamer called the *Edinburgh Castle,* and to set sail in August of 1840 to invade France with an army of fifty-six unreliable mercenaries. To his mast, he had tied a tame vulture that was supposed to represent the imperial eagle of yesteryear. Napoleon splashed ashore at Boulogne at dawn, once again attempted to harangue the local infantry barracks, once again was shouted down, and finally ran away. Captured dripping wet less than three hours after the start of his invasion, Napoleon now found himself sentenced not to a comfortable exile

in America but to life imprisonment in the fortress at Ham. And there he spent five dismal years, intermittently studying science and history, before a combination of official incompetence and official indifference enabled him to escape, back to the sanctuary of London, where he was still considered nothing more than an amusing adventurer.

But in London he now discovered Elizabeth Ann Haryett, the voluptuous daughter of a Brighton shoemaker, who had changed her name to Harriet Howard and indulged in a vocation for rich men, among them the Duke of Beaufort, the Earl of Chesterfield, and the Earl of Malmesbury. She had become fairly rich herself by the age of twenty-four, when she met this striking French exile who talked with such conviction of his struggles to become emperor. She was captivated. She bought a house in the St. James district, and took him in to live with her. And there Napoleon watched with distant satisfaction as the Parisians rose up against King Louis Philippe in February of 1848, watched as the king and queen fled to England in disguise, the king wearing goggles and a commonplace hat and calling himself Mr. Smith. Could Napoleon's imperial dreams be any more preposterous than that?

Far from rushing to join in the chaos of the nascent Second Republic, Napoleon was quite content to let others try to deal with the crises of hunger, unemployment, and rioting. Only in June did he cautiously offer his name for a seat in the legislature; he won in four different districts. The authorities decreed that the fugitive from Ham would be arrested if he returned to France, however, and so Napoleon calmly resigned his seat, declaring only that "if the people impose duties on me, I shall know how to fulfill them." And while the Parisian street violence was being brutally suppressed by General Louis Cavaignac, Napoleon turned his attention to fund-raising. For this, he mortgaged not only the property he had inherited on the recent death of his father but also the property that Harriet Howard had acquired from her various friends, notably a large estate at Civitavecchia, which she sold to Napoleon on credit so that he could mortgage it for 250,00 francs. When Napoleon was reelected to the legislature in five districts in September, the government offered no objection to his establishing himself at a hotel on the Place Vendôme, with Miss Howard around the corner, at the Meurice, on the Rue de Rivoli.

Having spent most of his life abroad, experienced in nothing but philandering and unsuccessful conspiracies, Napoleon hardly seemed over-

whelmingly impressive as a possibility for the presidency, but Miss Howard's money helped to spread his message far and wide, through posters and pamphlets, hired cabaret singers, hired newspapers. And the name was familiar. "The name of Napoleon is in itself a program," the newcomer declared. "It stands for order, authority, religion and the welfare of the people in internal affairs, and in foreign affairs for national dignity." Flaubert was more accurate when he wrote in *L'Éducation Sentimentale* that this was an age of hatred. "Hatred abounded: hatred of primary school teachers and wine-merchants, of philosophy classes and history lectures, of novels, red waistcoats, and long beards, of any kind of independence, any display of individuality; for it was necessary to 'restore the principle of authority.' It did not matter in whose name it was wielded, or where it came from, provided it was strong and powerful." When the presidential votes were counted in December of 1848, Citizen Bonaparte won a massive 5.4 million, compared to 1.4 million for the admired but also feared General Cavaignac and no more than a relative handful for the poet-politician Alphonse de Lamartine, one of the leaders of the provisional government that had replaced Louis Philippe. So the ex-fugitive returned in triumph to the Élysée Palace where, as a seven-year-old boy, he had said farewell to his uncle on the eve of Waterloo.

And nearby, at 14 Rue du Cirque, Harriet Howard maintained a luxurious hideaway. There was even a garden gate to connect the two establishments. Here Miss Howard maintained not only herself and an illegitimate son from one of her past friends but also the two sons of Napoleon and his prison laundress, Alexandre Louis Eugène and Alexandre Louis Ernest, who were destined to become the Count d'Orx and the Count de Labenne. It has been widely reported, probably falsely, that Miss Howard never hoped to become Napoleon's wife. Instead, she accepted the role that the French call *maîtresse en titre* (mistress by title). When Napoleon went traveling, she traveled with him. When he went out for an evening, he generally went with Miss Howard on his arm. There were even occasions when the two very publicly excused themselves at some soirée and retired to another room for an hour or so of relaxation.

As the official hostess at the Elysée Palace, however, Miss Howard would not do. For that role of social pseudo-wife, the president relied on his favorite cousin, Princess Mathilde. It was still an interestingly ambiguous relationship. After Mathilde's parents had forbidden any

thought of a marriage to the scapegrace young Louis Napoleon, she had been assigned to a far worse connection with the wealthy Russian Prince Anatole Demidoff, a hard-drinking rake who soon made the mistake of slapping her face in public. Mathilde walked out and demanded a large settlement, and when the prince disputed her demand, she went to Czar Nicholas I. An imperial decree awarded her a magnificent 200,000 francs a year and forbade Demidoff from coming within one hundred miles of her. Napoleon apparently proposed to her again after he became president, but she declined his offer because she was now rather openly involved with the dashing Count Nieuwerkerke. "I preferred the situation I had to the quite exceptional one which I was offered," Mathilde later recalled. "I did so without any hesitation and without the least regret. I could not have forfeited my independence when I felt that my heart was not involved."

Even with an official hostess and an official mistress, however, the forty-year-old president had now reached that combination of age and power at which longings become both easily sated and insatiable. He even used a distant cousin named Count Felix Bacciochi to act as his chamberlain, and unofficially as his "minister of pleasure," or, more simply, procurer. Psychiatric theoreticians disagree on whether such activities express an intense sexuality or a frightened insecurity about sex, but Bacciochi was not asked to have theories, only to provide willing women. What actually happened in the imperial chambers still remains somewhat uncertain. Only one of the scores of ladies who survived the scene left a detailed report of her experiences. Napoleon entered her bedroom in mauve silk pajamas, the Marquise Taisey-Chatenay recalled, and set promptly to work. "There follows a brief period of physical exertion," according to the Marquise, "during which he breathes heavily and the wax on the end of his moustaches melts, causing them to droop...." The end of these activities left the marquise "unimpressed and unsatisfied."

Napoleon took pride in being president, but he never doubted that his destiny was to be emperor, and so he began maneuvering against the rule that limited him to a single four-year term. His supporters proposed a constitutional amendment to allow him to continue in office. When the legislature rejected it in July of 1851, Napoleon started organizing a coup d'état. He controlled the army, he controlled the police, he needed only to weed out a few loyalists who believed in their oath to the young Republic. In the utmost secrecy, he planned his attack for December 2,

the anniversary of the crowning of Napoleon I and of his great victory at Austerlitz. On the evening of December 1, the president coolly attended his weekly reception until 10:00 P.M. His chief co-conspirator, Count Auguste de Morny, bastard son of ex-Queen Hortense and thus Napoleon's illegitimate half-brother, even more coolly went to the Opéra Comique that night, to the premiere of Limmandier's *Bluebeard's Castle*, where he sat next to the unwitting General Cavaignac and the Orléanist political leader Adolphe Thiers. Not until eleven o'clock did the presidential conspirators gather at the Elysée Palace to give the final orders.

The hour for the coup was 6:00 A.M. The plotters had drawn up a list of eighty possible opponents to be arrested—among them General Cavaignac, and Thiers, too—and they assigned ten policemen to wake and seize each one of them. More police printed and posted 10,000 copies of a presidential proclamation announcing a change in all the rules. By breakfast time, Napoleon controlled everything. Several hundred members of the legislature who tried to assemble at the Palais Bourbon were barred by African Chasseurs. At 11:00 A.M. Napoleon emerged from his palace and rode through the streets on a black horse, surrounded by troops shouting *"Vive l'empereur!"*

But it had been too quick, too easy. The next day, a number of barricades arose in the streets, and youths threw stones at advancing troops. Napoleon's commander, General Bernard Magnan, decided to let the opposition build up until he could see how big it was before he smashed it. And so, for the next twenty-four hours, more barricades arose, the crowds grew, and there were cries of *"Vive la République!"* Then General Magnan brought out his troops. Victor Hugo, in *The History of a Crime,* described the scene:

"Suddenly, at a given signal, a...shower of bullets poured upon the crowd.... Eleven pieces of cannon wrecked the Sallandrouze carpet warehouse. The shot tore completely through twenty-eight houses. The baths of Jouvence were riddled. There was a massacre at Tortoni's [café]. A whole quarter of Paris was filled with an immense flying mass, and with a terrible cry....

"Adde, a bookseller, of 17, Boulevard Poissonnière, is standing before his door; they kill him. At the same moment, for the field of murder is vast, at a considerable distance from there, at 5, Rue de Lancry, M. Thirion de Montauban, owner of the house, is at his door; they kill him.

In the Rue Tiquetonne a child of seven years, named Boursier, is passing by; they kill him. Mlle. Soulac, 196, Rue du Temple, opens her window; they kill her....

"New Year's Day was not far off, some shops were full of New Year's gifts. In the Passage du Saumon, a child of thirteen, flying before the platoon-firing, hid himself in one of these shops, beneath a heap of toys. He was captured and killed. Those who killed him laughingly widened his wounds with their swords. A woman told me, 'The cries of the poor little fellow could be heard all through the passage.' Four men were shot before the same shop....

"At the corner of the Rue du Sentier an officer of Spahis, with his sword raised, cried out, '...Fire on the women.' A woman was fleeing, she was with child, she falls, they deliver her by the means of the butt-ends of their muskets. Another, perfectly distracted, was turning the corner of a street. She was carrying a child. Two soldiers aimed at her. One said, 'At the woman!' And he brought down the woman. The child rolled on the pavement. The other soldier said, 'At the child!' And he killed the child....

"In the Rue Mandar, there was, stated an eyewitness, 'a rosary of corpses,' reaching as far as the Rue Neuve Sainte-Eustache. Before the house of Odier twenty-six corpses, thirty before the Hotel Montmorency. Fifty-two before the Variétés, of whom eleven were women. In the Rue Grange-Batelière there were three naked corpses. No. 19, Faubourg Montmartre, was full of dead and wounded. A woman, flying and maddened, with dishevelled hair and her arms raised aloft, ran along the Rue Poissonière, crying, 'They kill! they kill! they kill! they kill! they kill!'"

Alexander Solzhenitsyn once declared that "a great writer is a second government in his country," and so, as France was acquiring the empire of Louis Napoleon, it also acquired the heroic jeremiads of Victor Hugo. Though the riots at the opening night of Hugo's *Hernani* had marked the triumph of the Romantic movement back in 1830, though *Notre Dame de Paris* and *Le Roi s'amuse* and *Ruy Blas* were all now part of history, Hugo was still only forty-six when he and Napoleon were both elected to the legislature of the Second Republic. Hugo's father had been a general in the first Napoleon's armies, but the poet was hardly political at all. The second Napoleon respectfully paid him a call, disavowed any imperial ambitions, claimed that "I stand for liberty." Hugo believed him and supported his presidential candidacy. It was partly the sense of being lied

to and betrayed that turned Hugo into a raging tiger, and led him to describe Napoleon's coup as "an odious, repulsive, infamous, unprecedented crime."

Another witness to this crime was a nineteen-year-old art student, an ardent supporter of the murdered republic, Édouard Manet. Though safe at home when the shooting started, he couldn't resist venturing out into the streets with his friend Proust to see what was happening. A cavalry charge on the Rue Lafitte nearly ran them down, but a shopkeeper opened his door to give them shelter. A bit later, they were caught in the midst of a cannonade on the Boulevard Poissonière. Arrested finally, they were confined at an ambulance station until some friends in the neighborhood managed to win their release.

When the firing died down, Thomas Couture dutifully took all his young pupils to the Montmartre Cemetery to survey the corpses. There were five or six hundred arrayed there on beds of straw, with only their heads exposed to view so that searching wives and relatives could try to identify the missing. Amid occasional shrieks of recognition, Manet and his fellow students slowly filed past the corpses on rickety wooden walkways, stopping every once in a while to attempt a sketch of the scene. Proust recalled seeing Manet make one such sketch, but no trace of it has ever been found.

Fleeing into exile, Victor Hugo began a crusade that was to last for the next twenty years.

> "*Cet infâme,*" he wrote, "*apportait à Dieu son attentat*
> *Comme un loup que se lèche après qu'il vient de mordre.*
> *Caressant sa moustache, il dit—J'ai sauvé l'ordre....*°

But Victor Hugo probably misjudged the emperor whom he called "Napoleon the Small" as badly as he had misjudged the legislator who had said he stood for liberty. Napoleon could say such things and believe them and betray them and still believe them. "If you repeat a thing often enough," his mother once told him, "it will ultimately be believed." He

°"This monster brought his crime before God, / Like a wolf that licks its chops after it bites. / Caressing his moustache, he says—I have preserved order...."

also said that the empire meant peace, then led it into war, and yet hated war. He remembered that George Sand had written him kind letters when he was imprisoned at Ham, so when she now rebuked him for imprisoning his enemies, he asked her to name anybody she wanted freed, so she did, and he freed them.

"To fathom his thoughts or divine his intentions would try the powers of the most clear-sighted," the new British ambassador, Lord Cowley, wrote shortly after Napoleon's coup. "No one's advice seems to affect him. He seems a strange mixture of good and evil. Few approach him who are not charmed by his manners. I am told that an angry word never escapes him. His determination of purpose needs no comment."

Analysts sought precedents for the contradictions. Someone described the new emperor as a combination of Don Quixote and Machiavelli, but if he was both, he was also neither. Even after his fall nearly two decades later, nobody really understood him. Zola asked Flaubert for the details of those glittering state dinners at the summer palace in Compiègne, and Flaubert suddenly began a pantomime. "Flaubert in his dressing gown plays for Zola a classic emperor," Edmond de Goncourt recorded in his journal, "with dragging foot, one arm folded behind his back, twirling his moustaches, uttering characteristic idiotic phrases.

"'Yes,' he says, when he is sure that Zola has got his sketch in mind, 'that man was stupid, he was stupidity incarnate!'

"'Certainly I am of your opinion,' I say to him; 'but stupidity is usually loquacious and his was silent. That was his strength: it allowed people to suppose anything.'"

But they were all wrong, too, in the usual manner of intellectuals who judge a ruler by whether he has admired their books. Among Napoleon's many sins, stupidity, if that is a sin, was not one. It was by intelligence, by wit, by guile, by that essential political judgment of the right moment and the right opportunity, that he made himself emperor of France. And if ambiguity was inherent in his political genius, so was it in the empire that he created and governed. This was an empire that not only insisted on the frivolities of court uniforms and elaborate coats of arms but also redesigned and reconstructed the entire center of Paris, that built canals and sewage systems and vast railroad networks. And created millionaires overnight, and deepened the depths of poverty. How is one to judge

these things? It was an empire that prosecuted Flaubert for *Madame Bovary* and then acquitted him. It was an empire that prosecuted Baudelaire for *Les Fleurs du Mal* and then witnessed the Empress Eugénie offering to pay his fine. It was also an empire in which both *Madame Bovary* and *Les Fleurs du Mal* came to be written, and *Les Troyens* composed, and *Olympia* painted.

"He was very much better than what his previous life and crazy enterprises led one to expect..." said Alexis de Tocqueville, who was already famous for his report on the young America but who also served as foreign minister in the republic that Napoleon had overthrown. "In this way he deceived his foes and perhaps even more his friends.... As a private person he possessed some attractive qualities—a kindly disposition, humanity, gentleness and even tenderness, perfect simplicity.... He combined admirable courage at times of crisis with vacillation in his plans. His vulgar pleasures weakened his energies. His mind was full of big but badly coordinated ideas...."

<center>⁂</center>

Napoleon ordered a *Te Deum* sung in every cathedral on New Year's Day of 1852, and then set about transforming the Second Republic into the Second Empire. He ordered a new constitution rushed to his desk, which gave him a ten-year term as chief of state. After a year of maneuvering and propaganda, he scheduled a plebiscite on December 2, that anniversary of the first Napoleon's coronation, which was now the anniversary of his own coup, and the results gave him 7.8 million out of about 8.2 million votes cast.

"The shooting on the boulevards won the approval of Chavignolles," as Flaubert wrote of the Norman village in which he set his last novel, *Bouvard et Pécuchet*. "No mercy for the defeated, no pity for the victims! As soon as anyone rebels he is a scoundrel. 'Let us thank Providence,' said the curé, 'and then Louis Bonaparte. He surrounds himself with men of the greatest distinction....'

"'Do you want to know my opinion?' said Pécuchet. 'Since the bourgeois are savage, the workers jealous, the priests servile, and the people will accept any tyrant, so long as he leaves their snouts in the trough, Napoleon has done well! Let him gag them, trample them, exterminate them! Nothing will ever be too much for their hatred of the law, their cowardice, their ineptitude, their blindness!'"

If Napoleon was going to become a real emperor, though, he had to start searching for an appropriately regal empress to provide him with an heir who could carry on the Bonaparte dynasty. And if Princess Mathilde would not have him, then he would start prowling through the royal families of Europe. The first good candidate was the seventeen-year-old Princess Caroline Vasa, daughter of the Grand Duke of Baden. That was a relatively modest title, but Caroline was connected to the royal houses of Austria, Prussia, and Russia. She was also connected to Napoleon himself, being the great-granddaughter of Claude de Beauharnais, brother-in-law of the first Napoleon's Empress Josephine. That self-created emperor had once spoken of the need to find "some hideous German princess with big feet," but Caroline was rather attractive, and even willing to convert to Catholicism for the sake of such a marriage. Her parents, however, were dubious of the new Napoleon's prospects, not to mention the twenty-seven-year difference in ages, and the Habsburgs also disapproved, and so a letter from Baden to Paris declined the presidential overtures.

Napoleon's ambassador to London, Count Alexandre Walewski, the illegitimate son of Napoleon I and thus the illegitimate cousin of Napoleon III, had a somewhat more ambitious plan, to arrange a marriage with the nineteen-year-old Princess Adelaide, granddaughter of the Duchess of Kent and half-niece of Queen Victoria. The queen was not amused. In a meeting with Prince Albert and the foreign secretary, she worried about "the sad fate of all the wives of the rulers of France since 1789," and she worried even more that the prospective bride, lacking Victoria's sense of history, "should be dazzled if she heard of the offer." As indeed she was. Wiser heads decided such matters in those days, however, and so Paris was once again notified that the marriage would be unsuitable. "I feel your dear child is *saved* from *ruin* of every *possible* sort," Victoria subsequently wrote to Adelaide's mother. "You know what *he* is."

While Napoleon had greeted his first rejection stoically ("If the royal families of Europe do not want me among them, it is better for me...."), he greeted his second almost with relief. "*Mon cher*," he said to Walewski when the ambassador tried to report on his negotiations in London, "*je suis pris.*" In other words, he had fallen in love. He now cared nothing about Princess Adelaide or the sensibilities of Queen Victoria. For that matter, he no longer cared very much about the devoted Miss

Howard either. Though Napoleon feared and dreaded domestic confrontations, he brought himself to tell her one day in 1852 that their affair was finished. If any proof was needed, Miss Howard could read the signs in a visit from Napoleon's police, who swarmed through her home during one of her absences, searching for any compromising papers. Napoleon was not a cheap scoundrel, however. He gave her 5 million francs (actually 5,449,000 francs) in repayment of the fortune she had loaned him for his political adventures, plus interest. He also awarded her the title of Countess de Beauregard, after the 460-acre château that she had bought (for 575,000 francs) near Versailles. "His majesty was here last night, offering to pay me off," she wrote to a friend. "Yes, an earldom in my own right, a castle, and a decent French husband into the bargain.... Oh! the pity of it all: I could put up with a dose of laudanum.... The Lord Almighty spent two hours arguing with me.... Later, he fell asleep on the crimson sofa and snored while I wept...."

If Eugenia de Montijo's parental origins were not quite so problematic as those of Napoleon, they were nonetheless somewhat ambiguous. Her father, who had lost an eye in the armies of Napoleon Bonaparte, was a very aristocratic but impoverished soldier, Don Cipriano Guzman de Palafox y Porto Carrero, the Count de Teba, second son of the Count de Montijo. Her mother, Maria Manuela Kirkpatrick, was the daughter of a Scottish immigrant who had established himself as a wholesale fruit and wine merchant in Malaga, where he also served as U.S. consul. Since Don Cipriano was either in prison or under guard during much of the post-Napoleonic period when Eugenia and her older sister Paca were conceived, in 1825 and 1824, there is some doubt as to who their father was. The general view is that it was the dashing British diplomat George Villiers, later to become fourth Earl of Clarendon and British foreign secretary.

Doña Manuela nonetheless remained a staunch defender of her husband's official rights and privileges, one of the most important of which was his position as heir presumptive to his older brother's title of Count de Montijo. This widowed and childless brother, Eugenio de Montijo, suffered a stroke that left him partly paralyzed, so Manuela was dismayed to learn that he had remarried and that his new wife claimed to be pregnant. She burst into Eugenio's house and found that his new wife was already well advanced in her fake pregnancy and had acquired an orphan baby that she planned to present as the new heir to the Montijo

fortunes. Manuela pursued the supposed mother-to-be to her lying-in room and snatched the baby away.

Don Eugenio duly died, and Don Cipriano duly succeeded him as Count de Montijo, but by this time George Villiers had become British minister in Madrid, and Manuela had rather openly become his mistress. Her relations with Don Cipriano were consequently somewhat strained, and when her two beautiful daughters became of an educable age, she decided to take them to Paris. They first spent two years at the convent of the Sacré Coeur, then were enrolled at the Gymnase Normal. Among their extracurricular teachers was the young writer Prosper Mérimée, whom Manuela had met on a stage coach and to whom she allegedly told the story that he turned into *Carmen.* Mérimée became a lifelong friend of the family, and one evening he brought along another young friend, Henri Beyle, and Beyle returned often. The girls had not read *The Red and the Black,* which he had recently published under the name of Stendhal, but they loved to hear him tell stories of his days as a lieutenant in Napoleon's armies.

Early in 1839, when Eugenia was thirteen, Manuela received word from Madrid that Don Cipriano was seriously ill. She rushed south, telling the girls and their English governess to follow, but by the time they reached Madrid, Don Cipriano was dead. Though Villiers was still minister in Madrid, and though Manuela may now have hoped to marry him, she began leading a rather wild widowhood. "The comtesse de Montijo possessed lovers galore," according to an anonymous diary of the time, "and had a most delightful habit of kidnapping any male biped whose society she wished to enjoy...." This diarist recounted the case of a friend named José Hidalgo, who had been sauntering in the Prado when a coach stopped and he received an invitation to climb in and drive off. "He stayed many weeks under the tyrannical governance of Mme. de Montijo," this chronicle continues, "and a few other equally fascinating and pitiless lady pirates and a handful of young men, who like himself, after the fashion of Ganymede, had been stolen from their families. One of their pastimes, as recounted by Hidalgo, was for the men to get down on all fours on the floor, and for the ladies to straddle across their backs and tilt at each other as mounted knights might do at a tournament...."

Both Eugenia and Paca fell in love with the same young man, a pale and passive youth who bore the burden of being the fifteenth Duke of

Alba. Eugenia's love was somewhat more passionate than that of her sister, but Doña Manuela came to the traditional decision that her older daughter should take precedence. She so informed the young Duke of Alba, who politely agreed. Eugenia, by now seventeen, eavesdropped on this discussion and then wrote the duke a feverish letter threatening suicide ("There is an end to all things in this world and my end draws near. I wish to explain to you all that is in my heart, it is more than I can endure"). She went on to explain what she could endure: "You will say that I am romantic and silly, but you are good and will forgive a poor girl who has lost all those who loved her and is now looked upon with indifference by everyone, even by…the man whom she loves the most, the person for whom she would gladly have begged alms, and for whom she would have even consented to her own dishonor."

So Paca (legally Maria Francisca de Sales) duly became the Duchess of Alba, and Eugenia proceeded to fall in love with the Marques Pepe de Alcanizes. The marquis paid her frequent visits and wrote her many letters, and it was only after she had lost her balance that she realized that he was courting her in the hope of gaining access to her older sister. That was when Eugenia staged her scene with the poisonous brew of matchstick heads mashed up in milk. This was supposed to be fatal, but Eugenia lingered through a series of tearful negotiations. Doña Manuela sent the errant marquis to her bedside to comfort her. The marquis had other things in mind.

"Eugenia," he said, bending over the sickbed, according to the story later told by one of her nieces to an avid English chronicler, "where are my letters?"

"You are like the spear of Achilles," Eugenia is supposed to have replied, "you heal the wounds you made." With that, she finally consented to swallow an antidote that restored her to her normal state of volatility.

There was one more romance involving a young Italian who stole Eugenia's jewelry, and then Doña Manuela decided to take her excitable daughter to Paris in search of a suitable husband. They pursued the search in various resorts as well, in Biarritz and Spa and Eaux-Bonnes, and in Brussels, too, and in London and a number of English country houses, but it was in Paris that they found what they were looking for. Mérimée had already written to Manuela about the mysterious attractions of the newly elected President Bonaparte. "He surprises all who

come near him by that air of *self-conscience*," he wrote, in a dubious venture into English, "which one associates with legitimate monarchs."

Doña Manuela believed that she knew how to negotiate these things, and Mérimée was happy to help. He introduced the two Spanish visitors to Princess Mathilde, official hostess at the Élysée Palace, but it was Bacciochi, the court procurer, who arranged for them to be invited to meet the president at an Élysée reception on the night of April 12, 1849. "His looks are absolutely insignificant, but he carries himself well," Doña Manuela wrote home to Paca, adding that "he talked with me for a long time, unusual for him because normally he never chats with people at all." The president was particularly interested, however, in the sight of the girl who now called herself Eugénie, and he asked Bacciochi to perform the introductions. The twenty-two-year-old Eugénie, trying to appear sophisticated, told Napoleon that they had a mutual friend. When he asked who that might be, she named a female admirer whom Napoleon had long since discarded. Napoleon coldly turned away.

A few weeks later, however, the prince-president apparently decided that Eugénie was worth another try. Bacciochi delivered an invitation to Doña Manuela to bring her daughter to dinner at Napoleon's château in Saint-Cloud. The two ladies dressed for a large state occasion, but when they arrived at the château, one of the emperor's carriages took them on to a small private house where the only other dinner guests were Napoleon and Bacciochi. After dinner, Napoleon offered Eugénie his arm and invited her for a stroll in the park. "*Mon seigneur,* my mother is here," Eugénie answered. Various commentators have interpreted this as an artful suggestion that the host's arm should by rights be extended to the older lady, but it may simply have meant that Eugénie thought Napoleon too forward. Napoleon politely acquiesced and led Doña Manuela through the lengthening shadows while Eugénie trailed behind with Bacchiochi. There were no further invitations to Saint-Cloud.

Napoleon did have other things on his mind, like making himself emperor. And Eugénie, though she had declined a walk in the park, was not above writing a letter to Bacciochi to inform Napoleon that, as one biographer puts it, "all she possessed in the world would be at the President's disposal should developments make such assistance necessary." This was not necessary, to be sure, since Miss Howard had already helped to finance Napoleon's coup, but after the coup had cleared the way for an imperial restoration, and after Napoleon had also cleared

away Miss Howard, he again invited Eugénie and Doña Manuela to a number of official receptions and then to a great hunting party at Fontainebleau.

Eugénie was a first-rate rider, and hunting appealed to her Spanish spirit. At Fontainebleau, she was the first in at the kill. Napoleon, galloping up to the scene, was greatly impressed. And she made a splendid sight, her hair in braids twisted under a felt hat to which an ostrich plume was attached by a diamond clasp. And pearls in the handle of her whip. And a flaring skirt over her gray trousers and high-heeled patent-leather boots. Napoleon made her a present of the thoroughbred she was riding. He was more than impressed, he was entranced.

One morning when he took her out for a walk in the park, he wondered what time it was. She looked at her watch and found that it had stopped at six fifteen. Napoleon teased her about having forgotten to wind it, then took out his own watch and found that it had also stopped at six fifteen. "He was startled, he went pale, his mind suddenly seemed far away," according to the Spanish ambassador's report back to Madrid, for all of Napoleon's private life was a matter for diplomatic surveillance. "His superstitious sense had been aroused: and it was then that the marriage first occurred to him as a serious possibility." There was another such incident. An obscure and seemingly barren shrub at the Jardin des Plantes had burst into flower when the first Napoleon married Josephine in 1804, then lapsed into inactivity, and now, nearly a half-century later, it was flowering again. Upon hearing this news, the Spanish ambassador's report continued, Napoleon "there and then decided to marry [Eugénie]."

Others were less certain of Napoleon's plans—perhaps Napoleon himself was less certain—but as the Fontainebleau festivities stretched on from the planned four days to eleven, veteran diplomats marveled at Eugénie's skill in leading her middle-aged admirer toward the altar. According to one story, Eugénie stayed home from the hunt one day and was waiting with several other women on a balcony adjoining the palace chapel when Napoleon returned from the chase. "How can I reach you, *mesdames*?" he asked from below. "You can climb up if I hold my hand," said one of the more forward ladies, but everyone found it portentous that Eugénie said, "As for me, Prince, the only way I perceive is through the chapel."

A month later, just after the plebiscite that ratified Napoleon's impe-

rial ambitions, the new emperor seemed to confirm his romantic plans by inviting Eugénie to a two-week house party at Compiègne. There were 101 guests, including the ever-watching diplomatic corps and nearly 300 servants to tend them. The emperor left no doubt about his feelings. He was constantly at Eugénie's side, strolling with her, riding with her, sitting next to her in the imperial box at the theater. After dinner one night, he very publicly crowned her with a wreath of violets. That was not, of course, the real thing, and Eugénie wanted the real thing. The British ambassador reported back to London that "she has played her game so well that he can get her in no other way but marriage." The Austrian ambassador agreed: "A game played with extreme skill and crowned with complete success." And the Count de Morny said to a friend as he returned to Paris, "She will be empress!"

It was not just a game. Though Eugénie was never as much in love with Napoleon as she had once been with her various Spanish connections, she did feel a real affection and admiration for him. "He is a man with an irresistible will power, but he is not stubborn," she wrote confidentially to her sister. "He is capable of great sacrifices and small gestures: he will leave the fire on a winter's night to pluck a flower in the woods and so satisfy the fancy of the woman he loves—next morning, he will risk the crown rather than not share it with me." And again: "He has a noble and devoted heart." But he was also a great catch, and the women in the upper levels of imperial society found it hard to believe that such a catch could be caught by a relatively obscure Spaniard. One of these, Sophie de Contades, daughter of the Marshal de Castellane, spoke for the others when she urged Eugénie to become the emperor's mistress. "Remorse is better than regret," she said, meaning that the remorse she might feel over her lost virtue was better than the regret she would feel when her plans for a royal wedding had inevitably come to nothing. Eugénie answered, according to the Austrian ambassador's account of the meeting, that she expected to feel neither remorse nor regret.

It is not completely certain just when or just how Napoleon proposed to Eugénie. Possibly he never really did, and the engagement just came to be understood between them. Or perhaps the nearest thing to a moment of decision occurred on New Year's Eve of 1852, when the wife of the minister of education insisted on taking precedence over Eugénie in the line going to dinner at the imperial palace. "Lead on, Madame,"

said Eugénie, who then told Napoleon that she had been insulted and would leave France forever. Napoleon promised to end such insults by marrying her.

Before any marriage could take place, or could even be announced, a great deal of maneuvering was required. One of the first who had to be told of the emperor's plan was his official hostess and onetime fiancée, Princess Mathilde. The princess had accepted Miss Howard, though she despised her and never spoke to her, but an imperial marriage would displace Mathilde from the Élysée Palace. And an imperial birth would displace her brother, Prince Napoleon, known as Plon-Plon, from his position as heir-presumptive. On hearing Napoleon's plan, Princess Mathilde fell to her knees and begged him not to demean himself by marrying this penniless and inconsequential Spaniard. The emperor was not to be dissuaded.

And there were still negotiations to be conducted with Eugénie herself. The watchful Lord Clarendon, Eugénie's putative father, arranged a very private meeting at an apartment on the Champs-Élysées, where Napoleon warned Eugénie of the dangers ahead, of wars and coups and attempted assassinations. "It is only fair that I should set before you the whole truth," he said, "and let you know that if the position is very high, it is also very dangerous and insecure." Eugénie professed herself ready for anything. At this meeting, too, the middle-aged roué confessed one of his own anxieties: Was Eugénie really a virgin? Eugénie delicately replied that there had been occasions when her heart had been claimed, but, she added, "I am still as you would want me to be." Eugénie's chastity was not the only source of such concerns. In another secret meeting, Napoleon told Doña Manuela that he had heard reports that Eugénie's real father was that repeated visitor to Madrid, the Earl of Clarendon. "*Sire,*" replied Doña Manuela in a truly extraordinary denial of sin, "*les dates ne correspondent pas.*"*

The ladies who dominated Paris society were by no means ready to give in. At the court ball just after New Year's, Eugénie and her mother were escorted in by their banker, Baron James de Rothschild, and his son. The Rothschilds led the ladies to banquettes along the wall and then retired. Under the watching eyes of the entire assembly, Madame Drouyn de Lhuys, the wife of the foreign minister, accosted Eugénie

*"My Lord, the dates [of Clarendon's visits to Madrid] do not match."

and whispered something into her ear. Eugénie and her mother rose and looked around in embarrassment. The emperor hurried over to them and asked what the minister's wife had said. She had said that the banquettes were reserved for ministers' wives. Napoleon solicitously escorted Eugénie in her ivory brocade and silver tassels to the imperial dais. And all this was watched, smiled at, whispered about, by everyone at the ball.

Deciding to bring the matter to a conclusion, Napoleon finally wrote a letter three days later, January 15, 1853, to Doña Manuela. "Madame la Contesse," he declared, "I have loved Mademoiselle your daughter and wished to marry her for some time. I have therefore come today to ask you for her hand, for nobody is more capable of contributing to my happiness or more worthy of wearing a crown...." Doña Manuela's answer was scarcely in doubt, but the process of public acquiescence still had to continue. The following week, Napoleon summoned the Council of State and leading members of the legislature to the Tuileries so that he could announce his plans. In a remarkable statement, Napoleon not only accepted the disapproval of monarchical traditionalists but gloried in the accusation that he was a *parvenu*.

"When...a man is borne upward by the force of a new principle to the lofty height of the old dynasties," he said, "it is not by attributing antiquity to his escutcheon and by forcing himself into the family of kings that he makes himself acceptable. Rather, it is by remembering always his origin, by remaining true to his own character, and by frankly taking up before Europe the position of a *parvenu*: a glorious title when one succeeds to it by the free suffrage of a great nation." And in such circumstances, Napoleon felt free to decline all political marriages and to choose a woman he loved. "She whom I have chosen is of lofty birth," he went on. "French by education and by memory of her father's blood shed in the cause of the empire...endowed with every quality of mind, she will be an ornament to the throne, and in the hour of dangers one of its bravest defenders.... You, gentlemen, who have come to know her, will be convinced that...I have been inspired by Providence."

And that was how Eugénie came to be proceeding to the altar of Notre Dame, her hair gleaming with diamonds and orange blossoms. Once that ritual was completed, though—and Doña Manuela dispatched back to Spain forever—Eugénie knew perfectly well that her main function was to produce an heir to carry on the myth of a Bonaparte dynasty. Two months after her wedding, she found herself pregnant. A month

after that, she had a fall, and made the mistake of taking a hot bath, and began to suffer severe pains. The pains lasted for seventeen hours, and then the miscarriage came. "Who knows what would have been the fate of my child?" she wrote to her sister. "I should infinitely prefer a crown for my son less resplendent but more secure. Don't think I lack courage. You see my thoughts are not very gay, but remember that I…have pain in all my bones. Today I tried to stand but was too weak from loss of blood." The emperor concentrated more sternly on the main point. "The mistake," he replied to the condolences of the British ambassador, "can be put right."

Two years passed before Eugénie succeeded in becoming pregnant, two years poisoned by the distant havoc of the Crimean War, and the peace conference in Paris was just two weeks under way when the empress went into labor. And the labor went on and on. It started on a Friday and went on all through Saturday. Eugénie suffered violent spasms, then was made to remain standing for long periods, supported by attendants, to recover from the spasms. For most of that Saturday, the emperor sat out in the anteroom, listening to Eugénie's sobs and groans. With him sat Princess Mathilde, thinking her own thoughts, and her surly brother, Prince Plon-Plon, who would remain heir to his cousin's crown only until the birth of Eugénie's son. The doctor, Darralde by name, told the emperor that he would have to use surgical instruments in the delivery, and that he could not guarantee the lives of both mother and child. Then he asked the emperor that classic question: In case of an emergency, whose life should be saved? In defiance of dynastic imperatives, and of Catholic teachings, Napoleon unhesitatingly gave the right answer: Save Eugénie.

At three o'clock on Sunday morning, March 16, 1856, Eugénie finally gave birth to her baby. Her first question to the emperor at her bedside was the imperial question: "Is it a girl?" Napoleon drew aside the curtains on the imperial crib and then said no. "A boy?" she persisted, in her desire to hear that she had done what she was supposed to do, fulfilled her mission. Trying to stop her from asking questions, Napoleon shook his head from side to side, and in that state of uncertainty, Eugénie fell asleep. After she awoke and found that all was well and that her baby was a boy, to be known henceforth as Napoleon Eugène Louis Jean Joseph Bonaparte, known publicly as the Prince Imperial, known privately as Loulou, she asked Pope Pius IX to act as the infant's godfather.

But something went seriously wrong with the marriage at about this time. One basic difficulty was that the emperor had never had any real intention of being faithful. "I was faithful to her for six months," he told Princess Mathilde, "but I need little distractions and I always return to her with pleasure." Despite the widespread acceptance of the double standard, however, Eugénie hated and felt humiliated by her husband's "little distractions." She seems to have lapsed into frigidity, or even to have ended all sexual relations after the birth of the prince. One theory is that the difficult and painful birth filled her with a dread of sex; another is that she had never had very much interest in the matter anyway, and that in producing an imperial heir, she felt she had done her duty. From this point on, there were periodic reports of loud arguments in the private apartments of the palace. On several occasions, Eugénie suddenly departed on incognito voyages abroad, and she sometimes seemed quite obsessed with the new fad of spiritualism.

The banished Miss Howard was apparently no longer banished. Not only had she acquired an angora cat with a green ribbon on its tail, which a police spy described as a "gauge of affection from the absent one," but Napoleon regularly went to review the troops at Satory, near Versailles, where Miss Howard had her château, and she would wait for him in a nearby carriage. "He used to change his uniform for civilian clothes in the carriage," another observer reported, "taking off his military cap and tunic and putting on a top hat and frock coat but keeping on his red uniform trousers and polished boots...." And according to another police report: "The empress...has told her august husband that she intends leaving both Saint-Cloud and France if the emperor has no greater regard for his dignity and the duty he owes to the wife of his choice...."

Even more humiliating, because even more public, was the spectacular arrival in Paris, when Eugénie was six months pregnant, of Virginie Oldoini, the eighteen-year-old Countess de Castiglione. She was a cousin of Count Camillo Cavour, the prime minister of Piedmont, who had brought her with him to the Crimean peace conference. *"La belle Comtesse est enrollée dans la diplomatie Piémontaise,"* Cavour reported to his foreign ministry in Turin. *"Je l'ai invitée à conquêter, et s'il le faut, à séduire l'Empereur."*° To the young countess herself, Cavour was

°"The beautiful countess is enrolled in Piedmontese diplomacy. I have asked her to conquer and if necessary seduce the emperor."

almost equally explicit: "Succeed, my cousin, by any methods you like, only succeed."

For all her youth, the countess was unusually qualified for her new role. She was, by all accounts, beautiful, self-centered, and stupid. Her figure, according to Princess Pauline von Metternich, "was that of a nymph. Her throat, her shoulders, her arms, her hands...seemed as if sculpted from pink marble. Her cleavage, however excessive, did not seem improper, for this superb creature resembled a classical statue.... In a word, Venus descended from Olympus. Never have I seen such beauty, never will I see its like!" As for her husband, an understanding courtier in the service of Piedmont's King Victor Emmanuel, he summed up his own role by saying: "I am a model husband. I never see or hear anything." The countess knew her value. She was said to have accepted 20,000 pounds from an English lord for one night in his company. And when she contemplated her assigned target in the Tuileries palace, she later told a friend: "My mother was a fool. If she had brought me to France before I married there would have been not a Spaniard but an Italian in the Tuileries."

It was at one of Princess Mathilde's soirées that the countess met the emperor. The emperor duly instructed Bacciochi to invite her to his palace. She made her most spectacular appearance as the Queen of Hearts at a costume ball. Her costume was "exceedingly décolleté," according to Napoleon's cousin, Princess Caroline Murat, and "entirely open at the sides from the hips downwards. She wore her hair flowing loose over her neck and shoulders. Her conspicuous ornaments were crimson hearts thrown at random upon the dress, some in positions that were decidedly unexpected. The empress, congratulating her upon her achievement, added, looking at one of the symbols which was particularly conspicuous, 'But your heart seems a little low.'"

The inevitable affair had by now begun, and the British ambassador even reported to London that it was difficult to obtain an appointment with the emperor because he was "so much engrossed and occupied with the beauteous Castiglione." As an example of the emperor's infatuation, the ambassador went on to describe a *fête champêtre* at Villeneuve-l'Étang, "where His Majesty rowed the lady in a small boat alone and then disappeared with her in certain dark walks during the whole of the evening. The poor empress was in a sad state—got excited and began to dance, when not being sufficiently strong she fell very heavily...."

It is not clear exactly how the countess's seduction of the emperor might have furthered Count Cavour's policies. Cavour's goal was to recruit French military power to help make Piedmont the leader of a liberated Italy, but there were many pressures that pushed Napoleon in that same direction, and as for his Italian mistress, he told Princess Mathilde that she was "very beautiful, but she bores me to death." Still, if it seems frivolous to devote so much attention to the lesser sins of chiefs of state, it remains true that autocracy gives unusual importance to the vagaries of the autocrat. Napoleon discovered that importance when he was leaving the countess's establishment on the Avenue Montaigne at 3:00 A.M. and three assassins suddenly attacked his coach. Napoleon's coachman flailed at them with his whip and managed to drive the emperor to safety, but when the police captured the three attackers, they found them to be agents of the Italian radical leader Giuseppe Mazzini. Though the Italian countess was not implicated, Napoleon's chief ministers argued strenuously that the emperor should end this dangerously open liaison with Cavour's agent, and so he rather reluctantly did.

His reluctance may have been reduced by the fact that he was already much interested in another Italian beauty, Marie-Anne de Ricci Walewska, the wife of Foreign Minister Alexandre Walewski. On a family outing to Compiègne in October of 1857, the emperor and Madame Walewska were sitting in one compartment of the imperial coach, with Walewski, Empress Eugénie, and Princess Mathilde in the other, when the door between them accidentally flew open, and Mathilde observed her "very dear cousin sitting astride on Marie-Anne's knees, kissing her on the mouth and thrusting his hand down her bosom."

"I have such a disgust for life..." Eugénie wrote to her sister at the end of that year. "I often wonder to myself if it is worth the struggle...."

<center>⊙</center>

Princess Mathilde quite grandly went her own way. Once Napoleon had gained control of the national finances, he bestowed on her an annual income of 200,000 francs, subsequently increased to 500,000, as well as the title of Imperial Highness. Her salon at 24 Rue de Courcelles, and her country estate at Saint-Gratien, near Enghien, soon became the most fashionable places for the intelligentsia to flirt and curry favor. Flaubert appeared regularly, as did Dumas, Sainte-Beuve, the

Goncourts, Mérimée, Taine, Pasteur, even Rossini. Saint-Saëns played the organ for Mathilde in the premiere of his *Serenade* for piano, organ, and violin, and he dedicated the work to her. These encounters were not always so triumphant. Musset came to recite his *Cantate d'Auguste,* with Gounod at the piano, but got so drunk that he fell asleep in the midst of his recital. And then there were all those others whom the Count Horace de Viel-Castel characterized as "enemies in disguise, courtiers of the vilest kind, or simple buffoons.... Poor Princess Mathilde thinks she has a salon whereas it is only a sort of bazaar."

The Goncourts were characteristically ruthless in describing the princess at their first meeting: "She is a large woman, the remains of a beautiful woman: a rather mottled skin, a withdrawn face, rather small eyes whose expression one does not see very well, the manner of an aging courtesan.... The princess takes her place...beside a basketful of little pug dogs which she adores and which follow her everywhere...." Despite that maliciously patronizing tone, the Goncourts soon became genuinely fond of Mathilde, and genuinely respectful, too. Since the emperor and empress were essentially indifferent to culture, Mathilde's salon became what Edmond de Goncourt called "the pleasant seat of government for art and literature, the benevolent Ministry of Graces."

She fancied herself an artist, and so she liked those around her to accompany her in her artistic endeavors. The Goncourt account of the postprandial atmosphere at Saint-Gratien: "Gradually silence prevails in the studio. Nothing can be heard but General Chaucard's india rubber as he rubs something out, Popelin's pencil, the cuckoo-clock, the snoring dogs, and stifled sounds from the younger women.... The princess works in busy absorption." Princess Mathilde despised amateurism, however, and so when it came time for the official Salon, she submitted her own works as those of a serious artist, and since the Salon authorities affected objectivity by hanging all officially accepted artists in alphabetical order, the works of Princess Mathilde could be found near to those of Édouard Manet. She won an honorable mention in 1861, a medal in 1865.

Théophile Gautier, the celebrated poet whom Mathilde eventually hired to catalogue her library, came to review that Salon of 1861, paused to inspect Manet's *Spanish Singer* ("There is a great deal of talent in this life-sized figure") and then devoted nearly half his review to four nearby watercolors by his patroness. "It is astonishing," he observed, "that an imperial and feminine hand can achieve such strength in this genre,

which, even when handled by men, is ordinarily limited to freshness and grace."

In such a world, it did not take Mathilde too much effort to have her lover, Count Nieuwerkerke, made minister of fine arts, director general of museums, imperial court chamberlain, member of the Institute, commander of the legion of honor. She knew perfectly well, though, that he did not love her as she loved him. "He loved me for perhaps three weeks, he was unfaithful to me after two months," she later told a friend. "As I am proud, and a king's daughter, I didn't want to look ridiculous...." But this was an empire in which ridiculousness was a part of the escutcheon. Consider, for example, the January day in 1864 when Viollet-le-Duc, that paladin of pseudo-medieval restorations, was supposed to begin teaching at the École des Beaux Arts, and the students vowed that they would prevent him from doing so. Nieuwerkerke determined to overawe the fractious students by personally accompanying the new professor to his first day of classes, along with an establishmentarian honor guard of Gautier, Sainte-Beuve, and Mérimée. The students were ready for them.

As soon as Viollet-le-Duc opened his mouth and said, "Messieurs," a grand hullabaloo erupted. Each student reacted like some preassigned animal, thus providing, according to one account, "the clucking of chickens, the trumpeting of elephants, the roar of lions, the braying of donkeys, the mewing of cats, and the yapping of dogs." Nieuwerkerke and his honor guard tried to retreat with dignity out through the courtyard of the École des Beaux Arts and down toward the Seine and Nieuwerkerke's official sanctuary in the Louvre. But as they marched out, the students silently formed rows of four, as for an official funeral, and then marched in their wake. And as they marched, the students suddenly began mocking the retreating minister of fine arts by chorusing an aria from Rossini's *William Tell: "O ciel! Tu sais si Mathilde m'est chère."*

Nieuwerkerke reacted in the only way that government officials know (if, indeed, one can even imagine any American official being ridiculed by students singing a Rossini aria that makes fun of his private life), by turning and shouting at his pursuers, "I'll get you, all of you!" That only inspired the students to further ridicule, and a dissident faction immedi-

*"O heaven! You know whether Mathilde is dear to me!"

ately burst out in parody: "*À sa Mathilde, o ciel qu'il coute cher!*"° The jeering students followed Nieuwerkerke all the way to the Louvre, where the minister could not only find sanctuary but call in the police. Among those arrested was the distinguished Gautier, and when the chief of the gendarmes was asked how they could have made such a mistake, he helplessly answered, "Because of the length of his hair."

Princess Mathilde's involvement with figures like Gautier and the Goncourts showed that she regarded herself as a connoisseur not only of painting but of writing too. Readings were much in fashion, and to hear Flaubert bellow the latest pages of his *Éducation Sentimentale* was a scene almost worthy of being included in the novel itself. The princess was thrilled and flattered when Flaubert told her that he had written the whole book for her, "to inspire pity for these poor men so misunderstood, and to prove to women how shy they are." Inevitably, Princess Mathilde came to feel that she too had literary gifts. She wrote a little book and summoned her literary friends to her salon to hear her read it aloud. It was called *The Story of a Dog*. Everyone complimented her. Only Flaubert, with his passion for style, pointed out to her some of the weaknesses in her prose.

The writer whom Princess Mathilde admired most and loved best was the eminent critic Charles Sainte-Beuve. Though Sainte-Beuve was sixteen years her senior, and fat and homely as well, the friendship between them was somewhat more than literary. They exchanged visits several times a week, and wrote flowery letters between visits. "She has a high and noble forehead, made for the diadem," Sainte-Beuve wrote in his *Portrait of a Princess*. "Her light golden hair leaves uncovered on each side her broad, pure temples, and sweeps round to join again in wavy masses on the full, finely shaped neck.... The body is of medium stature, but is made to look tall by its suppleness and harmony of proportion. The carriage is instinct with race, and gives an indefinable impression of sovereignty and full-blooded womanhood." Mathilde, charmed, took up her pen to attempt a comparable portrait of her admirer: "...In the midst of all this dwells an eminent mind, subtle, caustic, stimulating, indulgent out of goodness of heart...smiling at every kind of malice."

Mathilde was truly generous not only with her money (she created and financed the Mathilde Asylum for 300 chronically ill girls) but also

°"To his Mathilde, O heaven, does he cost dearly!"

with her considerable political power. Sainte-Beuve hungered to be named to the senate, a lifetime position that paid 30,000 francs a year for very little effort. Mathilde persuaded the emperor to make the appointment, and so Sainte-Beuve basked in the comforts of official recognition. The celebrated author of the weekly *Causeries du Lundi* (Monday Conversations) thought, though, that he was still an independent writer, and so, when the editor of the pro-government *Le Moniteur* balked at some lines criticizing a prominent bishop, Sainte-Beuve took his article to the liberal *Le Temps*. Mathilde, who regarded *Le Temps* as hostile to the Bonaparte family, asked Sainte-Beuve not to publish there. Sainte-Beuve refused. Mathilde was furious, more than furious, enraged, a patroness scorned.

She got into her carriage and drove to Sainte-Beuve's home. The critic, in great pain from a kidney stone and a severe prostate condition—he was, in fact, dying—asked his secretary to deal with the princess while he took his medical treatment. The "Minister of Graces" began shouting at the secretary and referred to Sainte-Beuve as a disobedient "vassal of the empire." The secretary loyally protested that "there are no vassals any more, there are only citizens." As soon as Sainte-Beuve finished his medical treatment, he went to greet the princess, and then the terrible scene occurred. She was still furious when she told Edmond de Goncourt about it the next day, beating an embroidered corsage against her chest as she spoke: "And I told him when I went: 'But your house is a brothel, a filthy place, and I've come here for you....' Oh, I was hard! And I said to him: 'What are you? An impotent old man! You can't even attend to your personal needs.... What ambitions could you still have, then?... Listen, I wish you had died last year; you would at least have left me the memory of a friend!'"

The cause of Italy—the curse of Italy—haunted Napoleon for most of his life. Not only was the Italian struggle for unity and independence one of the great problems of nineteenth-century Europe but Napoleon was almost predestined to play a major part in it. The Buonapartes originally came from Florence, and the Corsica to which they migrated in the sixteenth century was to remain a Genoese dependency for another two hundred years. After Waterloo, several prominent members of the family found refuge in Italy, Napoleon's brother Louis in Rome, for instance,

and Jerome in Trieste (where his daughter Mathilde was born). Queen Hortense regularly took her sons to winter in Rome, and it was there, during the revolutionary upheavals of 1830, that young Louis and his older brother joined the insurgents fighting against papal forces in the Romagna, because, as Louis wrote his mother, "the name we bear obliges us to help a suffering people that calls upon us." When the ruling Austrians suppressed all these disturbances, Hortense had to rescue her wayward sons. The older one died of measles but Napoleon escaped across the frontier in the disguise of Hortense's footman.

It was beyond irony that when Mazzini's radicals established a republic in Rome and drove out Pope Pius IX during the turmoil of 1848, President Bonaparte sent a nine-thousand-man expeditionary force to recapture the city for the pope. This required three months of bombardment, with heavy casualties, but the Napoleon who had once felt an obligation "to help a suffering people" now announced that "our military honor is at stake." Mazzini fled to exile in London, and there his agents plotted to ambush Napoleon's carriage outside the doorway of the Countess de Castiglione. To men like Piedmont's Premier Cavour, who dreamed of a unified Italian monarchy under the rule of King Victor Emmanuel, Mazzini and his Republicans were dangerous criminals, but there were others who regarded Mazzini as a soft-hearted compromiser. Among these was Felice Orsini, a handsome young radical who had already escaped from two long prison terms and had served as a leader of Mazzini's short-lived Roman Republic. Orsini now designed and smuggled into France the bombs with which he and three confederates planned to kill Napoleon.

The emperor's coach, escorted by a troop of mounted imperial lancers, had just arrived at the red-carpeted entrance to the Opéra when Orsini and his conspirators attacked. The first two bombs landed among the guards and bystanders, spraying metal fragments in all directions. Orsini's bomb exploded under the imperial coach. When a policeman ripped open the door, Napoleon climbed out, bleeding from a cut on his nose, then Eugénie, her cheek grazed, her white opera dress spattered with blood. Napoleon made a vague attempt to comfort some of the nearby victims—there were eight dead and more than 150 injured—but Eugénie forbade it. "Don't be a fool," she snapped as she led the emperor into the opera house. "There has been enough stupidity already." When they marched into the theater, the orchestra welcomed them with

"Departing for Syria," that unofficial imperial anthem originally composed by Queen Hortense, and the audience gave the bloodied royal couple a standing ovation.

The consequences of this melodrama were in every way unexpected. Because the assassins had operated from sanctuary in Britain, noisy Bonapartists demanded retribution against political exiles in London, and when the British declined to give their police the arbitrary powers cherished by the Paris gendarmerie, the French press began talking of war. The French ambassador, the zealous Duke de Persigny, even put on full dress uniform, with ceremonial sword, to go and shout at the Foreign Office: *"C'est la guerre! C'est la guerre!"* ° As for the actual assassins, though, they portrayed themselves on the witness stand as pure-hearted idealists, and the ladies of fashion flocked to listen. "May your majesty not reject the words of a patriot on the steps of the scaffold!" cried Orsini. "Set my country free, and the blessings of 25 million people will follow you everywhere and forever." Even the Empress Eugénie was impressed, and, according to the Austrian ambassador, she "is in raptures over this murderer in kid gloves." The royal couple actually wanted to commute the assassins' death sentences, but their ministers unanimously protested. So Orsini alone was guillotined, after declaring that his crime had been "a fatal mental error," and the rest were spared.

On the question of Italy's future, however, the emperor went a long way toward granting Orsini's plea, though he naturally favored Cavour's royalist strategy rather than Mazzini's republicanism. In a secret meeting at the Vosges resort of Plombières in July of 1858 (even the French foreign minister was not informed), Napoleon and Cavour redesigned the map of Europe. The Piedmontese would sponsor a revolt somewhere against one of the Austrian-dominated principalities in central Italy, and then, when the Austrians tried to retaliate, the French would intervene with military force. Once the French had defeated the Austrian armies—an outcome that the two conspirators never doubted—Austria would be compelled to cede Lombardy and Venetia to the Piedmontese. Piedmont would thus become the dominant member of an Italian confederation, under the nominal leadership of the pope. The French, for their troubles, would acquire Savoy and Nice. And to seal this deal, in the traditional way, the emperor's cousin Prince Plon-Plon would be

° "This is war!"

married off to King Victor Emmanuel's fifteen-year-old daughter, Clotilde.

All the beginnings went as planned: The Austrians were provoked into invading Piedmont, and Napoleon marched south at the head of 200,000 men. He left his Empress Eugénie, still just thirty-three and hardly schooled in the arts of government, as regent of France, in full command of the imperial government. It could scarcely be said that Eugénie conspired to gain these powers, or that she pushed Napoleon toward war, but she certainly favored both developments, and they formed a pattern for future disasters.

"The emperor found it necessary to revive in the French people a feeling of generosity and glory," she told an Italian friend, "in order to make war acceptable in a country which was still suffering from the terrible experiences of the previous conflict." And if that seems rather oddly abstract, Eugénie wrote more confidentially to her sister: "We are about to have war.... The emperor will depart when the army is ready and I shall stay here as regent.... My responsibility is great, for you know that the Parisians are not always very easy to manage; but God will, I hope, give me all the knowledge which I lack, for I have nothing but the will to do well and not allow the smallest sign of disorder.... How bizarre is destiny! Don't you find it so? When we were children, who could have told us what was in store for us? When we listened so closely to M. Beyle as he talked to us of the campaigns of the Empire...."

Eugénie's regency was inevitably rather a caretaker government. She presided over the cabinet meetings three times a week, conscientiously read all the state papers that came flooding in, then gathered her ladies-in-waiting in the garden apartments at Saint-Cloud and spent her evenings in that traditional role of women in war, making bandages. But if Eugénie was a novice at governing France, so was Napoleon at commanding its armies. Almost by accident, his main force of 54,000 troops blundered into a slightly larger Austrian force dug in behind the Ticino River near the Piedmontese town of Magenta. In a daylong slaughter, the Austrians lost some 6,000 men, and the French 4,500 before the French Marshal MacMahon° arrived with enough Zouave reinforcements to capture Magenta. King Victor Emmanuel, whose Piedmontese

°Marie Edmé Patrice Maurice MacMahon, later Duke of Magenta and president of France, was descended from an Irish family that went into exile with King James II after the revolution of 1688.

forces had managed to avoid taking part in the battle, joined Napoleon in marching into Milan.

The Habsburg Emperor Franz-Josef, then twenty-eight, hurried south to rally his troops, and they made their stand just south of Lake Garda, around the village of Solferino. This time, each side numbered about 150,000 men, so the slaughter was correspondingly greater. "They disembowel each other with saber and bayonet," wrote the Swiss observer Henri Dunant (whose *A Memoir of Solferino* would lead to the foundation of the Red Cross). "There is no more quarter given, it is butchery, a combat of wild beasts, mad and drunk with blood." Napoleon, chain-smoking cigarettes as he watched from a nearby church bell tower, was only slightly less dismayed. "The poor fellows, the poor fellows," he sighed. "What a terrible thing war is!"

Once again, the French won a Pyrrhic victory. The Austrians lost some 23,000 men, the French 12,000, and even the Piedmontese 5,000. And then there were those scenes in which Dunant led parties of British tourists to provide water for the wounded while Italian peasants plundered the dying. Napoleon vomited after visiting a barn where the field surgeons piled amputated arms and legs in a bloody heap, but his telegram to Eugénie in Paris said only "GREAT BATTLE, GREAT VICTORY." So Parisian crowds cheered Eugénie as she went riding down the Rue de Rivoli. The information she received from the east was, however, alarming. The Prussians were massing troops on the Rhine, she reported to Napoleon, and there was every possibility that they might come to the aid of the Austrians by invading France. Napoleon's Italian campaign, she argued, should now be brought to an end as soon as possible.

Sickened by the bloodshed that seemed to follow inexorably from his own ineptitude, Napoleon agreed. Without telling any of his generals, he sent an envoy with a white flag to seek a conference with his fellow emperor, Franz-Josef, and when the two met alone at a private house near Villafranca, they settled the two-month-long war in an hour. Austria would give up Lombardy to Piedmont but would keep control of Venetia; the pope would be invited to head an Italian confederation that would include Piedmont, Venetia, and the various Habsburg principalities like Tuscany and Parma. Cavour and other Italian nationalists felt betrayed, and the planned confederation never came into existence, but Napoleon, aging and ailing, returned home to review his troops, hand out medals, and resume the good life.

Even then, reviewing his troops, Napoleon could be seen to have rouged his cheeks and dyed his beard to maintain an image of healthy youth. He was, in fact, fifty-one, and already suffering a combination of illnesses that would ravish his powers and bring to Empress Eugénie a greater authority than she had ever expected. As a boy, Napoleon had been sickly and backward, but a strenuous regimen of hiking and swimming carried him through his school years into a dissolute adulthood. His imprisonment at Ham took a further toll. He emerged with a limp caused by rheumatism and an eyeball apparently dilated by years of reading in bad light. Doctors treated him by applying leeches to the eye. Then came more years of dissolute living.

Shortly after the birth of Eugénie's son in 1856, her doctor, Louis Conneau, called in from England the eminent Scottish physician Dr. William Fergusson, professor of surgery at King's College. Dr. Fergusson found nothing seriously wrong with Eugénie, though he warned that her recovery would be a slow one, and that she would be periodically afflicted with depression. But while he was in Paris, he also examined Napoleon and found an encyclopedia of ailments, specifically "neuralgia, sciatica, dyspepsia, fatigue, irritability, insomnia, contraction of the fingers, loss of appetite and decline in sexual potency."

More serious than any of these was an affliction that was just now beginning, a stone in the bladder, which would torment Napoleon for the rest of his life, and ultimately kill him. Characteristically, Napoleon tried to avoid seeing doctors about his troubles, tried to ignore their prescriptions and recommendations, and never told Eugénie the extent of his illness. And since the royal couple now spent long periods in shifting between open conflict and armed truce, Eugénie could only guess at Napoleon's condition, but the guessing was hardly difficult. At one point of crisis during the Austro-Prussian war of 1866, when Napoleon tried to mediate and then backed down, humiliated by Prussian intransigence, Eugénie indiscreetly told the Austrian ambassador, Prince Richard von Metternich, that her husband was "sick, irresolute, exhausted." The emperor, she reported, could "no longer walk, no longer sleep, and scarcely eat."

Eugénie had also discovered, during her brief period as regent, that she enjoyed power, not merely the courtly deference due an empress but

real political power, the sense of it, the feel of it, cabinet ministers reporting to her and awaiting her decisions, her approval. She really knew very little of how power is gained or exercised. She had very little schooling, and little interest in learning; she had never commanded a regiment, organized a coalition, drafted a law, held a job, or even carried out an assignment, but once she had tasted the pleasures of having men do what she told them to do, the empire was never the same again.

She can hardly be said to have had a policy, but she had views and opinions that she insisted on with increasing authority. She very proudly insisted, for one thing, on the preeminence of Napoleon himself, on his duty to assert the imperial mandates of honor and glory, at any cost in bloodshed. To all talk of a "liberalized empire," an empire that might permit the legislature to exercise more power, might permit greater freedom of the press, greater divergence of opinion, she argued an adamant opposition. She insisted, too, on the duty of the emperor to support the Vatican in all its works at home and abroad, even in its temporal rule over much of central Italy. To her admirers, all this seemed no less than her royal obligations to family, church, and state, to morality and order, but her admirers did not include everyone.

"Superstitious and superficial..." wrote Maxime du Camp, a journalist and critic of some distinction, "frigid, without temperament, both miserly and extravagant, with no passion but vanity, she dreamed of playing the principal role, but was only a supernumerary, enveloped in a sovereignty which she did not know how to wear. I don't believe she ever had a serious idea about anything, but she excelled with her dressmaker, and knew as much about precious stones as an old Jewish courtier." To officials actually engaged in the process of government, the peculiarities of their rulers could present real difficulties. "I should like a little more ballast," another Austrian ambassador, Count Josef von Hübner, wrote of Eugénie, "much more reading, more solid instruction, a more balanced mind, less inclined to marvels and more to serious things. At the moment, she has thrown herself with all her Andalusian ardor into table-turning."

Spiritualism was not just a fad but a matter for searching inquiry, at a time when, after all, the young Louis Pasteur had only recently been made a professor at Lille and Charles Darwin's *Origin of Species* had not yet been published. One of the heroes of the movement was a young Scot named Daniel Douglas Home ("Mr. Sludge the Medium," Robert

Browning called him) who began staging séances at the Tuileries in 1857. An accordion held in the hands of the emperor "played some charming airs," as Eugénie wrote to her sister, "and a footstool at the end of the room came to me as if propelled by an unknown force.... I had put a cloth on the table, when suddenly the emperor said: Look what is pushing the tablecloth toward me. Touch it, said Home. Yes, it was a hand which pressed his." This appearance of unseen hands became even more dramatic at another séance held on the anniversary of Eugénie's father's death, a date that only she knew.

"As we sat around the table a hand never ceased to press mine or to pull my dress..." she wrote to Paca. "Surprised by such importunity, I said to it: So you love me? The response was a very distinct pressure of my hand. Have I known you? Yes. Tell me your name on earth. Spelling the letters came the reply: Today is the anniversary of my death. Those present asked me who it was, and I replied: My father."

Nor was spiritualism the only game at court. It had quickly become famous as a court that insisted on expensively elaborate artifice. Men with false titles appeared in false uniforms, and the women paid court not only to Eugénie but to her English couturier, Jacques Worth. The popular novelist Octave Feuillet wrote to his absent wife a remarkable account of the childish games played at the summer palace in Compiègne, like "Singe à la Mode," in which each of the lords and ladies tried to play monkey by picking up with their teeth a ring embedded in a plate of flour. Or "Toilette de Madame," in which each player represented some article of clothing, and the emperor ran from one to another, laughing wildly.

This makes it sound as though the court of Napoleon and Eugénie was entirely frivolous, and it was not. On the contrary, it was generally rather stiff and formal. It was often frivolous about serious things, as in its indifference to the growing power of Prussia or its attempt to buy the Grand Duchy of Luxembourg, but it was just as often intensely serious about considerably less important things, like the design of three blackbirds within a border of imperial eagles as a new coat of arms for the Count de Morny on his elevation to a dukedom.

Eugénie lived in a kind of wilderness. Her evolution from a beautiful girl with social ambitions into an imperious woman with political ambitions coincided with the evolution of Napoleon from an emperor on horseback into a man who yearned for peace and quiet. He had always

been a bit awkward in the imperial role. He had none of the lust for domination that had inspired his uncle, and none of the genius for combat either; he had pursued the role because he had felt it his duty and his destiny, and he was a third son who wanted desperately to impress his contemptuous father, but he was also amiable, good-natured, and profoundly indolent. He even felt a little guilty about his repeated betrayals of Eugénie, willing to indulge her as much as he could, and so now, sick and exhausted, he was neither shocked nor indignant when she proposed to him that he abdicate and let her remain as regent on behalf of the ten-year-old prince imperial. Indiscreetly confiding this to her friend Prince Metternich, Eugénie even more indiscreetly added, "We are marching to our downfall, and the best thing would be if the emperor could disappear suddenly, at least for the time being."

<center>⊙⊙⊙</center>

Eugénie was now embroiled in her most complicated and ambitious political maneuver, an attempt to impose a European Catholic monarchy on the independent republic of Mexico. Napoleon also had ambitions for political and commercial expansion into Latin America, but the Monroe Doctrine tended to deter him from military intervention. Eugénie, however, knew a number of rich Mexican émigrés who had drifted to Europe with sad tales of expropriations and anticlerical violence. Eugénie was greatly impressed. "If Mexico were not so far away and my son were not still a child," she told an American diplomat, "I would wish him to put himself at the head of a French army and with his sword inscribe one of the most glorious pages of the country's history."

Others at Napoleon's court took a more wordly view of the possibilities. His half-brother Morny invested heavily in Mexican bonds and argued in favor of their being honored. These bonds were typical of the confusion surrounding Mexican affairs. The nation itself was divided between two warring governments, the so-called Constitutionalists led by Benito Juarez, whose 1857 constitution expropriated the church and proclaimed the equality of all citizens, and a Conservative regime that rejected such disturbing ideas. The Conservative regime in Mexico City borrowed $15 million (in exchange for bonds worth $16.8 million) from a Swiss banker who actually paid only $1.5 million before going bankrupt. That left a lot of heavily discounted Mexican bonds in the hands of people like Morny, who were dismayed to hear, when Juarez

drove the Conservatives out of Mexico City in January of 1861, that he was suspending interest payments for two years.

The suspension of payments gave Napoleon a splendid pretext to recruit Britain and Spain into joining an allied expeditionary force to seize Veracruz until Mexico paid its debts—and the United States could do little about it because it was paralyzed by the outbreak of its own Civil War. Juarez managed to negotiate a settlement with the British and Spanish so that they returned home in April of 1862. That left a 6,000-man French force ready to march on Mexico City to demand full satisfaction.° When the Mexicans defeated the French invaders at Puebla, Napoleon sent 30,000 reinforcements to seize what he called "a country disintegrating through anarchy and misrule."

This had been the plan from the beginning, of course. At least, it was Eugénie's plan. When she and some of her Mexican friends talked about restoring the powers of Church and Crown, they naturally talked about who might achieve their goals. On the lists of possibilities, Archduke Maximilian of Austria always ranked high. The younger brother of the young Habsburg Emperor Franz-Josef, he had already served with distinction in the navy, developed the naval base at Trieste, and acted as governor-general of Lombardy and Venetia, but he seemed doomed to a life of princely subordination. As early as 1859, he was approached by Mexican exiles to see how he would feel about an offer of a crown. He was warily indifferent. This indifference changed markedly when Eugénie suggested the idea to Napoleon and Napoleon suggested it to the Austrian government, and the Austrian government thought the idea well worth exploring. "It is a question of rescuing a whole continent from anarchy and misery," Napoleon wrote to Maximilian in January of 1862, at about the time that French troops were landing in Veracruz, "of setting an example of good government to the whole of America, of raising the flag of monarchy ... in the face of dangerous Utopias and bloody disorders."

If Maximilian remained uncertain about "raising the flag of monar-

°Guillaume Apollinaire later claimed in several articles that this French expeditionary force included the painter Henri (the Douanier) Rousseau, who was thereby inspired to create his many jungle paintings. This seems to have been a fabrication by either Apollinaire or Rousseau himself. Working as a clerk in a lawyer's office, Rousseau was caught embezzling twenty-five francs. Hoping to avoid a prison sentence, he enlisted in the army and appeared in court in uniform. He received a one-month prison term, then served seven years in the army but never went to Mexico.

chy" in a distant land about which he knew next to nothing, his strong-minded young wife, Charlotte, did not. Just twenty-two at this point, the daughter of King Leopold of Belgium wrote to an ex-governess that she would "prefer a full and active life with duties and responsibilities—and even difficulties, if you will—to an idle existence contemplating the sea from the top of a rock." And when she realized that Eugénie was the one pressing for Maximilian to become emperor of Mexico, she wrote effusive thanks: "Your Majesty seemed obviously marked out by Providence to initiate a project which one might call holy."

The women had their way, and so when the French army captured Mexico City and sponsored a conclave of local grandees in offering the crown of Mexico to Maximilian, the archduke set sail for Veracruz. With him, he carried Napoleon's written agreement to maintain 28,000 French troops in Mexico and a pledge that "whatever should happen in Europe, France would never fail the new Mexican Empire." Maximilian spent the long days at sea drafting the rules of what he desired as court etiquette, a document that came to more than 500 pages. The realities of Mexico were somewhat different. The railroad line from the coast ended at Soledad, nearly 200 miles from Mexico City, and the rest of the trip had to be made on mules. In the royal suite of the palace, there were so many bedbugs that the new emperor spent his first night sleeping on a billiard table. "We have to struggle against the desert, the distance, the roads and the utter chaos," Charlotte wrote to Eugénie.

The political realities were equally challenging. Maximilian nourished dreams of reconciling progressive and conservative forces; the former regarded him as an alien usurper, the latter as a betrayer of their hopes. Church leaders, in particular, were infuriated by his reluctance to restore all their old powers. That left as his only real support the French army, which was billing his bankrupt treasury 40 million francs a year for its services as an occupying garrison.

Barely a year after Maximilian's arrival, the end of the American Civil War enabled Secretary of State William Seward to demand that Napoleon's forces be withdrawn. And Napoleon, as was becoming increasingly his practice, gave way. "It is not without pain," he wrote to Maximilian at the start of 1866, "that I find myself forced to come to a decision and put a definite term to the French occupation." The French evacuation "may cause Your Majesty temporary embarrassment," Napoleon wrote, but it would be gradual, and perhaps that would give

Maximilian time to organize an army of his own....

Maximilian was horrified, but the one who vowed to fight back was the Archduchess Charlotte, now known as Empress Carlotta. She set sail for France to argue Napoleon into honoring his written pledges of support. When she landed at Saint-Nazaire, she found nobody there to welcome her. The ailing Napoleon had just returned to Paris from taking the waters at Vichy, and now the whole French government was totally preoccupied with Prussia's devastation of Austria at the battle of Sadowa. Carlotta sent Napoleon a telegram saying she had to see him immediately to discuss "certain matters concerning Mexico." Napoleon's answer: "I...am forced to stay in bed so I am not in a position to see Your Majesty."

Carlotta had by now installed herself at the new Grand Hotel in Paris, and Eugénie went there to see if she could be placated. Carlotta spoke shrilly of the need for troops and money. Eugénie tried to make conversation about theatrical openings and new clothing styles. Carlotta demanded to know when she could see the emperor. Eugénie said he was too sick to receive visitors. Carlotta said she had to see him anyway. Otherwise, she added, in an ominous prophecy of things to come, *"Je ferais irruption dans son cabinet."*° She announced, despite anything Eugénie could say, that she was going to Saint-Cloud the following day to confront the emperor, and so she did. The three of them sat alone together for some two hours, and Carlotta played every card she had. She even waved at Napoleon the letter that had helped persuade Maximilian to go to his doom—*"Vous pouvez être sur que mon appui ne vous manquera jamais."*† The emperor's only response to this challenge was to weep, and to say that he could do nothing. Carlotta "did everything that was humanly possible," she later wrote to Maximilian, but the emperor "appeared to be utterly helpless, with tears pouring down his cheeks, continually turning to his wife for support."

The scenes kept getting worse. When it came time for a serving of sherbets, Carlotta refused to touch hers, beginning to suspect that the French wanted to poison her. Next day, Eugénie accompanied Carlotta to a meeting with the French ministers of war and finance, in which Carlotta charged that officials in Paris were stealing money supposedly

°"I shall make an eruption in his cabinet."

†"You can be sure that my support will never fail you."

being sent to Maximilian. Both Carlotta and the ministers began shouting. Eugénie burst into tears and then, perhaps by artifice, fainted dead away. Napoleon finally rose from his sickbed and went to Carlotta's hotel to tell her to give up her illusions. "Your Majesty is directly concerned in this affair and should also not indulge in any [illusions]," retorted Carlotta. To her husband in Mexico, she reported, "I have thundered at them and torn off their masks. Nothing so unpleasant has happened to them in their lives."

Since nothing could shame Napoleon into honoring his pledges— "He is the evil principle on earth ... the devil in person," Carlotta wrote to Maximilian—Carlotta pressed on to Rome to recruit Pope Pius to her cause. Pius made it clear that he could do nothing, and since Maximilian had proved himself reluctant to restore the Church's full powers in Mexico, the pope was not inclined to launch any crusade. Carlotta apparently became convinced that Napoleon's agents were pursuing her and trying to poison her even in Rome. She sought refuge in the pope's personal quarters, screaming wildly at anyone who tried to stop her. She refused to eat anything, according to a report that Queen Victoria wrote to her daughter in Berlin, except for what she could scavenge at the pope's table by "dipping her bread into his soup plate." She finally fainted and was carried away.

It is not impossible that she was right, and that Napoleon's secret police really were trying to poison her. Certainly they were quite capable of it. And certainly she was right in thinking that the powers who had urged Maximilian to accept the crown of Mexico were now betraying and abandoning him. But Carlotta, who protested too much, was now declared to have lost her mind, and so, still only twenty-six, she was confined. And she remained in confinement for the next sixty years, dying only in 1927, long after both Napoleonic and Habsburg empires had crumbled away.

The Emperor Maximilian, left to his own resources, did not last long. He tried to abdicate but was dissuaded; he tried to flee, then returned to Mexico City, then established himself in a new military headquarters at Querétaro, about 150 miles to the northwest. The last French troops left in March of 1867. Juarez's forces besieged Maximilian in his isolated citadel. They captured him in May, court-martialed him, convicted him, and, on June 19, shot him.

The first reports to reach Europe came considerably garbled. As late as June 26, *Le Figaro* published rumors in Paris that Maximilian had embarked for home. On July 4, *L'Indépendance Belge* reported a different outcome: "It is said today that he [Maximilian] has been hanged, and even that his body, cut into quarters, has been divided among the provinces of the Mexican Republic." But Napoleon received the official news of Maximilian's death on July 1 just before he was to distribute the prizes at the universal exposition. "I am inconsolable," he telegraphed to Emperor Franz-Josef in Vienna, "at having with the best intentions contributed toward such a lamentable result."

Very soon after *Le Figaro* first published the details of the execution, Manet began to plan a painting of the scene, the first large-scale historical work he had ever attempted. That work was interrupted, though, by the traditional family vacation in Boulogne, then by the death of Baudelaire, and the painting that Manet finally finished in September was really not finished at all. It is full of dark and anonymous passion, the emperor's head virtually blotted out by gunsmoke, the firing squad seen from behind and thus faceless in its massed and rigid concentration on killing. But this nightmarish scene is only the beginning of what was to become an almost obsessive yearlong series of repaintings, the nightmare repeatedly revisited and redefined and reexperienced.

The uncertainty about the details of the actual execution seems to have troubled Manet. His executioners originally wore uniforms rather in the style of Mexican cowboys; when Manet learned that their real uniforms were almost identical to those of the French army, he painted them over, but made no attempt to disguise the repainting. He also included a mysterious figure in brown who stands grimly behind the firing squad, looking not at the execution but at the viewer.

Manet may also have been troubled by his indebtedness to Goya's similar scene, *The Third of May, 1808*. He had seen it at the Prado on his trip to Spain just two years earlier, and that spectacle of the desperate prisoner flinging out his arms before the French firing squad is a sight not easily forgotten. The two pictures are quite different, of course, but there are also inescapable similarities: the dark force of death in the right center of the canvas, the highlighted victims on the left, the sense

of a moment of horror. There were odd political reverberations, too, in the fact that Goya's executioners were Napoleonic invaders while the executioners in Mexico had been brought to the firing line by the withdrawal of Napoleon III. Manet could hardly have been embarrassed by the connection to Goya; he loved artistic quotation and pastiche, almost insisted on it as a way of associating himself with the traditions he admired. But in contrast to, say, Giorgione's *Fête Champêtre* or even Titian's *Venus of Urbino*, Goya's *Third of May* is a great masterpiece, and to cite it inevitably calls attention to one's own inferiority.

Manet started over again, making important changes. The soldiers in the firing squad now wear French uniforms, French kepis, white leather belts and spats. Perhaps most important, the mysterious man in brown behind the firing squad has changed into a goateed noncommissioned officer who stands armed but inactive, staring into space, surprisingly indifferent to the execution taking place. Manet was so dissatisfied with this version that he abandoned it.

He started again, this time with a lithograph. Though the executioners in French uniforms remain about the same as in the second painting, the three victims, all desperately holding hands, have finally emerged from the gunsmoke. The Emperor Maximilian, oddly outfitted in a sombrero, looks stoically bewildered; the general on the left, already hit, throws back his head in a cry of pain and protest. The other new element is that the amorphous background has turned into a high wall, on top of which a number of bystanders noncommittally watch the proceedings.

But this, too, was just a new study for the painting that Manet envisioned, a work that he now saw as a major tableau to be submitted to the next Salon. Once again, he started anew, first in a rather small (twenty by twenty-four inches) preliminary study, and then on a much grander scale (100 by 120 inches).* Even in these two final versions, he kept making important changes. The line of bystanders atop the wall, who were only a sketchy presence in the lithograph, have finally become central, our representatives as witnesses (and thus silent participants) to the tragedy.

*The first version of *The Execution of Maximilian* is in the Boston Museum of Fine Arts; the second ended as four fragments in London's National Gallery; the third is in the Ny Carlsberg Glyptotek in Copenhagen, and the fourth is in the Kunsthalle in Mannheim, Germany. The lithograph, of which at least fifty prints were made, is in the Bibliothèque Nationale in Paris. Since the chronology is not completely certain, the various painted versions are often referred to by their locations.

And Maximilian keeps emerging more and more clearly from the gun-smoke, a figure of almost supernatural innocence, his sombrero now tilted back on his head in a way that some critics think evokes a Christian halo.

It has been all too easy, in fact, for *The Execution of Maximilian* to be interpreted as a pseudo-Christian passion play. In addition to the halo-like sombrero, the faint signs of blood on Maximilian's hands can be seen as a reappearance of Christ's stigmata. Then there are the two fellow victims at his side (there were, in actual fact, two generals executed along with the emperor), and Proust recorded the fact that Manet did talk of painting a crucifixion. "I would like to paint a Christ on the cross. Christ on the cross, what a symbol! One could search through all the centuries without finding anything like it.... It is the basis of humanity, it is the poetry of it." But though it is always tempting to interpret a work of art as something other than what it is, there remains the fact that it is what it is—in this case, the execution of the Emperor Maximilian, a humiliating defeat for the vainglorious ambitions of the Emperor Napoleon (and his wife, Eugénie).

And when one considers this painting as a political act, one becomes more and more struck by that uniformed figure standing behind the firing line, the officer with the goatee and the look of slightly guilty indifference, the one who stands at the opposite extreme from Maximilian, his counterpart, passive and apathetic to the killing in front of him. It is not difficult, then, to see this goateed figure as many of Manet's contemporaries might have seen him, as Napoleon himself. He did not take any part in the execution. He simply stood there, holding his gun unused, and looking away from the killing, looking at nothing.

Manet's contemporaries were not allowed to see any of this, however. The lithograph had to be printed and the prints brought it to the attention of the censors at the Ministry of the Interior. Manet received an official letter, now lost, telling him that his picture was forbidden. "I thought they could stop the publication but not the printing..." Manet wrote to Zola. "I feel that a word about this ridiculously high-handed little act would not be out of place. What do you think?" Zola was probably responsible for the fact that "a word" soon appeared in *La Tribune* on January 31, 1869, reporting the suppression, adding that Manet's lithograph "treated this subject from a purely artistic point of view," and sarcastically suggesting that the government might soon "pursue people

who simply dare to maintain that Maximilian was shot." Zola made the same point more fully in the following week's issue of *La Tribune*. He noted that the uniforms on the firing squad were "almost identical to those of our own troops," and so "you can understand the horror and anger of the gentlemen censors. What now! An artist dared to put before their eyes such a cruel irony: France shooting Maximilian!" If Manet wanted to satisfy the censors, Zola suggested, "I advise him to depict Maximilian alive and well with his happy, smiling wife at his side."

The censors were not moved. They also informed Manet, "unofficially," that if he submitted any painting of Maximilian's execution to the Salon, it would be rejected. By implication, they were warning him that any attempt to exhibit his work would be prosecuted. The situation became even more tangled when the printer of the lithograph, a man named Lemercier, refused to return the stone and apparently planned to obliterate Manet's picture. Manet had to go to court to retrieve his work, which thereafter remained locked up in his studio.

Not until 1880 was the *Execution of Maximilian* finally exhibited, in, of all places, Boston. An opera singer named Emilie Ambre persuaded Manet to let her take the painting with her on her tour of America, and so it was placed on display at the Studio Building and advertised with Barnumesque handbills ("Come and see the famous picture by the famous painter Édouard Manet") for twenty-five cents per customer. Not until 1884, when Manet and Napoleon were both dead, was anyone in France allowed to view the painter's judgment on the exiled empress's grand dreams of empire.

The strangest twist was still to come. After Manet's death, Léon Koëlla was unable to sell the second version of *The Execution of Maximilian*, which he himself regarded as an inferior painting, so he took the canvas off its stretcher, rolled it up, and stored it under some furniture in a shed outside his home. Then he decided one day to see if he could sell some part of the picture. He cut out the figure of the sergeant standing behind the firing line and sold that to a dealer named Portier, who sold it in turn to Degas. Koëlla rolled up the remnant and stored it away again. When the dealer Ambroise Vollard came by on a visit, Koëlla unrolled the remnant and offered it to him. "What a pity Édouard spent so much time working on that!" Madame Manet observed. "What a lot of nice things he could have painted in that time." Vollard bought the remnant for 800 francs and took it to be rebacked.

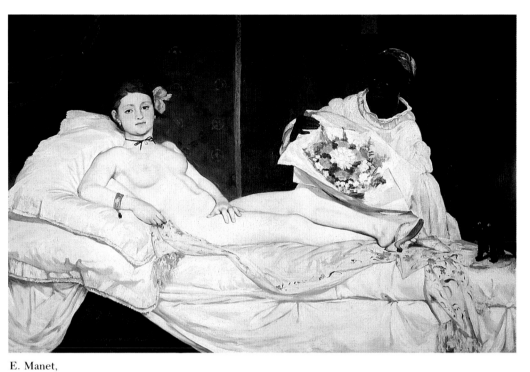

E. Manet,
Olympia, 1863. Musée d'Orsay, Paris.

E. Manet,
Portrait of Victorine Meurent, 1862.
Museum of Fine Arts, Boston.

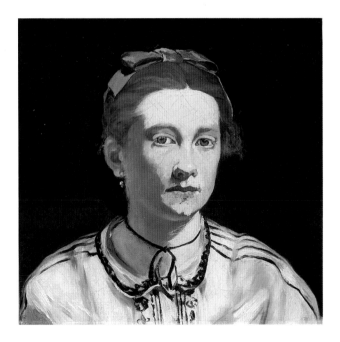

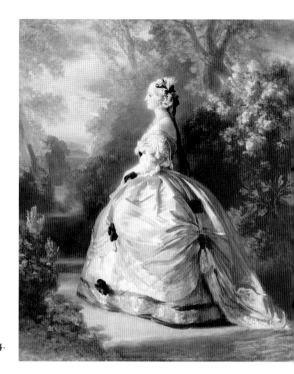

F. X. Winterhalter, *The Empress Eugénie*, 1854.
The Metropolitan Museum of Art, New York.

Napoleon III at the Battle of Magenta,
June 5, 1859. Lithograph. (COLLECTION VIOLLET, PARIS)

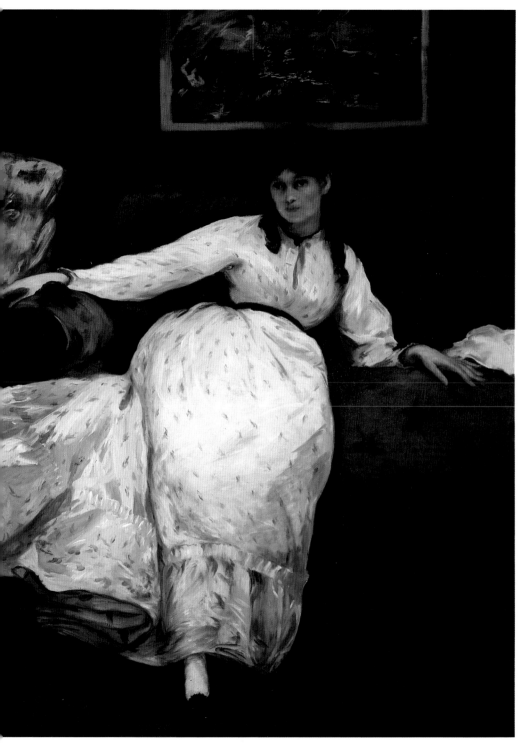

E. Manet, *Repose* (Portrait of Berthe Morisot), 1869.
Museum of Art, Rhode Island School of Design, Providence.

Pérignon,
Hortense Schneider
as the Grand Duchess of
Gerolstein by Offenbach.
(COLLECTION VIOLLET, PARIS)

Paris as remodeled by Baron Haussmann. The Place de l'Étoile with streets radiating from it.
Woodcut circa 1870. (THE BETTMANN ARCHIVE)

E. Manet, *Nana*, 1877. Kunsthalle, Hamburg.

E. Degas, *Laundresses*, c. 1884. Louvre, Paris.
(PHOTO GIRAUDON, SCALA/ART RESOURCE, NEW YORK)

E. Degas, *Portrait of Édouard Manet*, c. 1864.
The Metropolitan Museum of Art, New York
(Rogers Fund, 1918).

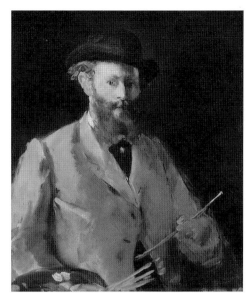

E. Manet, *Self-Portrait with Palette*, 1879.
Private Collection.

E. Manet, *Portrait of Émile Zola*, 1868,
Musée d'Orsay, Paris. (SCALA/ART RESOURCE, NEW YORK)

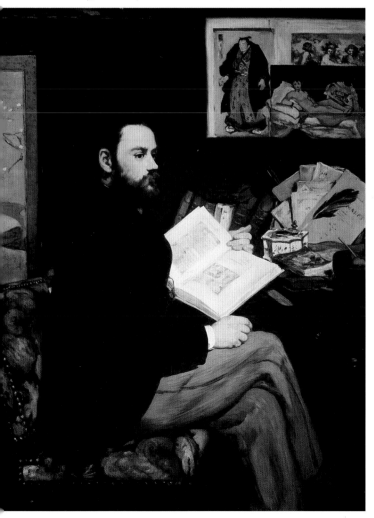

Battle of Sedan, September 1, 1870. (COLLECTION VIOLLET, PARIS)

Gambetta leaves Paris by balloon, October 7, 1870. (COLLECTION VIOLLET, PARIS)

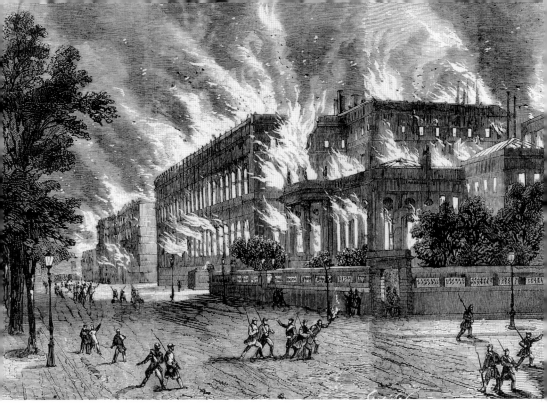

Cour des Comptes and Legion d'Honneur
on fire, Paris, evening of May 23, 1871.
Engraving. (THE BETTMANN ARCHIVE)

E. Manet,
The Barricade, 1871. Lithograph.
Museum of Fine Arts, Boston
(Gift of W. G. Russell Allen).

Rue de Rivoli during the Commune, 1871.
(COLLECTION VIOLLET, PARIS)

B. Morisot, *The Cradle*, 1873.
Louvre, Paris. (PHOTO GIRAUDON,
SCALA/ART RESOURCE, NEW YORK)

OPPOSITE PAGE:

G. Caillebotte,
Paris, a Rainy Day, 1877.
The Art Institute, Chicago (Charles H.
and Mary F. S. Worcester Fund).

E. Manet, *The Railroad*, 1873.
National Gallery of Art, Washington, D.C.
(Gift of Horace Havemeyer).

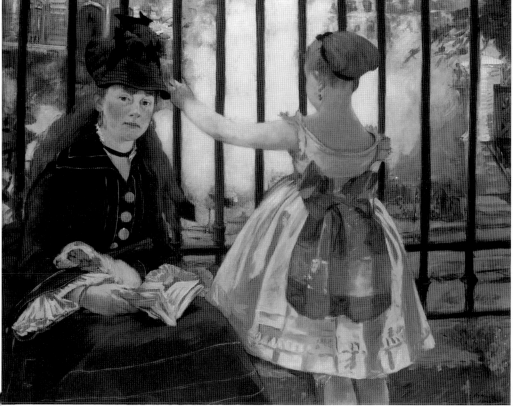

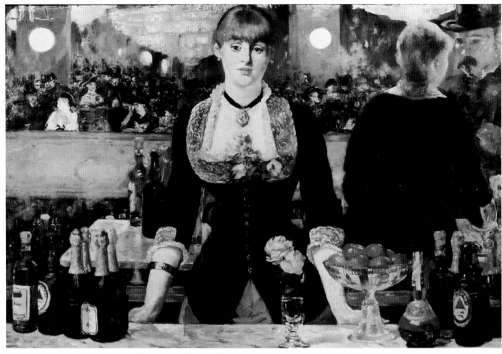

E. Manet, *A Bar at the Folies-Bergère,* 1881. Courtauld Institute, London.

E. Manet,
Pinks and Clematis, 1883.
Louvre, Paris.

"Surely," said the craftsman to whom he took it, "the *Sergeant* I rebacked for M. Degas must have been cut out of this canvas! He was told that the rest of the picture had been accidentally destroyed."

"When I showed Degas my canvas..." Vollard recalled, "he was dumbfounded and said indignantly: 'That's the family at it again! Beware of the family!' Then, recovering his temper, he took a stand between me and the picture, put his hand on it as if taking possession of it, and said: 'You're going to sell me this. And you must go back to Madame Manet and tell her that I want the legs of the sergeant that are missing from my fragment and also the piece that is missing from yours: the group formed by Maximilian and the generals. Tell her I'm prepared to pay for it.'"

Vollard returned to the Manet household, retrieved some fragments, and questioned Koëlla about his vandalism. Koëlla didn't seem to think he had done anything wrong.

"I thought that the sergeant looked better without his legs, which seemed to hang down like rags," he said, "and also that the soldiers taking aim looked better without the group of generals and what remained of Maximilian's head.... If I had ever imagined that a bit of canvas all spoiled by damp from the wall was of any value, I wouldn't have used it to light a fire."

Vollard told Degas only that the missing parts had been destroyed by dampness. Degas repeated his gloomy warning: "You see, Vollard, how you have to beware of the family." Degas then took his fragments and glued them onto a canvas that he estimated as the same size as the one that his friend Manet had originally used. When Degas's collection was sold after his death, *The Execution of Maximilian* ended at the National Gallery in London. The experts there, in the interests of authenticity or something, cut it up again in the same way that Koëlla had done, and so it remains to this day.

· 3 ·

BERTHE MORISOT

Men fill me with disgust. I have a horror of them....
—MARIE-CORNÉLIE MORISOT

One of the things that makes many of Manet's pictures so interesting more than a century after he painted them is their quality of mystery. Scenes that seem to represent the commonplaces of middle-class life somehow remain, as with the nakedness of Victorine Meurent picnicking in the woods, inexplicable. One of the most characteristic of these domestic enigmas is a picture that Manet began at Boulogne during the summer of 1868 and called simply *The Balcony*. Behind a railing of poisonous green, and between two shutters of about the same color, Manet assembled four figures all looking in different directions, all out of contact with each other. The woman seated in the foreground, with a red fan and a floor-length white gown, stares discontentedly off to her right. Beside and slightly behind her, also dressed in white but clutching a green parasol, stands a rather Oriental-looking woman who seems to be putting on gloves as though to depart. Just behind her, smoking a cigarette and apparently indifferent to his neighbor's impending departure, stands a portly and mustachioed figure in a rich blue cravat. And behind him, almost invisible in the darkness, a young boy seems to be bringing forward a pitcher of water.

Who are they? What are they all doing there, crowded together on this narrow balcony? To formalist critics, such questions are secondary (if not completely irrelevant) to the striking patterns of green that dominate the whole painting. To the historian of cultural influences, the key

78

fact is that Manet based the whole structure of his painting on a well-known engraving by Goya, *Majas on the Balcony*. But if we do not know just what Manet's enigmatic characters represent, we do know who they are. The boy in the background is, once again, Manet's unacknowledged son, Léon Koëlla. The man with the blue cravat is Antoine Guillemet, a minor but well-connected landscape painter who did Manet a number of good turns. The woman with the green parasol is Fanny Claus, a young concert violinist who often came to play chamber music with Suzanne Manet. But the central figure in the painting is the seated woman with the fan, whom Manet had only recently met and whom he soon grew to admire and to love. This was the first of his eleven portraits of Berthe Morisot.

Manet resisted those feelings, and so did she. Berthe Morisot was not a girl of the streets like Victorine Meurent, but the eminently respectable daughter of a high court official, so Manet's marriage represented an almost indestructible barrier between them. Manet characteristically tried to treat their new friendship with jocular raillery. "I quite agree with you, the Mlles. Morisot are charming," he wrote banteringly to Fantin-Latour, who had introduced him to Berthe and her sister Edma at the Louvre. "Too bad they're not men. All the same, women as they are, they could serve the cause of painting by each marrying an academician, and bringing discord into the camp of the enemy!"

The Morisots were a cultured family, counting the painter Fragonard among their antecedents. Tiburce Morisot had planned to become an architect, like his father, but for practical reasons he became a government administrator instead. He served in Valenciennes, Bourges (where Berthe, his third daughter, was born in 1841), in Limoges, Caen, and Rennes, then finally settled in Paris in 1851. He became a councillor of the Cour des Comptes and lived with his wife Marie-Cornélie and their four children in the Rue Franklin in what was then the outlying village of Passy. Berthe Morisot was given piano lessons and encouraged to read Shakespeare. When she was sixteen, her mother wanted to give her father a surprise by having all three girls produce pictures for his birthday. This required lessons from a teacher named Geoffrey Chocarne in the Rue de Lille. When Papa Morisot's birthday was over, his oldest daughter, Yves, gave up her paints and brushes forever, but the two younger girls, Edma and Berthe, clamored for more lessons, and from a more interesting teacher. Joseph Guichard, who had studied with both

Ingres and Delacroix, was found nearby in Passy. Guichard asked the girls to draw a sketch with a white accent. Berthe drew a landscape that included a flock of sheep. Guichard, impressed, took Madame Morisot aside and warned her that her girls were no ordinary students.

"Considering the character of your daughters," he said, according to Berthe's brother Tiburce, "my teaching will not endow them with minor drawing room accomplishments; they will become painters. Do you realize what this means? In the upper-class milieu to which you belong, this will be revolutionary, I might almost say catastrophic. Are you sure that you will not come to curse the day when art, having gained admission to your home, now so respectable and peaceful, will become the sole arbiter of the fate of two of your children?"

Madame Morisot professed herself quite prepared for these dangers.

"In that case, Madame," said Guichard, "the first thing to do is to apply for permission for them to work in the Louvre, where I shall give them lessons before the masters."

The Morisot sisters began working at the Louvre in 1858, when Berthe was seventeen. Guichard, along with teaching them, also introduced them to other painters working there, notably Henri Fantin-Latour and Felix Braquemond. Fantin-Latour soon became timorously infatuated with Edma. "Fantin expressed his admiration of your beauty, saying that he had never seen a creature as ravishing as you were a few years ago..." Madame Morisot later wrote to Edma in a secondhand account of an evening at Manet's home. "His friend Manet then told him that he should have proposed to you, but he answered that he had always heard that you did not want to marry. There was less talk about your painting, it seemed to me, than about your person. However, Manet mentioned the offer he had made to an art dealer when he saw something of yours that charmed him."

The Morisot sisters worked in the Louvre for two years, but Berthe was determined to pursue the new fashion of painting outdoors, *en plein air*, directly from nature, and Guichard considered that a violation of all correct artistic procedure. He sadly but dutifully introduced the Morisots to the aging landscape master, Jean-Baptiste Corot, who, like everyone else, was both charmed and impressed. He began coming to dine at the Morisot house every Tuesday, and Madame Morisot gave him special permission to smoke his pipe after dinner. Corot, too, set the sisters to copying, not Veronese paintings in the Louvre but his own land-

scapes. Like Fantin-Latour, he was particularly pleased by Edma, and he exchanged paintings with her. It was probably not coincidental that Berthe later destroyed all the copies she had made of Corot's work.

The sisters progressed. In 1865 they decided to send several of their paintings to the same Salon that was to be scandalized by Manet's *Olympia*. Because their names all began with *M*, their paintings should have been hung nearby, but when Madame Morisot went to look at them (the sisters had both anxiously gone to stay with an uncle in Chartres), she had some difficulty in searching for them. "I had to go to a great deal of trouble to find Berthe's and Edma's pictures, the ones listed as secondary exhibits," she wrote to her oldest daughter, Yves. "Berthe's *Cauldron* is all the less conspicuous because it is not hung in the hall of the *M*'s. Edma's *Pot of Flowers* can barely be detected in one of the square rooms at the end, next to Guillemet's landscape [Guillemet being that pompous figure in the blue cravat in *The Balcony*]. It cuts a sorry figure. ...Berthe's *Woman* is well-lighted, at least in the mornings, and does not look bad at all. I saw people pointing it out to one another...."

Berthe Morisot was not a painter who evolved or developed to any great degree. By her early twenties, she already had a clear vision of the kind of work she wanted to do. By her early twenties, she also had a very considerable talent, though she didn't seem to realize it, or to have much confidence in it. She had already painted beautiful landscapes, and beautiful portraits of Edma, but she didn't seem to know how magical they were. Paul Valéry, trying to analyze the uniqueness of her work, contrasted her to the other Impressionists by saying that "the peculiarity of Berthe Morisot...was to live her painting and to paint her life, as if the interchange between seeing and rendering, between the light and her creative will, were to her a natural function, a necessary part of her daily life. She would take up the brush, leave it aside, take it up again, in the same way as a thought will come to us, vanish, and return. It is this which gives her works the very particular charm of a close and almost indissoluble relationship between the artist's ideals and the intimate details of her life.... Her work as a whole is like the diary of a woman who uses color and line as her means of expression."

Although Berthe Morisot's artistic vision seemed fully formed in her early twenties, she had not yet begun what was to become one of the most extraordinary experiences of her life. She was back at work in the Louvre in the spring of 1868, copying *The Exchange of the Two Princesses,*

by Rubens, of all people, when Fantin-Latour approached her at the side of a blond-bearded man and introduced him as Édouard Manet. She had long admired and wanted to meet Manet and he had probably wanted to meet her too, so there were no simperings and circlings. They recognized each other immediately as artists and as friends. All the Morisots soon began attending the elder Madame Manet's Thursday evening gatherings, where they could meet such figures as Degas or Zola or Emmanuel Chabrier, who invariably began pounding on the piano. It was only a matter of time until Manet asked the inevitable question, whether Berthe would pose for him, and so she inevitably took her place on the balcony.

Manet had trouble with those figures on the balcony, and Madame Morisot was, as always, a bit malicious. "Antonin [Guillemet] says that he [Manet] made him pose fifteen times to no effect and that Mademoiselle Claus is atrocious," she wrote to Edma, "but both of them, tired of posing on their feet, say to him: 'It's perfect—there is nothing more to be done over.'"

There is no indication that Berthe Morisot ever complained about posing, or about what he made of her. According to contemporary photographs, the likeness was a very good one. Berthe Morisot's face was sharp, angular, and often animated, as in *The Balcony,* by a look of nervous discontent. But it was an intelligent face, a lively face, an interesting face, a face dominated by the most extraordinary green eyes. "They were almost too large," Valéry wrote many years later (he married one of her nieces, so he knew her as Tante Berthe), "and so powerfully dark that Manet, in the several portraits of her which he painted, shows them, so as to convey all their deep and magnetic force, as being black instead of green which they really were.... Is it ridiculous to suppose that, if one were to undertake a really strict analysis of painting, it would be necessary to make a close study of the vision and the eyes of the painter? It would be only to begin at the beginning."

The Salon traditionally opened on the first of May, and when Berthe went to look at the *M* room in that spring of 1869, she discovered Manet, the ordinarily cool, affable, sophisticated Manet, in a state of considerable anxiety. "I found Manet, with his hat on in bright sunlight, looking dazed," she wrote to Edma. "He begged me to go and see his painting as he did not dare put himself forward. I have never seen such an expressive face as his; he was laughing in an anxious way, assuring everybody

that his picture was very bad, and adding in the same breath that it was having a great success. I think he has a decidedly charming temperament. I like it very much. His paintings as usual give the impression of a wild or slightly green fruit." Madame Morisot, accompanying Berthe, took a darker view: "Manet looks like a madman."

So Berthe went and looked at *The Balcony,* and saw for the first time the final version of what Manet had seen in her. Several people had apparently told her that it was an unflattering portrait, but now as she looked at his vision of her, she was not at all unflattered, not at all. "I am more strange than ugly," she said in her letter to Edma. "It seems that the epithet of *femme fatale* has been circulating among the curious, but I realize that if I tell you about everything at once, the people and the paintings, I will use up all my writing paper...." And so, self-conscious and a little embarrassed even toward her beloved Edma, she moved on to describe the Salon opening as a social cotillion.

"For about an hour Manet, in high spirits, was leading his wife, his mother, and me all over the place, when I bumped headlong into Puvis de Chavannes. He seemed delighted to see me, told me that he had come largely on my account as he was beginning to lose hope of seeing me again at the Stevenses, and he asked if he might accompany me for a few minutes. I wanted to see the pictures, but he implored me so eagerly: 'I beg of you, let us just talk. We have plenty of time for looking at paintings.'... I had completely lost sight of Manet and his wife, which further increased my embarrassment. I did not think it proper to walk around all alone. When I finally found Manet again, I reproached him for his behavior; he answered that I could count on all his devotion, but nevertheless he would never risk playing the part of a child's nurse."

The reason why Berthe was writing to Edma, from whom she had never been separated before, was that an important change had divided them early in 1869: Edma had married a young naval officer named Adolphe Pontillon and gone to live in the Breton port of Lorient. Degas had recommended that she while away her time in reading Benjamin Constant's novel *Adolphe,* and so she now wrote to Berthe that it "grows on me, just as M. Degas told me it would." But mostly her letters to Berthe were filled with longing. "I am often with you, my dear Berthe," she wrote on March 15. "In my thoughts I follow you about in your studio, and wish that I could escape, were it only for a quarter of an hour, to breathe that air in which we lived for many long years." Berthe answered

with news of Degas, whom she had seen at a party at the Stevenses. "He talked about you to me last night;" she wrote. "He finds you very strange. From several things he said about you, I judge him to be very observing. He laughed on hearing that you are reading *Adolphe.* He came and sat beside me, pretending that he was making love to me, but this was limited to a long commentary on Solomon's proverb, 'Woman is the desolation of the righteous.'"

The main thing that now divided the Morisot sisters, however, was not just a matter of physical separation but of change in vocation. Edma, who had real talent, accepted the contemporary assumption that when a woman got married, any other activity became no more than a hobby. Berthe would never accept that; even when she did finally marry, that never made her any the less a painter. Now the two sisters tried to reconcile these differences—not by attacking each other's positions but on the contrary by trying to comfort and sympathize with each other.

"If we go on in this way, my dear Edma, we shall no longer be good for anything," Berthe wrote on March 19. "You cry on receiving my letters, and I did just the same thing this morning…. But, I repeat, this sort of thing is unhealthy. It is making us lose whatever remains of our youth and beauty. For me this is of no importance, but for you it is different. Yes, I find you are childish: this painting, this work that you mourn for, is the cause of many griefs and many troubles. You know it as well as I do, and yet, child that you are, you are already lamenting that which was depressing you only a little while ago. Come now, the lot you have chosen is not the worst one. You have a serious attachment, and a man's heart utterly devoted to you. Do not revile your fate. Remember that it is sad to be alone; despite anything that may be said or done, a woman has an immense need of affection…."

"You are right, my dear Berthe, in all that you say to me," Edma wrote back, a little disingenuously. "It is disheartening that one cannot depend on artists. My infatuation for Manet is over; as for Monsieur Degas, that is a different matter. For one thing, I am curious to know what he could have to say about me, and what he finds strange in my person. The commentary on the proverb must have been pretty and piquant…. Life here is always the same. The fireside, and the rain pouring down."

Berthe now began suffering some kind of eye affliction. "I am not any more cheerful than you are, my dear Edma, and probably much less so,"

she wrote in late April, just a week before the opening of the Salon. "Here I am, trapped because of my eyes. I was not expecting this, and my patience is very limited. I count the days passed in inaction, and foresee many a calamity, as for example that I shall be spending May Day here with poultices on my eyes. But let us talk about you...." Edma seems to have felt premonitions that she was soon to become pregnant, or was already pregnant, and Berthe warmly approved. "Men incline to believe that they fill all of one's life," she wrote, "but as for me, I think that no matter how much affection a woman has for her husband, it is not easy for her to break with a life of work. Affection is a very fine thing, on condition that there is something besides with which to fill one's days. This something I see for you in motherhood. Do not grieve about painting. I do not think it is worth a single regret." Having said all that, she then wrote a few days later to apologize for it. "Today my eye is beginning to open again; I am recovering some slight taste for life, and I reproach myself for having given in to my mania for lamentation."

If Berthe's slightly fading relationship with Edma was still warm and trusting, her newly important relationship with Manet was warm and untrusting, wary, competitive. They were not only fascinated with each other but fascinated with each other's work. Manet was nine years older, of course, and much better known, but Berthe was never his pupil; he learned as much from her as she did from him. That was hard for him to accept; indeed, he could accept it only by constantly teasing her, prodding her and provoking her. This was a natural style for him, as it is for many men addressing younger women who disturb them, but it was a style that was difficult for someone so serious and so self-doubting as Berthe. She hungered for Manet's praise but only rarely caught a glimpse of how genuinely he admired her. "There can be little doubt," the Irish poet George Moore wrote in his memoirs, *Hail and Farewell,* "that she would have married Manet if Manet had not been married already."

Pierre Puvis de Chavannes was quite different, as formal as his paintings, and just as serious as Berthe, whom he apparently thought of marrying. Berthe considered herself honored, but she felt only a mild affection for him. And Manet naturally made fun of the whole situation. "On Wednesday," Madame Morisot wrote to Edma, "while Stevens was giving me a letter from Puvis, politely inviting me, just as he was inviting Stevens, to visit him the next day, Manet took Berthe into a corner and

said to her, 'Don't be constrained. Tell him all the worst things that you can think of about his painting!'"

Puvis was by no means the only man who hoped to marry Berthe, but Berthe was not easy to win. She was introduced in this same May of 1869 to a suitor named Monsieur D., with predictable results. "I have missed my chance, my dear Edma," she wrote to her sister, "and you may congratulate me on having got rid so quickly of all my agitations. I think that I should have fallen ill, if at that moment I had had to decide in favor of Monsieur D. Fortunately this gentleman turned out to be completely ludicrous. I had not expected this, and was quite surprised, but by no means disappointed!" Having said that, she went on to report her plans for travel, including a visit to Edma in Lorient, and only then confessed that she had done virtually no work in the months since Edma's marriage. "This is beginning to distress me. My painting never seemed to me as bad as it has in recent days. I sit on my sofa, and the sight of all these daubs nauseates me. I am going to do my mother and Yves in the garden; you see I am reduced to doing the same things over and over again.... On Wednesday we went to the Stevenses. Yves has certainly made a conquest of Monsieur Degas. He asked her to permit him to paint a portrait of her. He is always talking about you, asking about you, and is indignant at my keeping you posted about his new infatuations."

If Berthe was not above being malicious, she was no more than a pupil of her vivacious mother, who also hastened to tell the distant Edma that Degas was "mad about Yves's face." And though she thought Manet behaved like "a madman," she enjoyed patronizing him. "Manet was laughing heartily," she wrote to Edma in yet another version of the opening of the Salon that featured *The Balcony*. "This made him feel better, poor boy, because his lack of success saddens him. He tells you with the most natural air that he meets people who avoid him in order not to have to talk about his painting, and as a result he no longer has the courage to ask anyone to pose for him. He has made indirect overtures to La Gonzalès; as for Madame Stevens, that prospect seems to have fallen through.... He said naïvely that Berthe was bringing him luck. He seems to me very nice because he is interested in Berthe..."

And Berthe was no less interested in him. "As for your friend Degas, I certainly do not find his personality attractive," she wrote to Edma. "He has wit, but nothing more. Manet said to me very comically yester-

day, 'He lacks spontaneity, he isn't capable of loving a woman, much less of telling her that he does or of doing anything about it.' Poor Manet, he is sad; his show, as usual, does not appeal to the public, which is for him always a source of astonishment. Nevertheless he said that I had brought him luck and he had had an offer for *The Balcony*. I wish for his sake that this were true, but I am very much afraid that his hopes will once again be disappointed."

Madame Morisot's maliciousness was not just a fluttery style. It could be deeply wounding to Berthe, and it was intended to be. Madame Morisot profoundly believed that the discontented Berthe should accept a husband and make a new home for herself, and to bend Berthe to that purpose, she was prepared to be quite disagreeable. "Your father seemed to be deeply touched, my dear Bijou, by the letter you wrote to him…" she wrote to Berthe after her youngest daughter had gone off to visit Edma. "He often says that he misses you. But I wonder why. You hardly ever talk to each other, you are never together. Does he miss you, then, as one misses a piece of furniture or a pet bird? I am trying to convince him on the contrary that it is a more complete rest for him not to see your poor little face bewildered and dissatisfied over a fate about which we can do nothing. It is a relief; this is what we have come to think.…"

If Berthe was daydreaming about Manet, as Madame Morisot probably suspected, probably accurately, she was ready to twist the knife in that wound too. "I have taken the books back to Manet, whom I found in greater ecstasies than ever in front of his model Gonzalès…" she wrote in the same letter. "He did not move from his stool. He asked how you were, and I answered that I was going to report to you how unfeeling he is. He has forgotten about you for the time being. Mademoiselle G. has all the virtues, all the charms, she is an accomplished woman."

This was not just social skirmishing either. Madame Morisot was developing a real antagonism toward her stubborn youngest daughter. When Berthe returned home from her travels in August, Madame Morisot wrote Edma a letter of remarkable animosity: "The great joy we have had in seeing each other again is more imaginary than real. It is cruel to admit this, nevertheless it is easy to explain. Berthe does not find me as communicative as I was before her departure; she also claims that I looked at her with surprise, as though I were thinking that she has grown decidedly plainer, which in fact I do—a little."

Berthe brought back from her visit to Edma two newly painted pictures, a portrait of her sister and a Lorient landscape. She gave the landscape to Manet and planned to submit the portrait to the Salon jury, but first she had to show that, too, to Manet. According to her letters to Edma, which may have been colored by jealousy, Manet kept talking about the talents of his new pupil, Éva Gonzalès, so the tormented Berthe was delighted to find that Manet still prized her above anyone else. "The Manets came to see us Tuesday evening, and we all went into the studio," she wrote to Edma. "To my great surprise and satisfaction, I received the highest praise; it seems that what I do is decidedly better than Éva Gonzalès. Manet is too frank for me to be mistaken about it. I am sure that he liked these things a great deal; however, I remember what Fantin says, namely, that Manet always approves of the painting of people whom he likes. Then he talked to me about finishing my work, and I must confess that I do not see what I can do.... As he exaggerates everything, he predicted success for me in the next Salon, though he has said many unpleasant things to me.... Manet exhorted me so strongly to do a little retouching on my painting of you that when you come here I shall ask you to let me draw the head again and add some touches at the bottom of the dress, and that is all. He says the success of my exhibition is assured and that I do not need to worry; the next instant he adds that I shall be rejected. I wish I were not concerned with all this."

The Salon of 1870 was still some months off, so when Edma returned to Paris for her first confinement, Berthe painted a completely new portrait of her, together with Madame Morisot. Puvis de Chavannes admired it but told her that the older woman's head needed some revision, so she did the head all over again and then asked him to come and look at the new version. Puvis complimented her on having done the work but said he was too busy to look at it. She then turned, inevitably, to Manet, and Manet began playing a rather unpleasant little game, in which he exploited all her dependence on him, all her doubts about herself. And so he achieved, under the guise of mentorship, a passing revenge on the respectability that kept them apart. "Tired, unnerved, I went to Manet's studio on Saturday," Berthe wrote to Edma. "He asked me how I was getting on, and seeing that I felt dubious, he said to me enthusiastically: 'Tomorrow, after I have sent off my pictures [to the Salon], I shall come to see yours, and you may put yourself in my hands. I shall tell you what needs to be done.'

"The next day, which was yesterday, he came at about one o'clock; he found it very good, except for the lower part of the dress. He took the brushes and put in a few accents that looked very well; mother was in ecstasies. That is where my misfortunes began. Once started, nothing could stop him; from the skirt, he went to the bust, from the bust to the head, from the head to the background. He cracked a thousand jokes, laughed like a madman, handed me the palette, took it back; finally by five o'clock in the afternoon we had made the prettiest caricature that was ever seen. The carter was waiting to take it away [to the Salon]; he made me put it on the hand cart, willy-nilly. And now I am left confounded. My only hope is that I shall be rejected. My mother thinks this episode funny, but I find it agonizing. I put in with it the painting I did of you at Lorient. I hope they take only that. Pity me, and now let us return to something else...."

Madame Morisot was not that amused about her daughter's unhappiness. "Yesterday she looked like a person about to faint," she wrote to Edma. "She grieves and worries me; her despair and discontent were so great that they could be ascribed only to a morbid condition; moreover she tells me every minute that she is going to fall ill. She overworked herself to such a point on the last day that she really could not see any more, and it seems that I made matters worse by telling her that the improvements Manet had made on my head seemed to me atrocious. When I saw her in this state, and when she kept telling me that she would rather be at the bottom of the river than learn that her picture had been accepted, I thought I was doing the right thing to ask for its return. I have got it back, but now we are in a new predicament: won't Manet be offended? He spent all Sunday afternoon making this pretty mess and took charge himself of consigning it to the carter.... You know how the smallest thing here takes on the proportions of a tragedy because of our nervous and febrile disposition, and God knows I have endured the consequences.... I do not think Berthe has eaten half a pound of bread since you left; it disgusts her to swallow anything. I have meat juice made for her every day. Oh, well!"

The opening of the Salon in May was almost a family drama. Apart from the Manet-Morisot collaboration on Edma and her mother, it included Degas's adoring portrait of Yves, Manet's portrait of Éva Gonzalès and a contribution by Éva herself, which Berthe judged to be "passable, but nothing more." As for her own altered work, which had

only recently made her feel suicidal, she now engaged in elaborate self-justifications. "It is my principle never to try to rectify a blunder," she wrote to Edma, "and that is the main reason why I did not profit from my mother's intervention. Now I am thankful; having got over my first emotion, I find that one always derives benefit from exhibiting one's work, however mediocre it may be."

Madame Morisot somewhat more cynically interpreted Berthe's acceptance as an acceptance of praise, and she herself did her best to accept Berthe's acceptance. "Berthe was somewhat revived by the exhibition …" she wrote. And a few days later: "Berthe is receiving quite a number of compliments on her exhibits: her spirits fall and rise again but there is no doubt that the activities of this week have diverted her a little. I fear that this will serve only to plunge her into greater gloom."

Berthe Morisot was not the only victim of that cruel streak that could suddenly well up from behind Manet's suave exterior. At about the same time that he was "improving" Berthe's picture, he suddenly took offense at the critic Edmond Duranty for having described one of his paintings as "a philosopher trampling on oyster shells." That same evening, he walked up to Duranty in the Café Guerbois and slapped his face. This was an action that required an exchange of seconds (Zola was one of Manet's two choices). Four days later, the dueling party trooped out into the forest of Saint-Germain so that Manet and his critic could attack each other with swords. Neither one of them knew anything about fencing, but they fought with "such violence," according to a subsequent police report, that they bent their swords. Manet managed to inflict a slight wound on Duranty's chest, which enabled the seconds to stop the fight. The duelists then began to wonder why they had been trying to stab each other. As a gesture of reconciliation, Manet offered his new shoes to Duranty, who tried them on but found them too small for his feet.

Éva Gonzalès, who caused Berthe Morisot so much anguish, seems to have been, unlike Berthe, a fairly simple and straightforward girl. She knew what she wanted, and she went for it. What she wanted was to be Manet's pupil. When she mentioned this to her father, Emmanuel Gonzalès, a popular novelist and journalist, he ridiculed any thought of her

becoming associated with such an unsuccessful and even scandalous teacher. Éva knew that her father was a friend of the fashionable painter Alfred Stevens, so she asked Stevens to introduce her to Manet, and Stevens gladly brought her to Manet's studio in February of 1869.

Manet was, as usual, impressed. Éva was not a great beauty—a bit heavy in the chin—but full of the vitality and enthusiasm of her youth (she was then twenty). With lots of rich black hair and a robust figure— Manet liked that. And she admired him enormously—he liked that too. Would she pose for him? Yes, but would he take her as his pupil? How could he refuse?

Éva Gonzalès had a modest talent—"Passable, but nothing more," as Berthe Morisot tartly put it—and she had already spent two years working with two lesser teachers named Chaplin and Brion. We can only guess what she made of the overpowering instructions from Manet. He had never had a pupil before—and he never had another—so he had no experience whatever in translating his own knowledge into words that could help an eager novice. We have only one piece of evidence on how the process worked, a recollection by the critic Philippe Burty, who apparently was present while Manet paced up and down his atelier and lectured the anxious Éva.

Manet would "arrange some grapes on the corner of a white table-cloth," Burty wrote, "a slice of salmon on a silver platter, as well as a knife, and say: 'Do this quickly! Don't pay too much attention to the background, seek out the values. You understand? When you look at all that, and especially when you think about rendering it as you feel it, that is in such a way that it will make the same impression on the public as it does on you, then you don't look at, you don't see the lines on the wallpaper over there. Right? Isn't that right? And then when you look at the whole thing, you wouldn't think of counting the scales on the salmon. You see them as little silver pearls against gray and pink. Right? And what a pink that salmon is, with the skeleton that goes white in the middle, and then the gray like the shadow of mother-of-pearl.

"'And as for the grapes, are you going to count the grapes? No, isn't that right? What is striking is their tone of light amber and the dust that shapes the form while softening it. And about this tablecloth, what is to be determined is the brightness, and then the places that are not touched directly by the light.... The folds will establish themselves if you just put them where they belong.'"

So much for Manet's teaching. Éva did get a number of her paintings accepted by the Salon, and ultimately hung in the D'Orsay museum. Even there, though, they look like what they are, efforts by a moderately talented pupil to emulate the work of a much admired master. Éva's more important function was to serve as the model for Manet's portrait of her, and, as part of that function, to serve as Manet's means of tormenting Berthe Morisot.

Manet had started painting Éva's portrait almost as soon as he met her, and yet he had great difficulty in capturing what he wanted. He worked on the picture off and on for nearly a year. And there is indeed something oddly stiff about it. Éva sits at her easel very unrealistically outfitted in a floor-length bluish-white muslin gown (a white peony mysteriously cast on the floor at her feet emphasizes the bluishness of the dress). And though she holds a paint brush up to a framed canvas of a vase of flowers, she is looking in a completely different direction. The whole picture resembles, as someone has said, one of those official royal portraits in which a king or prince pretends to be engaged in some worthy activity.

And yet this scene tormented Manet almost as much as he used it to torment Berthe Morisot. "Manet lectures me, and holds up that eternal Mademoiselle Gonzalès as an example," Berthe wrote to Edma in that August of 1869. "She has poise, perseverance, she is able to carry an undertaking to a successful issue, whereas I am not capable of anything. In the meantime he has begun her portrait over again for the twenty-fifth time. She poses every day, and every night the head is washed out with soft soap. This will scarcely encourage anyone to pose for him!"

Edma was, as always, sympathetic. "The thought of Mademoiselle Gonzalès irritates me, I do not know why. I imagine that Manet greatly overestimates her, and that we, or rather you, have as much talent as she...." Berthe and Edma, incidentally, had both been reading a relatively new and scandalous novel about the contemporary woman, and Edma wanted to compare notes. "Like you, I found *Madame Bovary* a very remarkable work from an artistic point of view, and very interesting as a realistic study," she wrote. "Decidedly this is where the superiority of contemporary art lies, and sooner or later its value will be generally recognized." But Berthe couldn't escape the accursed portrait of Éva. "We spent Thursday evening at Manet's..." she wrote in September. "As of now, all his admiration is concentrated on Mademoiselle Gonzalès,

but her portrait does not progress; he says he is at the fortieth sitting and that the head is again being scraped off. He is the first to laugh about it...."

Manet did finally finish the portrait, just a week before the March deadline for submissions to the Salon of 1870, and it was characteristic of Berthe Morisot that when she saw it on exhibit, she forgave him everything. "Manet has never done anything as good as his portrait of Mademoiselle Gonzalès," she wrote to Edma. "It is perhaps even more charming now than when you saw it."

The "very remarkable work" that Edma had been reading was remarkable in a number of ways. For one thing, it was Gustave Flaubert's first published novel, appearing when he was already thirty-six years old. For another, its subject, the contemporary middle-class woman, was one about which Flaubert knew very little. For yet another, Flaubert's masterpiece was a book that he strongly resisted writing at all.

Flaubert grew up in a hothouse, petted and pampered by his mother and older sister. When his father sent him off to study law, Flaubert began suffering quasi-epileptic attacks until his father reluctantly allowed him to return home and take up writing. During all these youthful years, Flaubert never had a female friend, only a few other young men with whom he daydreamed about being a hero and writing great epics. He first engaged in sex at the age of eighteen, on a furtive visit to his mother's chambermaid, but then, except for an occasional session with a prostitute, he remained at home. "A normal love, regular, steady, permanent, would take me out of myself too much," he wrote to a friend; "it would disturb me; it would lead me into a life of action, into physical reality, into the common path; and that is just what has always been harmful to me every time that I have tried it."

Flaubert was twenty-four when he met Louise Colet at a party. She was thirty-six, and very pretty, and a writer of some accomplishment; she had published several books of poetry and twice won the poetry prize of the Académie Française. She was married to a professor at the Conservatory, but, as she soon told Flaubert, once she began flirting with him, she had married Hippolyte Colet mainly as a way to get from her native Provence to Paris. Indeed, he had won his appointment at the Conservatory mainly through her friendship with the celebrated Victor Cousin,

philosopher, former minister of state, and author of *On the True, the Beautiful, and the Good.* She was proud that the father of her daughter Henriette was an eminent philosopher, not a second-rate musicologist, but their romance was finished now, and they met only for philosophical discussions.

Louise Colet did not reveal all these details in her first encounter with Flaubert at the atelier of the sculptor James Pradier. They talked about the vulgarity of the present age, and who could still write great poetry (Victor Hugo, they inevitably agreed). She invited him to visit her at home the following evening, so he did, and they talked about Shakespeare, and she read him some of her translations from *Macbeth* and *A Midsummer Night's Dream,* and they kissed for the first time. She invited him back for dinner the following evening, and she told him the details of her life, and he asked her opinion of adultery, and she said it was a terrible thing, but sometimes.... They went for a long carriage ride through the Bois de Boulogne, then back to her apartment on the Rue de la Fontaine-Saint-Georges, where Flaubert stayed until dawn.

They agreed to meet again that afternoon at Pradier's studio, but Flaubert never showed up. Louise sought him out at his hotel, where she found him staring glumly into space. He said he had to go home. Louise Colet was not a woman to be trifled with. When a journalist named Alphonse P. Karr publicly made fun of her manipulation of Victor Cousin, she followed him to his home and stabbed him in the back with a kitchen knife. By a mixture of sex, tears, and argument, she now kept Flaubert in Paris for another week, but his need to flee to his mother's home outside Rouen proved irresistible. From now on, their affair consisted mainly of ardent love letters.

What Flaubert passionately wanted to write was not a portrait of contemporary France, nothing of the realistic, the bourgeois, the vulgar, but rather romantic epics of ancient times, all filled with poetic descriptions of silken draperies and exotic perfumes. Inspired by Breughel's *Temptation of St. Anthony,* he decided to capture all those mystical torments in words, so he devoted a year and a half to that grand plan. When he was finished, he summoned his two best friends, both writers, Maxime Du Camp and Louis Bouilhet, to listen to him read the whole work aloud. "If you don't howl with pleasure at this, you're incapable of being moved by anything," he declared.

Flaubert was an enthusiastic reader of his own work. He roared and

bellowed and waved his arms. He read to his friends from noon until 4:00 P.M. and then again from eight until midnight, and that went on for four days. "The hours during which Bouilhet and I, exchanging an occasional glance, sat silently listening to Flaubert as he sang and chanted ... have remained very painful in my memory..." Du Camp later recalled. "After each reading, Madame Flaubert took us aside and whispered: 'Well? What do you think of it?' We dared not reply."

"When he had finally come to the end," Du Camp's account continued, "Flaubert pounded his fist on the table. "'Now!' he cried. 'Tell me frankly what you think!' Bouilhet was naturally timid, but...it was he who replied. 'We think you should throw it into the fire, and never speak of it again.'" If it speaks well of Bouilhet that he could be so painfully honest, it speaks even better of the shattered Flaubert that he accepted his friends' verdict without the slightest anger or resentment. He had already made plans to join Du Camp on a voyage to Egypt, and off to Egypt they went, galloping across the sands to the Sphinx, crawling on hands and knees into the bat-filled innards of the great pyramids, sailing up the Nile as far as the Second Cataract on the Nubian border. Flaubert made a great fuss about stopping at the establishment of a celebrated seductress named Kuchiouk Hanem; he wrote at length to Bouilhet to boast about the exertions that soon infected him with syphilis. While watching the Nile dash itself against the black granite rocks of the Second Cataract, according to Du Camp, he suddenly cried out: "Eureka! Eureka! I will call her Emma Bovary!" Du Camp has been widely suspected of fabricating this whole scene, since Flaubert had not yet heard the story that was to provide the plot of his masterpiece, but Flaubert had already met a Cairo hotelkeeper by the name of Bouvaret, and he may well have been thinking about some other unwritten tale.

When Flaubert returned after nearly two years in Egypt, he asked Bouilhet to help him decide which of three ideas to write next. One was called *A Night of Don Juan;* the second was a life of Anubis, "the woman who wished to be loved by a god," and the third was "my Flemish novel of the young girl who dies a virgin and mystic, having lived with her father and mother at the end of a garden of cabbages and fruit trees." This last was perhaps the most promising—was that Flemish virgin the girl whom Flaubert had decided to name Emma Bovary?—but it seemed to have no plot. Flaubert himself preferred the Don Juan story; he had already begun drafting an outline.

Bouilhet suddenly began telling him about a Madame Delamare, whom he had met at Madame Flaubert's house. This Madame Delamare had a son who had studied medicine under Flaubert's father, had never finished his exams at the Rouen hospital, had become a second-rate doctor. He had married a pretty girl of seventeen, a farmer's daughter, who had accepted him mainly to escape her home. She soon found herself bored with her adoring but tiresome husband, so she began squandering his money on clothes, took a lover, then another, went into debt, and finally swallowed poison. Flaubert showed no interest; he already knew the story. That, said Bouilhet, was the novel Flaubert should write.

Flaubert was appalled. He jumped to his feet with a cry of protest. What could be more tedious than the misfortunes of the provincial petty bourgeoisie? Bouilhet, who had quixotically devoted most of his own energies to a 3,000-line poem about ancient Rome, remained adamant. Village life in Normandy was something Flaubert knew to its depths, he said, not something he would derive from his beloved history books. And if he despised the bourgeoisie, as he kept saying he did, then the way to express that contempt was to describe the bourgeoisie exactly as it was. Let this be a novel about mediocrity, about narrowness, about the corruptions of false romanticism. How vulgar, Flaubert said. Bouilhet persisted. This had been Balzac's territory, and now that Balzac was dead, nobody of any importance was exploring it.

Flaubert still balked. He wrote a synopsis of his Don Juan novel, but it dissatisfied him. He thought more about Anubis. Then he got a letter from Louise Colet, whom he thought he had discarded several years before. Her husband had died, she had lost his pension, her latest play had been rejected—could Flaubert help her by trying to sell her collection of autographs of the famous people she had known? Almost mesmerized by this undaunted woman, Flaubert agreed, agreed to try to sell her autograph collection, agreed to a rendezvous, agreed to become once again her occasional lover. It was characteristic of their relationship, though, that Flaubert resisted all her attempts to visit his home outside Rouen and to meet his mother. Now, for the first time, Flaubert began talking to Bouilhet about writing the novel about the Norman doctor's wife, with Louise, of course, in the title role.

So he began writing, very slowly. He was capable of fretting all day about one word. Bouilhet, who made his living as a schoolteacher, came to Flaubert's house every Sunday, and Flaubert would read aloud what

he had written that week, usually about three pages, sometimes less. Then they would go over every sentence, every phrase. Bouilhet insisted on simplicity, clarity, none of the bombast of *The Temptation of Saint Anthony.* As for Louise, Flaubert sent her long letters about his difficulties. "My accursed *Bovary* torments and confounds me," he wrote. "Last Saturday Bouilhet made several objections concerning one of my characters and concerning the plan; I am quite unable to refute him, and yet, though there is some truth in what he said, I feel that the opposite is also true. Ah, I am utterly weary, utterly discouraged!... There are moments when it all makes me want to die like a dog."

One trouble was that he did not really know his heroine, that thwarted woman with her dreams of romance. "For two days I have been trying to enter into the dreams of young girls!" he wrote to Louise. "I am navigating in a milk-white ocean of literature about castles and troubadors with white-plumed velvet caps. Remember to ask me about this when I see you. You can give me some exact details that I need." She answered that she would be happy to help him in any way she could, but when they did meet, they devoted their time to other things. Louise wrote Flaubert of the consequences, and he was distraught. "The idea of causing the birth of someone horrifies me," he wrote her. "I should curse myself were I to become a father. I, have a son! Oh, no! No! No! I desire my flesh to perish and have no wish to transmit to anyone the humiliating impotencies and the ignominies of existence."

Louise did tell him about young girls' romantic dreams, and he did use what she told him. Beyond that, he stole. Some of her very words appeared in the mouth of Emma Bovary. Presents that she had given him became presents that Emma Bovary gave her lover. But though Emma Bovary began as Madame Delamare and then acquired many characteristics of Louise Colet, and though Flaubert started to portray her as an exemplar of the despised bourgeoisie, she gradually began to change into the heroine who still evokes the sympathy and compassion of every reader. For in some strange way that Flaubert himself only partly understood, he had begun to write about himself, about his own longings for excitement and love. Though he still complained of being "nauseated by the vulgarity of his subject," he began referring to his heroine as "my poor Bovary." Writing about her misfortunes, which he had once anticipated with a kind of gloating satisfaction, now became almost physically painful. "At six o'clock this evening," he wrote to Louise, "as I was writ-

ing the word 'hysterics,' I was so swept away, was bellowing so loudly and feeling so deeply what my little Bovary was going through that I was afraid of having hysterics myself. I got up from my table and opened the window, to calm myself." Years later, when interviewers asked him how he had acquired such intimate knowledge of a woman, he always answered that he himself was his heroine. *"Madame Bovary, c'est moi."*

Though Flaubert wrote to Louise Colet about once a week—and provided critiques of the poems she sent him—he went to Paris to see her only about once every three months. ("It may be a depraved taste, but I love prostitution," he wrote her, "and for itself, too....") He did acknowledge that Louise was "certainly the only woman who has ever loved me," but when he heard from Bouilhet, who had gone to Paris to get a play produced, that Lousie "wants—and hopes—to become your wife," Flaubert was panic-stricken. He decided to break off the relationship forever. Louise fought back. She shouted insults at him, slapped his face, kicked him. Flaubert looked at a log glowing in her fireplace and felt an overwhelming desire to smash her face in. Instead, he ran out of her apartment, determined never to see her again. When he occasionally returned to Paris, he would ride around in a curtained carriage to keep Louise from spotting him. (As a kind of revenge, he used a similar vehicle for the famous scene in which Emma Bovary first gives herself to the young law clerk, Léon.)

Still she pursued him. Once, when he was dining with Du Camp and another man, she burst into their private dining room because she had heard that he was with an actress; she retreated, followed by their laughter. Even then, she came three times to his Paris apartment, which prompted him to write this last letter. "Madame:...I was not in, and since I greatly fear that further persistence on your side would expose you to affronts from mine, good manners force me to warn you: I shall *never* be in." And even then, she came unannounced to his mother's house and started banging on the door. She did finally see Madame Flaubert, whom she later described as having a "long cold face [that] reminded me of the carven faces of figures on tombstones," but Flaubert intercepted any meeting by physically ejecting Louise from the house. Madame Flaubert, incidentally, was shocked less by Louise's appearance than by Flaubert's reaction. She told him later that she felt she had seen him "wound her own sex."

And so, at the rate of a few pages every week, with each sentence

scrutinized by Bouilhet, *Madame Bovary* finally got finished, nearly five years after the return from Egypt. Toward the end, Flaubert's identification with his heroine was total. "When I was describing the poisoning of Emma Bovary," he recalled later, "I had such a taste of arsenic in my mouth and was poisoned so effectively that I had two attacks of indigestion, one after the other—two very real attacks, for I vomited my entire dinner." The critic who best understood this process was, predictably enough, Baudelaire. "To accomplish the tour de force in its entirety," he wrote, "it remained for the author only to divest himself (as much as possible) of his sex, and to become a woman. The result is a marvel, for despite all his zeal as an actor he was unable to keep from infusing his male blood into the veins of his creation, and Madame Bovary, in the most forceful and ambitious sides of her character, and also the most pensive, remained a man."

Flaubert had never even tried to publish a book before, but now Du Camp was the co-owner and editor of a magazine, *La Revue de Paris,* and he insisted on serializing *Madame Bovary.* Flaubert agreed. Du Camp gave him a list of cuts he wanted made, partly for editorial reasons, partly for political ones, since editors who displeased the imperial government were subject to jail terms. Flaubert did not agree to any changes at all. "In God's name, no!" he protested. "I shall never try to publish in any magazine. Everything is so low these days that to become a part of anything at all is a dishonor and a disgrace." Du Camp made the changes on his own. All he would allow Flaubert to say was that he "declined responsibility" for the edited version, and that the reader should "consider them as a series of fragments, not as a whole."

Du Camp's efforts did him no good. The authorities decided to prosecute *La Revue de Paris* for publishing an immoral work. For technical reasons, they named as defendants not Du Camp but his managing editor, Léon Laurent-Pichat, Flaubert, and a printer named Pillet. Flaubert hired himself a good lawyer and began mobilizing support. When Lamartine, the poet and former cabinet minister, wrote in praise of *Madame Bovary,* for example, Flaubert immediately asked his help. Even Empress Eugénie spoke out in praise of the novel and there was a discreet intervention by Princess Mathilde. Flaubert knew that he could hardly lose. "Whether I am convicted or not, my reputation is made," he wrote. "And if *Bovary* is not suppressed, it will sell really well." But as the time of trial neared, Flaubert began to feel dark premonitions. "I

expect the summons," he wrote his brother Achille, "which will tell me the day when I must take my place on the bench of pickpockets and pederasts for the crime of having written in French. I expect a conviction because I do not merit it."

The trial was little more than a charade. The prosecutor had a very weak case and presented it badly, often to the derision of a court audience filled with literary figures. The defense was clearly stronger. The judge, who considered himself a connoisseur of literary matters, quickly threw out the case. "Be it known," he declared, "that it is not sufficiently proven that Pichat, Gustave Flaubert, and Pillet are guilty of the misdemeanor with which they are charged; the Court acquits them...and decrees a dismissal without costs."

Flaubert was so angry about the whole situation that he thought of forbidding any further publication of *Madame Bovary*, but Bouilhet didn't have too much difficulty in persuading him that publication in book form would be the only way to show his readers the complete and unedited text. So he sold all rights to the publisher Michel Lévy for five years for 500 francs. Lévy brought it out in April of 1857, and it sold 15,000 copies within two months. And Flaubert, turning his back on his masterpiece, went back to writing the kind of novel that he really wanted to write, the exotic melodrama of a Carthaginian princess named Salammbô.

"Salammbo went up to the terrace of her palace, supported by a slave girl carrying burning coals in an iron tray," Flaubert wrote of his new heroine's first appearance. "In the middle of the terrace was a small ivory bed, covered with lynx skins, with cushions of parrot feathers (a soothsaying creature sacred to the gods), and in the four corners rose four long burners full of spikenard, incense." It is quite dreadful, rather in the manner of Couture's *Romans of the Decadence*, and like that extravaganza by Manet's teacher, it was hugely successful.

Throughout all of Manet's involvements with Berthe Morisot and Victorine Meurent and Éva Gonzalès and all the others, there was, of course, a wife, Suzanne Manet. She was nearly two years older than he, so in the year when Manet met Éva Gonzalès and Éva was twenty and Berthe was twenty-eight, Manet was thirty-seven and his wife thirty-nine, a fairly significant series of differences. Romantic biographers have

noted that Suzanne almost never went to Manet's studio, and they have drawn from this the obvious conclusions. "He deceives Suzanne—" Henri Perruchot writes in his novelistic *Life of Manet,* "Suzanne who is no longer anything more to him than a 'habit'—without thinking about it, without paying great attention to his good fortunes, to those more or less easy women who pass from time to time, fugitive figures in his existence as a boulevardier and painter.... He makes love the way one eats a dish of ice cream."

There is not a whit of evidence for any of this, for anything Manet did or did not do with any of the women he encountered. And while it is perfectly possible that he occasionally indulged himself with some model, it is also perfectly possible that he found deep satisfaction in his domestic life with Suzanne. One must keep remembering, amid all the legends of the high times on the boulevards, that the French bourgeoisie was intensely bourgeois, and that Manet was a man who lived most of his life with his mother, both before and after his marriage. The only real evidence of the nature of his relations with Suzanne, just like the evidence of his relations with Victorine Meurent and Berthe Morisot, is the highly ambiguous evidence in the pictures he painted of all of them.

The first time Suzanne modeled for him was for a large canvas to be called *The Finding of Moses,* which he began in 1859. When he gave it up two years later, all that survived, cut out of the original canvas, was a fragment known as *The Surprised Nymph.* This is Suzanne, very fleshy and Rubensy, but in contrast to the supremely cool Victorine Meurent, Suzanne is much concerned with trying to cover herself up, her legs crossed, her arms folded across her chest, her face showing less surprise than anxiety and dismay. And this was a decade after the surprised nymph and her creator had already had a son whom they refused to acknowledge.

In 1865, Manet began a new portrait of Suzanne in a more natural element. Now, in a picture entitled *Reading,* she is sitting on a white sofa in a slightly bluish white gown bound at the waist with a black ribbon. It is surprisingly like the dresses in which Manet would soon portray both Berthe Morisot and Éva Gonzalès; indeed, the patterns of white on white also provided the background for the nakedness of Victorine Meurent as Olympia. Manet may have drawn fresh inspiration from Whistler's *The White Girl,* which attracted almost as much atten-

tion at the Salon des Refusés as *Le Déjeuner sur l'herbe*. Or it may have been, as with Melville, simply whiteness that fascinated him. His friend Antonin Proust recalled that during a stroll in 1862 or 1863 Manet was greatly struck by the sight of some workmen demolishing a wall. "Wreckers in white contrasted with the less white wall collapsing under their blows, enveloping them in a cloud of dust," Proust wrote in his memoirs. "Manet long remained absorbed in attentive admiration of the spectacle."

Suzanne looks peaceful and at home in *Reading*, and rather hand- some in her full-figured Dutch housekeeper way, but though she was indeed a Dutch housekeeper, who kept all the domestic wheels turning while Manet indulged himself in artistic fancies, she was also a highly accomplished pianist. In an age when genteel women were expected only to learn a few waltzes, she often performed the major works of Beethoven, Chopin, and Schumann, roughly the equivalent of some avant-garde New York painter's wife entertaining dinner guests with Schönberg, Bartok, and Boulez. And more: When Baudelaire lay para- lyzed and dying in 1867, Suzanne Manet went regularly to his sickroom and played him the outrageous new music that he loved, Wagner. The only negative side to all this—which Suzanne must have felt deeply—is that Manet had virtually no ear for music and no interest in it.

To Edgar Degas, it seemed perfectly natural to paint a joint portrait of his friends, the Manets, with her playing the piano and him lolling dreamily (or bored?) on a sofa. So he painted it, and was pleased with it, and proudly presented it to Manet, who gave him a still life of some plums in return. The next time Degas saw his picture, it had been muti- lated, slashed right through the face of Suzanne Manet at the piano. She had been sitting in profile, and the cut went straight through her temple. Everything to the right of that had been destroyed. Degas was naturally furious, and if Manet offered any explanation, it has not been preserved. It seems an almost psychotic act of rage on Manet's part. Degas stormed out of the Manet apartment with the ruined painting under his arm, and it was some time later before the art dealer Ambroise Vollard saw it and asked about it.

VOLLARD: Who slashed that painting?

DEGAS: To think it was Manet who did that! He thought that some- thing about Madame Manet wasn't right. Well...I'm going to try to "restore" Mme. Manet. What a shock I had when I saw it at Manet's.... I

left without saying good-bye, taking my picture with me. When I got home, I took down a little still life he had given me. "Monsieur," I wrote. "I am returning your *Plums*."

VOLLARD: But you saw each other again afterward.

DEGAS: How could you expect anyone to stay on bad terms with Manet? Only he had already sold *Plums*. What a beautiful little canvas it was! I wanted, as I was saying, to "restore" Mme. Manet so that I could return the portrait to him, but by putting it off from one day to the next, it's stayed like that ever since.

Degas never did get around to repairing his portrait of Suzanne at the piano, and so it remains a strangely mutilated relic, a memento of some inexplicable fury in Manet. Whatever it was that he so disliked in Degas's portrait, he decided to fix himself. He painted Suzanne in exactly the same pose, in profile at the piano, but if he thought Degas's version was unflattering, he hardly remedied that. He shows us not the handsome and reticent figure of *Reading,* just a few years earlier, but a stolid and heavy woman at least ten years older than Suzanne's actual thirty-eight. In future pictures, indeed, he often painted her from the back, or apologetically shadowed her face, but here he defiantly portrays a big-nosed, rubicund woman who is simply ugly. And strangely enough, she is not really playing the piano. Her hands simply lie motionless on the keyboard. If music was her artistic contribution to the household, Manet apparently neither heard it nor saw it.

Suzanne also inspired, unwittingly, one of Berthe Morisot's rare displays of a jealous nastiness worthy of the elder Madame Morisot. "I saw our friend Manet yesterday," Berthe wrote to Edma. "He left today with his fat Suzanne for Holland, and in such a bad humor that I do not know how they will get there...."

"As for her personal character," Paul Valéry wrote admiringly of Berthe Morisot, "it is well known that it was rare and reserved; distinction was of her essence; she could be unaffectedly and dangerously silent, and create without knowing it a baffling distance between herself and all who approached her.... This singularly painterly painter...passed through the world of yesterday as a lady, always tastefully dressed, remarkably clear-cut of feature, with an open, strong-willed countenance, and something tragic in the expression, at times with a certain smile—on the lips

alone—which dismissed people who did not matter with a hint of something they might have reason to fear."

That was the Berthe Morisot who, according to legend, came to Manet's studio one day in the summer of 1870 and wearily sat down on his sofa. He looked at her and told her not to move, and immediately began sketching. *Repose,* Manet's second major portrait of his friend, shows us once again a woman in a flowing white dress, bound at the waist by a black ribbon. Her dark hair curls down onto her shoulders, *à l'Anglaise.* Her barely sketched right hand holds, as it often does in his portraits of her, a fan.

This was not nearly so casual as it looks or sounds. Berthe's daughter, Julie, later recalled that the sittings were a torture. Berthe's left leg, drawn up out of sight beneath her, used to get painfully stiff, but Manet would not let her change her position because he did not want any change in the white skirt so elaborately spread out against the plum-colored sofa. But this is not what caused the odd distortion of Berthe's right hip, which juts out in a rather unnatural way. According to an X-ray analysis, Berthe originally sat up straight, and when Manet revised the whole pose to make her slump wearily toward one side, he didn't bother to repaint the skirt.

He didn't bother because he didn't care. In contrast to the twenty-five or forty repaintings of Éva Gonzalès, he had already captured just what he wanted of Berthe, that expression of sadness and reflectiveness and what Valéry called dangerous silence. Most remarkable of all, he had contradicted his own perception of reality to imbue Berthe with beauty, not just the sharp intelligence of the woman in *The Balcony* but real beauty. "When he paints Victorine, he paints her as a beautiful object," one contemporary observer commented, "but when he paints Berthe, he paints her with love and tenderness."

When Manet finally submitted *Repose* to the Salon of 1873, along with a much more conventionally popular picture in the manner of Franz Hals, *The Good Bock Beer,* the Paris critics were as perceptive and as gracious as ever. "A horror," said Édouard Drumont in *Le Petit-Journal.* "A lady resting after having swept the chimney herself," said Cham in *Charivari.* "Slapdash, uncouth daubing," said Ernest Duvergier de Hauranne. "A forlorn, miserable creature, and miserably dressed..." said Théophile Silvestre, "from woebegone face to tiny foot, she is wilted, wretched, and ill-humored as can be."

But Berthe Morisot, who knew perfectly well that she was not beauti-ful, must also have known perfectly well what Manet was saying to her, that he loved her. A decade after Manet died, and just a year before her own death, she tried to buy *Repose* when it came up for auction, but the agent commissioned to bid for her somehow failed to get it. And so it went to New York and was eventually bought by George Vanderbilt, whose widow bequeathed it to the Rhode Island School of Design, where it remains, breathtakingly beautiful, to this day.

THE GRAND DUCHESS
OF GEROLSTEIN

*I merely ask myself whether the Good Lord would not have
done better to leave women out of his scheme of things:
for they are rarely of much use...*
—RICHARD WAGNER

Manet was, to a certain extent, a creature of habit. He liked to do many
of the same things every day, and on a regular schedule. He liked to go
to lunch every day at the Café Tortoni, Number 22 on the Boulevard des
Italiens, which had by then become the main thoroughfare of theatrical
and literary social life. Then, at two o'clock, he liked to stroll down
toward the Seine and the garden of the Tuileries. "With Manet," said his
friend Proust, "the eye played such a big role that Paris never knew any
stroller like him, and no stroller strolled more usefully."

The Tuileries Gardens had largely replaced the Palais Royal as the
outdoor social center of Paris, but while the Orléans family's ownership
of the prerevolutionary Palais Royal had kept it immune from the Paris
police, thus leading to its popularity with bawds and cutpurses, the Tui-
leries was much more formal and genteel. "In this era," wrote Manet's
friend Théodore Duret, "the Tuileries palace, where the emperor held
court, was a center of the luxurious life, which extended into the gar-
dens. The music that was performed there twice a week drew a worldly
and elegant crowd." And Proust: Manet "went to the Tuileries almost
every day from two to four, making studies in the open air, under the
trees, of the children who played there and the groups of nurses who
had collapsed in their chairs. Baudelaire was his customary companion
there...."

So when Manet painted the extraordinary panorama that he called

simply *Music in the Tuileries* (1862), his first picture of a really contemporary scene, the tall figure in a top hat standing in front of a tree on the left side of the canvas is naturally Baudelaire. But the elegant bearded figure on the far left, with the striped trousers and the cane, is Manet himself, looking not at his creation but out at the viewer, and the equally elegant bearded figure eavesdropping on a conversation in the right-center is Manet's younger brother Eugène, who has not yet gone picnicking on the grass with Victorine Meurent. This whole picture, indeed, is a kind of portrait gallery of the Parisian art world of the Napoleonic Empire, including Gautier, Fantin-Latour, Zacharie Astruc, and many others whose identity is still being ardently debated by scholars of the period. Since this is a portrait not of gossip in the Tuileries but of music in the Tuileries, and since Manet has no way of telling us (if he cares) what music is actually being played, we can only infer the answer from the gaunt and bespectacled man who sits leaning against a tree just behind Eugène Manet. It is the man whose music everyone in the Tuileries would immediately recognize and enjoy, Jacques Offenbach.

Offenbach represented, as only an impoverished German immigrant could, the carefree spirit of the Parisian operetta under the empire. The son of a cantor from Offenbach-on-Main, whose family name was Eberst (or perhaps Wiener, or perhaps Levy), young Jakob Offenbach was a cello prodigy, and so his father determined to take him to Paris to enroll him at fourteen in the only major European conservatory that was open to Jews. But while Offenbach studied counterpoint in the academy sternly ruled by Luigi Cherubini, he also earned a living playing his cello in the orchestra of the Opéra Comique, and after only a couple of years of this drudgery, he struck out on his own. He had a strange talent for nonsense and parody and more nonsense. In one of his first triumphs, *Ba-ta-clan, a Musical Chinoiserie,* he burlesqued Meyerbeer's celebrated *Huguenots* and ended with a wild mixture of waltzes and a can-can: *"Valsons! Polkons! Sautons! Dansons!"*° Rossini, who had once been equally prolific but had now been suffering for about thirty years from one of the greatest writer's blocks in cultural history, saluted the newcomer as "the Mozart of the Champs-Élysées...." He was not really the Mozart of the Champs-Élysées, for he lacked Mozart's grace and subtlety, but rather the Rossini of the Champs-Élysées, displaying all that hectic and

°"Let's waltz! Let's do the polka! Let's jump! Let's dance!"

scurrying charm that had once animated the creator of *The Barber of Seville.*

Offenbach wanted to take charge of everything. Having been an orchestra cellist, he wanted to conduct; having become a conductor, he wanted to compose; having become a composer (he ultimately turned out an astonishing ninety operettas at a rate of about four a year), he wanted to manage his own theater. "I said to myself," he later wrote, "that the Opéra Comique was no longer the home of comic opera, and that the idea of really gay, cheerful, witty music—in short, the idea of music with life in it—was gradually being forgotten. The composers who wrote for the Opéra Comique wrote little grand operas. I felt sure that there was something that could be done by the young musicians...like myself."

Offenbach happened to hear that there was a very small theater vacant on the Champs-Élysées, near the Palace of Industry where the Emperor Napoleon planned to open an international industrial exhibition in May of 1855. As part of the imperial regime's control of cultural affairs, every theater needed a license that specified what kind of show it would produce, how its shows would differ from those of any other theater, and even how many people could be in the cast. By the time Offenbach got a license to produce only pantomimes and short musical sketches with no more than three characters,° the opening of the international exhibition was only three weeks off. Once again, Offenbach began scurrying. He commissioned a one-act play by a twenty-two-year-old government clerk named Ludovic Halévy, the grandson of another German cantor and nephew of the famous Fromental Halévy who had once instructed Offenbach in composition. To that he added a skit making fun of Parisian beggars—does the age of Napoleon III sometimes seem to sound familiar?—and a pantomime based on themes by Rossini. Les Bouffes-Parisiens was what Offenbach called his little theater, and his first show was soon sold out for months in advance.

Much of what Offenbach produced at Les Bouffes was hack work, of

°Offenbach eventually solved this problem, after being allowed to use four characters, by writing a five-character operetta called *Croquefer* (1859), in which the fifth character mutely spoke his lines by periodically waving a series of banners bearing the words he was forbidden to utter. To the chagrin of a watching cabinet minister, a musical ensemble that included this muted player was fulfilled by barks and catcalls, and so the authorities abandoned their restrictions on Offenbach's ingenuity.

course, but he didn't seem to care. "The new piece causes the old one to be forgotten," he declared. "The two are not compared or put side by side, and no analogies are sought between them; it is rather like a series of pictures, shown one after another in a magic lantern; when once the show is over, the most striking success weighs no more in the mind of the spectator than the rankest failure." The only trouble with Offenbach as an impresario was that he was hopelessly impractical. He squandered money on sets and costumes, and when a couple of seats in the audience were slightly damaged, he insisted on replacing all the seats in the theater. This improvidence inexorably led to indebtedness, and indebtedness in those days commonly led to bankruptcy and even imprisonment—but not before the debtor and his creditors played out an extended comedy of hide-and-seek.

So Offenbach was more or less in hiding while he composed *Orpheus in the Underworld,* a scenario originally sketched by Halévy and Hector Crémieux, and then taken over by Crémieux because Halévy got promoted to the more demanding post of general secretary in the Ministry for Algeria. In hiding and not in hiding, for nothing in the Paris theatrical world of that era was really secret, Offenbach kept on producing the most carefree music. *Le Journal Amusant* offered this account of the activities at Les Bouffes on the day of opening night in October of 1858: "Just when Offenbach was making some alterations in the score for piccolo someone came in and told him that Mlle. Tautin, who was playing the part of Eurydice, was insisting on being provided with a real tiger skin; otherwise she would be utterly incapable of producing the necessary Bacchanalian frenzy. Then a number of Germans trooped in and, in their capacity as his fellow countrymen, started pestering Offenbach for free seats. As soon as they had been shown out, Offenbach was informed that the piccolo player had an attack of fever and would be unable to perform that night. Then three mysterious-looking gentlemen appeared and disappeared again; evidently the bailiffs. Then a commissionaire handed in an anonymous letter the writer of which, evidently the author of a rejected masterpiece, threatened to make a disturbance during the first performance. Then the janitor came in and announced that the gas pipe in the street had just burst. Then Offenbach was informed that the Ministry of the Interior insisted on some more cuts being made in the text, and Villemessant [the founder of *Le Figaro*] appeared in the doorway and asked Offenbach to act as his second in a duel. And so it went on."

After all that, the opening night should have been a triumph, but it was only a moderate success, just another operetta, just another show. Then, more than a month later, the eminent Jules Janin of the eminent *Journal des Débats* produced a jeremiad denouncing *Orpheus* as a blasphemous outrage against "holy and glorious antiquity." This was much the most provocative thing that anyone had yet said about Offenbach's amiable burlesque of life on Mount Olympus, and the provocation took an interesting new turn when Offenbach's librettist, Crémieux, demonstrated that one of his "blasphemous" passages had been lifted entirely from one of Janin's commentaries on the ballet.

The prospect of controversy brought jaded Parisians flocking to Les Bouffes, and once they began looking at *Orpheus* a little more carefully, they began to see all kinds of hidden meanings that might or might not be there. What was one to make of a Jupiter who sang that his rule was based on "everything for decorum and through decorum"? Or of the lesser gods who began plotting revolution on the absurd grounds that decorum offended them? *"Abattons cette tyrannie,/Ce régime est fastidieux."** Or if that was absurd, what was one to make of the fact that the gods' abortive revolt resounded to the legally forbidden strains of "La Marseillaise"? Or that everything ended—to the chorus of *"Bacchus is King!"*—in another swirling can-can?

Offenbach and Napoleon III were, of course, made for each other. Just as Napoleon's empire was and was not a comic-opera fantasy, Offenbach's comic operas were and were not a satiric commentary on his reign. Yet, while the enigmatic modernity of Manet's painting brought him little but critical attacks, the smiling contemporaneity of Offenbach's music made him hugely fashionable. *"Orpheus in the Underworld* became more than an operetta," as Siegfried Kracauer has written in his biography of Offenbach, "it became a token, a portent of the times. After about the eightieth performance crowds flocked to see it in an unending stream...Offenbach was saved.... The music of *Orpheus* set all Paris dancing. The light infantry marched to it, and its waltzes and gallops became the rage, from the Tuileries to the smallest suburban taverns." Only after 228 performances did *Orpheus* finally close, and then it was revived in April of 1860 at a gala of the Italian opera, which Napoleon promised to attend only if *Orpheus* were performed. Offenbach, who

*"Let's overthrow this tyranny,/This fastidious regime."

had just recently become a French citizen, received a bronze from the Tuileries and a letter declaring that the emperor "would never forget the dazzling evening that *Orpheus in the Underworld* had given him."

The success of *Orpheus* established Offenbach in all the traditional ways. It enabled him to buy a villa at Étretat, and he was awarded the legion of honor. He even received word that the powerful Count de Morny, the emperor's illegitimate half brother and the president of the legislature and leader of the powerful Jockey Club, wanted to collaborate in the composition of an Offenbach operetta. Offenbach nervously called in Halévy, and Halévy nervously drafted a scenario about a Monsieur Choufleuri, who invited many fashionable guests to a musical soirée at which his three singers failed to appear. And so on. The lordly Morny indicated his satisfaction by offering a few suggestions as his contribution to the collaboration.

And Offenbach kept writing. *Genevieve of Brabant* and *The Canteen Girls of the Grand Army* in 1859, and *Daphnis and Chloë* and *Barkouf* in 1860, as well as a ballet, *The Butterfly*. Ballet had suddenly become very fashionable in Paris, so Offenbach conducted the rehearsals featuring the new star, Emma Livry, but they argued over the costumes. A man named Carteron had invented a method for fireproofing ballet costumes, and the technologically minded emperor had decreed in 1859 that all ballet costumes must be "carteronized." But the fireproofing process made the costumes look stiff and dirty. Emma Livry and a number of other ballerinas refused to wear them. One of the lesser dancers had a narrow escape during *The Butterfly*, when her untreated costume caught fire, but the blaze was quickly extinguished. Emma Livry's turn came two years later, during a rehearsal of Auber's *The Deaf Mute of Portici*. A wing light set her skirt on fire, and she was badly burned before anyone could rescue her. She lay dying for four months, and her funeral at Notre Dame was a national event.

But the imperial dance continued, and the Count de Morny's *Monsieur Choufleuri* was enough of a success in 1861 to convince him of his theatrical talents, and it was about this time that Manet installed Offenbach under a tree in the Tuileries. Offenbach's success kept growing throughout the 1860s. "His children would be noisily playing, laughing, and singing all around him," Halévy recalled later, "and friends and colleagues would call to see him. Offenbach would talk and joke with complete freedom, but his right hand would go on writing, writing all the

time." And so came, in 1864, his first unsuccessful experiment in serious opera, *The Fairies of the Rhine,* and then an oddity called *The Georgian,* which featured a "Marseillaise" for women with a chorus of "*À bas les hommes!*" ("Down with men!"), and finally his overwhelmingly successful return to that Parisian Greece of his own imagining, *La Belle Hélène.*

Just as it is impossible now to judge any story about the eve of the Trojan War without remembering what subsequently happened before the gates of Troy, it is almost equally difficult to judge Offenbach's farcical version of these events without recalling that the seemingly powerful French Empire had less than a decade to live. When Prince Paris sings to the Greeks, "*Je suis gai, soyez gais, il le faut, je le veux!*"* a modern listener keeps thinking, quite mistakenly, that Offenbach was somehow warning the Parisians of their folly. When Agamemnon complains of the Greeks' frivolity in a song that keeps repeating the warning "*Tu comprends/Qu' ça n'peut pas durer plus/longtemps,*"† we keep thinking, quite mistakenly, that Offenbach must have somehow heard the marching feet of Prussia's regiments.

To Offenbach's audiences, the most striking thing about *La Belle Hélène,* apart from its festive music and its devil-may-care attitude, was the fetching presence of the reigning queen of operetta, Hortense Schneider. She was originally from Bordeaux, the daughter of a German Jewish tailor who had died of drink. A rather thin-featured but voluptuous girl with reddish-blond hair, she arrived in Paris in 1855 at the age of twenty-two with only a few years of provincial theatrical experience and a letter of introduction to a singer named Berthelier. The singer took her to dinner, introduced her to Baudelaire, then took her home to bed, and then sent her the next morning to Offenbach, who had just opened Les Bouffes.

After hearing her try a few bars, Offenbach asked her whether she planned to take music lessons to improve her singing. She thought it diplomatic to say that she did.

"Miserable wretch!" cried Offenbach. "If you dare take it into your head to do anything so monstrous, I'll tear up your contract! Because I'm hiring you at 200 francs a month. Do you understand?" Whether she understood or not, she was soon playing at Les Bouffes in Offenbach's

*"I'm happy, be happy, you must, I command it."

†"You understand/that this can't go on/for long."

newest tidbit, *The Fiddler.* Loyalty was not one of Hortense's principal virtues, however. When Offenbach refused one of her repeated requests for raises, this time to 500 francs a month, she moved on to the Variétés, then to the Palais Royal. She also abandoned Berthelier for a nobleman who provided her with her first carriage and her first diamonds, then abandoned him for the young Duke Ludovic de Gramont-Caderousse, perhaps the most dashing of those Jockey Club rakes who liked to be known as *cocodès* (swells). Hortense and her lover were both then twenty-four, but the duke had already lost a million francs at cards, and he also was already coughing blood from consumption. So they played out their version of the Offenbach style. Instead of giving her a carriage, he gave her a giant Easter egg containing a coach, a coachman, and two horses.

The duke bet some friends that he could get arrested without committing any crime. He dressed himself as a tramp, strolled into an expensive café, ordered champagne, and pulled out a fistful of thousand-franc notes to pay for it. He won his bet. On another occasion, he filled the grand piano at the Café Anglais with champagne to see if it could serve as an aquarium. Some of his entertainments were less lighthearted. He liked challenging people to duels, and when he found himself in conflict with a sports journalist named Dillon who knew nothing about fighting with sabers, the duke calmly killed him. He and Hortense Schneider had a son, who turned out to have severe mental problems (one account calls him "an imbecile," while another speaks of "a nervous malady"). Hortense had the boy reared in seclusion, and the dying duke left him 1 million francs in his will.

When Offenbach and Halévy wanted to sign Hortense for *La Belle Hélène,* they found her packing for a trip to Egypt, where the consumptive duke had gone to spend his last days. Offenbach sat down at the piano and played some of his newest songs. Hortense was sorely tempted. She managed to get herself out of Paris, but as her ship was about to depart, she got a telegram from Offenbach pleading once again for her to be his star. Hortense's answer was to the point: "I demand two thousand francs a month." Offenbach accepted, Hortense became Helen of Troy, and the Duke of Gramont-Caderousse was left to die alone on the banks of the Nile. The duke returned to Paris early in 1865, however, and tried to resume his glittering life with Hortense, but he could see that he was no longer the life of the party. He retreated alone to the Pyrenees for a time, then crept back to Paris and shut himself up in his

home. When he died, there was only one friend at his side, not Hortense. But when Offenbach rolled out a new operetta the next year, *Bluebeard,* Hortense charmed everyone as the curious wife.

And when Offenbach abandoned the world of fantasy, later that year, for a very contemporary comedy, *La Vie Parisienne,* it was the greatest success he had ever had. The visiting khedive of Egypt, Khalil Pasha, who had recently commissioned Courbet's famous erotica, *The Sleepers* and *The Origin of the World,* was inspired to declare that Offenbach's newest hit made him feel that "the whole city of Paris is my mistress." More specifically, the khedive wanted Hortense Schneider to represent the city of Paris, and so he invited her to visit him in Vichy, where he was taking the waters. Unfortunately, the aide in charge of fulfilling the khedive's wishes misunderstood his instructions and sent the invitation to the famous arms merchant Eugene Schneider. The khedive's attendants were trained not to question the ruler's wishes, and so they did not question his request that the visitor be ushered into a luxurious suite at the Grand Hotel, that the suite be filled with flowers and perfumes, and that the visitor be invited to bathe in preparation for the khedive's arrival. What the khedive and the arms merchant said on their first encounter remains one of history's many unanswered questions.

Just as the Exposition of 1855 had given Offenbach a splendid opportunity to stage his first hit on the Champs-Élysées, the Emperor Napoleon's plans for a far grander international exhibition in 1867 gave Offenbach a far grander opportunity for a far grander success. He and Halévy were worthy of the occasion. They began planning something completely contemporary and completely absurd. Since Europe had just come through the shattering Prussian victories over Denmark and Austria, why not a burlesque of those ridiculous Teutonic principalities that kept waging war on each other?

There would be a frivolous grand duchy ruled by a frivolous grand duchess, whose favorite occupation was lining up her troops for inspection. (*"Ah! que j'aime les militaires/Leur uniforme coquet,/Leur moustache et leur plumet!/Ah! que j'aime les militaires!"* *) When her eyes light on a young fusilier named Fritz, she immediately makes him a corporal, then, all in the same scene, sergeant, lieutenant, captain, and

*"Oh, how I love the military/Their sexy uniforms,/Their mustaches and their plumes,/Oh, how I love the military!"

finally commander-in-chief. This causes a certain difficulty with her incumbent commander-in-chief, a most military *militaire* named General Boum, who is so bellicose that instead of taking snuff, he fires off his pistol and sniffs the smoke from the barrel. *"Et pif, paf, pouf! Et tara pa pa poum!"* the general introduces himself with a typical outburst of Offenbacherie, *"je suis, moi, le général Boum! Boum!"*•

This Ruritanian farce was originally called simply *The Grand Duchess,* but the imperial censors who worried about all the important visitors coming to the Exposition worried that the Russians might consider it a hostile burlesque of the romantic excesses of the late Empress Catherine (as, indeed, they did). One of Offenbach's friends, Camille Doucet, had the happy idea of attaching the frolicking grand duchess to an imaginary principality in Eugène Sue's *The Mysteries of Paris.* "Simple," he said of the censors' worries about the title, "just add, 'of Gerolstein.'" And so *The Grand Duchess* became *The Grand Duchess of Gerolstein,* and could anyone possibly play the part better than Hortense Schneider? Obviously not.

She threw herself into it with such enthusiasm that she even designed for herself a very aristocratic royal medal, a broad ribbon leading to a huge star. The imperial censors continued playing their burlesque roles with such dedication that they forbade her to wear her star on the ground that it might resemble some unknown but real medal and thus offend some valuable foreign sensibilities. Up until the last minute, Hortense threatened to boycott the opening unless she could wear her royal medal, but in the end she succumbed to the tradition that the show must go on. By way of compensation, she had a full-length portrait painted of herself wearing the forbidden star and going out for a stroll with her favorite terrier, Carlo, which lived in her fur muff. She had, in fact, eight dogs backstage, ranging in size from Carlo, who weighed less than a pound, to a Great Dane named Gilda. The rest were mainly pugs, bearing names like Love, Puck, Vicki, and Mimi. They were taken out for rides every day in the Bois de Boulogne in one of Hortense's carriages.

As the audience waited for the curtain to rise on *The Grand Duchess of Gerolstein,* the main topic for chatter was that Princess Pauline von Metternich, the wife of the Austrian ambassador and the great friend of Empress Eugénie, was wearing a straight dress, in that year's fashionable

•"I am, me, General Boom! Boom!"

shade of chocolate brown, known for some reason as "the Bismarck color"—which meant that the era of crinolines, which Jacques Worth had originally designed to disguise the Empress Eugénie's pregnancy, was suddenly over. But then the show did finally go on. "On Friday, April 12, at half-past eight, the curtain went up on the first act of *The Grand Duchess*," as Halévy wrote. "I promise you that at that moment a lovely shiver runs from head to foot, you're so impatient for the first reaction. The important thing is to break the ice. Once you have the public with you, everything goes well, but the first burst of laughter, the first murmur of approval, the first applause, is hard to win and delicious to hear. Our suspense didn't last long. From the first words of Couder [General Boum], and thanks, it must be admitted, to his incredible verve, the theater was set alight.... What a beginning! Too good! It was too good to be true! We sensed that, and were both thrilled and frightened at this success...."

Offenbach loved to spice his operettas with all kinds of parodies in the heroic style of Meyerbeer's *The Huguenots* or in the sentimental rhetoric of the latest offering from Italy. After the success of Verdi's *Il Trovatore*, for example, he whipped out *L'enfant trouvère* (The Child Troubador), billed as a tragedy by Jacomo Offenbacchio. (Such parodies and counter-parodies were a sort of local sport: Rossini's charming collection of piano pieces entitled *The Sins of Old Age*, which appeared between 1857 and 1868, included an utterly witless *Little Caprice* subtitled "In the style of Offenbach.") The only such effort that Offenbach undertook in a spirit of real hostility was a lampoon of Richard Wagner, who had arrived in Paris in the fall of 1859 and was widely ridiculed in the local press as the self-styled creator of "the art of the future." (It was probably not coincidental that Wagner was also known as the author of a recent polemic entitled *Jewishness in Music*, though Offenbach was the most casual of Jews, who converted to an equally casual Christianity to oblige the parents of his Catholic wife.) For his new *Carnival of Revues* at the Bouffes in 1860, Offenbach included a jeering sketch on "the musician of the future."

Mozart, Gluck, Weber, and various other musicians of the past are lounging around in Offenbach's Elysian Fields when a bumptious new-comer announces that his artistic revolution has overthrown all their works. There will be no more sharps or flats, no more harmony, no more notes.

"No more music?" asks Gluck.

"Yes; but a strange, unknown, vague, indescribable music!" says the newcomer.

The masters of the past ask to hear a sample, and so the revolutionary hands out the scores for his "Symphony of the Future," a sort of tone poem about a rustic wedding (remember that the latest of Wagner's widely unproduced operas was *Lohengrin*). As the Wagnerian intruder conducts his pretentious creation, he shouts out the significance of each new theme, the wedding march, the departure for the town hall, the mother's farewell, and so on. When the musicians of the past complain about this symphony of the future, the conductor tries to play them a grotesque "Tyrolean dance of the future," until Mozart and Gluck join in chasing him off the Elysian stage.

Wagner, who had no sense of humor whatever, felt genuinely hurt. He was hurt, too, by the gossipy Paris press making up jokes at his expense and attributing them to that benign elder statesman of the musical scene, Rossini. According to one of these fabricated tales, for example, Rossini welcomed friends to his epicurean table by serving them *turbot à l'Allemande,* which consisted of nothing but a rich sauce, and which Rossini supposedly explained by saying, "Isn't it the same with the music of Wagner? Good sauce but no turbot? No melody."

Rossini felt obliged to offer a public protest (if only because his natural wit was somewhat more subtle), and so various intermediaries brought the provocative German to visit the aging maestro. Rossini had never heard any of Wagner's operas—virtually nobody in Paris had—but he loved to hold forth to all visitors on all aspects of the musical theater. He liked to expound his theory that the decline of the great *bel canto* tradition had been caused by the disappearance of *castrati,* and his recollection of how he had narrowly escaped becoming one of those creatures himself. The whole custom of castrating gifted children to serve in church choirs had been based on poverty, after all, and the Rossinis had been poor. "As a child, I had a very pretty voice," the composer once recalled, "and my parents used it to have me earn a few paoli by singing in churches. One uncle of mine, my mother's brother, a barber by trade [this was one aspect of that trade that Rossini's Figaro neglected to mention in "Largo al factotum"], had convinced my father of the opportunity that he had glimpsed if the breaking of my voice should not be allowed to compromise an organ which—poor as we were, and I having shown *some*

disposition toward music—could have become an assured source of income for us all. Most of the *castrati*, and particularly those dedicated to a theatrical career, in fact lived in opulence. My brave mother would not consent at any price."

"And you, Maestro, the chief interested party?" asked one of Rossini's guests.

"Oh, me," said Rossini, "all that I can tell you is that I was very proud of my voice.... And as for any descendants that I might leave..."

"Little you cared!" Rossini's second wife interrupted. "Now is the moment for making one of your jokes."

Wagner cared nothing for jokes (and nothing for *castrati*). He wanted to discuss music with the utmost seriousness, and though he admired Rossini's technical virtuosity, as well as his amiable hospitality, he himself blamed the decay of opera on empty technique. "Those bravura *arias*," he complained, "those insipid duets fatally manufactured on the same model, and how many other hors d'oeuvres that interrupt the stage action without reason!" Rossini, who had made rather a specialty of "insipid duets," interrupted to recall how his audiences ordinarily reacted to any violation of tradition by "throwing sliced potatoes...or even ones that hadn't been sliced."

"Clearly, Maestro, *convention*...is imposed upon one," Wagner grudgingly conceded, but how could the Parisians throw potatoes at him, Wagner, when they never even produced his operas? When all that appeared on the Parisian stage was a mocking parody by Offenbach?[*] "There you have the abuse against which I am reacting," he complained to Rossini. "But they have wanted to muddy my thought. Don't they represent me as an arrogant man...denigrating Mozart?"

Rossini was a master at turning aside wrath. "Mozart, *l'angelo della musica*..." He sighed. "But who, short of sacrilege, would dare to touch him?"

"I have been accused, as if it were a mere trifle, of repudiating all existing operatic music..." Wagner persisted. "They refuse, clearly with closed minds, to want to understand my writings."

[*]"Offenbach has the warmth that Auber lacks," Wagner later said bitterly, "but it is the warmth of the dung-heap." Wagner fired his final salvo in 1870, when he celebrated the Prussian siege of Paris by writing a gloating farce entitled *Eine Kapitulation*, which he described as "the parody of an Offenbach parody." It included this bit of doggerel: "*O wie süss und angenehm,/Und dabei für die Füsse so recht bequem! / Krak! Krak! Krakerakrak! / O herrlicher Jack von Offenback!*" This is untranslatable but can be rendered as "Oh, how comfortable and sweet, / And how grateful to the feet! Krak! Krak! Krakerakrak! / Is noble Jack Offenback!"

It is all too easy to make fun of Wagner, so vain, so arrogant, so full of himself, and yet it should be possible to sympathize with someone in his painful position. At the age of forty-six, at the height of his immense powers, he had to live in exile, debt, and neglect, knowing not only what he could create some day but what he had already created and never heard. He had just finished composing the last act of *Tristan* in a Swiss hotel room, and yet he could see virtually no prospect of hearing this great music performed. He had finished both *Das Rheingold* and *Die Walküre* and could see no prospect of seeing either one of them on stage. Facing arrest anywhere in Germany because of his involvement in the uprising in Dresden in 1849, he could only wander from sanctuary to sanctuary, more and more deeply embittered and in debt. His friend Franz Liszt had urged him several times to make his headquarters in Paris, and so, in September of 1859, having borrowed all the money he could from various sponsors in Switzerland and Germany, he moved himself into a house near the Étoile. "Fate has forced me to make the choice," he wrote with typical grandiloquence, "to consider myself a resident of Paris for the rest of my life."

Fate had actually brought Wagner to Paris fully twenty years earlier, when, at twenty-six, newly married to a pretty actress named Minna Planer, and possessed of nothing more impressive than the scores of the unsuccessful *Liebesverbot* and the unfinished *Rienzi,* plus a large Newfoundland named Robber, he arrived in the French capital and found it a disappointment. "It all seemed much narrower, more confined," he later wrote, "and I had visualized the famous boulevards in particular as being far more vast."

Even before arriving in Paris, though, Wagner had met a Jewish woman who had given him a letter of introduction to the famous Giacomo Meyerbeer, born in Berlin as Jakob Liebmann Beer, sometime follower of Weber, of Salieri, of Rossini, but ever since 1832, when he and Eugène Scribe created *Robert le Diable,* the reigning panjandrum of the Paris opera scene. Meyerbeer was remarkably generous with letters of introduction to various opera officials, and in view of Wagner's subsequent denunciations of Meyerbeer as a typical "Jewish composer" of "utterly foolish and trivial" music, one can only wonder whether he presented himself to the older composer as a fellow victim of religious prejudice.

It may seem grotesque to suggest that the famous anti-Semite was

himself of Jewish origin, and yet the question persists. It derives most directly from his apostate disciple, Friedrich Nietzsche, who asked in *The Wagner Case* (1888) whether the creator of the Teutonic mythology of *The Ring* "was...a German at all." Nietzsche was assuming, of course, a highly debatable antithesis between the concepts of being German and being Jewish. Echoing Wagner's own arguments in *Jewishness in Music,* Nietzsche claimed that Wagner had simply "learned to imitate much that is German," and that it "is difficult to discover in him any German trait whatever." Nietzsche apparently based this theory on the uncertain evidence—which the composer may well have confided to him—that Wagner was the illegitimate son of a wandering actor named Ludwig Geyer, who boarded in the Wagner household and subsequently married the widowed Johanna Wagner. Geyer, the German word for vulture, is one of those "comic" names that German officials imposed on the Jews when they emerged from the ghettos at the start of the nineteenth century.

In any case, Meyerbeer did what he could to introduce the young Wagner to Parisian musical authorities, but Wagner had little more than future possibilities to offer. At friends' urgings, he wrote a few songs. A publisher hired him to produce piano transcriptions of Donizetti, and a little guide to playing the trumpet. He wrote articles about concerts that he had never attended. He even wrote a novelette, *An End in Paris,* about an idealistic composer who dies of neglect, rejected even by his runaway dog. That, too, happened to Wagner. And he pawned his wedding ring, and Minna's, too. Could a young musician's life get worse? Yes, continually. He heard Berlioz conduct his new *Romeo and Juliet,* and that made him feel like "a mere schoolboy." Trapped by his creditors, Wagner was even imprisoned for debt until Minna got help from relatives. And when he finally managed to write his libretto for *The Flying Dutchman,* the Opéra offered him 500 francs to turn the project over to a third-rate composer named Dietsch. It was only when he sent both libretto and music to Berlin, where Meyerbeer warmly recommended its performance, that Wagner was able to abandon the conquest of Paris and return to his native land.

"May heaven only grant," Wagner wrote to Meyerbeer, "that some opportunity may arise for me to render you even a thousandth part of what thanks I owe you. I can hardly hope, however, that Heaven will be so generous to me; on the contrary, I see that I shall follow you from aeon to aeon stammering my thanks...." To his sister Cäcelie, who lived

in Paris with her husband and had loaned him substantial sums of money, he wrote more candidly: "Ah, how I hate Paris—vast, monstrous, alien to our German hearts."

Now, twenty years later, a political exile and far more deeply in debt, he decided in Switzerland that it was "fate" that forced him to summon the estranged Minna from Dresden with her dog and parrot and to establish himself once more in the opera capital of Paris. His dream was to organize a spectacular premiere there for *Tristan*—his real dream, actually, was to somehow organize a German opera company in Paris that would adopt all his widely unperformed works as its basic repertoire and ultimately produce a completed *Ring*—but the director of the Théatre Lyrique, Léon Carvalho, persuaded him that Parisian audiences wanted only to hear the most celebrated of his early works, *Tannhäuser.* So Wagner dressed himself up in a green-fringed yellow cap and invited Carvalho to an audition. "He sang, he shouted, he threw himself about," according to a friend named Agénor de Gasperini, who witnessed the event, "he played the piano with his hands, his wrists, his elbows, he smashed the pedals, he ground the keys...." Carvalho's own recollections were even more vivid: "He began by giving me the first part of *Tannhäuser;* then, dripping with perspiration, he disappeared, to return this time in a red cap decorated with yellow braid; his blue braid coat had been replaced by a yellow one embellished with blue braid. In this new costume he sang for me the second part of his opera. He howled, he threw himself about, he hit all kinds of wrong notes, and to crown it all in German! And his eyes! The eyes of a madman!" According to the other witness, Carvalho "stammered out a few polite words, turned on his heels, and disappeared."

Nothing could be more alien to the Paris of Napoleon III than this medieval Teutonic drama, in which the hero renounces his life with Venus and seeks forgiveness from the saintly Elisabeth. Yet Wagner now set about getting his Romantic German verses translated into French. One of the people he commissioned to undertake a translation was a young customs clerk who had recognized his name at the Paris customs station; another was an opera singer who had recently shot off his arm in a hunting accident. Meanwhile, to establish his musical presence in Paris, Wagner decided to conduct three concerts of his works, selections from *Tannhäuser* and *Lohengrin*, the overtures to *The Flying Dutchman* and *Tristan.* He seemed not to know or to care that he would have to pay

all the expenses himself, and that these three concerts would leave him about 11,000 francs further in debt. With equal nonchalance, he sent out no invitations to the press, and the press reacted accordingly. "Fifty years of this music, and music is dead," declared the critic for *Ménestrel*, "for melody will have been slain, and melody is the soul of music." "If this is true music," said another, "I prefer the false."

In Manet's lifelong struggles with the Parisian newspapers, their criticisms are generally ascribed to the critics' ignorance, bad judgment, snobbery, social climbing, and sheer incompetence, but Wagner, in his autobiography, attributed the persistent "hostility" of the press largely to the corrupt machinations of Meyerbeer. It is still not clear exactly why the young Wagner's fawning on Meyerbeer turned to such deep hostility, but it was probably simple guilt and paranoia about Meyerbeer's very real help. Wagner himself liked to claim that he had suddenly seen the empty artificiality in Meyerbeer's love of pageantry, and he now claimed that Meyerbeer's operas were successful largely because of the composer's willingness "to pay out the most monstrous bribes." And because of a general Jewish vulgarization of musical taste. Without naming Meyerbeer, except as "a widely renowned Jewish composer of our time," Wagner pilloried him in *Jewishness in Music* as "someone who would like to create and yet at the same time realizes that he cannot." History has not been kind even to Meyerbeer's greatest successes, *Robert le Diable, The Huguenots,* and *The Prophet* (these last two being oddly devoted to Protestant heresy), but was he really the great corruptor of Parisian taste? It would be convenient to let that be answered by one of the sly witticisms of a fellow expatriate, Heinrich Heine: "Meyerbeer will be immortal during his lifetime, and perhaps for some years afterwards, for he pays in advance." Except that Heine, too, had an unfortunate penchant for using his pen to win financial favors and settle scores.

Paris's most important music critic was the painfully honest Hector Berlioz. Ten years older than Wagner, a great dramatist and a master of orchestration, Berlioz had once made Wagner feel like "a mere schoolboy," and the German probably still felt somewhat the same way when he sent Berlioz a copy of the score of *Tristan,* inscribed, "*Au grand et cher auteur de 'Roméo et Juliette'...*"* He suffered accordingly when Berlioz left the manuscript unacknowledged for nearly a month. Berlioz

*"To the great and cherished author of 'Romeo and Juliet'... "

tried to be magnanimous in reviewing Wagner's concerts in *Le Journal des Débats*. He praised much of *The Flying Dutchman* and *Lohengrin*, though the prelude to the latter struck him as little more than "a sort of chromatic moan." He said that he had reread this score several times, but that "I still have not the least notion of what the composer was driving at." His incomprehension of the prelude to *Tristan* was even more complete. "If this is the new religion, I am far from professing it," he wrote. "I have never professed it, I do not profess it now, and I will never profess it: I raise my hand and swear, *Non credo.*"

It is always possible, just as Stravinsky and Schönberg resolutely ignored each other's music during their years of shared and unshared exile in Los Angeles, that no cultural radical can ever understand a rival radicalism. It is also possible that Berlioz, just like Wagner, suffered from the poisonous effects of having major works unperformed, unheard. For years, he had struggled to complete his gigantic opera *Les Troyens;* for years, he had struggled to get a hearing, or even the possibility of a hearing, and now the talk of Paris was a young newcomer from Germany. Berlioz felt all the sicknesses of ill-suppressed rage. At Wagner's concerts, he suffered from laryngitis so severe that he could hardly speak.

What Wagner could not blame on Meyerbeer, who happened to have arranged some performances of Berlioz's music shortly before the Wagner concerts, he blamed on Berlioz's shrewish second wife, Marie, who seems to have regarded everyone as a threat to her husband. "I was not offended," Wagner wrote to Liszt of Madame Berlioz's antipathy. "I merely ask myself whether the good Lord would not have done better to leave women out of his scheme of creation: for they are rarely of much use, while as a rule they work us much mischief without in the end doing themselves any good. The Berlioz case has shown me once more, with anatomical accuracy, how a malignant woman can ruin a brilliant man to her heart's delight and make him ridiculous."

Despite these remarkable hostilities, Wagner's reception in Paris naturally included admiration and applause as well. The composer was pleasantly surprised, for example, to discover that the young Camille Saint-Saëns, who regarded the popularity of Offenbach as "the collapse of good taste," could perform his entire *Tristan* at the piano from memory. Baudelaire wrote him a letter to say that he had gone to his concerts without great expectations but—"I want to tell you, he declared, "that I owe you the greatest musical joy that I have ever experienced in my life."

Princess Pauline von Metternich knew little about Wagner or his music, but she had made herself a kind of arbiter of what was fashionable. "She drinks, she smokes, she swears, she is as ugly as sin, and she tells stories!" the Count de Viel-Castel wrote in his carping memoirs. The princess had apparently seen the original production of *Tannhäuser* in Dresden more than a decade earlier, and though she retained only dim memories of its magic, she understandably considered it her duty to smooth over the wounds of the recent Franco-Austrian fighting in Italy by singing to Napoleon the praises of peaceable Germanic culture. So be it, said Napoleon. Let *Tannhäuser* be performed.

Wagner would take part in all the casting decisions, in the design of sets and costumes, in all orchestral rehearsals. There was only one problem, according to the director of the institution, Alphonse Royer. "Nothing caused him so much worry as to convince me of the need to change the second act, as the insertion of a big ballet at this point was absolutely unavoidable," Wagner wrote. Wagner was presumably aware of the great new vogue for ballet, but he seems to have been only vaguely aware that the opera required a ballet at the start of the second act because the members of the Jockey Club liked to come swaggering from their dinner to the opera just about then, and because they cared about nothing at the opera except the spectacle of the ballerinas who might be sampled after the curtain. This was not a matter of artistic choice but of social law: All performances at the Paris Opera required a ballet in the second act. Even Verdi, Meyerbeer's main rival, had to begin the second act of *Il Trovatore* with Gypsies dancing around their campfire. The Jockey Club would accept no deviations.

Wagner at least pretended to seek a compromise. He had never been satisfied, he said, with the Venusberg scene at the start of *Tannhäuser.* Venus herself was only a half-formed character, and the supposedly orgiastic scenes in her domain had never seemed overwhelmingly orgiastic. By now, the composer of *Tristan* had lots of new ideas, so if the Parisian opera authorities wanted an elaborate ballet, he would be happy to expand and elaborate on his orgy, filling it, as his biographer Ernest Newman observed, with "Cupids, Graces, sirens, nymphs, satyrs, bacchantes, goddesses, water-sprites, slaughtered rams, fauns, maenads, sphinxes, great cats, tigers, panthers, griffins, and what not." Splendid, splendid, the opera authorities said, but the Jockey Club connoisseurs who insisted on a ballet would not yet have arrived from their dinners

before the end of the first act, and so they would miss the whole orgy. "I have declared that I could not take orders from the Jockey Club, and would withdraw my work," Wagner wrote to Mathilde Wesendonk in Switzerland. "However, I mean to help them out of their difficulty; the performance need not begin until eight o'clock, and then I will amplify the unhallowed Venusberg in a suitable way...."

In the midst of all this, Wagner had to move out of his house near the Étoile, on the Rue Newton, and to find himself a new establishment nearer to the Opéra, on the Rue d'Aumale, and his wife Minna complained bitterly that she was reduced from two servants to one, and the exiled composer's nerves began to fray. "Wagner is in such a state of agitation as to cause me the gravest concern for his health," the conductor Hans von Bülow wrote to a friend early in 1860. "He would gladly give himself up to the executioner the next day if only he could have conducted a good performance of his *Tristan* the night before." By the following autumn, he simply began to disintegrate—his own diagnosis was typhoid fever—with no local friends except Gasperini to look out for him. "In my fevered paroxysms," he wrote later, "I insisted on his calling in all kinds of medical assistance...I imagined that Princess Metternich and Mme. Kalergis were setting up a complete court for me, to which I would also invite the Emperor Napoleon.... Finally, I insisted on being taken to Naples where I promised a speedy recovery if I could only have an unlimited association with Garibaldi. Gasperini...and Minna managed to restrain me in spite of my enraged struggles in order to put the requisite mustard plasters on my feet."

How like the third act of *Tristan,* in which the fevered hero awakens and begins to cry out, "Where am I? Who is calling me? What was it I heard? How did I come here?" When Wagner ventured out into the streets again and returned to the Opéra, he found all the *Tannhäuser* rehearsals in a state of disarray. Nobody seemed to think this complicated novelty would ever really be produced, and nobody very much cared.

But Wagner had just finished writing what he conceived to be the splendid Venusberg ballet for Act I. "I completed it one sleepless night at 3:00 A.M." he wrote, "at just the moment Minna came home from the grand ball at the Hôtel de Ville, which she had attended with one of her lady friends." This had no effect whatever on Count Alexandre Walewski, the emperor's new minister of culture. "He insisted," as Wagner wrote, "that a ballet in the first act counted for nothing, because those

habitués who went to the opera solely on account of the ballet were now accustomed to dining at around 8:00 P.M., and thus could get to the theater only at about 10:00 P.M., or right in the middle of the performance. I objected that, even if I could do nothing for these gentlemen, I might still make a proper impression on another part of the audience, but he countered with unshakable solemnity that these gentlemen were the only ones who could be counted on to produce a favorable outcome, that they alone had enough power.... When I turned a deaf ear to all this and offered instead to withdraw my work completely, I was assured with the utmost seriousness that, according to the command of the emperor, which everyone had to obey, I was the person in charge...."

The premiere of *Tannhäuser* was expected toward the end of January of 1861, then postponed until the third week in February—Madame Tedesco, the soprano hired to play Venus, was having great difficulty in relearning her rewritten part—then until February 25, then March 8— now Madame Tedesco complained of feeling ill—and finally March 13. The delay had, if nothing else, given the Jockey Club time to equip its members with silver hunting whistles engraved with the words *"Pour Tannhaeuser."* This fractiousness on the part of the Jockey Club was traditionally ascribed entirely to the dissolute members' sportive obsession with ballerinas, but there were a number of larger issues involved. One was the Jockey Club's view of itself as a representative of the "real" aristocracy, half-suppressed during the last two or three coups and revolutions, but still more entitled to privilege of rank than that upstart adventurer in the Tuileries palace and those vulgar merchants who were enriching themselves under his rule. No less important, the Jockey Club liked to consider itself a center of specifically French aristocracy, patriotically French aristocracy, and so it enjoyed challenging the expensive presentation of a new German opera at the instigation of an Austrian diplomat's wife.

And even without the Jockey Club, the last two rehearsals of *Tannhäuser* came near to chaos. The conductor, Pierre Dietsch, that hack who had once been commissioned to write the music for the young Wagner's libretto of *The Flying Dutchman,* had now taken his place on the podium, but Wagner sat nearby on the stage, giving different cues to both singers and orchestral musicians. More than a hundred more or less hostile journalists had acquired good seats and spent much of their time whispering and snickering. The Tannhäuser himself, Alfred Niemann,

claimed an attack of vertigo so severe that he had to leave at the end of the first act, and the rest of the dress rehearsal continued with the hero missing.

Still, when opening night finally arrived on March 13, 1861, the authorities did their best to assert their authority. The emperor established himself in the imperial box, with Eugénie at his side, and Princess Metternich nearby, and the revamped Venusberg scene—which is a little peculiar under the best of circumstances—provoked no disturbances. "Though the execution of the spectral dance of the divinities in the Venusberg fell far short of Wagner's expectation—the three Graces appearing in pink ballet skirts—I began to breathe again," recalled one of the composer's friends, Malwida von Meysenbug, "and to hope that our fears had been superfluous." But then came the horn melody from the shepherd boy, and a taunting response from one of the Jockey Club whistles, and shouts of protest from the Wagner enthusiasts, and more whistling.

As usual in the aftermath of such celebrated uproars, nobody really knows exactly what happened. According to several accounts, the organized Jockey Club whistling and cat-calling—all led by white-gloved signals—halted the music for as long as fifteen minutes at a time. But the shouts of those who wanted to hear more added their contribution to the chaos. And so the opera started and stopped and started again, and did continue to the end. The result, according to Frau von Meysenbug, "was so deranged and mangled that not even for the well-disposed was there the least possibility of forming a right conception of it as a whole." Niemann, the vertigo-vulnerable tenor at the center of the storm, recalled the premiere in yet more tempestuous terms: "*Tannhäuser* made a fiasco such as has probably never been known in Paris before. It was literally hissed off, hooted off, and finally laughed off.... The row was beyond belief; even the presence of the emperor could not keep it within bounds. Princess Metternich, to whose patronage the production of the opera was mainly due, was compelled to leave the theater after the second act, the audience continually turning around toward her and jeering at her at the top of its voice." On the other hand, Wagner himself soon wrote for the German press a *Report on the Production of Tannhäuser in Paris* in which he praised the Parisian audience for its "quick responsiveness" and "truly magnanimous sense of justice." And as for those long interruptions of the music, he ascribed them not to the Jockey Club's

whistles but to "repeated outbursts of applause a quarter of an hour long."

Tannhäuser was supposed to run for several months, and if the results of the opening-night skirmishes were inconclusive, undecided, then both sides were ready to renew the combat, the authorities with a second performance (delayed from March 15 to 18 because Niemann was once again indisposed) and the Jockey Club with its whistles. The authorities were far less resolute than they seemed, however. Royer, the head of the Opéra, had already made to Wagner the odd proposal that the controversy might be reduced by attempting some rather substantial cuts in the score. Wagner, oddly numbed by the whole uproar, reluctantly agreed. It was "very difficult," according to Royer, to get "a man so convinced of the merit of his work as M. Wagner is to consent to cuts." Perhaps he had already heard that worse cuts were in prospect. "At the behest of the emperor..." he later wrote, "these gentlemen of the Jockey Club...had been requested to allow at least three performances to take place, after which, it was promised them, the opera would be cut sufficiently to permit it to function as a curtain-raiser for an ensuing ballet...."

At the second performance, Napoleon and Eugénie once again made their appearance, and once again Wagner was delighted to hear strong applause at the finale of the first act. Madame Tedesco, resplendent in a gold wig for her role as Venus, waved up toward the composer's box to assure him "that everything was now in order and we had carried the day." Once again, it was a false dawn. "When shrill whistles were suddenly heard in the middle of the second act," Wagner recorded, "M. Royer turned to me with an air of complete resignation and said: '*Ce sont les Jockeys; nous sommes perdus.*'"° And so, once again, bedlam. Royer, Wagner noted bitterly, "abandoned all resistance, in spite of the support of the emperor and his consort, who stoically kept their seats throughout the uproar caused by their own courtiers."

Everybody shouted. Princess Metternich broke her fan banging it against the railing of her box. The demonstrators recognized Minna Wagner (who never understood why her husband couldn't simply add a ballet to the second act), and she, as Wagner wrote, was not "spared insults from her neighbors." Her attendant maid, a Swabian girl named

°"'Those are the Jockeys; we are lost.'"

Therese, responded to one of them with what Wagner called "a resounding '*Schweinhund!*'" By now Wagner was again talking somewhat disingenuously of "withdrawing" his opera from the Parisian stage, while Royer talked of further cuts even as he kept insisting that the show must go on.

The third performance was scheduled for a Sunday, March 24, and the Jockey Club traditionally ignored the Opéra on Sundays. Wagner indignantly vowed to stay home as well. Napoleon and Eugénie also turned to other things. But the Jockey Club rowdies returned to the theater after all, more determined than ever to assert their views. "I was told that during the first act alone there had been two fights lasting fifteen minutes each and causing the performance to come to a standstill..." Wagner wrote. "When everybody on my side was utterly exhausted by shouting and clapping and calling for order and it appeared as if peace had been restored once more, the Jockeys could effortlessly again begin blowing their hunting whistles and flageolets, so that they won every round."

History's perception of this scandal is, as usual, the perception of history's winners. Wagner was a genius, and so the Jockey Club rioters who "won every round" eventually won nothing but disgrace. Yet the most original musical mind in Paris predicted even before the opening of *Tannhäuser* that "Wagner is plainly mad," and that he "will die...of a brain fever." Hector Berlioz went to that famous premiere, of course, and he saw no signs of any music of the future. "God in heaven!" he wrote to a friend. "What a performance! What outbursts of laughter! The Parisian showed himself yesterday in an entirely new aspect; he laughed at the bad musical style, he laughed at the absurd vulgarities of the orchestration.... As for the horrors, they were splendidly hissed." Berlioz went to the second performance, too, and his view did not change. "The second performance was worse than the first," he wrote to his son. "This time the audience did not laugh so much; it was furious; it hissed enough to bring the roof down, in spite of the presence of the emperor and empress. On the staircase, as people were going out, they openly treated this wretched Wagner as a rogue, an insolent fellow, an idiot. If they go on like this, one of these days the performance will not finish, and there will be nothing more to be said...."

Things did not go on like this. After the third performance, Wagner demanded somewhat more forcefully that the performances of

Tannhäuser end forthwith, and the authorities somewhat reluctantly swallowed their financial losses and agreed. The posters on the walls of the opera were already announcing performances of Offenbach's *The Butterfly*. And so Wagner abandoned not only this production but the whole idea of finishing *The Ring* in Paris. Indeed, if there was one good consequence of the *Tannhäuser* scandal, it was that the endorsement of Napoleon forced the princelings of Germany to reconsider their ostracism of the exiled composer. The kingdom of Saxony eased its ban that summer, and there was talk of a *Tristan* premiere in Karlsruhe, or perhaps in Vienna. Wagner packed up once again and headed east.

"What will Europe think of us?" Baudelaire wrote after the Jockey Club riots. "What will they say of Paris in Germany? A handful of rowdies has disgraced us *en masse.*" And all of that was in the air when Suzanne Manet made her journeys to Baudelaire's hospital room to play to the dying poet the new music of Wagner.

The reason why Wagner had to evacuate his house on the Rue Newton so suddenly was that he had been abruptly notified that the whole street was being lowered by more than ten feet. "To my astonishment," he recalled, "I found the street being dug up right at my doorstep and quite deeply as well; at first no carriages could get through, and before long, no one could get there on foot either. Under these circumstances, the owner of the house had no objection to my leaving forthwith, demanding only that I sue him for damages, as this would be the only way he himself could get anything back from the government." It was obvious that the landlord had known something of the government's plans. That was why he had demanded a three-year lease, all payable in advance, why he refused to make any alterations before Wagner moved in but benignly acquiesced in Wagner's redecorating the place at his own expense. Wagner did sue but gained nothing except a heightened sense of Parisian commercial practices.

This kind of activity—both the dramatic rebuilding and the financial scheming—was taking place all over Paris during the imperial years, for one of the most extraordinary aspects of Napoleon's somewhat capricious reign was his determination to rebuild his capital. This had been

one of his dreams ever since his imprisonment in the fortress of Ham, when dreams were all that he had to live on. "I want to be a second Augustus," he wrote from his cell in 1842, "because Augustus...made Rome a city of marble." Previous rulers of France had cherished similar dreams, of course. Henry IV had built the Place des Vosges, Louis XIV the *"grands boulevards"* on the Right Bank, Louis XV the Place de la Concorde, but Paris had absorbed them all and remained its anarchic self, a chaos of Baroque palaces and rat-infested slums, busy thorough-fares and impassable alleys, Gothic monasteries, open sewers. And pesti-lential: the cholera epidemic of 1848–49 killed nearly 20,000 people in Paris alone. And constantly growing, from 547,000 in 1801 to just over 1 million when Napoleon took power in 1851 to nearly 1.7 million (with the newly annexed suburbs) a decade later.

Occasionally, there have been autocrats like Peter the Great who determined to build whole cities in their own honor. Occasionally, there have been cataclysmic disasters like the London fire of 1666 or the Lis-bon earthquake of 1755 that provided opportunities for large-scale urban reconstruction. But nobody had ever attempted to tear apart the entire center of a modern city and transform it into something radically new. That was exactly what Napoleon III planned. And on June 30, 1853, the day on which the new prefect of the Seine drove to Saint-Cloud to be sworn in, wearing full-dress uniform complete with plumed hat and sword, the emperor took him aside after lunch and showed him a map of Paris on which he had drawn elaborate diagrams in different colored crayons, red for the most urgent projects, then blue and green. This map showed what he wanted done: new boulevards, parks, bridges, markets—a new city.

It is possible that this transformation of Paris might have taken place under some other prefect, but destiny had presented Napoleon with his perfect tool, instrument, weapon, Georges Eugène Haussmann. They knew each other only slightly. In their few meetings, however, Hauss-mann had impressed the emperor as a man who would do anything for the greater glory of the empire, a man, in short, who could prove very valuable. Haussmann came from that sort of stock, a Protestant of Alsa-tian origins, though he himself had been born in Paris in 1809. His grandfather had built a very successful textile plant near Colmar; his father had been an officer in the Napoleonic armies, and his mother the daughter of an equally military Baron Dentzel (hence Haussmann's sub-

sequent claim to be known as Baron Haussmann).

A bright and ambitious boy, he attended the Lycée Henri IV, then studied law at the Collège Bourbon, where he met classmates as diversely useful as the Duke of Orléans and the poet Alfred de Musset. He also took cello and organ lessons at the Conservatory and decreed himself, as an artist, "passably good." Government administration was the vocation that summoned him, however, to a series of positions in Poitiers, Auvergne, Provence, and finally Bordeaux. He was appointed prefect there on the eve of Napoleon's coup d'état, and he made sure that a respectable number of Bordeaux citizens turned out in the streets to offer spontaneous cries of *"Vive l' empereur!"* And it was in Bordeaux that the prince-president, beginning to campaign for his transformation into emperor, defined the coming era in almost Haussmannian terms: "We have huge uncultivated areas to develop, roads to build, ports to construct, rivers to make navigable, our whole network of railways to complete."

To carry out any such program in Paris required a very special sort of man, and the official in charge of finding him was the minister of the interior, Jean-Gilbert de Persigny. He undertook to interview five provincial prefects, and as soon as he came to Haussmann, he knew that his search was over. "I had before me one of the most extraordinary types of our time," he later recalled. "Large, powerful, vigorous, energetic, and at the same time sharp, shrewd, resourceful, this bold man was not afraid to show himself for what he was. With visible self-satisfaction he put before me the highlights of his career, sparing me nothing; he would have talked for six hours without stopping as long as it was on his favourite subject, himself.... While this absorbing personality spread itself before me with a sort of cynical brutality, I could not hide my keen satisfaction.... Where the most intelligent, clever, upright and noble men would inevitably fail, this vigorous athlete, broad-shouldered, bull-necked, full of audacity and cunning, capable of pitting expedient against expedient, setting trap for trap, would certainly succeed. I rejoiced in advance at the idea of throwing this tall, tigerish animal among the pack of foxes and wolves combining to fight the generous aspirations of the empire." The emperor agreed. When Persigny reviewed the list of candidates, Napoleon stopped him and said, "Useless to go further. That's the man I need."

Because of Paris's radical history, the city had not for years been

allowed to have an elected mayor, only an appointed prefect; its municipal council, similarly, was not elected but appointed by the minister of the interior. While the prefect theoretically enjoyed vast powers, he had no popular mandate, no political authority; he also had to share many of his powers with another appointed official, the prefect of police. And no sooner had Haussmann taken office than he heard the emperor outline new plans to encumber his prefect with an official commission for planning. Haussmann immediately protested that committees were inherently inefficient; they might not understand the emperor's wishes as well as he did. "You mean that if there were none, that would be best?" the emperor inquired. Haussmann quickly agreed. The emperor, as was typical with him, offered no further argument. The matter never came up again. Hausmann took charge of the capital city, and of the emperor's crayoned map.

They were an oddly contrasted pair, these two, the crafty and serpentine Napoleon and the blustering Haussmann, and neither one has often been accused of being an artist. On the contrary, the emperor's aesthetic tastes were and still are generally considered to lie somewhere between vulgar and nonexistent, while the baron seemed to be interested mainly in getting his work done and making profits. And yet when we consider the Paris that they built—and they built everything from the Boulevard Saint-Germain to the Bois de Boulogne, from Les Halles to the square in front of Notre Dame and the avenues radiating outward from the Étoile—did they not create a supremely beautiful work of art, of a grandeur beyond anything even imagined by a painter like Manet? Or, for that matter, by all the Impressionists together, who so often painted what these two Philistines had built? "Haussmann created the great nineteenth-century city..." as S. Gideon wrote in *Space, Time and Architecture*. "The huge scale of this work is genuinely overwhelming. Haussmann dared to change the entire aspect of a great city, a city which had been sacred for hundreds of years as the center of the civilized world."

The emperor's map was, of course, only a beginning, a sketch, a dream. (Indeed, it subsequently disappeared in a fire, and the only reason that we know of its details is that Napoleon gave a copy to the king of Prussia during the Exposition of 1867, and this, duly filed away and forgotten, was finally rediscovered in the royal archives in Berlin.) One of the first things that Haussmann learned when he took office was that the emperor's map was inaccurate, for no correct and comprehensive map of

the city had ever been made. So one of the first things he set out to do was to make one. For several years thereafter, Parisians had to accustom themselves to the appearance of high towers of scaffolding that sprang up over the rooftops at busy intersections. In surveying itself, the city was reconsidering itself, reassessing itself. The finished maps, on a scale of 1/5,000, measured nine by fifteen feet. Haussmann sent them out to all his major offices but kept one in his study. "Many an hour," he said later, "have I spent in fruitful meditation before this altar-screen."

The emperor's first great project—which was probably the first because it had attracted and then thwarted Napoleon I—was to extend the Rue de Rivoli eastward until it could join the Rue Saint-Antoine and thus become the major east-west artery through the heart of the city. The first emperor had pushed the Rue de Rivoli eastward from the Place de la Concorde as far as the Pavillon de Marsan, now the Place des Pyramides, and there it was blocked by a dense slum that sprawled southward toward the Seine. Here stood, as Balzac wrote in *Cousin Bette* in 1846, "a dozen or so houses with crumbling façades, which the landlords never repair and which are the remnants of an old quarter condemned since the days when Napoleon decided to finish the Louvre.... These so-called houses are hemmed in by a marsh in the direction of the Rue de Richelieu, by an ocean of paving stones in that of the Tuileries, by little gardens and tumble-down hovels toward the Galeries...." "It was a great satisfaction to me," Haussmann later recalled, "to clear all that as my first job in Paris."

This all sounds fairly straightforward, but any such project in the heart of a city like Paris inevitably encounters unprecedented complexities at almost every corner. Just a few blocks east of the Louvre, for example, the builders of the Rue de Rivoli had to pass next to the Tower of Saint-Jacques-la-Boucherie, the 170-foot belfry of a vanished sixteenth-century church that had long served as one of the starting points on the pilgrimage to Santiago de Compostela in northwestern Spain. The tower stood on a ridge that would have to be removed to make way for the avenue, but could the ridge be removed without the demolition of the tower? Haussmann was just beginning then, and anything seemed possible. He propped up the tower on scaffolding, dug away the ridge underneath it, built a new stone base for the tower, and the Rue de Rivoli moved on.

The Rue de Rivoli was only one part of the grand plan, of course, and

it was right here, next to the Tower of Saint Jacques, that the plan neared its center. Boulevard du Centre was actually the name that Napoleon attached to the north-south avenue that he wanted to build, parallel to the medieval Rue Saint-Denis, to intersect the Rue de Rivoli near the Hôtel de Ville and then end at the Seine. An admirable idea, said Haussmann, but why stop there? As the prefect contemplated the great map of the city, his eye saw a huge cross. Let us not only push Rue de Rivoli east to the Bastille and beyond, but let our great north-south boulevard (a section had already been started under the name of the Boulevard de Strasbourg, leading south from the Gare de Strasbourg, later the Gare de l'Est)—let our great north-south boulevard smash through all those slums on the Île de la Cité and then cut through the Left Bank as an artery to be called the Boulevard Saint-Michel.

Now that we regard such Haussmann creations as the Boul' Mich as ancient thoroughfares, we may find it difficult to realize what radical innovations they were, how artfully designed and how bitterly contested. The royal metropolis that Haussmann intended to transform was also a rats' nest of slums that had been fortified by rebel barricades no less than nine times during the previous quarter century. Haussmann's overriding plan, as outlined to the municipal council, thus combined urban renewal, public health, and public security. His first goal, he said, was "to disencumber the large buildings, palaces, and barracks in such a way as to make them more pleasing to the eye, afford easier access on days of celebration, and a simplified defense on days of riot." The second objective was "the amelioration of the state of health of the town through the systematic destruction of infected alleyways and centers of epidemics." The third was "to assure the public peace by the creation of large boulevards which will permit the circulation not only of air and light but also of troops." Only then did he mention that the fourth goal was "to facilitate circulation to and from railway stations by means of penetrating lines which will lead travelers straight to the centers of commerce and pleasure, and will prevent delay, congestion, and accidents."

Though Haussmann's boulevards were the most spectacular element in his reconstruction of Paris, they were perhaps less important than what Haussmann built underground, a completely new system for piping in water and flushing away sewage. "I am particularly attached to this considerable piece of work because it is really mine," he later declared. "I did not find it in the program of the transformation of Paris drawn up

by the emperor, and nobody in the world suggested it to me. It is the fruit of my observations."

Paris traditionally pumped water directly from the Seine, though Napoleon I had greatly enlarged the supply by building a canal to the Ourcq River. Still, most Parisians got their water from public fountains or from water wagons. Only one house in five had pipes. The need for improvements was beginning to attract entrepreneurs, and the banker Charles Laffitte nearly persuaded the emperor to let him take over the entire system. Haussmann managed to talk him out of that, then brought in a young engineer named Eugène Belgrand to find the best new supplies. After a number of false starts and a considerable amount of opposition, Haussmann and Belgrand decided to tap the springs in the valley of the Vanne, some eighty miles southeast of Paris, and to build a huge aqueduct from Sens to the capital. Overall, Haussmann roughly doubled the city's water supply of 27 million gallons a day; within the city he doubled the length and capacity of the water mains and quintupled the number of houses with running water.

The system for disposing of wastes and sewage had been equally medieval. The main sewer was, as it had always been, the Seine. Zola wrote in *L'Assommoir* (*The Bar*) of surveying the river near the Pont Royal and observing "the surface...covered with greasy matter, old corks and vegetable parings, heaps of filth." A speaker in the legislature spoke simply of "the black torrents." When Haussmann began building his first great north-south avenue, which was now changed from the Boulevard du Centre to the Boulevard de Sébastopol, he also began building the new sewage lines underneath it. But his greatest innovation was to devise a system that would carry sewage three miles to the northwest of the city, thus cutting across the great loop that the Seine makes west of Paris, before dumping it twelve miles downstream at Asnières. "Today nothing seems simpler than this solution when one looks at the map of the area," Haussmann proudly wrote when the battles were over, "but no one thought of it, and it was after a great deal of meditation and profound discouragement that it occurred to me suddenly, one sleepless night in front of the plan of Paris."

Despite these subterranean accomplishments, most of Haussmann's time and money was spent on the emperor's new boulevards and the great buildings that anchored them. Seventy-one miles of new roads built, 400 miles of pavements laid, 27,500 houses demolished but

102,500 built or rebuilt. The central markets at Les Halles had been condemned as early as 1844 as "a handful of inconvenient buildings, narrow roads, ramshackle houses," and so the municipal authorities had hired an architect named Victor Baltard to design a new market. Baltard was a Prix de Rome classicist who believed in stone and pillars, and as his construction rose, Parisians began to mock it as the Fort de la Halle. Napoleon, newly established in power, went to inspect the scene, ordered work stopped, and requested a competition for new designs. Haussmann, who had not been responsible for Baltard's unsatisfactory plan, and who raised no objection to the competition, took the precaution of asking the emperor how he envisaged the new market. The emperor had apparently admired the iron girders and sheets of glass in the newly opened Gare de l'Est, but he gave only a rather cryptic answer: "Vast umbrellas are what I need; that's all." He provided Haussmann, however, with a pencil sketch of what he meant.

Haussmann took the sketch away and summoned the humiliated Baltard to his office. "You're going to have your revenge," he said. "Make me, as quickly as possible, a design like this. Iron, iron, nothing but iron!" Baltard argued stubbornly that iron was not a material worthy of such a project, but Haussmann insisted. Baltard returned with a plan for a market built with stone walls and some iron girders under the roof. Haussmann demanded a second version. Baltard's second version still relied on stone pillars to uphold the iron superstructure. Haussmann demanded a third version, which finally appeared all in iron. Haussmann hid it away until the emperor had seen and rejected all the entries in his competition. With a show of hesitancy, Haussmann then brought out Baltard's final plan and was pleased to hear the emperor say that it was just what he wanted. And who was this architect, the emperor asked. The same one who had designed the original version, Haussmann said, "the same architect but not the same prefect."

It was almost the same at the Bois de Boulogne, a rather neglected royal hunting ground that had been laid out in 1679 with nothing more than a few long straight pathways though the wilderness. Napoleon, recalling his years of exile in London, dreamed of better things. "We must have a river here, as in Hyde Park, to give life to this arid promenade," he said to some companions as they reconnoitered the area. It seemed a simple matter of landscaping, so the emperor hired an elderly gardener named Varé who had once worked for his father. Build me a

river, said the emperor. When Haussmann first discovered the gardener's plans, he assigned an engineer to analyze them, and the engineer soon found that the gardener's river was so laid out that it would continually run dry at one end and overflow at the other. What the emperor needed for his park, Haussmann persuaded him, was two lakes connected by a waterfall. And so it was done. And so Haussmann also added meandering pathways, and thinned the underbrush, and while he was at it, he built a new race course at Longchamps to please the Count de Morny and the rest of the Jockey Club. It was always a good idea, Haussmann knew, to please the Jockey Club.

Parks and trees were an integral part of Haussmann's plans from the beginning. Though he was thwarted in his idea of building a circular green belt that would connect the Bois de Boulogne in the west to the Bois de Vincennes in the east, he could boast that the city's parkland increased from forty-seven acres in 1850 to 4,500 in 1870—and all of it open to the public—and that he had doubled the number of trees along the streets to nearly 100,000. "If not already the brightest, airiest, and most beautiful of all cities, it is in a fair way to become so," an English landscape gardener named W. Robinson wrote admiringly in 1869 in *The Parks, Promenades, and Gardens of Paris.* "And the greatest part of her beauty is due to her gardens and her trees.... In Paris, public gardening assumes an importance which it does not possess with us.... It follows the street builders with trees, turns the little squares into gardens unsurpassed for good taste and beauty...presents to the eye of the poorest workman every charm of vegetation."

There must have been times, though, when Haussmann seemed a giant octopus with a tentacle reaching into every corner of the city. After Orsini and his band of Italian radicals threw bombs at the emperor's carriage outside the Opéra, for example, Haussmann quickly decided that it was time to start building a new and more easily guarded opera house. And no sooner had he decided to build than he began secretly buying land on the Boulevard des Capucines, where he envisaged not only a grand new opera house (duly completed a decade later) but the beginning of a grand new Avenue Napoleon (now the Avenue de l'Opéra) running all the way down to the Palais Royal. And just beyond that lay the Île de la Cité, where the noble Cathedral of Notre Dame (which Viollet-le-Duc was already renovating) stood virtually engulfed by some of the city's worst slums, a swarm of nearly 15,000 people. "The mud-colored

houses, pierced by a few windows, their frames worm-eaten, almost touched at the top, the roads were so narrow," as Sue wrote in *The Mysteries of Paris*. "Black foul alleys led to even blacker fouler stairways, so steep you could hardly climb them with a rope fixed to the damp walls...." By the time Haussmann was finished, three quarters of the island had been swept bare, the antiquated Hôtel Dieu hospital completely rebuilt, and a great open space lay before the doorway to the cathedral.

And all through the rest of the city, the building continued. At the height of the boom in the mid-sixties, an estimated 20 percent of all Parisian workers were engaged in construction. Haussmann himself figured the money spent on building between 1851 and 1869 at 2.5 trillion francs, roughly fifty times the city's annual budget. The Boulevard Raspail and the Rue de Rennes suddenly cut through the Left Bank. The Étoile grew from five intersecting avenues to twelve (hence the loss of Wagner's house). The Théâtre de Chatelet arose, Paris's largest, and the Church of Saint-Augustin, and the Parc Monceau.

Haussmann even decided at one point that the overcrowded graveyards of Père Lachaise and Montmartre should be superseded by a vast cemetery fifteen miles north of the city in the commune of Méry-sur-Oise. He secretly bought some 1,200 acres of land there. He even had his engineers draw up plans for a special railway that would link the main Parisian cemeteries with his palatial suburban mortuary. This was to be one of Haussmann's few failures, blocked partly by the revulsion expressed by Victor Hugo: "The expropriation of the living is being followed up by the expropriation of the dead and the deportation of corpses, centralized in a necropolis which will be the Botany Bay of deceased Parisians.... The owner of a well-kept hotel does not allow people to die in his house: Paris has become the hotel of the world; M. Haussmann cannot stop people dying there, but he does not want them to be buried there any more; that would discredit his establishment...."

It is easy enough to describe all of Haussmann's achievements in terms of growth and profits, but as we know from having lived through decades of highway building and "urban renewal," we never seem to get far beyond the accusation by the James Thurber lemming: "You keep cutting down elm trees to build insane asylums for people driven mad by the cutting down of elm trees." Even when the great builders have the best intentions—as with Robert Moses creating New York's parkways—and all the more so when they serve the forces of megalomania—as with

Albert Speer designing Hitler's version of a postwar Berlin—there is some inhuman element that almost inevitably comes to dominate every planned city. In Paris, thousands of working-class people were driven out of their traditional neighborhoods and forced to fend for themselves on the bleak outskirts of the city. Those boring rows of privately built luxury apartment houses that still line the boring avenue that was so appropriately named the Boulevard Haussmann are both a memorial and an accusation. Each one also represents a social portrait of the era: shops on the ground floor, manorial apartments overhead, unheated garrets for the servants under the eaves. Still, even in their stolid uniformity, there is a certain grandeur to them. They were built to make money and to honor money, and they still do.

One of the most remarkable aspects of the great building program was that Napoleon insisted from the beginning that it be carried out without any increase in local taxes. It thus had to be financed out of the existing city budget, or by asking funds from the national legislature (which generally rejected such requests), or by floating loans. Nearly half of Haussmann's first projects were financed by such loans ("It was as if I had put my foot in an ant's nest," the prefect recalled), which introduced a warm relationship between the builders and the men who had money. The most notable of these was James Rothschild, personal banker and friend of the imperial family, who had moved to Paris in 1812 and in due time controlled a treasure of more than 600 million francs, substantially more than his ten nearest rivals combined. It was a situation that inspired Heine to observe that "money is the God of our time and Rothschild is his prophet." The prophet had his own associates, however, and no survey of these could ever avoid the name of the Count de Morny, the emperor's illegitimate half-brother, collaborator of Offenbach, speculator in Mexican bonds, a man who was everywhere.

Hardly less important, though, were the Pereire brothers, Émile and Isaac, originally from Portugal, who first worked for Rothschild, then broke away and became bitter rivals. It was the Pereires who bought a quarter mile along the north side of the new Rue de Rivoli and built the arcades that still ornament the street to this day. They also built there the Hotel du Louvre, and the success of that inspired them to build the famous Grand Hotel, just across from the new opera, a hostelry that boasted of being able to seat 600 people at once in its sumptuous dining room. And when the Pereires opened a new palace

for themselves on the Rue Royale, awed guests noted that Émile Pereire stood happily in the gilded doorway and kept saying, "I know there is too much gilt."

In his hunger for borrowed capital, the emperor and a number of his top advisers found comfort in the writings of the Count Claude de Saint-Simon, who had advocated, long before the birth of John Maynard Keynes, deficit spending on public works during hard times. France had gone into a recession in 1847. Iron production dropped by a third, coal by a fifth, and the building of railroads came to a complete halt. The revolution the following year, which first brought Napoleon back from exile, was not by any means inspired solely by the personal shortcomings of King Louis Philippe. Public building on borrowed money provided thousands of jobs; it provided an economic stimulus; it also suited the Emperor's style.

How to borrow the billions to pay for it was purely a matter of technique, and the private bankers of Paris, the Rothschilds and their colleagues, were experts in such techniques. The first scheme, authorized by decree in February of 1852, organized the creation of the Sociétés de Crédit Foncier, which soon turned into one conglomerate Crédit Foncier. The government started it with an investment of 60 million francs and then sent it out to finance mortgages. The second scheme was the Pereires' Société du Crédit Mobilier, which was supposed to attract smaller investors but also attracted high government officials like Morny and Persigny. Between the two, these organizations could arrange to finance anything Haussmann wanted.

How to repay all the borrowing was more complicated. The official budget acquired in 1859 an adjunct fund for special projects, the Caisse des Travaux, which was authorized to issue bonds for 30 million francs, then 100 million, then 125 million. Building contractors were paid at the start of work in "bons de délégation," redeemable when the work was done, but they were allowed to sell off those bonds at discount in a growing bond market. Haussmann liked to justify his unorthodox practices by invoking the term "productive spending," by which he meant—again a man ahead of his time—that borrowed money could eventually be repaid out of the increased taxable value of the land for which it had been borrowed. This, as we know, is now considered a perfectly acceptable policy, though there have occasionally been people who describe it as voodoo economics.

Haussman himself seems to have been financially honest. He received, after all, a very handsome salary of 50,000 francs as prefect, plus 30,000 as a Senator (that sinecure for which Sainte-Beuve so prostrated himself), plus a budget of 230,000 for official entertaining, plus 25,000 for miscellaneous expenses, plus a free apartment in the Prefecture and a free house in the Bois de Boulogne, plus two official carriages, plus various odds and ends (the amount he spent on Francine Cellier, a singer at the opera, remains unrecorded). Such comforts enabled Haussmann to report in his memoirs several specific occasions when he declined large bribes. But men in situations of such power can rarely resist other corruptions, the need to control, the need to manipulate and dominate, the need to keep things secret. Official funds moved mysteriously in and out of various accounts until Finance Minister Achille Fould complained to the emperor in 1865 that "the city has no budget because neither its resources nor its needs can be exactly known."

Late in 1867, Jules Ferry, one of the leaders of the small but growing opposition in the legislature, began venting some of these financial extravagances in *Le Temps*. "1867!" he wrote. "Year of disenchantment for the country, of searchings of conscience for those in power..." Haussmann's new budget was not such a mystery as Fould claimed but rather "the balance sheet of his [Haussmann's] mistakes." And as Ferry's attacks continued, they became increasingly ferocious: "Haussmann lacks all sense of legality.... He breaks the law with abandon, you might say with coquetry." And again: "It goes higher and deeper than the finances of the capital; it lays bare all the dangers of personal power. The whole system is there, with its fundamental lack of foresight, its systematic irresponsibility, its supreme disdain for public opinion or the law...." Along with his rhetoric, Ferry assaulted Haussmann with something almost equally dangerous, a famous pun; he called his exposures *Les Comtes Fantastiques d'Haussmann*. Though he and all his readers knew that *Les Contes Fantastiques d'Hoffmann*° had been a huge hit at the Odéon in 1851, they could not know that Offenbach would seize on the tales of E. T. A. Hoffmann as his last work, his effort to transcend the world of operettas and achieve something more permanent. The composer never lived to hear it, but a year after his death in 1880, Jules

°"The Fantastic Accounts of Haussmann"; "The Fantastic Tales of Hoffmann."

Ferry, by then premier of the Third Republic, attended the opening night.

But 1867 really was not, as Ferry had written, a year of disenchantment, much less a year of searchings of conscience for those in power. On the contrary, it was a year of almost feverish extravagance and self-celebration. "Never did people amuse themselves more frenziedly," according to one contemporary chronicle, "or with such...violent gusts of uneasiness." The emperor had decided on an international exposition that was to be the greatest of its kind, the biggest, the richest, the most spectacular. Baron Haussmann, inevitably, was in charge.

<center>۞</center>

The former Lillie Greenough of Cambridge, Mass., was pretty and talented and married to the banker Charles Moulton, so she traveled in high society. When she complained to Baron Haussmann at one of the emperor's dinner parties that a new boulevard had destroyed her croquet court, Haussmann formally awarded her a small piece of the Bois de Boulogne on which to play the game. She and Prince Metternich tried to introduce croquet at Compiègne, but Napoleon and Eugénie, despite much cheating, showed little interest. The emperor liked to hear Mrs. Moulton sing, though, and recalling his days of exile in America, he asked for whatever she could remember of Stephen Foster. He was much moved by her rendition of "Massa's in de Cold, Cold Ground."

At another soirée, she sang Massenet songs with Jules Massenet as her accompanist, and that was how she met Franz Liszt, who, despite having taken orders as an *abbé* just two years earlier, eyed her ardently as he improvised at the piano. They went to the opera together and sat in the box reserved for Daniel Auber, head of the Conservatory. "The orchestra played Wagner's overture to *Tannhäuser*," she wrote home to her family. "The applause was not as enthusiastic as Liszt thought it ought to be, so he stood up in the box, and with his great hands clapped so violently that the whole audience turned toward him. He cried, 'Encore!' And the audience in chorus shouted, 'Encore!' And the orchestra repeated the whole overture. Then the audience turned again to Liszt and screamed, '*Vive Liszt!*' Auber said such a thing had never been seen or heard before...."

This was in June of the Exposition year, and music was everywhere.

At the Metternichs' ball, Mrs. Moulton reported home, "the walls were hung with lilac and pink satin, and the immense chandelier was one mass of candles and flowers," and when Napoleon and Eugénie entered the ballroom just after 11:00 P.M. Johann Strauss, specially brought from Vienna for the occasion, waved his baton to start the first Paris performance of his newest waltz, "The Blue Danube."

The Metternichs and Auber also took Mrs. Moulton to see one of the fads of the season, a musical phenomenon she identified only as Blind Tom. "An American Negro," she wrote, "he is blind and idiotic, but he has a most extraordinary intelligence for music.... Blind Tom has learned his repertoire entirely by ear; therefore it was very limited, as he could only remember what he had heard played a few days before. His memory did not last long."

Blind Tom could apparently mimic anything he heard, not only any piece of music but the style in which he had heard it played. When the impresario learned that Auber was in the audience, he publicly asked whether the composer could come up on stage and play something. The Metternichs urged Auber to challenge the freak by playing some fragment from his new opera, still unperformed and unknown. "Auber mounted the platform, amid the enthusiastic response of the audience, and performed his solo," Mrs. Moulton recalled. "Then Blind Tom sat down and played it after him so accurately, with the same staccato, old-fashioned touch of Auber, that no one could have told whether Auber was still at the piano...."

This seems to have nettled Prince Metternich, the Austrian ambassador, who also fancied himself a cultural emissary of some distinction. He decided that he was the one to expose the limits of Blind Tom's gifts. "Prince Metternich...[mounted] the stage," Mrs. Moulton continued, "rattled off one of his *own* fiery, dashing waltzes, which Blind Tom repeated in the prince's particular manner."

It was all too strange. The princely party went backstage to catch a closer glimpse of the blind man, perhaps even to question him on his peculiar gift. Backstage, though, there was no celebration. "We...found poor Tom banging his head against a wall," Mrs. Moulton wrote, "like the idiot that he was. Auber remarked, '*C'est humiliant pour nous autres.*'"°

°"'It's humiliating for the rest of us.'"

The only important picture of the Exposition of 1867 was painted by Manet, who, almost inevitably, had been excluded from any participation in it. His panoramic *View of the Universal Exposition* observes the scene, just as inevitably, from the outside. Painted in June of that year, when Renoir and Monet were also making their first experiments with cityscapes, it seems to adopt a vantage point on the hillside of the Trocadéro, across the Seine from the fairgrounds on the Champ-de-Mars, but the perspectives are so distorted in so many different ways that the vantage point really existed only inside Manet's head. Some critics have suggested once again that Manet was technically unable to paint what he saw; others have suggested reasons for each of the distortions. The most striking of these, in many ways, is that the Seine, which should occupy the middle ground, has been virtually abolished, so the figures in the foreground and the Exposition buildings in the background are simply pushed together. Hardly less striking, though, is the mysterious appearance in the upper-right-hand corner of the great balloon, Le Géant (the giant), built and operated by Manet's friend, the photographer Nadar. Le Géant was actually tear-shaped, but Manet has calmly changed its shape into that of a globe, a kind of ironic comment on the universality of the Exposition that it surveys.

The giant Exposition building, the Coliseum of Labor, had originally been planned as a globe, too, but when the authorities decided to build it on the rectangular Champ-de-Mars, that conveniently empty parade ground that had served as the site for the first national industrial exhibition back in 1798, a globe wouldn't fit. So the designers elongated it into an ellipse (1,608 feet by 1,266 feet), consisting of seven concentric galleries, all iron and concrete and glass; everything that could be painted was painted in chocolate and gold. The seven galleries increased in size from a modest palm garden with inspirational statues at the center to a mighty Gallery of Machines on the outside. This outside was all that an observer could see from the Trocadéro, but Manet offered other totems as well. Most notable among these were two rival lighthouses, the elegantly sheathed and conventionally gaslit Phare des Roches-Douvres and the shockingly skeletal and electrical British model ("their electric light which disgraces the Champ-de-Mars with its fleshless frame," as one scornful Parisian journalist wrote).

If the fairground on the Champ-de-Mars was a sort of battlefield, so

was the phantasmagorical Paris that Manet sketched in behind it. The Palace of Industry, which was holding the annual Salon that Manet had decided to boycott, should have appeared on the left side of his panorama, but he ignored it, abolished it. But to the Pont de l'Alma, near which Manet was staging a private show of his own paintings, he attributed a legendary importance, strengthening its pylons and giving it a special prominence. In the background, he did include the dome of the academicians' Institut de France, but he left it so faint as to be nearly invisible. "This discussion of the topography of Manet's panorama, with its inclusions, exclusions, exaggerations and diminutions, is not intended to impute to Manet an articulate programmatic intent," Patricia Mainardi somewhat slyly suggests in *Art and Politics of the Second Empire,* "but rather to suggest that 'seeing' is dependent as much on attitudes and expectations as on the topographical reality of the sight seen."

Even more enigmatic, though, are the figures in the foreground, no less than sixteen of them, and representing an extraordinary variety of Parisian characters, types, classes. None of them can be taking part in the distant exhibition, but some of them are markedly observing it, others just as markedly ignoring it. Critics of Manet's technique have naturally emphasized that the proportions and perspectives are often distorted, as though the various strolling figures were hardly part of the same scene at all, while others have emphasized that these figures are all meticulously arrayed on two shallow diagonal axes, like a great horizontal X imposed on the front of the fairground. But all technique aside, what a remarkable cast of characters they provide! One of the great axes starts on the lower left with a blue-shirted workman raking a flower bed, then proceeds upward through an elegantly bonneted woman on a horse, two urchins playing on the grass, two dandies looking out at the fair, and three uniformed Imperial Guards lounging off-duty, interested only in their own chatter. The other axis begins in the middle left with a group of four women, two in baggy working-class dress and two in high fashion, then proceeds downward past a pair of tourists ogling the balloon, intersects the other axis at the woman on horseback, and ends with the ubiquitous Léon Koëlla, his back to the fair, expensively outfitted in white trousers and a blazer as he walks a large dog on a leash. Having created this panorama of the Paris of 1867, Manet seems to have inexplicably left it not quite finished. It now hangs unsigned in the National Gallery in Oslo with an apparently uncompleted area along its left side. Not that

any such final touches could answer any of the obvious questions. Why has the Seine disappeared? Why do the two axes intersect at an isolated woman on a black horse? What are all these out-of-scale people doing on this battleground-above-the-battleground? Can the answers be seen from Nadar's balloon?

Baron Haussmann, of course, was concerned with more important things. Like whether enough new space could ever be found for the 52,000 different exhibitions, which seemed to keep increasing every day, and whether the new double-track railroad circling the Champ-de-Mars could get the mountains of equipment into place, and whether, in the process, it would ruin the park, and whether two windmills would provide enough auxiliary pumping power to keep water flowing from the new reservoir on the Trocadéro. And whether the March rains would ever end. On the official opening day, April 1, the emperor and empress led Haussmann and his engineers through the muddy wasteland, smiling with imperial optimism at the tarpaulins and packing crates. "The ceremony left a heart-rending impression," according to one contemporary chronicler, "like baptizing a sickly child which seems born only to die. No one had faith in it; neither the public, nor the exhibitors, nor the Imperial Committee."

Was it ever otherwise? Has an international commercial exhibition ever been finished on schedule? By the time the May sunshine reached Paris, the city was aswarm with tourists (the number of visitors would total 11 million by closing day in October), and they all wandered around with that familiar mixture of awe and suspicion, anxiety and delight. And each country sent to the Exposition the customary displays of national self-portraiture and national vanity. The Egyptians provided a Pharaonic temple with a row of sphinxes, the Swedes a log cabin, the Russians a reproduction of the imperial stables, complete with twenty imperial horses for Czar Alexander II to use during his visit. The Prussians displayed Krupp's largest cannon. The British installed, along with their controversial electric lighthouse, a supposedly typical "English cottage," a half-timbered and brick-chimneyed construction that contained a great deal of expensive pottery but included, as Parisian journalists skeptically observed, no cellar, no kitchen, no bedrooms, and no bathrooms. The palatial French pavilion, on the other hand, was described by one equally skeptical commentator as "deserving a place on the shores of the Bosphorus or in an oasis of the Yemen."

Orientalism seemed to be the prevailing theme—if there was really any theme other than French self-display—for European imperialism was still trying to assess its relationship with what Kipling would call "lesser breeds without the law." The enforced opening of Japan was still very new, as was the commercial subjugation of China, but many Europeans still retained a half-suppressed racial fear of the Emperor Suleiman at the gates of Vienna, a fear that could now be accepted only in displays of comic exoticism. The Bey of Tunis sent to the Paris Exposition a reproduction of the façade of the Bardo; crowds flocked to the Moorish café to nibble on couscous. There was, as always, a certain coarseness in these affairs, and some observers disapproved. "The exhibition is vulgar and speculative," one British official wrote to a friend, "a congeries of incongruous interests, of real individual usefulness and the lowest form of gratified curiosity. You see Lord Shaftesbury haranguing between the Chinese dancing girls and the great guns."

Flaubert was, for once, more tolerant. Deeply rutted in *L'Éducation Sentimentale,* he raised up his head for an invitation to a ball at the Tuileries Palace in June. "Their majesties wishing to take a look at me, as one of the most splendid curiosities of France, I am invited to spend the evening with them next Monday," he wrote jocularly to his niece, Caroline. But when it was over, he was rather slavishly grateful to Princess Mathilde: "The Tuileries ball stays in my memory as something from a fairy tale, a dream." Even to his new friend George Sand, he sounded uncharacteristically euphoric about the imperial atmosphere. "No joking whatever: it was splendid," he wrote. "Indeed the whole trend in Paris now is toward the colossal. Everything is becoming crazy and out of proportion. Perhaps we're returning to the ancient East. I keep expecting idols to come out of the ground. There's the threat of a Babylon. And why not?"

For Babylonian music, the imperial authorities turned to the seventy-five-year-old master, Rossini, who, though unable to finish an opera in the four decades since *William Tell,* did undertake an occasional assignment. In 1862, for example, Baron James de Rothschild asked him to write some ceremonial music to welcome the Emperor Napoleon to a hunt at the new Rothschild establishment, the Château de Ferrières. Rossini responded with a *"Choeur de chasseurs démocrates"* ("Chorus of Democratic Hunters"), scored for tenors, baritones, basses, two drums, and a tam-tam. Now, for the great exhibition, he produced an extrava-

gant "Hymn to Napoleon III and His Valiant People," which he inscribed as "Hymn (with accompaniment of large orchestra and military band) for baritone (solo), a pontiff; chorus of high priests, chorus of vivandières, of soldiers, and of people—dances, bells, side drums, and cannon." When it was performed on the occasion of Napoleon's handing out prizes and awards—when he also heard the first word of the Emperor Maximilian's execution in Mexico—800 instrumentalists and 400 choristers assembled to perform Rossini's hymn.

When Manet learned a few months before the Exposition that Count Nieuwerkerke was limiting the official art exhibit to painters who had previously won medals at the Salon, he angrily decided not to submit anything at all to that year's Salon. It was just as well. Though the official jury did accept paintings by Degas and Berthe Morisot, plus Fantin-Latour's admiring portrait of Manet, it rejected more than two-thirds of the 3,000 painters who offered their works, including Renoir, Cézanne, Pissarro, Sisley, and Monet—"all those," as Zola wrote, "who are taking the new road." A number of the rejected painters formally petitioned Nieuwerkerke to permit a new Salon des Refusés, but that, too, was refused.

Manet decided instead to take his own new road by building a private gallery all his own, on the Place de l'Alma, and exhibiting all his main works himself. This was not actually as unprecedented as it might seem. Jacques David had done much the same thing at the turn of the century as he worked his way from the court of Robespierre to that of Napoleon. So had Gustave Courbet, after his paintings had been rejected at the Exposition of 1855. Courbet, indeed, also built himself a new gallery on the Place de l'Alma, but the old radical was by now far gone in drink and self-admiration. He took no interest in his prospective neighbor. "I myself shouldn't like to meet this young man..." he said of Manet. "I should be obliged to tell him that I don't understand anything about his painting, and I don't want to be disagreeable to him."

About equally sympathetic was Manet's mother, who took this occasion to remind him not only that his paintings earned no money but that he was squandering his inheritance. In a little memorandum entitled "Note for my son Édouard," she specified that in the four years since his father's death, he had sold off a good share of the family land holdings in Gennevilliers and spent a total of 80,000 francs. "It is time, I think, to stop this ruinous slide," she declared. Manet was not to be deterred. "To

exhibit is for the artist the vital concern, the sine qua non," said the cata-
logue that he provided for this exhibition, "for it happens that after look-
ing at something, you become used to what was surprising.... To exhibit
is to find friends and allies for the struggle." Madame Manet sighed and
surrendered. She loaned Manet the money he needed for his exhibit,
which eventually amounted to a very burdensome 18,000 francs.

Manet rented a private garden on the northeast corner of the Avenue
Montaigne and the Avenue de l'Alma (now the Avenue Georges V) and
hired workmen to start building a wooden gallery about thirty feet wide.
Work began in February, to be completed on the opening day of the
Exposition, April 1, so that everybody strolling from the Champs-Élysées
to the Champ-de-Mars would have to pass by the Manet exhibition. But
the work did not get finished, shortages of this and shortages of that, not
enough time, and the rain kept falling—it was almost a parody of the
delays that were plaguing Haussmann and his engineers on the Champ-
de-Mars itself. Manet's outflowing construction funds were more limited.
To economize, he and Suzanne and Léon all moved in with the senior
Madame Manet in a new apartment she rented on the Rue Saint Peters-
bourg (now Rue Leningrad), just off the Place de Clichy.

When Manet's private gallery was finally finished and opened on May
24, only a month or so after the emperor's great Exposition, Manet put
on display there an absolutely stunning collection of his works, *Olympia*
and *Le Déjeuner sur l'herbe*, Victorine Meurent as a street singer, Vic-
torine as a matador, Victorine with a parrot, and the concert in the Tui-
leries, the absinthe drinker and the tragic actor and the Spanish singer. A
little sign announced that the admission was fifty centimes, and not
everyone bothered to pay that modest price.

Manet had declined Zola's offer to reprint his eulogies as the cata-
logue for the show. It would be in bad taste, he said. Instead, he pro-
duced an unsigned and rather modest manifesto, generally considered
to be the work of Zacharie Astruc but probably edited and revised by
Zola and Manet himself. "Since 1861 Manet has been exhibiting, or try-
ing to exhibit," the document announced. "This year he has decided to
show the sum total of his works directly to the public.... He has seen
himself rejected by the [Salon] jury too often not to think that, if an
artist's beginning is a struggle, at least one must fight with equal
weapons. That is to say one must be able also to exhibit what one has
done."

There followed then a brief statement of the official argument that the official juries accepted all works of real merit. "In these circumstances the artist has been advised to wait," Manet's catalogue continued. "To wait for what? Until there is no longer a jury? He has preferred to settle the question with the public. The artist does not say today, 'Come and see faultless work,' but 'Come and see sincere work.' This sincerity gives the work a character of protest, although the painter merely thought of rendering his impression. Manet has never wished to protest. It is rather against him who did not expect it that the people have protested…. He has merely tried to be himself and not someone else…."

To submit oneself to such public judgment can be very risky. What is the public, after all? The few hundred people—out of all the millions who constitute posterity—who might happen to wander into this odd exhibition on the Place de l'Alma? And how does such a public make its judgment? Does it really see what is hung up on the walls, or does it see primarily what it has been told to see, what it thinks it should see? Manet's friend Proust described the scene as a repetition of the worst uproars about *Olympia* at the Salon. "The public was pitiless," he wrote. "They laughed in front of these masterpieces. Husbands escorted their wives to the Pont de l'Alma. Wives brought their children. The entire world had to avail itself of this rare opportunity to shake with laughter…. The crowd gave the impression of enormous pumpkins laughing at the jokes of a melon at a convention of squashes. The press was unanimous or nearly unanimous in echoing them. Never at any time was seen a spectacle of such revolting injustice."

Proust seems to have been exaggerating and melodramatizing. So was Zola in his declaration that any official rejection of Manet "would be virtually murder," and that "he who was once defeated by the public cannot be refused his splendid revenge as a victor." The reality was that relatively few people came to Manet's exhibition, and few cared much about it. Periodicals like *La Gazette des Beaux-Arts* and *L'Artiste* never mentioned it; *L'Illustration* and *Le Monde Illustré* mentioned it but no more than that. It was in these circumstances that an exasperated Manet began reworking and reworking his apocalyptic vision of the death of the Emperor Maximilian, then fled with his family to the sanctuary of the beach at Boulogne. The ultimate judgment on Manet's exhibition, at which *Olympia* was offered for sale, *Le Déjeuner sur l'herbe,* the *Woman*

with a Parrot, Music in the Tuileries all offered for sale, was that not one of the fifty-three pictures on exhibition was sold.

<center>⊕⊛⊕</center>

"Too good! It is too good to be true!" Ludovic Halévy was thinking about the applause that welcomed the spectacular arrival of *The Grand Duchess of Gerolstein*. And it was true—that it was too good to be true. The second act featured yet another Offenbachian parody of Meyerbeer, and Parisian audiences were beginning to tire of such things. So was Offenbach himself. "Your second act...is extremely well worked out, but ...it absolutely lacks gaiety," he had complained to Halévy and his co-librettist, Henri Meilhac. But the rush toward opening night at the start of the Exposition had been so hectic that only in the restless darkness of the actual performance could the creators sense the spread of a faint chill. "Even great theater pundits were perplexed," Halévy wrote later. "Was it a big success? A middling success? A failure? Opinions were divided. Our friends didn't know what to say to us."

Offenbach knew what to say. Even as he watched the opening night, he began in his head to make what he liked to call, in his Germanic way, *"des bedides goupures"* (*des petites coupures*) some little cuts, then some revisions, and then some more little cuts. By the next morning, new sections were beginning to slide into place, and by the third night, a substantially altered score was already spinning forth. The waves of applause soon demonstrated that the Exposition of 1867 now had the music with which to celebrate itself. And everybody had to come and join in that celebration. The Emperor Napoleon paid his first visit on April 24 and applauded heartily—one may still wonder exactly what he was applauding: an absurd German army that spent most of its time drinking and dancing, or an obviously French lack of military style and determination?—and he returned a few days later with the Empress Eugénie, who applauded all the same absurdities, whatever they might be.

Czar Alexander II may indeed have worried that the Parisians were making fun of Catherine the Great, but his worries were such that he telegraphed from Cologne to have his ambassador in Paris reserve him a box at the Variétés on the night of his arrival, June 1. Once there, he could only join the rest of the audience in admiration of Hortense Schneider. Already in regular attendance at her pink-papered dressing

room was the Prince of Wales. "Poor dear Edward.... What a faithful and good Prince of Wales he was!" Hortense reminisced afterwards (she lived on to be a pious recluse until her death in 1930). "Did you know that he loved to walk my dogs in the Passage des Panoramas while I was on the stage?"

Passage des Panoramas! *"C'est le Passage des Princes,"** one malicious actress remarked. Indeed, there survive group pictures of more than thirty sovereigns who trooped to Paris for the Exposition that year, and trooped to the Variétés to pay homage to the Grand Duchess of Gerolstein: the emperors of France and Russia and the sultan of Turkey (the only reigning emperor who failed to meet Hortense Schneider was Franz Josef of Austria, who was in official mourning because of that unpleasantness about his younger brother in Mexico), and then the kings of Portugal, Belgium (welcomed by the Garde Municipale playing excerpts from Wagner's *Lohengrin*), Sweden, Bavaria (yes, that half-demented young Ludwig II who had just taken on the full sponsorship of Wagner, and who now came to inspect Viollet-le-Duc's fake-Gothic château at Pierrefonds, near Compiègne, so that he could gain inspiration for the fantasy castles where he could reign as the swan king over his protégé's productions of the *Ring of the Nibelungen*).

And then, as the representatives of reality, there came King William I of Prussia, together with Crown Prince Frederick and Chancellor Bismarck and the army chief of staff, Count Helmuth von Moltke. They had journeyed to Paris partly to join Napoleon's great parade at Longchamps on June 6, when some 30,000 French troops were put on display before the visiting sovereigns—row upon row of mounted lancers with their fluttering pennons, more rows of Chasseurs in green, Zouaves in bright red. They were all insufficient, though, to safeguard the carriage bearing Napoleon and the Czar when a Polish nationalist rode up and fired several wild pistol shots at the Czar. "Now we have been under fire together," Napoleon said with characteristic nonchalance. The Czar shuddered. Some years later, a terrorist bomb would tear him to pieces.

After this extraordinary demonstration of French power and French vulnerability—"Everyone is afraid without really knowing why," Prosper Mérimée said of this whole period—Bismarck put aside his gleaming white cuirassier's uniform and went with General von Moltke to inspect

*"It's the Passage of Princes."

The Grand Duchess of Gerolstein. It apparently delighted him to see that the farcical principality of Gerolstein—so obviously modeled on those Badens and Saxonies that he was determined to subordinate to Prussian leadership—was ruled by a susceptible woman who spent her time singing *"Ah! Que que j'aime les militaires!"* It is a little hard to imagine Bismarck confiding his views to Moltke in French, but by all accounts, he leaned over the taut commander who would soon march on Paris and said of the ridiculous court of Gerolstein, *"C'est tout à fait ça."**

But what did Bismarck actually see on the stage of the Variétés? And was it the same as what Napoleon and Eugénie had seen? And what did Czar Alexander see, and the Prince of Wales, and the khedive of Egypt? For that matter, what did Halévy and Offenbach see? It is always a little dangerous to try to interpret satire and farce, and Offenbach's operettas are so absurd that they particularly resist interpretation. Gerolstein could be either Germany or France, could be the whole idea of militarism, of war, but when Offenbach was making fun of that, what was he really saying? It was an easy joke for General Boum to boast of his ignorance as to what the impending war was about, just so long as there could be a war, but did anything improve when the Grand Duchess promoted Fritz to the high command and sent him off to battle largely because she was nervous about his romantic feelings? *"J'ai mes nerfs, mes nerfs,"* she sings, and the others all cheerfully join in this all too realistic justification for combat, *"Elle a ses nerfs! Elle a ses nerfs!"†*

Fritz's boastful account of how he will wage war has also become rather painfully familiar in Pentagon pronouncements: *"Je serai vainqueur,/Grâce à ma valeur!/Mon artillerie/Ma cavallerie,/Mon infanterie..."‡* And so on. Not only does Fritz timelessly list his superiorities but he no less proudly announces how he will use them: *"Nous brûlérons tout,/Pillerons partout ..."§* The Offenbachian wit, bizarre as it is, consists in General Boum and several anti-Fritzian conspirators inverting the same verses to describe Fritz's ruin and defeat. Thus it will be the enemy who *"brûleront tout/Pilleront partout..."*

*"That's just the way it is."
†"I have my nerves, my nerves." "She has her nerves! She has her nerves!"
‡"I'll be the winner,/Because of my valor!/My artillery,/My cavalry,/My infantry."
§"We will burn everything/We will plunder everything."

War does not really lend itself very well to humor; only those far from the battlefront enjoy making fun of it. But if war as waged by Fritz is a satire—he eventually wins the four-day conflict simply by getting the enemy drunk, so that in the end "no one was killed"—what is one to make of the fact that the operetta ends with Fritz marrying his peasant fiancée, the Grand Duchess accepting a dim-witted prince as her husband, and General Boum once again regaining his command? In terms of Offenbach's universe, the Grand Duchess sums up everything when she says of her prospective marriage: *"Quand on n'a pas ce que l'on aime, il faut/aimer ce que l'on a."**

True enough, but was it simply this that made Napoleon and Eugénie smile and applaud? And if so, what did Bismarck see that made him smile?

*"When you can't have what you love, you must love what you have."

• 5 •

NANA

*"Men!" she answered. And pushing him away with a languid
gesture, she added, "You're all villains!"*
—FLAUBERT, MADAME BOVARY

The very first song that Helen of Troy sings in Offenbach's *La Belle
Hélène* is an appeal to Venus for an explosion of love: *"Il nous faut de
l'amour, nous voulons de l'amour./Les temps sont plat et fades./Plus
d'amour! Plus de passion!"*° And in her very first dialogue with the high
priest Calchas, Helen explains more exactly what she has in mind. She
has already heard that Venus has promised the princely "shepherd" who
judged her the most beautiful of all the goddesses that he would win the
love of the most beautiful woman in the world, whom Helen knows to be
herself. "The hand of fatality weighs upon me," she sighs, hopefully. That
is a very good excuse, the high priest encourages her. Helen suggests an
even better excuse, the legend that her birth resulted from the seduction
of her mother, Leda, by Zeus appearing in the form of a swan. "I, the
daughter of a bird, can I be anything but a *cocotte?*" Helen wonders.
Prince Orestes then comes dancing in to sing of his own predilection for
cocottes. "It's with these ladies that Orestes/Makes Papa's money dance
away./Papa doesn't mind at all/Because it's Greece that's going to pay."

France's kings and aristocrats had a long tradition of enjoying them-
selves—Louis XV maintained what was practically a private bordello at
Versailles—but Napoleon III was something of a populist, an elected
chief of state. His reign, a period of great commercial expansion, marked

°"We must have love, we want love./The times are flat and dull./No more love! No more passion!"

not only the apotheosis of paid sex, but the spread of that activity throughout the conventionally respectable bourgeoisie. There were an estimated 40,000 prostitutes in Paris, far more than in any other European capital, but that was hardly more than a guess, for who could estimate all the singers and seamstresses who might be bought? It all seemed rather exciting and romantic, though the realities of the system were often grim. And so Offenbach's idea of the queen as *cocotte*—or, more diplomatically, the *cocotte* as queen—epitomizes the spirit of Paris under the empire, an era in which all women seemed to be for sale, along with everything else, and Papa didn't mind because it was Greece that would pay.

The satisfaction of the imperial libido had by now become an engineering problem worthy of Baron Haussmann's technicians. "When a woman is brought into the Tuileries," the Goncourt brothers recorded in their journal, "she is undressed in one room, then goes nude to another room where the emperor, also nude, awaits her. [An attendant] gives her the following instructions: You may kiss His Majesty on any part of his person except the face."

Though the supply of willing women seemed unlimited, Napoleon was captivated during the mid-sixties by a curly-haired blonde named Marguerite Bellanger, who had been brought to an imperial hunt at Saint-Cloud by one of the young army officers with whom she was keeping company. Originally Justine Leboeuf, a name that lent itself to unfortunate puns, Marguerite Bellanger was rather different from the ladies at court. She had been a hotel chambermaid in Boulogne, then ran off to join the circus, became an acrobat and a bareback rider. It was said that she could do all kinds of things while standing on her hands, and it was this skill that particularly aroused the jaded appetites of the emperor. He bought her a house on the Rue des Vignes in Passy.

Empress Eugénie had learned to tolerate the moral standards of Offenbach's operettas, but there were limits. "The emperor and the empress are hardly on speaking terms," the British ambassador reported to London. "She taxes him with his present liaison to his face—calling the lady the scum of the earth." When her denunciations had no effect, Eugénie departed for a rest cure at a spa in Germany, but this only enabled Napoleon to take Marguerite for his own rest cure at the resort of Vichy. When they were all reunited in the capital, Eugénie decided to take more direct action. Accompanied by a court lawyer named Amédée

Mocquard, she drove in her brougham to Marguerite's establishment in Passy and accused her of ruining the emperor's health. "*Mademoiselle,* you are killing the emperor," she declared. "This must stop. I command you to leave. Off you go. Leave this house..." Perhaps some pliant marquise would be overwhelmed by the imperial wrath, but the former circus bareback rider was less impressed. "Your husband comes here because you bore him and weary him," she retorted. "If you want him not to come here, keep him at home with your charm, your amiability, your good humor and gentleness."

The lawyer Mocquard was so horrified by this extraordinary exchange that he fled out into a corridor, and so we do not know the rest of the dialogue in the salon. The cowering attorney heard only angry voices, which then died down. When he finally crept back into the salon, he was astonished to find the two antagonists sitting next to each other on a sofa and reminiscing like old friends. They shortly embraced and parted, and the emperor continued his imperial practices, until, in the spring of 1866, he met the Countess Louise de Mercy-Argenteau, presented her with a bunch of violets, and told her, "From now on, you are our empress." Marguerite the bareback rider was pensioned off with a Prussian husband and a house in the country.

Manet's most characteristic painting of this kind of Parisian woman was the portrait that he named *Nana* (1877). He seems to have been inspired not by Zola's novel of the same name, which appeared only in 1879, two years after the painting, but rather by the first appearance of this same girl in Zola's *L'Assommoir* (1876). (Manet is known to have sent a friend a copy autographed by the author.) As the daughter of the alcoholic Coupeau and Gervaise, the young Anna is already doomed by Zola's determinism to a life of destructive sensuality, but she is still young and full of possibilities. "Since the morning, she had spent hours in her chemise before the bit of looking glass hanging above the bureau..." Zola wrote. "She had the fragrance of youth, the bare skin of child and of woman."

Manet literally took that as his scene, but he also created a Nana of his own by painting the portrait of an actress of the day, Henriette Hauser. Manet had met her at the Café Tortoni when she had starred in various operettas, but now that she was aging, perhaps twenty-seven, she was best known as the mistress of the Prince of Orange, who asserted his proprietorship by naming her "Citron," or Lemon. She seems to have

been a jolly creature, plump and red-haired, and with no sign of any interest in anything but having a good time. It is primarily the top hat and tuxedo of her bewhiskered visitor that makes her seem so undressed, for the center of the picture is actually her blue corset, that and the lacy white petticoat that curves across a callipygous bottom. She also wears figured white stockings and high-heeled brown shoes as she powders her nose in front of a tall mirror.

The contrast between Nana's luscious youth and the wintry age of her dwarfish admirer, who is cut in half by the right edge of the painting, inspired Manet to a mocking set of parallels in his design. The old man's black top hat on the right is balanced by a vividly green flower pot on the left, his crooked black trouser leg on the right by a blue petticoat casually thrown across a chair on the left. And, of course, his wearily vacant gaze into thin air by her flirtatious look directly out at the viewer. Even the scholarly cataloguer of the great Manet exhibition of 1983, Françoise Cachin, is moved to attempt a description of that look: "'How can men be so stupid!' she seems to say."

To a modern eye, Manet's *Nana* seems an innocuously lighthearted picture, far better than the portrait of the opera singer Jean-Baptiste Fauré, which Manet submitted with *Nana* to the jury for the Salon of 1877. This Fauré portrait illustrates once again Manet's odd practice of creating troubles for himself. The baritone had been one of Manet's most loyal patrons and had commissioned this portrait of himself starring in Ambroise Thomas's opera version of *Hamlet*. After posing several times, the singer went on tour and was dismayed to discover on his return that Manet had repainted his legs, in tights, from some model he had found. Fauré protested that the model's legs did not look like his. Manet insisted that the model's legs were handsomer than Fauré's, and he refused to change them. Fauré thereupon refused to buy the painting that he had commissioned. The Salon jury promptly accepted the Fauré portrait, but as for *Nana,* though fifteen years had passed since the uproar over *Olympia,* she, too, was rejected as indecent.

Scorned once again by the official Salon, Manet once again tried to take his case to the public, and to exhibit *Nana* in the window of the Giroux shop on the Boulevard des Capucines. "From morning to night, crowds gather before this canvas," J. K. Huysmans wrote in *L'Artiste,* "and…it draws screams of indignation and derision from a mob stultified by the daubs that the Cabanels, Bouguereaus, Toulmouches, and the

rest see fit to hang on the line [of the Salon] in the spring of each year." After an extended description of the picture, Huysmans went on to declare: "Manet is absolutely right to give us in his Nana a perfect speci-men of the type of girl his friend and our *cher maître,* Émile Zola, will depict for us in a forthcoming novel."

While Henriette Hauser was the physical model for *Nana,* Manet also relied on another woman for his mental image of this whole female type. She was a buoyant spirit named Anne-Rose Louviot, who called herself Méry Laurent. She, too, had once starred in Offenbach's *La Belle Hélène,* but that was not her métier. She was, as John Richardson has written, "an indifferent actress but a courtesan of genius...[who] man-aged to have liaisons with many of the richest, most attractive and bril-liant men of the time."

She was not supremely beautiful, if Manet's ten or more portraits of her can be believed (but can Manet's portraits ever be believed?). Her nose was long, her chin a little heavy, and her fondness for short hair only emphasized her rather stolid features. But painters sometimes have difficulties in capturing vitality, gaiety, charm, and Méry Laurent had those qualities in abundance. One admirer said she had "the smile of a prize baby." She captivated Stéphane Mallarmé, who teasingly called her "peacock" and wrote adoring poems in her honor:

> *Ouverte au rire qui l'arrose*
> *Telle sans que rien d'amer y*
> *Séjourne, une embaumante rose*
> *Du jardin royal est Méry.*°

One of her many lovers in later life was Reynaldo Hahn, the opera composer, who introduced her to Marcel Proust, and so she became one of several models for Odette Swann. Proust, too, seemed disturbed by her unorthodox appearance. "Her profile was too sharp, her skin too del-icate, her cheekbones too prominent, her features too tightly drawn," Proust wrote of Odette. "Her eyes were fine, but so large that they seemed to be bending beneath their own weight, strained the rest of her

°The clever rhyme in the second line makes this particularly difficult to translate, but one version goes: "Unto the laughing rain unclose—/No bitterness can therein be/Retained—for such a fra-grant rose/In royal garden is Méry."

face and always made her appear unwell or in an ill humor. Some time after this introduction at the theater she had written to ask Swann whether she might see his collections, which would interest her so much, 'an ignorant woman with a taste for beautiful things.'"

Méry Laurent, similarly, wanted to visit Manet's studio (she lived not far away in the Rue de Rome), and so when he was rejected by the official jury for the Salon of 1876, and when he characteristically decided to stage a private showing of what he called "his canvases rejected by the jury of 1876," notably the appealing domestic scene called *The Laundress,* one of the admirers who promptly appeared at his atelier was Méry Laurent, comfortably established on the arm of one of her protectors.

"But this is wonderful," one of Manet's more imaginative biographers quotes her as saying in the doorway.

"Who are you, Madame," the charmed Manet inquired, "to find good what everyone finds bad?"

Who indeed? She was one of those girls from the provinces—Nancy, in this case—who, after a brief marriage to a local youth, repeatedly turn up on the Paris stage. She was playing one of those thinly veiled goddesses at the Châtelet when she caught the eye of none other than Marshal François Canrobert, who was already nearing sixty but had many heroic tales to tell. He had fought through the Carlist wars in Spain, fought the Kabyles in Algeria, fought the Russians in Crimea (wounded twice at Sevastopol), fought the Austrians at Magenta and Solferino. He had been in all those places for which Baron Haussmann kept naming new boulevards, so when a goddess at the Châtelet impressed him, he was in a position to be helpful.

Introduced to higher social circles, Méry Laurent duly caught the eye of Dr. Thomas Evans, that Philadelphia dentist who had become such a good friend of Empress Eugénie. Dr. Evans was respectably married, of course, but this was Paris, not Philadelphia, and Dr. Evans felt inspired to pay Méry Laurent 50,000 francs a year in return for her friendship. The relationship was never intended to be monogamous, however. Méry enjoyed the company of artists, and she never expected them to pay the way Dr. Evans paid. When somebody wondered why she didn't leave the dentist, she said with a laugh, "That would be a nasty thing to do. I'm quite content just to deceive him."

She liked Manet's *Laundress* the moment she saw it, and he liked

her for liking it. "There are some women who know, who see, who understand," he said later. But their affection was not just flattery on one side and vanity on the other. They really enjoyed each other, this cool observer and this warm *cocotte,* and while George Moore made the inevitable suggestion that they had an affair, the relationship seems to have been both more abstract and more intimate than that. "She consented to let me do her portrait," Antonin Proust recalled Manet saying. "I went to talk to her about that yesterday. She has had Worth make her a pelisse. Ah! what a pelisse, my friend, a tawny brown with old-gold lining. I was stunned. And as I was admiring the pelisse and asking her to pose, Elisa [her maid] entered to announce Prince Richard de Metternich. She did not receive him. I was grateful. Oh, these intruders. I left Méry Laurent saying, 'When the pelisse is worn out, let me have it.' She has promised it to me. It will make a splendid backdrop for some things I have in mind."

Since Manet and Méry lived just around the corner from each other, it was easy enough for Manet to pause outside her window, and for Méry to signal with her handkerchief if she wanted to see him. So it happened one evening that Dr. Evans, who may well have bought Méry her new pelisse, bade her good night. She wasn't feeling well, she said, too tired to go out, and he offered no objection to the traditional dismissal. Then she went to the window and left her signal for Manet, who soon saw it and came calling. Wouldn't he like to take her out, she wondered. Why, of course. They were just descending the stairway (Méry in her pelisse?) when who should arrive and proprietarily let himself in at the door but the distinguished Dr. Evans? Ah, feeling better, my dear? Going out for a bit after all, my dear? The dentist apparently sulked for three days thereafter, but sulking did him no good. Méry Laurent followed her own rules, and Dr. Evans knew them as well as anyone.

But if Dr. Evans bought her the pelisse, it was Manet who painted her in it. Antonin Proust, by now an increasingly important government official, commissioned Manet in 1881 to do a series of female portraits to represent the four seasons. He began, typically enough, with a beautiful young actress named Jeanne Demarsy as Spring, Spring walking through the garden in a lacy white dress, Spring with pink and white flowers in her hat and a white parasol on her shoulder. But Manet's mood was autumnal now—his health was already crumbling—and so he turned to Méry Laurent as Autumn, Méry in her brown pelisse. He posed her not

against any yellowing autumn foliage but, on the contrary, against a bright blue Japanese robe/wall covering, speckled with chrysanthemums, which Manet had borrowed from Proust. It is, in a sense, a study in blues, the watery blue of the flowered Japanese robe, the blue of the diamond-encircled sapphire at Méry's ear, the blue of her wise eyes. The only thing autumnal, in fact, is the sadness of Méry's expression, and the sadness with which Manet painted it.

<center>☙❧</center>

To call a painting *Nana,* though, was to weight it with a heavy load of implications, for Zola's famous heroine embodied all his dark theories of preordained sin. Not sin in a religious sense but in the hyper-Darwinian sense that Zola and his contemporaries liked to consider scientific. Nana's good-hearted mother, Gervaise, had been beaten by her drunken father, and had gotten pregnant by a scoundrel named Lantier, so although she did marry the amiable roofer Coupeau before giving birth to Nana, she inevitably infected her baby with all of Zola's favorite inherited curses: sensuality, alcoholism, and violence. Nana's very birth was a scene of degradation. When Gervaise began to feel the labor pains, she tried to fend them off by cooking some mutton cutlets for Coupeau's dinner, then by setting the dinner table. "She had to put the bottle of wine down again quick; she couldn't get to the bed in time, but collapsed onto a mat on the floor. And there it was that her baby was born. The midwife delivered her when she arrived a quarter of an hour later."

And it was the sinful child, of course, who set her hardworking parents on the road to ruin. The roofer was accustomed to taking risks as he worked on the heights, but his daughter's cries interrupted his work. "'Daddy, Daddy!' she yelled at the top of her voice. 'Daddy, look at me!' He went to lean forward, but his foot slipped. Suddenly, stupidly, like a cat whose feet have got mixed up, he slid down the gentle slope of the roof and couldn't stop. 'Christ!' he muttered in a choking voice. Then he fell. His body came down in a sagging curve, turned over twice and flopped into the middle of the road with the dull thud of a bundle of washing dropped from a great height...."

Gervaise nurses Coupeau back to health, but he remains psychologically crippled. He cannot bring himself to climb any more roofs, takes to drinking instead, and Nana grows up wild. "Nana reigned supreme over this crowd of brats [the children of the slum apartment house]...." Zola

scolds. "The little hussy was forever suggesting playing mother, undressing the little ones and dressing them up again, and she insisted on examining the others everywhere, playing about with their bodies with the tyranny and inventiveness of a grown-up with a dirty mind...." And when Gervaise inevitably joins in the drinking, and inevitably gets seduced by the persistent Lantier, Nana is watching as her illicitly reunited parents tiptoe past the unconscious and vomit-covered body of Coupeau and into the bedroom. "The child's vicious eyes, staring wide," Zola tells us, "were lit up with a lubricious curiosity."

Coupeau eventually dies in an alcoholic delirium, and the equally alcoholic Gervaise starves to death, but Nana, because of her beauty, has a glittering future ahead of her. "At fifteen she had shot up like a beanstalk, had a lovely white skin, and had filled out and was as plump as a pincushion," Zola reports, leaving that whole future to the imagination. "Yes, that's how she was at fifteen, fully developed and no corset, with a real magpie face, milky complexion and skin as velvety as a peach, a saucy little nose and rosebud lips.... A mass of fair hair like ripe oats seemed to frame her forehead in a cloud of gold dust, a reddish gold crowning her with sunshine...."

It is quite possible, as scholarly admirers of Manet's work like to argue, that just as the painter derived his inspiration from Zola's *L'Assommoir,* Manet's portrait of Nana inspired the novelist, in turn, to a clearer image of his own heroine in the new novel that he named after her. After her triumphant opening at the Théâtre des Variétés as Venus in an operetta that sounds remarkably like something by Offenbach, Zola introduces us into her boudoir as she receives the stuffy Count Muffat de Beuville. The room "was hung with some light-colored fabric and contained a cheval glass framed in inlaid wood, a lounge chair and some others with arms and blue satin upholsteries...." It is exactly Manet's scene. The chief difference is that while Manet's top-hatted admirer sits in docile attendance, Zola's Count Muffat has the effrontery to ask that Nana devote some of her new income not to paying off debts but to aiding the poor people of the neighborhood. Which she characteristically does.

Nana is, of course, a type—Nana, Nini, and Niniche were among the most popular names chosen by actresses of the period—but Zola was an assiduous interviewer and note-taker. He not only haunted the operetta theaters on his own but interrogated more worldly colleagues like

Ludovic Halévy on how things really worked. He used several of *les grandes horizontales* as models for Nana, and he was particularly inspired by the spectacular career of a Russian-Jewish girl of the streets named Theresa Lachmann, who was to become famous as La Païva. Dark and seductive, she soon escaped from the streets to the dance halls, and there she attracted the attention of Henri Herz, a skilled and popular pianist, who also manufactured pianos and composed scores of rondos, nocturnes, potpourris, and other salon pieces ("What more does he want than to amuse and become rich?" Robert Schumann wondered). Theresa Lachmann's affair with Herz introduced her to a higher level of bohemia, but when Herz went off to tour America ("We should rather compare his execution to the most delicate flower work which the frost fairies draw upon the window pane in their frolicsome hours of winter moonlight..." the *New York Tribune* gushed), he left her to fend for herself.

She was so successful in doing so—"she lived in grand style," according to one chronicle, "and associated with a slightly disreputable clique of magnates, German millionaires, and English lords"—that when she encountered an impoverished Portuguese nobleman named the Marquis de Païva-Aranjo, she decided to marry him, pay off his debts, then divorce him and establish herself as a free and independent marquise, henceforth known as La Païva. This was a bit scabrous for even the hallucinatory aristocracy of the Second Empire, and La Païva was angry that nobody ever invited her to the Tuileries palace. She made up for that by attaching herself to a German mining millionaire named Count Guido Henckel von Donnersmarck, who, if he couldn't introduce her to the Empress Eugénie, could at least spend a good share of his fortune on her.

When the Prussians conquered and occupied Paris, all the mansions on the Champs-Élysées were shut down except for that of La Païva (which still stands at No. 25). There Prussian officers could find an oasis of hospitality. After the military unpleasantnesses were finally settled, La Païva finally married her Count Henckel von Donnersmarck and took him to a gala performance of Offenbach's *La Périchole*. There was so much hissing at her appearance that she decided to leave the theater early. This might have seemed a defeat, but La Païva was not someone who accepted defeat. From Berlin came an official protest about the discourtesy shown to the Count and Countess Henckel von Donnersmarck,

and so the president of the Third Republic, Adolphe Thiers, offered formal recompense by inviting the offended couple to a presidential dinner.

Note how the years seem to blur the social distinctions between the empire and the following Third Republic (everything remained for sale). Manet's and Zola's *Nana* were both created in the late 1870s, when Napoleon was long dead, and yet Zola makes a point of referring to the Exposition of 1867, as though to emphasize to the censors who still reigned over the world of letters that Nana was a creature of the wicked empire, not of the virtuous republic. One character says he has just been to the Champ-de-Mars and inspected the "infinite confusion" of the still-unopened Exposition. "Things will be ready," another character responds. "The emperor wishes it."

Looking back over the decade, both Manet and Zola may have believed that there was indeed something unique about the *cocottes* of the imperial age. Antonin Proust recalled the painter touching on this—and a number of other things, in a number of nonsequiturs—when the two of them were walking on the Champs-Élysées with another friend, Arsène Houssaye, former director of the Comédie Française. "The conversation came around to women and the women of the Empire..." Proust recalled. "'Yes,' said Manet, 'the woman of the Second Empire was the type for an epoch, just as Père Bertin had been the type for the bourgeoisie of 1830. What a masterpiece that portrait of Père Bertin is.'

"'Yes,' said Houssaye, 'but dry.'

"'Dry! Dry! Go on! Ingres chose Père Bertin to stylize an epoch. He made him the Buddha of the bourgeoisie, the wealthy, sated, triumphant bourgeoisie. The people who destroy that will be Vandals. You were speaking of women. I have not done the woman of the Second Empire but the woman of the time since then.... I don't have the pretension to sum up an epoch, but I do have the ambition to paint an extraordinary type....'"

Zola shared that ambition, and his Nana was nothing if not an extraordinary type. Attempting to describe her debut as the star of the Offenbachian *Blonde Venus,* Zola became quite breathless. "A shiver went round the house," he wrote. "Nana was naked, flaunting her nakedness with a cool audacity, sure of the sovereign power of her flesh. She was wearing nothing but a veil of gauze; and her round shoulders, her Amazon breasts, the rosy points of which stood up as stiff and straight as spears, her broad hips, which swayed to and fro voluptuously, her

thighs—the thighs of a buxom blonde—her whole body, could be divined, indeed clearly discerned, in all its foamlike whiteness, beneath the filmy fabric. This was Venus rising from the waves, with no veil save her tresses.... There was no applause. Nobody laughed any more. The men's faces were tense and serious...."

This may seem somewhat extravagant for a scene of mere voyeurism, but Zola, who has hitherto portrayed Nana simply as a lighthearted girl, appears to regard her sexuality as something threatening, even malevolent. "A wind seemed to have passed over the audience," he writes, "a soft wind laden with hidden menace. All of a sudden, in the good-natured child the woman stood revealed, a disturbing woman with all the impulsive madness of her sex, opening the gates of the unknown world of desire. Nana was still smiling, but with the deadly smile of a man-eater." Yes, *"mangeuse d'hommes"* is Zola's oddly frightened phrase in the original.

Nana realizes perfectly well that she is part of a venerable tradition. Once she has conquered the theatrical world and picked up a millionaire named Steiner, she takes a coachload of her new friends to visit a great château owned by an octogenarian courtesan of the first Napoleonic era. "And the stunning tales about her! Dirty doings and money flung about...." The retired courtesan's private park is so vast that Nana's coachman has a hard time finding the château. "Suddenly the path gave a final turn, the wall ended, and as they came out on the village square, the mansion house stood before them, on the farther side of its grand outer court. All stopped to admire the proud sweep of the wide steps, the twenty front windows, the arrangement of the three wings.... Henry IV had inhabited this historic mansion, and his room, with its great bed hung with Genoa velvet, was still preserved there. Breathless with admiration, Nana gave a little childish sigh. 'Great God!' she whispered very quietly to herself."

Just then, Nana and her friends see the aged courtesan emerge from the village church. "Vespers were just over, and *Madame* stood for a moment in the church porch. She was dressed in a dark brown silk, and looked very simple and very tall, her venerable face reminding one of some old marquise who had survived the horrors of the Great Revolution.... Very slowly, she crossed the square, followed at some fifteen paces by a footman in livery. The church was emptying, and all the inhabitants of Chamont bowed before her with deep respect.... 'That's

where one gets when one is methodical!' said Mignon."

Nana, however, is not methodical. She just enjoys herself. She delights in squandering her lovers' money. She buys houses, furniture, jewelry, flowers, whatever pleases her. The stodgy Count Muffat, who originally came to ask her for a donation to charity, has by now become her slave. And Zola is constantly frowning and scolding as he observes his creations. It is not clear whether he really disapproved, or whether he was just kowtowing to the censors, or whether he secretly yearned for Nana. "One of Nana's pleasures consisted of undressing herself in front of the mirror on her wardrobe door..." he wrote. "She would take off all her clothes and then stand perfectly naked, gazing at her reflection and oblivious of everything around her. A passion for her own body, an ecstatic admiration of her satin skin and the supple lines of her figure, would keep her serious, attentive, and absorbed in the love of herself."

On this particular occasion of self-adoration, Nana has given Count Muffat a copy of *Le Figaro* to read, because it contains a solemn article about her, or rather about someone whom the newspaper's essayist describes as "a girl descended from four or five generations of drunkards, her blood tainted by a long inheritance of misery and drink, which in her case had taken the form of a nervous exaggeration of the sexual instinct." In this Darwinian scenario, Nana is "a dung-heap plant" who is destined to "avenge the beggars and outcasts of whom she is the product." Her "rottenness" will rot the aristocracy. "She becomes a blind force of nature, a ferment of destruction, unwittingly corrupting and disorganizing all Paris, churning it between her snow-white thighs as milk is churned by housewives."

When Muffat finishes reading this Jeremiad, the naked Nana asks him: "Well?" Muffat cannot answer. "Muffat sat looking at her. She frightened him. The newspaper had dropped from his hands. For a moment he saw her as she was, and he despised himself. Yes, it was just that; she had corrupted his life, he already felt himself tainted to his very marrow...."

If Zola had accepted the rules of modern romances, Nana would have sailed on from triumph to ecstasy, but he was obsessed by ruin and decay. Nana repeatedly defies the rules, courts disaster. She breaks off from Count Muffat and takes up with an actor named Fontan, who periodically beats her. He doesn't even support her, so she starts going out as a call girl. When there are no assignments, she and her friend Satin

become streetwalkers. "Eventually they always returned to the main boulevards, for it was there they had the best luck. From the heights of Montmartre to the Observatory plateau, they scoured the whole city, on rainy evenings, when their boots got worn down, and on hot evenings when their underwear clung to their skins. There were long waits and endless walking; there were jostlings and quarrels, and the brutal caresses of a passerby taken to a miserable furnished room...."

Unlike some Romantics who liked to portray prostitutes as bold sensualists who enjoyed their trade, or as rebels who had liberated themselves from conventional respectability (e.g., *La Dame aux Camélias* and *La Traviata*)—Zola saw clearly that most prostitutes live lives of boredom, squalor, violence, and degradation. And with good reason, they generally come to detest men. Nana had encountered admiring lesbians during the course of her decline, but she at first rejected them. When her partner Satin starts to make overtures, Nana no longer objects. They take a room in a grubby hotel, but just as they are beginning their liaison, the police raid the place, searching for women whom they can compel to register as licensed prostitutes. While Satin docilely leaves to take part in this long charade of "vice squads" attempting the regulation of sex, Nana characteristically climbs out the window and hides on the roof until the police depart.

From that nadir, Nana is rescued by the reappearance of the obsessed Count Muffat, who now offers her a town house near Baron Haussmann's new Parc Monceau if she will only promise to make herself available for him alone. Still *débrouillarde,* she laughs at him. "As to money, my poor pet, I can get that whenever I want to, but I trample on it, I spit on it!" What she really wants, she admits, without admitting that this is also a matter of money, is the title role in *The Little Duchess,* which is going into production at the theater where she once starred. The producer is horrified, the playwright is horrified, but the count's money is powerful. The result is a disaster. "She was atrociously bad," Zola observed, "she displayed such pretensions to high comedy that the audience became hilarious. They did not hiss—they were too amused. From a stage box Rose Mignon [who had originally had the lead role before the count intervened] kept greeting her rival's successive entrances with a shrill laugh, which set the whole house off...." Nana is enraged, of course, but by no means crushed. On the contrary, she vows to get revenge. "I'll bet a hundred louis," she tells the count, "that I'll get

all those who made fun of me tonight to lick the ground at my feet."

Only now does Nana turn into one of the grand courtesans, no longer interested in pleasure so much as in acquisition and despoliation. "Nana thereupon became a woman of fashion, mistress of all that is foolish and filthy in man, marquise in the ranks of her calling. It was a sudden but decisive start, a swift rise into the celebrity of gallantry, into the garish light of mad expenditure and the wasteful audacities of beauty. She at once became queen among the most expensive of her kind. Her photographs were displayed in shop windows, and she was quoted in the newspapers. When she drove in her carriage along the boulevards, people would turn and tell one another who that was.... She was an aristocrat of vice, and proudly and rebelliously trampled upon a prostrate Paris like an all-powerful mistress. She set the fashion, and great ladies imitated her."

Nana spends more than 300,000 francs in furnishing her new house on the Parc Monceau, which has eight horses in the stable and five carriages in the coach house. (Remember that a workman's pay was about five francs a day.) The count gives her 12,000 francs a month "and demanded nothing in return save absolute fidelity. She swore fidelity." She nonetheless begins an affair with Count Xavier de Vandeuvre, who pays her another 8,000 or more per month. This new admirer "was finishing the last of his fortune, [and] Nana was going to swallow his last château, near Amiens." Despite all this, however, Nana is nearly bored to death. "She had men for every minute of the night, and money overflowed even among the brushes and combs in the drawers of her dressing table. But all this had ceased to satisfy her; she felt that there was a void somewhere...."

Riding in her coach in the Rue Montmartre one day, she notices "a woman trotting along in down-at-heel boots, dirty petticoats, and a hat utterly ruined by the rain." It is, of course, Satin. Nana sweeps her up into her coach, takes her home, and resumes their affair, first as a kind of game, then more seriously. Her only reward is that Satin soon runs away. Nana searches for her, finds her, brings her back. Count Muffat, informed of all this by an anonymous letter, asks for an explanation, but Nana just laughs at him. "That's a matter which doesn't concern you, dear old pet," she says. "How can it hurt you?" Indeed, the affair is by now so open that the two women flirt even in the count's presence. At a dinner party, "Satin, having peeled a pear, came and ate it behind her

darling, leaning on her shoulder and whispering little remarks in her ear.... She wanted to share her last piece of pear with Nana, and presented it to her between her teeth. Whereupon there was a great nibbling of lips, and the pear was finished amid kisses." The degraded Count Muffat is described only as "watching them with his serious expression."

Zola almost obsessively describes Nana's corrupting sexuality in terms of money. "This was the epoch in her existence when Nana flared upon Paris with redoubled splendor. She loomed larger than heretofore on the horizon of vice, and swayed the city with her impudently flaunted splendor, and that contempt of money which made her openly squander fortunes.... Never had eye beheld such a rage of expenditure. The great house seemed to have been built over a gulf, in which men—their worldly possessions, their fortunes, their very names—were swallowed up without leaving even a handful of dust behind them. This courtesan, who had the tastes of a parrot, and gobbled up radishes and burnt almonds, and pecked at the meat upon her plate, had monthly table bills amounting to 5,000 francs...." All in all, Nana's extravagance by now amounts to nearly a million francs a year, and so she often finds herself short of cash. She resorts to borrowing from her servants or asking her various lovers to give her whatever change they have in their pockets. As a "last resource," she even reverts to visiting a nearby bordello, where she can always earn twenty-five louis for an afternoon's encounter.

Nana's tastes keep getting more depraved. The count by now feels "comparatively at peace" when he leaves Nana with Satin because that will "keep the men off her," but Nana "deceived Satin as she deceived the count, going mad over some monstrous fancy or other, and picking up girls at the street corners. Coming back in her carriage, she would suddenly be taken with a little slut.... She would take the little slut in with her, pay her, and send her away again. Then, disguised as a man, she would go to infamous houses, and look on at scenes of debauch to while away hours of boredom...."

This increasing depravity, too, is expressed in terms of money, and of feeding. Nana's old friend Steiner now owns a steel factory in Alsace, where workmen "blackened with coal dust and soaked with sweat strained their sinews day and night...to satisfy Nana's pleasures. Like a huge fire, she devoured all the fruits of stock-exchange swindling and the profits of labor. This time, she finished Steiner; she brought him to

the ground, sucked him dry to the core, left him so cleaned out that he was unable to invent a new roguery." Another admirer named La Faloise has an inheritance in "landed estates, houses, fields, woods, and farms. He had to sell all, one after the other.... At every mouthful, Nana swallowed an acre. The foliage trembling in the sunshine, the wide fields of ripe grain, the vineyards so golden in September, the tall grass in which the cows stood knee-deep, all passed through her hands as if engulfed.... Farm by farm, field by field, she ate up the man's patrimony."

Beyond the money, though, there is also the question of power. In plundering her lovers, Nana humbles them, unmans them. "The rage for debasing things was inborn in her," Zola wrote. "It did not suffice her to destroy them, she must also soil them, too." She makes Count Muffat get down on his hands and knees so that she can ride horseback; she makes him play dog and fetch her handkerchief so that she can beat him if he is too slow in retrieving it. "Just think," she says, fully aware that he is a chamberlain at Napoleon's imperial court, "if they were to see you like that at the Tuileries." Like most of her fellow citizens, she has no idea that courtiers at the Tuileries would consider such sports rather commonplace.

But Nana has more radical fantasies. "She was seized with a whim, and insisted on his coming to her one night clad in his magnificent chamberlain's costume...with the sword and the cocked hat and the white breeches, and the full-bottomed coat of red cloth laced with gold, and the symbolic key hanging on its left-hand skirt." This key inspires Nana to various lewd thoughts and "extremely filthy discussion." Then follow various games of degradation. She kicks him. "Oh, those kicks! How heartily she rained them on the Tuileries, and the majesty of the imperial court, throning on high above an abject and trembling people!" Then she makes the count take off the grand imperial uniform and spread the coat on the ground. "She shrieked, 'Jump!' and he jumped; she shrieked, 'Spit!' and he spat. With a shriek, she bade him walk on the gold, on the eagles, on the decorations, and he walked on them....Nothing was left; everything was going to pieces. She smashed a chamberlain just as she smashed a flask...and she made filth of him, reduced him to a heap of mud at a street corner."

In writing about prostitution, in painting its portrait, the artists of the Second Empire were carrying out the dictates of modernism. To be

modern was to regard and reflect one's surroundings—the streets of Paris, the new buildings, the women. Baudelaire had laid down the law in his influential essay *The Painter of Modern Life* (1863), ostensibly a salute to the work of Constantin Guys but beyond that a prescription of what modern art should be. This inevitably reached its apotheosis in Baudelaire's description of the contemporary courtesan. "Against a background of hellish light, or if you prefer an *aurora borealis*—red, orange, sulphur yellow, pink (to express an idea of ecstasy amid frivolity)....there arises the Protean image of wanton beauty. Now she is majestic, now playful...now tiny and sparkling, now heavy and monumental. She has discovered for herself a provocative and barbaric sort of elegance.... She advances toward us, glides, dances, or moves about with her burden of embroidered petticoats...; her eye flashes out from under her hat, like a portrait in its frame. She is a perfect image of the savagery that lurks in the midst of civilization...."

If this was the essence of modernity, it was also, of course, a situation of considerable antiquity. Before France even existed as a political entity, Charlemagne issued a decree in the year 800 banishing all prostitutes from his empire. St. Louis tried again in the thirteenth century, declaring that "women and girls who prostitute themselves will be driven out, from the towns as well as the hamlets." All that it meant to be driven out, however, was to be driven beyond the town walls, where the outcasts resumed their occupation. As Paris kept expanding, it kept reacquiring its outlawed *folles femmes* (crazy women), and finally an ordinance of 1367 accepted the inevitable by ordering "all women of dissolute life to live in the public places designated for them." It then listed these designated places, a list that changed very little over the centuries.

Prostitution as such was not illegal. The authorities simply kept trying to regulate and control it, first by location, then by hours. An ordinance of 1395 decreed that prostitutes must remain in their bordellos after 6:00 P.M. in the winter and after 7:00 P.M. in the summer. Then clothing. A decree of 1420, for example, forbade headdresses and dresses with upturned collars and trains. Throughout the Middle Ages, this was essentially a matter of morals. Prostitutes were sinners. With the coming of the Renaissance (and of syphilis), it became something quite different, a medical problem and a political problem.

This was the age in which the emerging national state insisted not only on asserting its power over various local authorities but also on

amassing information about whom and what it ruled. The police were gradually learning that the best way to find out about prostitution was not to incarcerate its practitioners but to use madams as their representatives and informants. And thus, in the mid-eighteenth century, there appeared the officially regulated brothels, the *maisons de tolérance.* They were required to be no less than fifty meters from any church or school for example, and they were required to have frosted windows on the ground floor. The madams could be held responsible for the myriad regulations—no public disturbances, no minors, and, of course, the weekly medical examinations.

Though the police regulations seemed to cover just about everything, they had little connection with the substantial numbers of women who sold themselves on a more private basis, women who were supported by one or more lovers and never dreamed of soliciting strangers on the street. The police tried in 1817 to have a special agent find *femmes galantes* who might need medical examinations. This agent, a "Monsieur V—," corraled about sixty women, who were then inspected by the official doctors, but there were so many protests from their protectors that the campaign was abandoned. The police tried the same tactic in 1820, and again in 1830, with much the same results. "Courtesans remained unpoliced for the rest of the century," according to Jill Harsin's admirable analysis, *Policing Prostitution in Nineteenth-Century Paris,* "ironically depriving the upper classes entirely of what slight security the [medical] examination provided."

As with drugs in our time, all the efforts to control prostitution seemed to encourage its spread. The system brought profits not only to landlords and madams—and, of course, the prostitutes, too—but also to the police morals brigade, which had already grown to sixty-five men. The more women they could catch and register, the more money they made. Police and prostitution corrupted each other. Still, like the enthusiasts of "wars" on narcotics, the police insisted that they were doing the best that could be done, and in due course they found their champion, their defender, and their scholar, the first serious investigator of sexual commerce in Paris.

Alexandre Parent-Duchâtelet was a young doctor just beginning a career in public hygiene when he received an assignment from the Ministry of the Marine to investigate a mysteriously toxic freighter named the *Arthur.* This ship had sailed from Rouen with a cargo of fertilizer

known as *poudrette,* dried and pulverized dung. When it arrived at Guadeloupe in the summer of 1818, half of its crewmen were dead and the rest seriously ill. Parent's investigation took him to Montfaucon, a hill on the northeastern edge of Paris which had served until the recent Revolution as the place where criminals were publicly hanged. The large stone blocks that had once provided the base for the gibbet now served as the frame for vast pits where the dung carts of pre-Haussmann Paris came to deposit their collections, the source for the *poudrette.* If anything else were needed to complete this Boschian scene, Montfaucon also included the rotting carcasses of some 30,000 to 40,000 horses, cattle, and whatnot brought here from various butcher shops and spread out on twelve acres of hillside to decay in the sun.

Parent discovered that the *poudrette* had become wet while being loaded aboard the *Arthur* in the rain, and that moisture combined with the heat of a tropical voyage made the cargo of *poudrette* give off a toxic combination of ammonia and hydrogen sulfate. All future shipments, he said, should be in watertight and airtight barrels. While he was at it, he recommended that Montfaucon be shut down and its functions moved farther out of the city.

In the course of his investigations, which helped to make him a member of the government's Public Health Council in 1825, Parent seems to have acquired a morbid fascination with morbidity, particularly putrid smells. He went on long expeditions through the pre-Haussmann sewers, which he once described as Paris's "most useful monuments." Determined to prove that bad smells had no harmful effects, he once joined in digging up forty-three greenish corpses rotting in the cellars of the church of Saint-Eustache, which stank so much that the parishioners complained of being unable to concentrate on their prayers. He even tasted the brown liquid dripping out of a cesspool just to show that it would not make him sick.

This was the man who decided to undertake the first scientific study of prostitution. He said he was asked to do so by an anonymous philanthropist who died before Parent's research was finished, and then he continued on his own. His goal, he said, was "to see things as they really are...to call things by their names." He not only studied police records but went to brothels to interview the inhabitants, always, he insisted, with a police officer accompanying him. "If, without scandalizing anyone, I was able to enter the sewers, handle putrid matter, spend part of

my time in the refuse pits, and live as it were in the midst of the most abject and disgusting products of human congregations," Parent wrote, "why should I blush to tackle a sewer of another kind (more unspeakably foul, I admit, than all the others) in the well-grounded hope of effecting some good by examining all the facets it may offer?" After eight years of work, and in the year of his own death at forty-six, Parent published the results of all his examinations in a two-volume book entitled *On Prostitution in the City of Paris* (1836).

It became the textbook for what is known as "regulationism" or "the French system." Parent believed, as the Parisian police believed, as St. Augustine had believed before them, that prostitution was an inevitable system for fulfilling men's needs. Many moralists went further and justified it as a safety valve that helped to protect respectable women from assault. "Prostitutes are as inevitable in an agglomeration of men as sewers, cesspits, and garbage dumps," Parent wrote in another of his cloacal analogies. "Civil authority should conduct itself in the same manner in regard to the one as to the other: its duty is to survey them, to attenuate by every possible means the detriments inherent to them, and for that purpose to hide them, to relegate them to the most obscure corners, in a word to render their presence as inconspicuous as possible."

But though Parent fully endorsed the police views on the need to regulate prostitution, his massive statistical evidence on the prostitutes themselves, on where they came from, and who their parents had been, and how old they were when they first sold themselves, began to change the public perception of the prostitute from an idle woman of depraved appetites and low morals to a working-class victim, unable to earn a living in any other way. "Of all the causes of prostitution, particularly in Paris..." Parent wrote, "there is none more active than the lack of work and misery, the inevitable result of insufficient salaries. What are the earnings of our dressmakers, our seamstresses...? Let one compare especially the price of their labor with that of their dishonor, and one will cease to be surprised to see such a great number fall into a disorder that is, so to speak, inevitable."

The learned studies and learned debates continued. In 1878, the year after Manet painted *Nana*, there were 3,991 registered prostitutes in Paris, 1,343 of them working in *maisons de tolérance* and 2,648 listed as "independents." The exact number of unregistered prostitutes remains, of necessity, unknown, but most experts guess that it was at least as large

as the number of the registered. They came from all kinds of backgrounds, mostly working-class, but they also included a few sales clerks and teachers. Their education was at about the same low level as that of other working-class women. Of 5,440 prostitutes registered in Paris during the 1880s, more than 80 percent could at least read and write. They had lost their virginity, on the average, at the age of sixteen. Fully 38 percent had lost it to laborers, 17 percent to tradesmen, 11 percent to men in the "liberal professions," 5 percent to their husbands, and only 3 percent to those villains of Victorian melodrama, the employer or his son. Less than 10 percent incidentally, were born illegitimate.

Old-time Parisian brothels had traditionally been concentrated near the Seine, but now that Baron Haussmann had cleared out all these slums, the Parisian authorities wanted their *maisons de tolérance* dispersed. A police regulation of 1878 specified a minimum distance that had to separate one from another. Once a woman went to work in these places, she generally dropped her real name and acquired a *nom de guerre*. The most popular were generally rather theatrical: Carmen, Mignon, Manon, plus a lot of diminutives like Paulette, Brunette, Violette, Odette, Minette. By contrast, the most common real names on the police registers were considerably more plebeian: Marie, Jeanne, Louise, Joséphine. Prices varied widely, of course. In the better houses, there was an entrance fee of ten to twenty francs, and at least half as much again to the prostitute herself. In the lowest *maisons d'abattage,* where the men got a numbered ticket and were told to wait in line, the girls got as little as 50 centimes. The amount of activity varied widely too; one study by a member of the Paris Municipal Commission reckoned that the average inmate of a *maison de tolérance* served seven or eight customers every night.

Such places were little more than assembly lines, but the fancier establishments kept getting fancier. One government report described a brothel built in the form of "a very rich Greek temple." It also included opera sets, Louis XV salons, Calypso's cave, and an "electric fairyland," where the use of the new illumination was said to cause "sexual hypnotism." Money fueled the imagination. Customers engaged in *tableaux vivants* on black velvet carpets that supposedly brought out the whiteness of their bodies. The electricity that created "sexual hypnotism" could also provide erotic shocks: whips, chains, and perfumed thongs were almost commonplace. Dr. Louis Fiaux reported that some bordel-

los specialized in spectacles of women engaging in sexual intercourse with Great Danes, a breed that had become newly fashionable. Others featured Newfoundlands. Establishments of this sort became known as *maisons de débauche*.

The odd thing about this so-called French system, so elaborately worked out to make prostitution readily available but protected against both crime and disease, was that it soon went into decline. Throughout the whole reign of Napoleon III, the number of *maisons de tolérance* in Paris steadily shrank, from 217 at the time of his accession in 1852 to 152 at his downfall in 1870. One reason for this was the great building program of Baron Haussmann, which not only wiped out prostitution-infested slums like those on the Île de la Cité but sent rents soaring all over central Paris. Another was the weakening of social barriers, the bourgeoisification of both the aristocracy and the working class, and finally the triumphant emergence of the nonregistered, nonregulated *femme galante* in all her many manifestations, the *demimondaine,* the *cocotte,* the *lionne,* the *lorette,* the *grisette,* the *marmite,* the *femme de brasserie,* the *femme de café,* the *grande horizontale.* If Baron Haussmann had unwittingly penalized the *fille soumise* in her condemned bordello, he had just as unwittingly opened the way for her to disport herself on his boulevards and in his parks.

"They are everywhere," the Paris Police Prefect Charles Lecour wrote in 1870, "in the brasseries, the café-concerts, the theaters and the balls. One encounters them in public establishments, railway stations, even railway carriages. There are some of them on all the promenades in front of most of the cafés. Late into the night, they circulate in great numbers on the most beautiful boulevards, to the great scandal of the public, which takes them for registered prostitutes violating the regulations and hence is astonished at the inaction of the police in their regard."

Lecour had no way of knowing how many of these women were wandering around in Paris—much encouraged, of course, by the crowds attending the Universal Exposition of 1867—but less authoritative observers were willing to make guesses. Thus Flaubert's friend Maxime Du Camp estimated in his book on Paris that there were 120,000 women more or less for sale. These ranged from unregistered prostitutes to shopgirls and dancers up to "the great lady who, before selling herself, demands and receives a million francs in newly minted pieces of gold."

Du Camp's guess was an astonishing thirty times the number of prostitutes whom the police had laboriously registered; that it was nothing more than a guess becomes clear in his complaints about how hard it was to tell who was who. The old rules of differentiation had been abandoned, and just as Nana dressed like a countess, the aristocrats thought it chic to dress like demimondaines. "One does not know nowadays," as Du Camp put it, "if it's honest women who are dressed like whores or whores who are dressed like honest women."

If this troubled Du Camp, it troubled Prefect Lecour and his morals police a lot more, as can be seen in his complaint about a scandalized public thinking that the police were not doing their duty. On the other hand, there were no less scandalous instances of the police seizing respectable women on some street corner and detaining them on suspicion of solicitation. While the police felt themselves engulfed by a rising tide of sin, as usual, they suddenly found themselves attacked from the rear by a band of zealots who demanded the complete abolition of their vice brigade, their supervision and controls. The inspiration for this seems to have been the transfer of the "French system" to Great Britain, where the Contagious Diseases Acts of 1866, 1867, and 1869 established the idea of having prostitution officially supervised.

To the attack came Josephine Butler, the wife of a school principal in Liverpool, who published in 1870 a manifesto demanding repeal of the new legislation. She also became head of the Ladies' National Association to lobby for that repeal. The Quakers joined in; so did various feminist groups; so did that celebrated old philanderer, Victor Hugo. In 1874, Mrs. Butler first crossed the channel to inspect the capital of iniquity. She was shocked by conditions at the prostitutes' clinic of Saint-Lazare. She demanded an interview with Police Prefect Lecour, who, in the words of one chronicler, "received her somewhat curtly." Mrs. Butler was not to be stopped. "The best of the restrictions imposed by law," she said, "is that which encourages and, if necessary, forces citizens of both sexes to practice self-respect." In 1877, Mrs. Butler and some 700 like-minded reformers gathered in Geneva and organized the British and Continental Federation for the Abolition of Prostitution.

This was not just a matter of naïve idealism. The abolition of prostitution, a step considerably beyond the original opposition to the official toleration of commercial sex, appealed to all kinds of moral reformers, to Protestant puritanism, to the growing forces of feminism, and to several

varieties of political radicalism. Though these groups differed on what they favored as alternatives to the "French system," they found a certain unity in their hatred of the corrupt Morals Brigade. Here the attack was led by a journalist and economist named Yves Guyot, who said he had been converted to the cause by reading about the suicide of two *filles soumises*. One of them, Marie D——, had thrown herself out a third-floor window of her boardinghouse to escape the morals police during one of their raids. The other, Mélanie M——, was resisting arrest by the morals police when she fell under an omnibus that crushed her legs. Then, while being driven to the police station, she threw herself out of the carriage and drowned herself in a river. Guyot attacked the authorities so fiercely, in a newspaper called *Les Droits de l'Homme,* that he was prosecuted in 1877 on a charge of insulting the police and sentenced to six months in prison (and the newspaper folded).

Guyot returned to the attack the following year in *La Lanterne,* and this time the police had the newspaper's business manager imprisoned for three months. But Guyot eventually got elected to the Chamber of Deputies in 1885, even becoming minister of public works in 1889, and the police powers over prostitution were gradually trimmed. But not abolished, for as the defenders of the system gave ground on the powers of the police, they gained on another front, the terror of venereal disease. It was all very well for puritans to declare that everyone should "practice self-respect," but realists knew perfectly well that there would either be regulated prostitution or unregulated prostitution. The unregulated prostitutes, the *filles insoumises,* had always suffered a higher rate of venereal disease, and this now began to seem a national peril.

So the police finally won, by changing prostitution from a question of law and order to one of public health, thus keeping matters under their watchful control until the end of World War II. It was also in this atmosphere of shifting perceptions and shifting politics that Zola rather opportunistically wrote *Nana,* and Manet, in his innocence, painted her.

The brilliant portraitist of the Parisian prostitute was not Manet, however, but his friend Degas. He returned to such women over and over again, almost compulsively. The most coarsely realistic of these portraits, by a man who was never otherwise coarse, is a series of some fifty monotypes of brothel scenes, apparently done in 1879 and 1880, and thus

exactly contemporaneous with *Nana*. The art dealer Ambroise Vollard declared that another seventy similar pictures were destroyed by Degas's brother, after the artist's death, because he considered them obscene. The surviving pictures are too grim to be obscene. The naked whores, rather fat, rather bored, rather unattractive, loll about on their sofas. Occasionally a top-hatted customer nervously intrudes at the edge of the scene, but mostly the whores just sit around, endlessly waiting to be hired.

We do not know the circumstances of these morbidly inquisitive pictures. The smudged and improvisatory technique suggests that they were hastily sketched during some visit to a brothel, or perhaps from memory, or possibly even from Degas's imagination. A monotype has to be done in a studio, and no preliminary sketches have ever been found. We do not know, because we know almost nothing about Degas's private life. Stiff and formal, courtly, hot-tempered and acidic but also reserved, inhibited, he never married, and there is no record of his ever having had an affair with anyone. He did wonder occasionally, as in a notebook entry for 1858, when he was twenty-four: "Couldn't I find a good little wife, simple and quiet, who understands my oddities of mind, and with whom I might spend a modest working life! Isn't that a lovely dream?" But when the historian Daniel Halévy asked him many years later whether it was true that he had wanted to marry Halévy's cousin Henriette, Degas laughed and said, "When I was helping her into a cab I said, 'Mademoiselle Henriette, your father has given me permission to ask for your hand.' So, instinctively, she gave me her hand...." He amiably explained to Halévy that the whole misunderstanding had arisen because he had fired his housekeeper that morning, telling her, "You make me regret that I am not married. How can a man live with an idiot, a fool like you?" Shortly thereafter, he wrote to a friend: "I am meditating on the state of celibacy, and a good three-quarters of what I tell myself is sad."

Inevitably, there has been speculation that Degas was a repressed homosexual, though there is no evidence of that either. There are some grounds, though, for suspecting that he may have been impotent. Edmond de Goncourt recorded in his journal a conversation with a novelist named Léon Hennique, in which Hennique said that "he had once had a mistress whose sister had slept with Degas and that the so-to-speak sister-in-law had complained about the insufficiency of Degas's

amorous capabilities." Manet was maliciously blunt in telling Berthe Morisot, who liked and admired Degas, that he "isn't capable of loving a woman, even less of telling her that he does or of doing anything about it." Vincent Van Gogh responded to the collegial gossip by elaborate theorizing. "Why do you say that Degas has trouble having an erection?" he wrote to a young Symbolist poet named Émile Bernard. "Degas lives like a little notary and does not love women because he knows that if he loved them and spent a lot of time kissing them he would become mentally ill and inept in his art. Degas's painting is vigorously masculine and impersonal precisely because he has accepted the idea of being personally nothing but a little notary with a horror of sexual sprees." Van Gogh knew nothing specific, of course, and neither do we, nothing about what the trouble might have been, whether it was physical or psychological, or nonexistent.

Beyond the unambiguous *filles soumises* of the brothel monotypes, Degas was fascinated by women in a number of related professions: ballet dancers, cabaret singers, laundresses, milliners. It was widely assumed, rightly or wrongly, that most of the women in these occupations were available for a price, and it seems likely that Degas shared in that assumption and assumed that his viewers did too. He rarely showed them flirting or offering themselves, however, but rather concentrated on their preoccupation with their work, the young ballerinas contorting their bodies according to the demands of the dance, the laundresses bending wearily over their ironing boards.

Beyond that, Degas returned endlessly to more abstract portraits of women in private, women taking baths, or drying themselves after a bath, women languidly brushing their hair, or having it brushed for them. Degas never tells us outright that these women are prostitutes, but many critics have argued that they must be, even if only because prostitutes of necessity washed themselves frequently, while respectable women generally regarded bathing as unhealthy. These women's surroundings also suggest the chambers in the more elegant *maisons de tolérance,* and besides, would any respectable woman of the nineteenth century pose in the nude for a painter?

Again, we do not really know who these models were, whether they were real prostitutes or real laundresses, or models hired to pose as such, or even whether there were any models at all. Or what Degas really meant when he wrote to James Tissot from New Orleans in 1872:

"Everything is beautiful in the world of the people. But one Paris laundry girl, with bare arms, is worth it all for such a pronounced Parisian as I am." The first time he actually painted such a girl with bare arms—a sturdy and handsome brunette known as *La Repasseuse* (*The Laundress*) (1869), now adorning the Neue Pinakothek in Munich—he portrayed not a real laundress but one of his favorite models, Emma Dobigny. It is striking, though, how many of Degas's women are seen from the rear, and thus faceless and anonymous, without any identity except that of their hair and shoulders and thighs. "Can you imagine what we pose for with Degas?" one model told a critic named Gustave Coquiot. "Well, it's for females climbing into tubs and washing their rear ends." "He is an odd monsieur," another one remarked. "He spent four hours of my posing session combing my hair." Still another recalled that she had been reluctant to take off her clothes. "Yes, indeed, I remember that I was the first to see you naked," Degas agreed. "But it didn't happen easily. You didn't want to take off your shift. Louise had to tear it off you. You looked so chaste; it was charming."

"Just think!" said the model, whose name was Pauline. "Taking all your clothes off in front of a man!"

"Is an artist a man?" Degas asked with a shrug.

How much would any painter as skilled and disciplined as Degas actually need to rely on any model? He used them, of course, but more as tools than as subjects. His greatest hero among his predecessors was Ingres, who once told him: "Young man, never work from nature. Always from memory, or from the engravings of the masters." Degas himself expressed almost the same belief when he said to Georges Jeanniot: "It is very good to copy what one sees; it is much better to draw what you can't see any more but in your memory. It is a transformation in which imagination and memory work together. You only reproduce what struck you, that is to say the necessary. That way, your memories and your fantasy are freed from the tyranny of nature."

The tyranny of nature. Friends were occasionally surprised to find Degas painting landscapes indoors. (He began having serious eye trouble in the 1870s—it would ultimately blind him—and bright sunlight caused him pain.) "Just an occasional glance out the window is enough when I am traveling..." he said to Vollard. "With a bowl of soup and three old brushes, you can make the finest landscapes ever painted." Similarly, painting his beautiful horse-racing scenes, he relied on memory and a set

of small wooden horses. "When I come back from the races, I use these as models," he told Vollard. "I could not get along without them. You can't turn live horses around to get the proper effects of light."

"What would the Impressionists say to that, Monsieur Degas?" Vollard maliciously inquired about the group that Degas himself had helped to launch.

"You know what I think of people who work out in the open," Degas retorted. "If I were the government I would have a special brigade of gendarmes to keep an eye on artists who paint landscapes from nature. Oh, I don't mean to kill anyone; just a little dose of birdshot now and then as a warning."

Degas's myriad pictures of women were actually only one element in an almost encyclopedic ambition to portray contemporary Paris. "Draw all kinds of everyday objects," he wrote in his notebooks in about 1876, "placed, accompanied in such a way that they have in them the *life* of the man or woman—corsets that have just been removed, for example, and which retain the form of the body, etc., etc. Series on instruments and instrumentalists, their forms, the twisting of the hands and arms and neck of a violinist; for example, swelling out and hollowing of the cheeks of the bassoonists, oboists, etc. Do a series in aquatint on *mourning,* different blacks—black veils of deep mourning floating on the face—black gloves—mourning carriages, undertakers' vehicles—carriages like Venetian gondolas. "On smoke—smokers' smoke, pipes, cigarettes, cigars—smoke from locomotives, from tall factory chimneys, from steam boats, etc. Smoke compressed under bridges—steam...."

"On bakery, *Bread**—series on bakers' boys, seen in the cellar itself, or through the basement windows from the street—backs the color of pink flour—beautiful curves of dough—still-lifes of different breads, large, oval, long, round, etc. Studies in color of the yellow, pinks, grays, whites of bread...."

"After having done portraits seen from above, I will do some seen from below—sitting very close to a woman and looking up at her. I will see her head in the chandelier, surrounded by crystals...."

Because of this encyclopedic approach, Degas delighted in portray-

*Though some members of the family changed their name to de Gas and claimed an aristocratic lineage, the painter's grandfather was a baker, and his father made his fortune by speculating in grain.

ing women in intimate moments that no previous painter had considered worthy of attention. They dry the backs of their necks or wash between their toes. Many of the titles express that cool neutrality of observation: *Dancer with Arms Behind Her Head* (1873), *Standing Dancer Seen from Behind* (1873), *Women Combing Their Hair* (1875), *Woman Leaving Her Bath* (1876). He even made in 1879–80 a series of twenty-two aquatints of successive stages of the same woman leaving the same bath. "It is essential to do the same subject over again, ten times, a hundred times," he wrote to a friend. Degas was fascinated by the possibilities of the camera, which he used with great skill, but now he seemed to be thinking of inventing the documentary movie some ten years before Thomas Alva Edison first astonished Chicago's Columbian Exposition of 1893 with his film of a laboratory assistant sneezing.

Nobody ordinarily engages in dense psychoanalytic speculations on why anyone should want to film a man sneezing, just as nobody ordinarily sees hostility and discrimination in portraits of bassoonists with swelling cheeks, but because Degas often painted women in awkwardly intimate situations, some critics began to spread the misguided idea that he despised his subjects. J. K. Huysmans, that puzzling figure who wrote his first novel about a prostitute named Marthe but eventually became an oblate in a Benedictine monastery, was the earliest important advocate of this view. In reviewing a series of pastels that Degas exhibited in 1886, Huysmans wrote that his images of women bathing showed "an attentive cruelty, a patient hatred," and a "disdain for the flesh." He attributed this hostility not only to Degas but to his subjects' view of themselves, "the penetrating, sure execration of a few women for the devious joys of their sex, an execration that causes them to be overwhelmed with dreadful proofs and to defile themselves, openly confessing the humid horror of a body that no lotion can purify."

Huysmans' criticism is manifestly untrue, and yet there seems to be a lingering suspicion that Degas really was guilty of "misogyny," an accusation now considered so dire that it no longer needs to be proven, only charged, like similar accusations of racism or anti-Semitism (yes, Degas really was an anti-Semite, as were Renoir and Cézanne). Degas derived a characteristic satisfaction from such accusations. "Oh! Women can never forgive me," he once remarked to Jeanniot. "They hate me, they can feel that I am disarming them. I show them without their coquetry, in the state of animals cleaning themselves.... They see in me the enemy.

Fortunately, for if they did like me, that would be the end of me!" This was largely a hyperbolic manner of speaking, for nineteenth-century France was an extremely chauvinist society (let us not forget that it included General Chauvin himself), and Degas liked to affect the air of a disdainful dandy. As when he said to a model: "You are a very rare case; you have pear-shaped hips. Like Mona Lisa." Or when he said admiringly of his friend and protégée Mary Cassatt, "I am not willing to admit that a woman can draw that well." Or when he denied the more common charge of misanthropy (misogyny was hardly considered a crime in those days): "I am not a misanthrope, far from it. But it is sad to go on living surrounded by swine."

It is hardly accidental that Degas liked and admired Mary Cassatt, who was rather plain ("I would have married her, but I could never have made love to her," he once said). Or that he liked and admired Berthe Morisot, and Suzanne Valadon. Georges Rivière, an eminent art critic, shared in Huysmans's delusion about Degas's pictures, but he saw that the painter was at ease among women. "Degas loved the company of women," he wrote. "Although he often painted them with real cruelty, he liked being with them, enjoyed their idle talk, and said flattering things to them. This attitude was in curious contrast with that of Renoir, who depicted women seductively...and yet in general derived no pleasure at all from what they valued."

Anyone who looks at Degas's picture with a nonideological eye can see that he adored the women he portrayed. Obsessively so, perhaps; fetishistically so, perhaps; impotently so, perhaps; but nonetheless with a fascinated adoration that his critics seem unable to understand. It is common nowadays, in this psychiatric age, to analyze pictures of nudes in terms of an imaginary viewer, always male, and of his supposed desire for domination and possession. Degas thought just the opposite. It is true that his eye was intrusive, and that he delighted in showing women's bodies as they would never have wanted any outsider to see them, but it was only by violating the privacy of their bathing that he achieved the sense of intimacy that he wanted. Manet's *Olympia* in her bedroom is very much on public display; so are Titian's *Venus of Urbino* and Velázquez's "Rokeby Venus"; Degas's anonymous bathers are not. Degas himself felt that strongly. "Hitherto the nude has always been represented in poses which presuppose an audience," he said to the Irish writer George Moore, "but these women of mine are honest, simple folk,

unconcerned by any other interests than those involved in their physical condition. Here is another; she is washing her feet. It is as if you looked through the keyhole."

In that revelatory last sentence, Degas destroys much of his own argument, of course, for he reestablishes himself (and implicitly the viewer) as a voyeur. Having emphasized the privacy and independence of the bathers, as Degas's biographer Roy McMullen put it, the reference to the keyhole makes it clear that "these happy, intent, liberated creatures are actually being examined very closely by a prying male eye, and their manifest obliviousness of the fact can be considered an aggravating circumstance. Indeed, there is probably no way to keep a depicted naked woman from losing part of her human dignity and becoming to some extent a mere sight for men, unless or until one is prepared to… change the economic organization of Western society."

Ah, well. Degas probably would not have minded in the least a change in the economic organization of Western society, as long as it would enable him to go on admiring beautiful women without anyone feeling any loss of "human dignity." But by his late fifties, his failing eyesight was costing him so much of his own human dignity that he had to wander around with what he called an "ominous looking contraption over my eyes." It screened out everything from his right eye and permitted his left eye only to see through a thin slit. But he refused to give in. "Ah! Sight! Sight! Sight!" he wrote to a friend in 1891. "My mind feels heavier than before in the studio and the difficulty of seeing makes me feel numb. And since man, happily, does not set a limit to his capabilities, I still dream of projects; I am hoping to do a suite of lithographs, a first series on nude women at their toilet and a second one on nude dancers. In this way one continues to the last day figuring things out. It is very fortunate that it should be so."

Being a remarkable journalist, Zola was able to make it appear that *Nana* derived from his intimate familiarity with the glittering women of the Parisian demimonde. The reality was quite different. Zola spent considerable time interrogating more experienced friends like Flaubert, de Maupassant, and Halévy about their adventures. Though he may have occasionally visited a brothel, he seems to have remained quite faithful for many years to his wife, Eléonore-Alexandrine Meley, whom

he married at the age of thirty. He seems never to have loved her, though. He thought her "handsome and intelligent," and he wanted somebody to keep house for him while he worked. So he was a rich and successful author of forty-eight—with Nana nearly a decade behind him—when his wife hired a servant named Jeanne Rozerot, a twenty-year-old country girl from Burgundy. Rather like Count Muffat, Zola fell desperately in love, perhaps for the first time in his life. He persuaded the girl to quit her job in his house so that he could install her in an apartment of her own on the Rue Saint-Lazare. Unlike Nana, Jeanne Rozerot appeared perfectly content to be kept. To Zola's delight, she bore him his first child, Denise, the following year, and his first son, Jacques, two years later.

But he couldn't marry her because he couldn't bear to separate from his wife, couldn't bear even to tell her about his affair. When she learned of it from an anonymous letter at about the time of Jacques's birth, her rage was terrible. It has been reported that furniture flew across the room, but one can only imagine the denunciations and imprecations. That this moralist, this preacher of truth and integrity, should be secretly keeping a little family, his mistress and his bastards—! It is easier to imagine her accusations than Zola's answers. For he really did love his mistress, but he really did need his wife, and both the women clung to the adulterer as tenaciously as he to them. So he spent the last decade of his life in an endless series of quarrels and negotiations and bargains about what was to be permitted. When the Zolas went to spend their summers at their country house in Médan (largely financed by the success of *L'Assommoir* and *Nana*), Jeanne brought the children to stay in the nearby village of Verneuil. Madame Zola refused to allow them in Médan, then relented, somewhat. When the quarreling resumed, friends had to intervene. "My wife is going crazy," Zola wrote to one of them. "Can you come right over...and do what has to be done?"

Zola's most heroic act was to write *J'Accuse*, his devastating exposure in 1898 of the military conspiracy to frame a Jewish Army officer, Alfred Dreyfus, on a false charge of espionage. Zola was promptly convicted of libel and fled to England to escape a prison sentence. Hiding out in the secluded village of Addlestone, Surrey, calling himself Émile Beauchamp and trying to learn English from a bilingual edition of Oliver Goldsmith's *Vicar of Wakefield*, Zola had to have friends conduct elaborate negotiations with his two women so that

they could take turns visiting the great crusader in his exile.

But to return once again to *Nana,* Zola didn't know exactly how he wanted to end his novel. He knew that he wanted to kill off his heroine in some way that would demonstrate both her degradation and the corrupted state of the nation. The obvious answer was syphilis, but that took years to fester and kill, and he wanted Nana's death to be sudden, even a little mysterious. So he had her sell off all her possessions, for 600,000 francs, then set out for Cairo and Russia. She returns to find her neglected son dying of smallpox, then catches it herself, and a friend installs her in a room at that new temple of Haussmannian splendor, the Grand Hotel. Zola asked a friend who had been to medical school to send "an exact scientific and very detailed description of a death masque of a female victim of smallpox, and at the same time a description of a room in the Grand Hotel." The friend not only provided all that but also some photographs of smallpox victims. "You simply cannot imagine how vividly these scientific photographs reveal the horror of the thing," he told Zola.

Instead of writing a great death scene, Zola shrewdly disposed of Nana in the classic way Shakespeare disposed of Lady Macbeth, offstage. The Count Muffat sits on a bench outside the Grand Hotel and periodically approaches a porter to inquire about the condition of the lady upstairs, but on his last approach, he doesn't even need to ask before the porter says, "She's dead, Monsieur, this very minute." Zola insists on the rather heavy irony of Nana's various lovers all remaining down on the street, safe from the contagion of the sickroom, while only her female rivals venture upstairs to take care of her during her last hours. And, to some extent, to gloat. "Did she suffer much?" asks one of them. "Oh, yes," says another. "I was there when she died. I tell you, it was not at all a pretty sight. She had a fit of shuddering—"

She cannot finish her description because her words are drowned out by the crowds shouting outside: *"À Berlin! À Berlin! À Berlin!"* In the heaviest of all Zola's ironies—but also a very striking one—he kills off Nana on the very day when the French legislature misguidedly votes to declare war on Prussia. That action inspires even the women at Nana's deathbed to start arguing about politics. "This is the end," says one. "They're out of their minds at the Tuileries. France ought to have driven them out yesterday." But most of the women admire Napoleon. One of them recalls the revolution of 1848 and then adds, "Oh, if you'd only

been through all that, you would go down on your knees before the emperor, for he's been a father to us; yes, a father to us."

Only after the women finally leave Nana's corpse alone in the Grand Hotel does Zola move in, almost like a movie camera dollying in for a last closeup, to show us what his friend had called the horror of the thing. "The pustules had invaded the whole face, so that each touched the next one. Withered and sunken, they had taken on the grayish color of mud, and on that shapeless pulp, where the features were no longer recognizable, they already resembled some decaying mold from the grave. One eye, the left eye, had completely foundered in the bubbling purulence, and the other, which remained half open, looked like a dark, ruined hole. The nose was still suppurating. A large, reddish crust started at one cheek and invaded the mouth, which it twisted into a dreadful grin. And over this horrible and grotesque mask of death, the hair, the beautiful hair, still blazed like sunlight and flowed in a stream of gold. Venus was rotting. It seemed as though the poison she had picked up in the gutters, and from the carrion left by the roadside, the ferment with which she had poisoned a whole people, had now risen to her face and turned it to corruption."

Much worse things were to follow, of course, not just one beautiful woman dying of disease but tens of thousands of men cut to pieces on the battlefields of Gravelotte, Spicheren, Sedan, but Zola left that implicit in the mindless roar of the crowds marching past Nana's deathbed and chanting "À Berlin! À Berlin! À Berlin!"

EMPRESS EUGÉNIE (II)

Men are ferocious and conceited brutes.
—GEORGE SAND TO FLAUBERT ON THE START
OF THE FRANCO-PRUSSIAN WAR

I curse women: they are the cause of all our woes.
—FLAUBERT TO GEORGE SAND ON EMPRESS EUGÉNIE'S ROLE
IN STARTING THAT WAR

The bonneted women in black all cluster together under their umbrellas, waiting stoically for something. It is not yet dawn. Nothing in Manet's powerful etching tells us why the women have assembled here, but one can guess that they are hoping for a chance to buy food. As for why they must wait in the rain, Manet's only clue, poking above the umbrellas in the center of the scene, is a lone bayonet held high by an unseen soldier on guard duty. Manet has returned to the world of Goya, whose *Disasters of War* he knew all too well, only now the disasters are not those of Spain in 1812 but of his own Paris in 1870.

The Queue at the Butcher Shop is the unassertive title of this picture, and it is the only one that Manet is known to have done on the five-month Prussian siege of Paris. He had, of course, other things to occupy him. He had evacuated his wife and son and mother to Oloron-Sainte-Marie, in the Pyrenees. He had shut down his studio at 81 Rue Guyot and sent his thirteen most important pictures to a friend, Théodore Duret, for safekeeping in a cellar vault. They included Victorine Meurent in *Olympia* and *Le Déjeuner sur l'herbe* and Berthe Morisot in *The Balcony* and *Repose*. "In case I should be killed," he wrote to Duret, "I would like you to keep, according to your choice, *Moonlight* or *The Reader*." Two days later, on September 18, the first Prussian troops arrived on the eastern outskirts of Paris.

"At the moment there is no more *café au lait,* and the butchers are

only open three times a week, and one has to queue at their doors from four o'clock in the morning…" Manet wrote to Suzanne on September 30 in one of the letters that could leave encircled Paris only by balloon. "We are down to one meat meal and I think all Paris will have to do the same. Today Paris is one vast camp; from five o'clock in the morning until evening, volunteer militia and the National Guards who aren't regular servicemen drill and are being turned into real soldiers.…"

Manet's wartime letters to his distant wife were almost unfailingly cheerful and optimistic. To his young pupil Éva Gonzàles, who had fled to Dieppe, he showed himself considerably more anxious. "I believe that we unhappy Parisians are going to play the parts of actors in something dreadful," he wrote her. "It will be death, fire, plunder, carnage, if Europe does not arrive in time to stop it."

At the age of nearly thirty-nine, Manet enlisted in the National Guards and took his place in an artillery unit assigned to defend the city ramparts. So did his friend Degas.° Renoir joined the cuirassiers and was sent to train cavalry horses in the Pyrenees; Bazille joined the Zouaves. Some of their colleagues were less dutiful. Monet and Pissarro, for example, spent the months of war in London. Cézanne avoided the conscription officers by moving to the obscure Mediterranean port of L'Estaque. Zola, too, found himself clerical work in the safety of the south. "I wish you could see me in my big artillery cloak—an excellent garment, absolutely indispensable for active service," Manet wrote to Suzanne. "My soldier's knapsack is also filled with everything essential for painting and soon I'm going to start making some studies from life.… I will have every opportunity of doing some interesting things.…"

Just four months earlier, excited crowds had gone milling through the streets of Paris, shouting for war against Prussia, singing "La Marseillaise," chanting "*À Berlin!*" Various political leaders made speeches calling for war. The crowds cheered. Of all the people who were blind to France's future, perhaps the blindest was the Empress Eugénie. "May God grant that there be no war," she wrote to a friend. "But peace

°Degas enlisted in the infantry, but when he went to Vincennes for target practice, the painter discovered that he could not see the target with his right eye. "It was confirmed that this eye was almost useless," according to Paul Valéry's memoir, "a fact which he blamed (I heard all this from his own lips) on a damp attic which for a long time had been his bedroom."

bought at the price of dishonor would be as great a misfortune."

And so, on July 5, 1870, Emperor Napoleon III declared war. There were reported to be tears in his eyes as he did so. He was, in fact, grievously ill. He suffered a kidney disease and a stone in his bladder; he had to use a catheter in order to urinate; he was in extreme pain much of the time. He had difficulty in thinking of anything else, in concentrating, in governing his empire. For several years he had been under increasing pressure to liberalize his regime, to create a constitutional monarchy with a legislature of real authority, and when the liberal opposition nearly won a majority in the elections of 1869, Napoleon gave in. He invited the liberal leader, a forty-four-year-old lawyer named Émile Ollivier (who also happened to be the brother-in-law of Richard Wagner), to form a "representative" cabinet and introduce a new system known as the liberal empire.

It remained very much Napoleon's own empire, however, even though his chief ambition now, as he sat in long moody silences, was to abdicate as soon as the prince imperial reached the age of eighteen in 1874, just four years hence. Then perhaps he could settle down and devote himself to writing books, like his two-volume *History of Julius Caesar.* All he really wanted, he wrote to Eugénie after the disaster, was to live with her and their son "in a little cottage with bow windows and climbing plants." But now, stifling his pain, he had to lead his troops into war, on horseback. Eugénie insisted on it.

The relations between them had for some time been rather formal. Eugénie, who had won his offer of marriage by rejecting him on any other terms, felt deeply offended by his continued philandering. After the difficult birth of the prince imperial in 1856, when Eugénie was warned that another pregnancy might prove fatal, she apparently decided to retaliate against the emperor by refusing all further intercourse. "There is no longer any Ugénie," she wrote to her friend Prosper Mérimée, mimicking the way Napoleon mispronounced her name. "There is only the empress." As empress, she reigned supreme over the social glitter of Napoleon's empire, its dressmaking and dancing, and when she went to the last of its great masked balls, she went, with wonderful prescience, as Marie Antoinette.

As empress, she also was at least as imperious as Napoleon. She had acted as regent when he led his army off to Italy in 1859, into the bloodbath of Solferino; she had argued strenuously for the bungled attempt to

impose a European monarch on Mexico; and now she was passionately involved in the succession to the throne of her native Spain. The dissolute Queen Isabella II, last of the Bourbon line, had been driven from power by a military coup, and after a considerable amount of maneuvering and intrigue, the victorious generals secretly offered the crown to Prince Leopold of Hohenzollern-Sigmaringen, a cousin of King Wilhelm I of Prussia.

This seems to have been a plot artfully devised by Wilhelm's chief minister, Otto von Bismarck, as what he called "a red rag to the Gallic bull." Why the French and Germans should have felt compelled to wage war against each other for century after century now seems a question of political psychopathology, but after the repeated invasions and despoliations by Louis XIV and Napoleon, Bismarck's Prussia was herding the lesser German principalities toward the power inherent in unification. The French, perhaps anticipating the danger of German revenge, regarded the prospect of such unification east of the Rhine as a threat to be resisted by force. Bismarck, possessed by his dream of a united Germany, welcomed the prospect of a new French attack as a means of rallying the south German states like Baden and Bavaria behind Prussian leadership. This was a rather risky view. Though Bismarck's troops had humiliated first Denmark in 1864 and then Austria in 1866, the French army was generally considered the best and strongest in Europe.

The revelation that a Hohenzollern king might soon reign in Madrid shocked and outraged the French, who had long considered Spain a kind of dependency (and recent French capital investments in Spain were indeed substantial). The French foreign minister, Antoine Agénor, the Duke de Gramont, whom Bismarck once characterized as "the stupidest man in Europe," declared that the very idea of a Prussian king in Madrid was "nothing less than an insult to France," that it would "imperil the interests and honor of France," and that "we know how to fulfill our duty without hesitation and without weakness."

Prince Leopold, as it happened, felt no great desire to take over the uncertain throne of Spain, and King Wilhelm had no great desire to fight the French, and so the prince formally declined the offer from Madrid. Bismarck was dismayed. But instead of accepting victory gracefully, the French insisted on the impossible. With the emperor ailing, the key officials gave due deference to the empress, who, according to the Austrian ambassador, Prince Metternich, was "worked up in favor of war." She

kept talking of honor and duty, and, in the words of one of her atten-
dants, "the empress...is so desirous of war that it seems impossible we
shall not have it." *"Il faut en finir,"* she said. ("We must finish with it.") It
was later denied, though, that she had also said, *"C'est ma guerre."*
("This is my war.")

The official instructions from Gramont to his ambassador to Berlin,
Vincente Bénédetti, ordered him to pursue King Wilhelm to the sum-
mer resort of Bad Ems, and there to tell him that France demanded an
official statement declaring that the House of Hohenzollern renounced
forever any claim to the Spanish throne. The king shook his weary head
and bade the French ambassador good day. He then sent a telegram to
Bismarck to report his dismissal of the troublesome envoy. Bismarck,
after some artful editing, leaked the telegram to the press, making it
sound as though the French had been summarily rebuffed. The French
professed to be shocked and outraged. The canny old Adolphe Thiers,
who had once served as chief minister to King Louis Philippe, protested
in the legislature that the empire seemed ready to "pour out torrents of
blood over a mere matter of form," but Émile Ollivier said he was ready
to accept that responsibility *"d'un coeur léger"* ("with a light heart"). And
so war came.

The French expected a quick victory. Their best troops had been
trained in several decades of North African warfare, their new breech-
loading Chassepot rifle was considered a marvel, and War Minister
Edmond Leboeuf publicly declared of the army's general readiness,
"Not even a gaiter button is wanting." When the sickly Emperor
Napoleon reached his forward headquarters in Metz, however, he found
everything rather different. He expected to meet 385,000 troops ready
for action; he soon discovered that he had about 220,000, many of them
on furlough, many ill-trained and ill-equipped. "Nothing is ready," he
reported back to Eugénie, who had once again been made regent of
France. "We do not have enough troops. *Je nous considère d'avance
comme perdus."**

In hindsight, there has spread a legend that the French went blun-
dering into battle and were cut to pieces by Helmuth von Moltke's
superbly trained and equipped legions, but as usually happens, the first
clashes of the Franco-Prussian War were exercises in ignorance, incom-

*"I consider us, in advance, as lost."

petence, and brute slaughter. In one of the first encounters at Wörth on August 5, the Prussians suffered 10,500 killed and wounded, the French 11,000. At Spicheren the following day, the Prussians lost 4,500 men, the French 2,000. In both cases, though, the Prussians doggedly kept fighting and ended by taking many French prisoners, 9,000 at Wörth, 2,000 at Spicheren. It was true that the French went to war like blind men, equipped only with maps of Prussia, not of France, and French cavalrymen at one point charged gallantly into an unmarked ditch fifteen feet deep. The main advantages that the Prussians had, though, were a superb commander, Count von Moltke, a superb general staff that kept analyzing and correcting battlefield errors, and a superbly accurate breech-loading cannon, manufactured by Krupp and displayed at the great Paris Exposition of 1867, where it had been generally ignored by the misguided rulers of France.

Severely battered in these opening engagements, Napoleon and his generals decided to pull back toward Paris and reorganize their defenses. When they informed the empress of their decision, however, she countermanded the move and ordered them forward, onto the attack. She also dismissed Ollivier from the cabinet and replaced him with a general, Charles-Guillaume-Antoine Count de Palikao; that was the end of the "liberal empire." How this untrained Spanish woman acquired the authority to overrule an emperor, a leading cabinet minister, and a general staff remains something of a mystery, but so it happened. The military commanders who had already withdrawn as far as Chalons turned around and marched eastward again. Moltke, amazed at their folly, force-marched his troops around behind them. Near the town of Sedan, Moltke was waiting for them with an army of more than 200,000 men. According to Zola's account in *The Debacle,* anyone with a knowledge of the terrain could see that it was a trap, but the French commanders saw nothing (except, of course, for the general who stoically declared, *"Nous sommes dans un pot de chambre, et nous y serons emmerdés"°*). At dawn on September 1, in thick mists rising from the River Meuse, Moltke sprang his trap.

"I never dreamed of a catastrophe so appalling," Napoleon later reported to Eugénie. "After several hours of fighting, our troops broke into a rout and tried to reenter the town. The gates were closed; they

°"We are in a chamber pot, and there we will be shat on."

clambered over them. The town was then full of a dense crowd, mixed up with vehicles of all descriptions, and on the cluster of human heads the shells rained down...tearing off the roofs and setting the houses on fire."

Never free of pain, and strangely rouged to disguise his condition, the emperor spent hours galloping to and fro across the battlefields, almost deliberately risking death from the Prussian cannonades. Then, when the outcome appeared completely obvious, he gave the order to surrender. That, too, was rejected, this time by General Emmanuel de Wimpffen, a vainglorious commander who had just arrived from Paris with orders to take charge and give no quarter. "Your Majesty may be quite at ease," Wimpffen declared amid all the signs of failure and defeat. "Within two hours, I shall have driven your enemies into the Meuse."

About two hours further into the disaster, Napoleon complained to one of his generals, Barthélemi Lebrun, "Why does this useless struggle still go on? An hour and more ago, I ordered the white flag to be flown."

Lebrun carried a white flag to Wimpffen.

"Drop that rag!" Wimpffen shouted. "I mean to fight on."

Napoleon ordered the white flag flown. Wimpffen resigned. Napoleon then sent a staff officer to carry a letter to King Wilhelm of Prussia, who had brought much of his court to watch the spectacle. "*Monsieur mon frère,*" the letter began, "having been unable to die in the midst of my troops, there remains to me nothing but to give up my sword into the hands of Your Majesty...."

Truce negotiations among the generals dragged on all that evening, with Wimpffen constantly objecting to the Prussian demands for complete surrender. At dawn the next morning, Napoleon finally crawled into an open carriage and had himself driven toward the German lines. The carriage stopped in the village of Frenois so that a staff officer could ride ahead to find Bismarck. The Prussian chancellor arrived on horseback. The emperor asked if they could meet in a nearby weaver's cottage so that he would not have to endure the torment of any further travel. Bismarck agreed. The two entered the cottage and talked for a quarter of an hour. Then Bismarck rode away again, and Napoleon walked up and down in the garden, chain-smoking cigarettes. When a troop of Prussian cavalrymen rode up and surrounded the cottage, Napoleon seemed surprised at being taken captive, but he went quietly.

"I should have preferred death to the pain of witnessing so disastrous

a capitulation," he wrote to Eugénie that evening. "Nevertheless, it was, under the circumstances, the only means of avoiding the slaughter of 80,000 people....I have just seen the king. He spoke to me with tears in his eyes of the distress I must feel. He has put at my disposal one of his châteaux near Cassel. But what does it matter where I go! I am in despair. Adieu. I kiss you tenderly."

In Paris, disbelief. Incredulity. Denial and rejection. The idea that the most powerful army in the world had simply surrendered, that the emperor himself was a humble prisoner—it was not possible. "Who will be able to paint the dejected faces," Edmond de Goncourt wrote in his diary, "the heedless coming and going of feet aimlessly beating the pavement, the anxious asides of shopkeepers and concierges on their doorsteps, the black crowds at street corners...the rush to the newspaper kiosks, the triple lines of people reading under every street light...? Then there is the rumbling clamor of the crowd, among whom anger follows on stupefaction. Then there are large bands running along the boulevards with flags in front of them, repeatedly shouting, 'Down with him!'"

And then on the next day, September 4: "A frightening silence here, under a gray sky that makes everything sad. Around four o'clock, this is the way the Chamber of Deputies looks on the outside. On the gray façade from which the sun has gone, before and around the columns and on the steps, a crowd, a world of men, whose blouses make white and blue spots against black broadcloth. Many have branches in their hands and green leaves on their round hats.... A hand rises above all the heads and on a column writes the list of members of the provisional government in chalk in great red letters. Somebody has already written on another column: *The Republic has been proclaimed.* Applause, shouts, hats thrown into the air, people climbing the pedestals of the statues, making a group around the figure of Minerva...."

Again we confront the puzzling question of authority. Those various politicians who "proclaimed" the Third Republic had no legal right to do so; their choice of the stodgy Paris commandant, General Louis Trochu, as head of a "Government of National Defense" was nothing more than an improvisation; they represented nothing but themselves and a shouting crowd milling around the Hôtel de Ville. The last time the French people had been called on to express a political judgment, the previous May, just two months before the war began, they had supported

Napoleon's newly liberalized regime by a thunderous 7.4 million to 1.6 million. And the Empress Eugénie was still the regent and the sovereign power in France. She was, however, in a state of distraction, pacing around the palace in her unchanged black cashmere dress. "For three or four days I had received no telegrams, no letters, from the emperor," she later recalled. "And that long and inexplicable silence kept me in a frightful state of anguish. I could not eat, I could not sleep. I was choked with sobs...." Then came a telegram from the emperor: "The army has been captured. I have had to surrender my sword...." The empress screamed. "Do you hear what they say—that the emperor has surrendered?" she cried to two amazed attendants. "A Napoleon never surrenders.... Why did he not die? Why is he not buried beneath the walls of Sedan? Could he not see that he was disgracing himself?" Then she began weeping. Then she fainted.

On September 4, her last day on the throne, the empress went to mass, then attended an inconclusive cabinet meeting. After lunch, a delegation from the Legislative Assembly came and asked her to abdicate, but she equivocated. "My one care, my one ambition," she said, "is to fulfill completely the duties which have been imposed on me." Outside the palace windows, there were cries of *"Vive la République!"* and *"Á bas l'Espagnole!"*°

Three cabinet ministers came to tell the empress that the mob had seized control of the legislature in the Palais Bourbon, that crowds were marching up the Rue de Rivoli toward the Tuileries, that her very life was in danger. The empress asked the general in command of the palace guard whether he could hold off the crowds without violence.

"Madame, I do not think so," he said.

"I am not afraid to die," the empress said.

"Is it Your Majesty's wish," asked Pierre Fiétri, the prefect of police, "to cause a general massacre of your attendants?"

Eugénie hesitated a moment, then gave in. "I will go," she said. "I have done my duty."

Hastily outfitted in a black straw bonnet, a veil, and a long cloak, the empress started down the main stairway in the company of two diplomats and one lady-in-waiting, but she soon learned that the mob had already forced its way into the palace courtyard, and that there was no

°"Down with the Spanish woman!"

way to reach an imperial coach. Indeed the only way out of the palace was through the closed galleries of the Louvre. Through the Grand Galerie, past those stately Poussin portraits of Orpheus and Eurydice, past La Tour's somber *Adoration of the Shepherds,* past the frolicking heroines of Boucher and Fragonard, and then past all the royal jewelry in the Galerie d'Apollon, the crown of St. Louis and the 137-carat Regent diamond, until finally Eugénie found herself pausing before Géricault's grandiose *Wreck of the Medusa.* "How strange!" she later recalled thinking. "How strange that this picture should be the last one I should ever look at in the galleries of the Louvre!"

Down three flights of broad stone steps, then, the empress and her companions fled, past all those tombs and monuments of the half-forgotten pharoahs of Egypt, all the relics that the first Napoleon had brought back in triumph from his campaigning along the Nile.

"Are you frightened?" asked one of Eugénie's escorts, the Italian ambassador, Constantine Nigra. They could all hear the shouting of the mob in the distance.

"You are holding my arm," said Eugénie. "Is it shaking?"

Just inside the outer door, the ambassador counseled caution.

"We must wait a little longer," he said.

"No," said Eugénie. *"Il faut de l'audace."*°

And so they emerged onto the street in front of the church of Saint-Germain-l'Auxerrois, and there they found an ordinary taxi stand, and the ambassadors put the two ladies into a closed carriage. They just narrowly avoided discovery. *"Voilà l'Impératrice!"*† a street urchin shouted. Ambassador Nigra boxed his ears and told him to keep quiet.

The carriage took the empress and her lady-in-waiting, Madame Lebreton, to the home of a court chamberlain who could help the fugitives reach London. When they reached his place on the Boulevard Haussmann, however, the chamberlain was not there, so the empress had to seek some other protector. She decided to call on Dr. Thomas Evans, the Philadelphia dentist. There was only one difficulty. Empresses do not generally carry money, and the three francs that Madame Lebreton had used to pay off the coachman were the last three francs she had. So the two ladies had to walk across Paris to the dentist's house on what is now

°"We have to be daring."

†"There's the empress!"

the Avenue Foch but was then called the Avenue de l'Impératrice. Dr. Evans was not at home either, so the two women simply sat down to await his return. When he did return, he did escort them safely to London, where Eugénie's exile was to last another fifty years.

<center>❦</center>

The poets are the ones who keep score, and so it was the long-banished Victor Hugo who wrote the epitaph for Napoleon III, himself an exile in England for another two years before his bladder ailment killed him:

> *Le grand regard d'en haut lointain et formidable*
> *Qui ne quitte jamais le crime, était sur lui;*
> *Dieu pousse ce tyran, larve et spectre aujourd'hui*
> *Dans on ne sait quelle ombre où l'histoire frissone,*
> *Et qu'il n'avait encore ouverte pour personne,*
> *Là, comme au fond d'un puits sinistre, il le perdit.*

It is always difficult to translate poetry, and it is particularly difficult to translate the muscular rhetoric of Hugo's verse. This is an approximation:

> *From on high, the distant and formidable eye*
> *That never winks at crime was upon him;*
> *God pushed this tyrant, today just a ghost,*
> *Into who knows what darkness, where history shudders,*
> *And where He never before consigned anyone.*
> *There, as at the bottom of some sinister pit, He lost him.*

<center>❦</center>

Once the Prussian siege was under way, Manet went on a tour of northeastern Paris and found a state of virtual chaos. "Everybody has left," he wrote to his wife by the balloon postal service. "All the trees have been cut down. They're burning everything. Haystacks are burning in the fields, pillagers are hunting for potatoes which haven't been dug up.... I believe we are ready to put up a stiff defense...."

Manet's letters are surprisingly enthusiastic and combative. He missed his wife, but he was also glad that she had left. "To begin with, women are only a worry to the men...." he wrote, "and besides, very few

women have stayed behind. Even a lot of *men* have gone away, but I think that they will pay for it on their return. This evening I went with Eugène [his younger brother] to the meeting in Belleville where the names of absentees were read out, and it was proposed to post their names throughout Paris and to confiscate their goods and sell them for the benefit of the nation...."

Men who remained in Paris, on the other hand, were subject to sudden outbreaks of public hysteria about Prussian spies. Several Jews were roughed up for speaking with German accents. An American clergyman who was sitting on a bench on the Champs-Élysées and writing in his diary what he had eaten for breakfast suddenly found himself under arrest on a charge of drawing a secret map of Paris. Even Auguste Renoir, sketching one of the bridges across the Seine, aroused the suspicion of some National Guards, who arrested him as a spy. A crowd quickly gathered and began shouting for a summary execution. The soldiers took Renoir to their headquarters, where an official recognized him and set him free.

"Here we are at the decisive moment..." Manet wrote in late September, long before any decisive moment was near. "There is fighting on all sides all around Paris. The enemy yesterday inflicted some rather considerable losses. The mobile forces took the fire with courage.... I haven't written you these last few days because I have been on guard duty on the fortifications. It's very tiring and very hard. We sleep on straw and there isn't enough for everybody. Still, war is war...." And again: "The day before yesterday, we fired 25,000 artillery shells at the enemy, which inflicted some rather considerable losses." And again: "The Prussians have the air of repenting having undertaken the siege of Paris." And again: "The Prussians dare not and cannot attack us."

During this noisy stalemate on the ramparts, another kind of war was beginning—also a noisy stalemate—and that pitted many of the Parisian workers and soldiers against their own government. The city's so-called Red Clubs, outlawed under the empire, had reopened again as centers of argument, agitation, and boisterous social life. Manet was among those who went to take part. "Yesterday, I went with Degas and Eugène to a public meeting at the Folies-Bergères," he wrote to Suzanne. "We heard General Cluseret [later a leader of the Commune]. It was very interesting. The provisional government actually has very little popularity, and the true republicans seem to be proposing to overthrow it after the war."

The National Guards, which had recruited such patriotic idealists as Manet and Degas in the defense of Paris, also served as a kind of welfare relief organization. Its pay of one and a half francs a day provided its 300,000 men with the only wages available in the besieged city, but since the army's suspicious commanders gave the guards little military responsibility, many of them spent much of their time grumbling and carousing. And after General François Bazaine surrendered on October 29 the 180,000-man army that the Prussians had bottled up in Metz, the Parisians foresaw a national surrender. Apparently quite spontaneously, a crowd besieged the Hôtel de Ville and kept General Trochu and his aides prisoner for several dangerous hours. Only after much maneuvering and bargaining could the so-called Government of National Defense restore what passed for order in its own capital.

Manet was very casual in mentioning to his wife that he had been to see "the Morisot ladies," and that they would "undoubtedly decide to leave Passy, which will undoubtedly be bombarded." Berthe Morisot, now nearly thirty, was one of those women who remained in the besieged city. "I have made up my mind to stay," she wrote her departed sister Edma in Gascony, "because neither father nor mother told me firmly to leave; they want me to leave in the way anyone here wants anything— weakly, and by fits and starts. For my own part I would much rather not leave them, not because I believe that there is any real danger, but because my place is with them, and if by ill luck anything did happen, I should have eternal remorse. I feel very sad and completely silent. I have heard so much about the perils ahead that I have had nightmares for several nights, in which I lived through all the horrors of war. To tell the truth, I do not believe all these things...."

The Morisots were particularly worried about Berthe's brother, Tiburce, a lieutenant in the imperial army, now missing in action near Sedan. In Manet's warlike mood, his visit to the Morisots was a mixed blessing. "The tales that the Manet brothers have told us about all the horrors that we are likely to experience are almost enough to discourage the most stout-hearted," Madame Morisot wrote. "You know how they always exaggerate, and at present they see everything in the blackest possible light. Their visit has had a bad effect on your father, who is again taking up his favorite theme, trying to persuade us to go away with-

out him. His overwrought nerves are very trying; he would drive an entire regiment crazy, and at present he is exasperated by my calm.... The fact is, things never turn out as well or as badly as one anticipates.... The Manets said to Berthe, 'You will be in a fine way when you are wounded in the legs or disfigured.' Then Berthe took me to task for refusing to believe such things possible."

Berthe Morisot soon found, as people do, that she could get used to all the dangers Manet so cruelly threatened her with. "Would you believe that I am becoming accustomed to the sound of the cannon?" she wrote to her sister. "It seems to me that I am now absolutely inured to war and capable of enduring anything." And in mid-October, Madame Morisot reported that they even went out in the streets to look for signs of fighting. "Each day we hear the cannonading—and a great deal of it," she wrote her daughter. "All the fighting is taking place near us.... It is impossible to keep still; Berthe and I got as wet as water spaniels when we went to see where the fighting was taking place, and we almost fainted when we saw a body on a stretcher...."

And then they played hostess. "Monsieur Degas was so affected by the death of one of his friends, the sculptor Cuvelier, that he was impossible," Madame Morisot wrote. "He and Manet almost came to blows arguing over the methods of defense and the use of the National Guards, although each of them was ready to die to save the country.... We are very much on edge, very sad. Berthe worries me a great deal. She seems to be getting consumption. She fainted last week...."

<center>❧❧❧</center>

Manet's letters to his wife continued heroic. "The army of Paris made a grand sortie against the enemy positions on Friday," he reported on October 23. "There was fighting all day. I think the Prussians lost many men." But Manet himself was suffering from an unexplained "foot ailment" that kept him confined to quarters much of the time. And smallpox had broken out. And the food shortage was beginning to be a constant torment. "For the moment, we are reduced to seventy-five grams of meat per person; milk is for children and the sick," he wrote on October 23. And the following week: "We are now on a diet of horse flesh; donkey is regarded as a feast fit for princes."

The Germans had thought that the siege would last only about two weeks. Bismarck had scornfully predicted that "eight days without *café*

au lait" would be too much for the degenerate Parisians to endure. The French had not known quite what to expect, and, as in most other aspects of this war, they had made few plans. Shepherds brought flocks of sheep and cattle to pasture in Napoleon's cherished public gardens in the Bois de Boulogne, and the trees there were chopped down for fire-wood, but the Bois itself was outside the city walls, and the government seemed to have no plans to impose rationing, to prevent hoarding or speculation. A siege of a modern metropolis of 2 million people was simply unimaginable. It could not happen.

When the cattle of the Bois de Boulogne had been eaten, the unimaginable began to be imagined. Two trotting horses that Czar Alexander had given to the emperor, prize animals valued at more than 50,000 francs, went to a butcher for 800. It was no longer possible to feed the animals at the zoo, and the animals themselves went on the block. Not all at once. The first to go were those of which the zoo had many specimens, deer and antelope, for example, and camels. The lions and tigers survived, perhaps because of their value, perhaps because nobody wanted to attack them. But the monkeys were also spared, at least for a time, out of what an English journalist called "a vague and Darwinian notion that they are our relatives." All in all, according to one less than infallible accounting, the Parisians devoured 65,000 horses during the five-month siege, plus 5,000 cats and 1,200 dogs. The fashionable Jockey Club listed "rat pie" on its menu.

Even more than in Manet's letters, food becomes a kind of leitmotif in the brilliant journals of Edmond de Goncourt. For all his vanity and snobbishness, Goncourt was a superb reporter, working for a newspaper that existed only in his own head. Grief-stricken by the death of his younger brother and collaborator, Jules, who had succumbed to syphilis just before the war began, Goncourt abandoned the joint journal they had kept since 1851, but he could not resist recording the fall of the Empire and then the great siege. He went everywhere, recording, recording. When the Republicans opened up the imperial archives and began searching for evidence of scandal and corruption, Goncourt inevitably went to the Tuileries to watch, inevitably felt guilty, inevitably joined in the search. "Unpainted wooden filing cases are ranged against the walls clear to the ceiling, and overflow with papers in bundles and cartons," he wrote. "Tables on sawhorses sag under the disorderly mountain of letters, papers, receipts, bills of sale. Held by a tack stuck into the

gold frame of a mirror is the *Instructions for Inventory of the Correspondence*. I feel as though I have entered the black chamber of the revolutionary inquisition, and this detestable opening up of history is somehow repugnant to me.... I pick up one of the papers at random; it is a bill to that great spender Napoleon III for darning his socks at twenty-five centimes apiece."

Goncourt was fascinated by the spectacle of the city of Paris trying, like some blind but powerful organism, to provision itself and protect itself against the impending disaster. He knew, of course, that the poor went hungry even in peacetime, but he watched with a kind of bemused stoicism as even the prosperous began to encounter unfamiliar difficulties.

"September 24:...Restaurant bills of fare are becoming limited. The last oysters were eaten yesterday; eels and gudgeons are all that is left in the way of fish....

"September 27: Yesterday a big demonstration by people on the Boulevard des Italiens against butchers. They demand that the government sell its cattle without the intermediary of these speculators in human misery.... Paris is anxious about its daily pittance. Little groups of women gesticulate vigorously; at the corner of the Rue Jean-Jacques Rousseau and the Rue Saint-Honoré I come upon an angry group beating against the closed shutters of a grocer's shop....

"October 1: Horsemeat is slipping quietly into the Parisian diet. Day before yesterday Pélagie [his servant] brought home a piece of steak which, seeing her doubtful expression, I did not eat. At Peters' yesterday they brought me roast beef; I examined the meat, which was watery, without fat, and striped with white nerves.... The waiter assured me, though not very firmly, that this horse was beef.

"October 10: This morning I go for my ration card. I feel as though I am beholding one of those long lines of the time of the Revolution...a mixed group of people waiting, old women in rags, guardsmen in kepis, and lower-middle-class men all standing about in improvised premises with whitewashed rooms where you recognize your none-too-honest local tradesmen seated around a table...supreme disposers of what you get to eat....October 20: The big Central Market is very strange. Where they used to sell fresh fish all the stalls are selling horsemeat; instead of butter they have beef or horse fat in big squares like yellow soap. But the movement and animation are at the vegetable market, which is still in

good supply, thanks to the foragers. There is a crowd around little tables laden with cabbages, celery, cauliflower, which the women vie for...and carry home in napkins....

"October 23:...In the utter darkness of the Rue de Tournon a hole of light under an awning from which cauliflowers and strings of garlic are hanging. A group of people in front of it. It is a fruit store where half the display spills out over the sidewalk; in a pool of blood you see two large deer, their throats slit and their entrails cast aside as though to a pack of dogs. Enormous carp push their bluish noses to the surface of the rippling water in a child's bathtub. By the light of a candle guttering in an old copper candlestick you see the golden neck of a young bear pierced by a round hole, and his four paws folded in death. These were boarders at the zoo whom ravenous Paris will fight over tomorrow....

"October 29: ... This evening I have donkey steak for dinner....

"November 7: ... At every street corner there are people selling things to eat. In front of Thiers' house a man from the country with two rabbits. On the Place de la Bourse a woman who carries a live hen from group to group, pulling back its feathers to show how fat it is. The strange transformation that businesses are undergoing these days!... A butcher shop on the Rue Neuve des Petits Champs has changed it name to Hippophagie and displays under the bright gaslight an elegant skinned animal with the abdomen cut out in festoons and lace and garlanded with leaves and roses; the animal is a donkey.

"November 24: ... The ragman on our boulevard, who nowadays is standing in line at the public market for a cookshop proprietor, was telling Pélagie that he has bought cats at six francs apiece, rats at one franc apiece, and dogmeat at one franc a pound for his principal....

"December 6: On today's bill of fare in the restaurants we have authentic buffalo, antelope, and kangaroo....

"December 8:...You talk only about what is eaten, can be eaten, or can be found to eat. Conversation does not go beyond that. 'You know, a fresh egg costs twenty-five sous!'.... I saw some dog cutlets; they're really very appetizing: they look just like mutton chops.'... Hunger is beginning and famine is on the horizon....

"December 28:...Potatoes are now twenty francs a bushel....

"December 31:...I am curious enough to go into the shop of Roos, the English butcher on the Boulevard Haussmann. I see all sorts of bizarre spoils. Hanging on the wall in the place of honor is the trunk of

young Pollux, the elephant in the zoo; and among nameless meats and exotic horns an employe offers camel kidneys for sale.

"The proprietor is exhorting a circle of women: 'It's forty francs a pound for filet and trunk.... Yes, forty francs.... You think that's high? But you know, I'm not sure that I'll manage to break even. I counted on 3,000 pounds, and it has only come to 2,300.... The feet, you want to know the price of the feet?... Twenty francs.... Oh, let me recommend the blood sausage. Don't forget that elephant blood is the most generous blood of all. His heart, did you know, weighed twenty-five pounds.... 'And there is onion, ladies, in my blood sausage.'

"I settle for two larks, which I carry off for tomorrow's lunch....

"At Voisin's this evening I see the famous elephant blood sausage again; indeed I dine on it."

<center>⊙⊙⊙</center>

The killing of the zoo's celebrated elephants, Castor and Pollux, also inspired Victor Hugo to bitterly comic poetry.

"Nous mangeons du cheval, du rat, de l'ours, de l'âne," he wrote in *The Terrible Year,* a fat volume of verse devoted to many different aspects of the siege.

> *Paris est si bien pris, carré, muré, noué,*
> *Gardé, que notre ventre est l'arche de Noé;*
> *Dans nos flancs toute bête, honnête ou mal famée,*
> *Pénètre, et chien et chat, le mammon, le pygmée,*
> *Tout entre, et la souris recontre l'éléphant....* °

Hugo, the Empire's great public enemy, had just returned to Paris in triumph on the eve of its encirclement. A member of the legislature of the Second Republic, he had misguidedly supported Napoleon for the presidency but angrily broke with him on the night of Napoleon's coup d'état. Indeed, he had gone to the Bastille that day and harangued the soldiers and police in an effort to keep them loyal to the Republic. The police came to his house at night, searched the place, smashed furniture,

° "We're eating horses, rats, bears, donkeys. / Paris is so well caught, squared, walled in, tied up, / Guarded, that our belly is Noah's Ark; / Into our guts, every animal of good or ill repute, / Penetrates, both dog and cat, the mammoth, the pygmy, / They all enter, and the mouse encounters the elephant. ..."

and terrified Hugo's wife and daughter. Only at the insistence of his mistress did he flee to Belgium in disguise. After nearly twenty years of noisy exile on the island of Guernsey, Hugo clearly saw that Napoleon's declaration of war against Prussia would soon mean the end of his empire and the end of Hugo's own exile. On the day of Sedan, Hugo was awaiting the debacle in Brussels, less than one hundred miles away. He wept at the news and boarded the next train to Paris. By the time that train reached the Gare du Nord, thousands of Parisians had gathered to welcome the white-haired exile. *"Vive Victor Hugo!"* they shouted. They threw flowers. They even recited whole verses of Hugo's *The Punishments*. Again, the old man wept.

Hugo wrote an impassioned appeal to the Prussians to accept the fall of the empire as the limit of their victory, but neither Bismarck nor Moltke was inclined to spare the French capital from the hardships of total defeat. Goncourt went with Théophile Gautier to call on Hugo and described the returned hero with characteristic malice: "The god is surrounded by female creatures. There is a whole sofa full of them; the honors of the salon are done by an old silver-haired woman in a dress the color of dead leaves, with a low-cut neck revealing a considerable expanse of old skin.... As for the god, he seems old to me this evening. His eyelids are red; his complexion is brick-color... his beard and hair are tangled. A red jersey sticks out beyond the sleeves of his coat; a white scarf is wound around his neck. After all sorts of activity, doors opening and closing, people entering and leaving, actresses coming for permission to recite something from *The Punishments* in the theater... Hugo drops down on a low chair and in his slow speech which seems to come out after laborious reflection, he begins, apropos of microscope photography, to talk about the moon, the great desire he has always had to know about its details...."

Goncourt, who kept referring to Hugo as old, was then forty-eight, Hugo sixty-eight, but the younger man was almost morbidly fascinated by Hugo's lechery, describing him as "one of those sexagenarians attacked by acute priapism." Aside from his wife and mistress, whom he left in charge of his grandchildren, Hugo would set out from his hotel every evening at ten and go to the home of a sympathetic journalist named Paul Meurice. "Where," as Goncourt quoted Madame Meurice in his journal, "one, two, three women were waiting for him and frightening the tenants who ran into them on the stairs. These women were of

every sort, from the most distinguished to the most sordid. And through the ground-floor windows of Hugo's room Madame Meurice's maid, strolling in the garden, would witness naked bits of strange sexual rites. This seems to have been Hugo's chief occupation during the siege."

No, Hugo had many occupations, and like all other Parisians, he was much obsessed with food. The zoo authorities sent him gifts of bear steaks and antelope chops, which he gratefully ate, but he also ate humbler fare and even wrote a small cookbook advising his fellow Parisians how they could best make use of such necessities. "Horsemeat has never been regarded as a delicacy," he wrote. "When twice boiled, however, it can be delicious, particularly when served with horseradish sauce." And further: "Garden weeds, lightly boiled, make an excellent substitute for vegetable soup." And again: "Civilized men and women find it difficult to eat rat meat when it is served broiled or baked. We are the victims of our prejudices. It has been discovered, however, that this meat, when chopped into small pieces to resemble minced beef, makes a palatable filling for meat pies...."

Bismarck and Moltke disagreed from the beginning on how to make Paris surrender. Behind its thirty-foot walls and its ring of defensive forts, and guarded by nearly 500,000 French troops, the city was virtually invulnerable to infantry attack, but its very monumentality made it correspondingly vulnerable to two other tactics: blockade and artillery fire. Bismarck wanted the city shelled into submission; Moltke and his generals insisted that hunger was a more effective weapon. Bismarck, who conscientiously read his Bible every morning, seemed to think that there was some moral purpose in the destruction of the city that his own wife referred to as "that mad Sodom." When the generals resisted Bismarck's demands, the chancellor blamed their opposition on the sentimentality of Crown Prince Frederick's English wife and mother-in-law (Queen Victoria). "The assertion of the generals that they do not have enough ammunition is untrue," he declared. "They do not want to start [a bombardment] because the heir apparent does not wish it. He does not wish it because his wife and mother-in-law are against it."

Bismarck finally got his way, as he usually did, because the generals' strategy did not work. The siege that was supposed to last through a few weeks of mounting hunger dragged on month after month. The Parisians

went hungry but refused to surrender. And so, on New Year's Eve, King Wilhelm reluctantly issued the orders to begin the systematic shelling of Paris. "May we not have to repent our folly..." the crown prince wrote in his diary.

There had been artillery fire on both sides from the beginning, of course, but that involved troops firing at each other. The target now was the city itself, the city and its 2 million civilian inhabitants. The Prussians began with a cannonade that silenced the forts at Issy and Vanves, on the southwestern side of Paris, and then moved their guns forward to within easy range of Montparnasse and the Latin Quarter. What is believed to be the first shell in the bombardment exploded in the Rue Lalande, on the Left Bank, on the morning of January 5. Shell fragments splattered over a baby asleep in its cradle. Another one of the first shells slashed open a girl walking home from school near the Luxembourg Gardens. The Prussian range of 7,500 yards could not reach beyond the Seine, but the Prussian gunners could hit almost anything on the Left Bank. They fired about 300 to 400 shells per day, every day. They used the domes of the Panthéon and the Invalides as targets. They also apparently aimed at the Salpetrière Hospital, despite the red cross on its roof, and a good many shells landed among the 2,000 old women and 1,000 insane people housed there.

"The bombardment...has had little effect," Manet wrote jauntily to his wife. He had become a headquarters staff officer in December, serving as a lieutenant under Jean-Louis-Ernest Meissonier, that popular painter of military scenes, whom Degas once described as "the giant of the dwarfs"; the two artists-in-arms pretended not to know each other. "The Prussians have sent us up to this moment something like seven to eight thousand projectiles, which have only killed or wounded a very few people.... I think we can hold on here for a long time; at least, we will do it as long as possible. Hatred is mixed up in it. The bastards are making us suffer too much; they'll have to watch out if they get beaten.... I went with Eugène to see the Morisot ladies; they are suffering and have difficulty in bearing the privations of the siege; they wish they could change places with you. So be patient...."

Madame Morisot wrote more gloomily to her daughters Yves and Edma. "We celebrated the birth of the new year in sadness and tears. Berthe's health is visibly affected.... The bombardment never stops. It is a sound that reverberates in your head night and day; it would make

you feverish if you were not already in that state. This is not my complaint but Berthe's. Yet the bombs do not do much harm—all told there are not many dead and only a few wounded, and so far there is little destruction. The Panthéon and the Grenelle quarter receive most of the bombs. However, some did hit Auteuil and the Point du Jour.... It could be supposed that we would be afraid but we are not all frightened; it is curious how much of its force an evil loses when faced at close quarters. Paris does not lose its courage. I find it superb, and yet what suffering, what dire need. It is heart-rending...."

The Prussian shelling did inflict remarkably little damage. During nearly a month of constant cannonading, the Prussians fired about 12,000 shells, killed only 97 people, wounded 278 and damaged 1,400 buildings. The Krupp guns were essentially instruments of terror—Goncourt read of a German newspaper declaring that "the psychological moment for bombardment has arrived"—and yet the psychology of terrorization is still an imperfectly understood weapon. The London Blitz seems to prove one thing, Hiroshima the opposite. When a funeral was held in Paris that January 11 for six small children all killed by a single shell, were the survivors demoralized or determined to fight harder? U.S. ambassador Elihu Washburne, the only major envoy to remain at his post throughout the siege, thought the latter: "It apparently made the people more firm and determined."

This moment of bloody stalemate Bismarck chose for the strange culmination of all his policies foreign and domestic, the triumph for which he had originally provoked—if it was indeed his provocation—the war. In the Palace of Versailles, that monument to the Sun King Louis XIV, who had so often sent his troops smashing into prostrate Germany, King Wilhelm of Prussia now proclaimed himself on January 18 to be the kaiser or emperor of all the Germans. He did not want the title, but Bismarck insisted. He even bribed the Wagnerian King Ludwig of Bavaria to make an official request. "It is not easy," Wilhelm once said, "to be emperor under such a chancellor."

Though neither shelling nor blockade had subdued the Parisians, Bismarck now acquired a new weapon, the coldest winter in years. Goncourt began recording the effects as early as December 8: "We shall lack not only food but also light. Oil for lamps is becoming scarce, candles are at an end. Worse than that, with the cold weather we are having

we are getting close to the time when we will be without coal, or coke, or wood. Then we shall endure famine, cold, and darkness....

"December 9: What weather for a war in this frost and snow! You think of the suffering of men condemned to lie down in this frozen dampness. You think of the wounded finished off by the cold....

"December 25: It is Christmas. I hear a soldier say: 'By way of celebration we had five men frozen in our tent....'

"December 26: ... It is a question of a supply of wood for making charcoal which people have begun to pillage. The cold, the frost, the lack of fuel with which to heat the little meat that people get has put the feminine part of the population in a fury and they are falling on trellises and wooden fences, tearing away everything on which they can get their angry hands.... If this terrible winter weather goes on, all the trees in Paris will go down to satisfy people's urgent need of fuel...."

Along with war and famine, the horsemen of the Apocalypse also included pestilence, and in the frozen week of January 14–21, 1,084 Parisians succumbed to pneumonia and other respiratory ailments, a figure more than six times the rate just eight weeks earlier. Deaths from smallpox climbed to 380, more than double the rate at the start of the siege. Typhoid killed another 375, more than eight times the presiege rate.

Even Manet was beginning to lose his enthusiasm. "The life that I lead is unbearable," he wrote to his mother on January 15, "and I rejoice every day that I made you leave...." And to his wife that same day: "No more gas, only bread, and the cannon all day and all night. The poor Saint-Germain quarter is going to be in a sad state. Still nothing from our side. And when does it end? Soon, I hope...."

In theory, Paris's defenders could always have fought their way out of the encircled city, but on the several occasions when they tried, they were beaten back. Though they outnumbered the thinly spread Prussians, more than half the French forces were (like Manet) poorly trained, poorly equipped, and poorly led National Guards. General Trochu and his chief aides deeply distrusted the National Guards, suspecting them all of disobedience and radicalism. So it was partly punishment and partly desperation that inspired Trochu to assign the Guards to the forefront of the last great sortie, on January 18, toward the southwest, toward Buzenval, toward Versailles.

"It was a great and proud spectacle, that army marching toward the guns booming in the distance," Goncourt reported from his vantage point at the barricade by the Étoile. "Among the men are gray-bearded civilians who are fathers, beardless youngsters who are sons, and in the ranks women carrying their husbands' or their lovers' rifles slung over their shoulders. It is impossible to convey the picturesqueness brought to the war by this citizen multitude convoyed by cabs, unpainted omnibuses, moving vans for Erard pianos, all converted into military supply vehicles." Victor Hugo, too, wrote of watching the marching columns, "drawn by that grand and vital sound/That humans make when they go forward." He was particularly struck by the presence of the women carrying guns "in the tradition of the women of Gaul." And at the city gates, he professed to "hear voices say: 'Adieu—Our guns, women!' /And the women, their brows calm, their hearts breaking,/Give them the guns that they have first kissed."

The reality was considerably less poetic. Loaded down with about eighty pounds of gear, the Guards had to wait for hours until all the troops arrived. Many of them fought bravely, but confusion and incompetence dominated the battlefield at Buzenval. There was something characteristic in a regiment described by one of Trochu's staff officers, Captain Maurice d'Herisson: "The drummer beat the charge; the colonel gave the word of command, 'En avant!' the regiment shouted, 'Vive la République!' and—nobody stirred. That went on for three hours—Ducrot [General Auguste-Alexandre Ducrot, Trochu's right-hand man] appeared on the scene in person and shouted 'En avant!' He was answered by shouts, but nobody moved." This went on all day, and at dusk the Guards opened fire on d'Herisson's party, claiming to believe that they were German Uhlans.

When Trochu ordered a withdrawal the next morning, a tallying of casualties showed that the French had lost 4,000 men, the Prussians only 700. "Hardly was the word retreat pronounced than...the debacle began..." General Ducrot reported. "Everything broke up, everything went.... Across the open country, the National Guards were taking to their heels in every direction.... Soldiers wandering, lost, searched for their company, their officers...." There was now no alternative to surrender. On January 23, Captain d'Herisson set out across the Seine in a leaky rowboat with the white-haired top-hatted figure of Jules Favre, the foreign minister in the Government of National Defense, to find Bis-

marck. When they reached German headquarters, Favre talked windily of Paris's resistance. "Ah, you are proud of your resistance?" Bismarck retorted. "...Do not talk to me of your resistance. It is criminal!"

"I am struck more than ever by the silence, the silence of death, which disaster brings in a great city," Goncourt wrote. "Today you can no longer hear Paris live. Every face is that of a sick man or a convalescent. You see only thin, drawn, pale faces; you see only yellowy pallor like horse fat."

Manet was in bed with the flu during these last days of the war. "I hope to be over it soon," he wrote from his fireside on January 18, the day of the last great sortie. "I'm supposed to be on duty tomorrow, and I'm really annoyed that I cannot get on a horse, but these days it's easy to get an inflammation of the chest. There are 4,000 people dead this week in Paris from illness alone...." And then, finally, on January 30: "It's all over and the three of us [the three Manet brothers] are still on our feet and all in one piece. There was no way of holding out. We were dying of hunger and even now we are suffering very much. We are all thin as laths. I myself have been sick for several days as a result of getting over-tired and from bad food.... You really have to have gone through what we did to know what it is like.... I will come and fetch you as soon as possible."

Berthe Morisot was sick of it all. She was quite literally ill. "Berthe has grown thinner," her mother wrote in early February. "She has hollows in her cheeks. This morning she is in bed with stomach cramps.... Provisions are not coming in very quickly; we have been living on biscuits for about twelve days, for the bread is impossible and makes us all sick." The only good news was that her son Tiburce had survived Sedan, had been taken prisoner, had escaped. But Berthe was also suffering from a kind of malady of the spirit, a combination of depression and rage. "I have come out of this siege absolutely disgusted with my fellow men, even with my best friends," she wrote to Edma. "Selfishness, indifference, prejudice—that is what one finds in nearly everyone.... I have been as much demoralized as sick."

Nor was the ordeal over. "You are right, my dear Edma, in believing that nothing will be spared us. The Prussians are to enter on Wednesday, and our arrondissement is explicitly mentioned among those to be occupied by them.... All this is very sad, and the terms are so severe that one cannot bear to think about them." When one cannot bear to think about

things, one often begins to make accusations, and when one has suffered, one often wants to accuse those who have not suffered the same. "Do you know," Berthe wrote Edma, "that all our acquaintances have come out of the war without a scratch, except for poor Bazille, who was killed at Orléans, I think. The brilliant painter Régnault was killed at Buzenval. The others made a great fuss about nothing. Manet spent his time during the siege changing his uniform. His brother writes us today that in Bordeaux he recounted a number of imaginary exploits."

What bitterness! What bitterness from the young woman who less than a year earlier had sat in that flowing white dress on that mauve sofa for the ravishing portrait known as *Repose,* and what bitterness toward the man who had created it! Now Berthe Morisot decided to get out of Paris and paint. Indeed, the elder Morisots had already decided to move to the bucolic serenity of Saint-Germain-en-Laye, in March, but Berthe wanted to go farther, to stay with her sister Edma in Cherbourg, and work. "I hope that you can put yourself in my position, and understand that work is the sole purpose of my existence," she wrote to Edma in advance of her arrival, "and that indefinitely prolonged idleness would be fatal to me from every point of view.... I do not know whether I am indulging in illusions, but it seems to me that a painting like the one I gave Manet could perhaps sell, and that is all I care about."

So she painted, and as usual, she painted Edma, strolling along the Cherbourg waterfront with her daughter Jeanne, now eighteen months old, and Edma pregnant again. *The Harbor at Cherbourg* is a wonderfully serene painting, a cool study in brown and gray tones, a study in geometric shapes of the bare-masted little fishing schooners lying at dockside, but once the eye has taken in all that background, it comes to rest on the tiny white figures of Edma and Jeanne out for a stroll. It should have been a picture to delight any mother's heart, but Madame Morisot was her gifted daughter's most relentless critic.

"She has perhaps the necessary talent—I shall be delighted if such is the case—but she has not the kind of talent that has commercial value or wins public recognition," Madame Morisot wrote to Edma. "She will never sell anything done in her present manner, and she is incapable of painting differently. Manet himself, even while heaping compliments on her, said: 'Mlle. B. has not wanted to do anything up to now. She has not really tried; when she wants to, she will succeed.' But we know that she wants to, and that when she does something, she sets about it with the

greatest ardor. But all she accomplishes is to make herself sick. If one has to do bad work in order to please the public...she will never do the kind of work that dealers buy....I am therefore a bit disappointed to see that Berthe won't settle down like everybody else."

Madame Morisot's chief concern, of course, was not the salability of Berthe's paintings so much as that of Berthe herself. Compromises must be made, and just as Berthe refused to compromise in her painting, she refused to compromise in the choice of a husband. "I am earnestly imploring Berthe not to be so disdainful," Madame Morisot wrote to the patient Edma. "Everyone thinks that it is better to marry, even making some concessions, than to remain independent in a position that is not really one." Manet, whom Berthe so obviously admired, was just as obviously unavailable, and his unavailability was such that it could not even be considered, only jabbed at, as with an umbrella, in the question of the eligibility of his younger brother Eugène, whom Madame Morisot described as "crazy most of the time." Otherwise, one could only contemplate the miseries of spinsterhood. "We must consider that in a few more years she will be more alone," Madame Morisot continued her threnody. "She will have fewer ties than now; her youth will fade, and of the friends she supposes herself to have now, only a few will remain." Almost as an afterthought to all these maneuverings, Madame Morisot added a sad conclusion: "I am beginning to dislike everyone."

Edma understood. She was older than Berthe, after all, but they had both been art students together, and both had gone off to the Louvre together to copy masterpieces, and so they had both met Braquemond, Fantin-Latour, Manet. But Edma lacked Berthe's determination, Berthe's passion. She was content to get pregnant, and when she gave birth to her second child toward the end of 1871, Berthe captured that dreamy contentment in one of her most magical paintings, *The Cradle.* It shows the baby Blanche lying peacefully asleep in a beautifully veiled crib, and Edma looking on with a mixture of pride, wonder, and adoration. It is also, of course, a painting, and thus inspired one of Berthe's academic biographers, Charles F. Stuckey, to describe the "washes of white and gray scumbling" as "a tour de force of free brushwork." Then he adds a comment that is curiously appropriate to someone who had just emerged from the Prussian siege of Paris: "*The Cradle* is most explicitly a picture about looking, Morisot's subject of preference for the next few years."

But the siege of Paris was far from over. The Prussians, though tamed now by victory, remained outside the walls. What gradually changed during the spring of 1871 was the nature of the besiegers and the nature of the besieged.

Bismarck's peace terms were harsh: the cession to Prussia of all of Alsace and most of Lorraine, and the payment of 5 billion francs in reparations, and even a symbolic parade by Prussian troops through the all-too-proudly-named Arc de Triomphe. Bismarck also professed to doubt whether the so-called Government of National Defense actually had any authority to sign a peace treaty, and so he insisted on a new national election. This election, on February 8, produced remarkable results: of the 768 representatives to the Republican legislature, more than 400 were monarchists. More generally, they were overwhelmingly conservative, rural, and dedicated to peace at any price. They chose as their leader Adolphe Thiers, the white-haired little Orléanist who had opposed the war from the start. Now seventy-three, Thiers was a shrewd maneuverer and a ruthless believer in order, but before he could rule, he had to sign Bismarck's peace treaty. Tearfully, he signed.

The treaty did not disarm the rebellious National Guards in Paris, however; that was to be one of Thiers's first tasks. Among the Guards' weapons were 200 cannons that had been bought by public subscription—partly at the noisy urging of Victor Hugo—and when the Guards heard rumors that Thiers planned to disarm them, they hauled "their" cannon up onto the heights of Montmartre. Thiers sent some 15,000 regular army troops to recapture the guns. The regulars caught the Guards by surprise at about 3:00 A.M. on March 18 and seized the guns. But by some strange oversight, the invading troops had neglected to bring along any horses to remove the captured cannons. While they sent for horses, Montmartre began to bestir itself. A radical schoolteacher named Louise Michel, who had been nursing a Guardsman wounded in the attack, ran through the streets with a rifle, shouting "Treason!"

Church bells began sounding the tocsin. "Three in the morning," Goncourt noted on the far side of Paris. "I am awakened by the alarm bell, the lugubrious tolling that I heard in the nights of June 1848. The deep plaintive lamentation of the great bell at Notre Dame rises over the sounds of all the bells in the city, giving the dominant note to the general

alarm, then is submerged by human shouts, which seem to me to be a call to arms."

In Montmartre itself, the center of the conflict, the women who were up early in their daily search for food began gathering at the crossroads, and the word of the army's attack kept spreading, and the crowds kept growing, not knowing quite what to do but increasingly determined to do something. "The alarm had been sounded..." Louise Michel later wrote. "A column was formed. The whole Vigilance Committee was there.... Montmartre arose...to the attack on the fortified heights; we went up with the speed of a charge, knowing that at the top there was an army in battle formation."

The great question in such confrontations is always the same: Will the soldiers shoot at the crowd? "We were greatly mistaken in permitting these people to approach our soldiers," General d'Aurelles de Paladine subsequently declared, "for they mingled among them, and the women and children told them: 'You will not fire upon the people.' This is how the soldiers of the 88th, as far as I can see, and of another line regiment found themselves surrounded and did not have the power to resist these ovations that were given them." Many of the soldiers turned their rifles upside down as a gesture of solidarity with the crowds. Some even took part in "arresting" their own general, Claude-Martin Lecomte, who was beaten and reviled and then confined to a National Guard post in a dance hall. When the crowd became threatening, the Guards removed Lecomte to a small house in the Rue des Rosiers, but the move only attracted new crowds of predators demanding an interrogation, a trial, an execution. Lecomte alone might have escaped with his life, but another band of Guards arrived at the Rue de Rosiers with another captured general, the white-bearded Clément Thomas who had commanded the Guards at the time of the slaughter at Buzenval. The spectacle of these two frightened captives seemed to inspire the crowd to shout for blood. One Guards officer made the mistake of calling for a show of hands. Everyone raised his hand for a death sentence. Without any pretense of a trial, the Guards dragged the two generals out into the garden and opened fire, and missed, and fired again. "Kill me!" shouted old General Thomas. "You won't stop me from calling you cowards and assassins." The Guards kept firing at Thomas until he fell dead. Then they finished off General Lecomte. Then they kept on firing. Then, as a shocked Goncourt later wrote,

"two women began to piss on the corpse, which was still warm."

Thiers had been waiting at the foreign ministry on the Quai d'Orsay since 5:00 A.M. for news that the strike force had succeeded in seizing the cannons on the heights of Montmartre. Instead came reports of mob resistance, mob violence, mob victories. Thiers's minister of war, General Charles Le Flô, estimated that only about 6,000 of the 300,000 National Guards in the city were loyal to Thiers's regime. Thiers began considering a drastic move—the same move that he had unsuccessfully urged on King Louis Philippe during the revolution of 1848: the immediate evacuation of his own capital. To prevent any further subversion of what remained of his armed forces, he would simply lead everyone who would follow him to Versailles and abandon Paris to the mob. A few of his ministers protested, but then they looked out the windows and saw a swarm of Guards assembling on the quay below. "We're done for!" shouted War Minister Le Flô, and under that bold watchword, Thiers and his entourage hurried to a secret stairway that led them from the foreign ministry to a discreet exit on the Rue de l'Université, and from there they fled to Versailles.

One of the first to realize that the government was in full retreat was a forceful young lieutenant named Paul-Antoine Brunel, who had been released from a prison term for subversion less than a month earlier. He rounded up some Guards and marched on the heavily fortified Hôtel de Ville, the headquarters of Paris Prefect Jules Ferry. Realizing that he was not only surrounded but abandoned, Ferry fled out a back window on a ladder. And so, almost by accident, and in a single day, the disorganized rebels had seized Paris. From all over the city, they came and crowded into the Hôtel de Ville and argued about what to do next. Despite a great deal of shouting, nobody seemed to know. The nearest thing to a ruling organization was a new and inexperienced group that called itself the Central Committee of the National Guards, but this committee had neither planned nor organized the uprising. The most eminent leftist leader, Auguste Blanqui, had recently been rearrested by Thiers's gendarmes. So the Central Committee decided to hold a municipal election, and within a week about half of Paris's 485,000 voters went to the polls and elected ninety legislators who promptly named themselves the Commune.

This name sounds like something inspired by Karl Marx, who was then ensconced in London and trying to expand the influence of the

International Workingmen's Association, but Marx and the International actually had little effect on the Commune. The term and the idea both derived from the repeated struggles of medieval cities to free themselves from seigneurial rule. In Paris, the revolutionaries of 1789 had created a Commune that transformed itself, in 1792, into the Revolutionary Commune, and it was this that inspired the large faction of Communards who now called themselves the Jacobins. For the rest, the Commune included a widely diverse collection of local politicians, skilled craftsmen, teachers, shopkeepers, intellectuals, Polish refugees, journalists, adventurers. At the start, it was revolutionary mainly in its passionate republicanism, its passionate opposition to what it suspected was Thiers's secret plan to restore the monarchy. It was also revolutionary in demanding Paris's right to autonomous self-government, which had been suspended ever since the Revolution of 1789. And it was revolutionary in its determination to somehow continue resisting the invading Prussians, who were still camped on the eastern outskirts of Paris, rather than acquiescing in the Thiers government's surrender.

Beyond that, the Commune's first edicts included nothing that would have shocked Thomas Jefferson. It disestablished the church and decreed public control of education. It outlawed gambling. It canceled the Rent Act, by which the Thiers government had authorized absentee landlords to collect back rents unpaid during the siege. It forbade the sale of goods that had been left in pawnshops. In much of this supposedly radical legislation, one can see an effort to remedy some of the hardships inflicted on the poor during the glittering reign of Emperor Napoleon. While the emperor, for example, gave the Countess de Castiglione a pearl necklace that cost more than 400,000 francs, plus an allowance of 50,000 francs a month, the average Parisian workman earned four to five francs for a standard eleven-hour day. Overall, Parisian wages rose about 30 percent during the two decades of the Empire while the cost of living rose 45 percent or more. The boulevards carved through the city by Baron Haussmann caused rents to double, and Haussmann himself estimated that about half the city's inhabitants lived "in poverty bordering on destitution."

The poorest of all, as one might expect, were the women. It not only shocked Goncourt that two women had defiled a slain general's corpse but it shocked a lot of observers and chroniclers of the Commune that women played such an active part in almost every outbreak of mob vio-

lence, that they often carried weapons and wore parts of guard uniforms, and that in the final battles they fought bravely on the barricades. Echoes of the bloodthirsty *tricoteuses* of '93, those legendary harridans (like Dickens's Madame Defarge) who knitted while the guillotine blade fell. It was all somehow unnatural.

Yet the Parisian workman's average wage of four to five francs a day was beyond the hopes of many women. Of 112,000 working women in Paris in 1870, fully 60,000 earned their living through needlework, for which they earned an average of two francs for a thirteen-hour day, and some made no more than fifteen centimes. "And still," *Le Journal des Demoiselles* noted, "the thread or silk must be deducted from this sum." In this grim struggle for survival, the underpaid seamstresses of Paris suffered the competition of the religious orders, which could perform similar work for about 25 percent less money, since the nuns received no pay at all. Because professions like law and medicine were virtually barred to even the most well-connected women, the highest position to which one could reasonably aspire was that of schoolteacher, and teachers were often paid even less than seamstresses, sometimes as little as 100 to 200 francs a year. While a Manet or a Zola extolled the beauties of the demimonde, it was poverty, pure and simple, that drove thousands of Parisian women to part-time or full-time prostitution.

Louise Michel, the former schoolteacher who had helped to rouse Montmartre to the attack on its cannons, was naturally one of those elected to the Commune, naturally because she had worked to feed and shelter 200 children during the siege and now she was helping to organize for women's rights. "Everything was beginning, or rather beginning again, after the long lethargy of the Empire," she wrote. "The first organization of the Rights of Women had begun to meet on the Rue Thévenot with Mme. Jules Simon, André Léo, and Marie Desraismes...." Louise Michel was not primarily interested in political power for women—"Power is evil" became one of her anarchist maxims—but rather in economic and social rights. "We women must simply take our place without begging for it...." she declared. "Equal education, equal trades, so that prostitution would not be the only lucrative profession open to a woman—that is what was real in our program."

The idealism of the Commune was mixed with a good deal of inefficiency and incompetence, particularly in the retraining and reorganization of the unruly National Guards. Perhaps the most striking example of

radical ineptitude occurred in the bungled attempt to take control of the Bank of France. Charles Beslay, a former banker who had been chosen chairman of the Commune simply because he was seventy-five, the oldest man at its first meeting, arrived at the bank's headquarters to find himself confronting 400 bank employees prepared to defend their offices with sticks. The official in charge, the Marquis de Ploeuc, warned Beslay that any interference with the bank would bring the entire French economy to a standstill. Beslay docilely acquiesced, leaving the marquis in charge while he himself moved into a nearby office. So the Commune paid its bills and its troops with money borrowed from the Rothschilds, and the marquis smuggled out to Versailles not only money but the plates with which to print it.

The most important thing the Commune failed to do, however, was to march on Versailles. In the early days, the Communards were delighted to hear that similar communes had been proclaimed in Lyons, Marseilles, Toulouse, Narbonne, and Saint-Étienne, but they failed to realize that they had to take the initiative and the offensive. Their vague efforts to discuss relations with the national government were scorned in Versailles. Granted a reprieve, Thiers rallied all his local forces, crushed the various provincial communes, organized a new army of 60,000 men under Marshal MacMahon, and announced that he was now ready to achieve "the end of a struggle which will have been painful but short."

Too late, the Communards decided to march on Versailles. Thiers struck first with a probing attack on Courbevoie, just northwest of Paris. Once again, the National Guards resisted at the start, then broke and ran. Thiers rejoiced, and so did many anti-Commune Parisians (notably including Goncourt), but the Commune still ruled Paris, and many of its citizens simply carried on as best they could. "In the midst of raging artillery fire," Goncourt wrote on April 3, "people have become so accustomed to living to the sound of cannons and have acquired such insouciance that I see gardeners quietly laying turf alongside workmen who are resetting gates with all the calm of former springs. It is unbearable, this uncertainty, this lack of knowledge about an action going on before your eyes, which you can follow with a pair of glasses but which you cannot understand." And then a week later: "I go into a café at the foot of the Champs-Élysées; and while the shells are killing up the avenue at the Étoile, men and women with the most tranquil, happy air in the world drink their beer and listen to an old woman play songs by

Thérésa° on a violin. Then, preceded by many National Guards, coffins covered with red flags go by."

In their disorganized efforts to defend their revolution, the Communards often became absurd. One commander, for example, swaggered around in what was reputed to be a Cretan uniform, including blue pantaloons and a large scimitar; another had a wife who brandished pistols in her eight-button gloves and demanded to be known as *"la générale."* Yet there was a sinister side to all this *opéra bouffe*. When the Versailles forces began shooting prisoners as "deserters"—"I proclaim war without truce or mercy upon these assassins," declared one of Thiers's fiercest generals, the Marquis de Gallifet—the Commune passed a law declaring that anyone who aided Versailles would be prosecuted, and anyone convicted would be held as a hostage. Among those arrested by the increasingly powerful police chief Raoul Rigault was the white-bearded archbishop of Paris, Monsignor Georges Darboy. But since a revolution eats its own children, as Georg Büchner had written, Rigault's roundup of public enemies and saboteurs included not only innocent bystanders but also a good number of former leaders of the faction-ridden Commune as well.

Combining both the sinister and the absurd was the Commune's determination to tear down the huge column that Napoleon I had built in his own honor in the Place Vendôme to replace a statue of Louis XIV that had been pulled down by a mob in 1792. This was a daylong extravaganza, with a band playing the "Marseillaise" and crowds cheering while a team of one hundred workmen hauled on ropes and pulleys until the giant column toppled into what one observer called "a huge mass of ruin." This was ominous because some of the Commune's zealots had larger plans. Indeed, Goncourt was shocked to hear from the poet Paul Verlaine, who worked sporadically as chief of the Commune press office, that "he has had to fight against a proposal to destroy Notre Dame."

Paris was in a festive mood, though, on the afternoon of May 21. Crowds strolled along the sunny boulevards. There was an open-air concert by some 1,500 musicians in the Tuileries Gardens, and a Commune official declared that "Mozart, Meyerbeer, and the great classics chased out the musical obscenities of the Empire." The applauding crowds had no idea that Marshal MacMahon's forces had just broken through the

°Stage name of Emma Valadon, a popular comic singer.

city walls. For some unknown reason, the Commune forces had left completely unguarded the gate at the Point du Jour, just south of Auteuil. An anti-Commune engineer who was out for a Sunday afternoon walk spotted the gap, climbed onto the rampart, and waved a white flag to the Versailles forces below. Within a few minutes, MacMahon's army began pouring through the undefended gate. By 3:00 A.M., 70,000 troops had entered the city and seized the heights of the Trocadéro; by dawn, they had captured Auteuil and Passy and crossed the Pont de Grenelle onto the Left Bank.

Now the Communards belatedly began erecting barricades, and now they belatedly discovered that Baron Haussmann's handsome new boulevards had changed the rules of urban warfare, enabling an invading army to outflank barricades, enabling artillery to clear the streets. And so MacMahon's troops inexorably pressed forward, forcing the Communards back into the center of the city. But what looks like high strategy to the commanders looks like chaos to the people at the center of the fighting. Goncourt, who had wakened once again to the sound of the church bells ringing the tocsin, set forth the following morning to find out what was happening. "I can't stay home," he wrote. "I need to see, to know. When I go out, I find everybody assembled under porte-cochères, an excited, grumbling, hopeful crowd.... Suddenly a shell burst over the Madeleine, and all the residents immediately go back indoors. Far off by the new opera house, I see a National Guardsman being carried away with a broken leg.... In the Place de la Bourse there is a gathering before a pastry-shop window which has just been shattered by a shell.... Complete confusion. Not a senior officer giving orders...."

By the next day, even Goncourt was pinned down inside a friend's apartment while gunfire ripped across a new barricade in the street below. "This is what I see through the open curtain of the window," he wrote. "On the other side of the boulevard a man is stretched out on the ground; I see only the soles of his boots and a bit of gold braid. Two men, a National Guard and a lieutenant, stand near the corpse. Bullets make the leaves of a little tree spreading over their heads rain on them....Behind them in a recess in front of a closed porte-cochère a woman is lying flat for her whole length on the sidewalk, holding a kepi in one of her hands.

"The National Guard, with angry violent gestures, shouting to someone offstage, indicates by signs that he wants to pick up the dead man.

The bullets continue to make leaves fall on the two men. Then the National Guard, whose face I see red with anger, throws his rifle on his shoulder, butt in the air, and walks toward the rifle shots, insults on his tongue. Suddenly I see him stop, put his hand to his forehead, for a second lean his hand and forehead against a little tree, then half turn around and fall on his back, arms outspread.

"The lieutenant had remained motionless by the side of the first dead man, calm as a man meditating in his garden.... Then, without rushing, he pushed his sword behind him with disdainful deliberation, then bent down and attempted to lift up the body. The dead man was tall and heavy...and slipped out of his arms to one side or the other. Finally the lieutenant lifted him up and, holding him tight against his chest, he was carrying him off when a bullet, breaking his thigh, made them turn together in a hideous pirouette, the dead man and the living man, and fall on top of each other....They told me this evening that the woman lying on the ground was the wife of one of those three men...."

As the Versailles forces kept pressing inward, the Communards resorted to the ultimate weapon: setting fire to the city around them. The Tuileries palace on fire, the Hôtel de Ville on fire, the Palais Royal on fire, the Ministry of Finance on fire, the Palais de Justice on fire, whole blocks of riverside streets like the Rue de Lille casting an orange glare across the Seine. It was a catastrophe that seemed—and still seems—almost beyond imagining. Émile Zola, who actually spent these days in the safety of the South, tried to recreate the holocaust at the end of *The Debacle* by having a bemused Prussian officer describe it to some French refugees on the heights of Saint-Denis: "Look, that black hump standing out against the red background is Montmartre.... The fire must have been started in the rich neighborhoods, and it's gaining ground, gaining ground.... Just look over there to the right, that's a new fire being started! You can see the flames, a fountain of flames with smoke rising.... And others, still others, everywhere." A British clergyman actually watching in Saint-Denis was reminded—as Paris so often reminded so many—of Babylon. "Alas, alas," he recalled a passage from *Revelation,* "that great city, that was clothed in fine linen, and purple, and scarlet, and decked with gold, and precious stones, and pearls! For in one hour so great riches is come to naught."

It is not certain to this day exactly how much of the conflagration was the result of Communard arson. Some of the fires undoubtedly were

started by Versailles troops' shelling, and every blaze spread wildly through the old buildings because of dry and windy weather. There were widespread rumors, too, of *pétroleuses,* Communard women who were supposedly seen scurrying through the streets and flinging firebombs into stairwells and cellar windows. But though these rumors led to a number of innocent women being summarily executed, nobody ever proved that they had done anything worse than carrying a half-empty wine bottle in their shopping bags.

At the Tuileries palace, however, the arson was openly and proudly undertaken. Jules Bergeret, one of the Commune's first military commanders, ordered his troops to stack barrels of gunpowder in the ornate Salle des Maréchaux and to splash tar on the rich wall hangings in the corridors. Just after ten o'clock on the night of May 23, the whole palace went up in flames. Zola again: "The Communards had set fire to both ends of the palace…and the fire was rapidly moving toward the Pavillon de l'Horloge in the middle, where a big explosive charge had been set— barrels of powder piled up in the Salle des Maréchaux. At that moment there were issuing from the broken windows of the connecting blocks whirling clouds of reddish smoke pierced by long blue tongues of fire. The roofs were catching, splitting open into blazing cracks, like volcanic earth from the pressure of the fire within. It was the Pavillon de Flore, the first to be set on fire, which was burning most fiercely, with a mighty roaring from the ground floor to the great roof. The paraffin, with which the floors and hangings had been soaked, gave the flames such an intense heat that the ironwork of balconies could be seen buckling and the tall monumental chimneys burst with their great carved suns red-hot." After the great dome collapsed in ruins, Bergeret sent to the Hôtel de Ville a message that said, "The last relics of royalty have just vanished."

Victor Hugo was appalled that the revolution should end in this orgy of destruction, and he assumed the role of prosecutor in a poem entitled "Who Is to Blame?"

You have just set fire to the library?
> Yes.
I started the fire there.
> But that is an unheard-of crime!
A crime you have committed against yourself, you villain….

Hugo carries on at length about how the arsonist has destroyed the treasures of civilization, Plato, Milton, Voltaire, how he has destroyed his own past, how he has destroyed freedom, and progress, and reason, but at the end of the indictment, he gives to the arsonist the one-line answer: "I don't know how to read." Zola provided his hero with more elaborate reasons for the destruction. "Let Paris collapse and burn like a huge sacrificial fire," the Communard Maurice tells himself, "rather than be given back to its vices, miseries, and the old social system corrupted with abominable injustice! And he indulged in another bleak dream, the gigantic city in ashes, nothing left on both sides of the river but smoking embers, the wound cauterized by fire, an unspeakable, unparalleled catastrophe out of which a new people would emerge...."

That sounds like literary rhetoric, but there were flesh-and-blood Parisians who really did feel that way. Louise Michel, born the illegitimate child of a chambermaid in a provincial château, also saw the arson as a sacrificial fire. "In my mind, I feel the soft darkness of a spring night," she wrote some years later. "It is May 1871, and I see the red reflection of flames. It is Paris afire. That fire is a dawn, and I see it still as I sit here writing....

"In the night of May 22 or 23, I believe, we were at the Montmartre cemetery, which we were trying to defend with too few fighters. We had crenellated the walls as best we could, and, except for the battery on the Butte of Montmartre—now in the hands of the reactionaries, whose fire raked us...—the position wasn't bad. Shells tore the air, marking time like a clock. It was magnificent in the clear night, where the marble statues on the tombs seemed to be alive. When I went on reconnaissance, it pleased me to walk in the solitude that shells were scouring.... Always the shells arrived too early or too late for me. One shell falling through the trees covered me with flowered branches....

"In the midst of all this Jaroslav Dombrowski passed in front of us sadly on his way to be killed. 'It's over,' he told me. 'No, no,' I said to him, and he held out both his hands to me. But he was right."

He was right. The cemetery was one of the last Communard strongholds to be captured by MacMahon's forces, and when they overran it, they discovered the corpse of the slain Archbishop Darboy lying among the murdered hostages. Their revenge was typical. They took 147 of their prisoners to the cemetery and shot them. By then, the army's shooting of prisoners had become a mass slaughter. Teams of soldiers

went from house to house and routed out anybody who looked suspicious. Anyone with a gun was shot. Anyone wearing any part of an army uniform was shot. Anyone smeared with gunpowder or what looked like gunpowder was shot. Even men with watches were shot, on the theory that they must be Communard officials. When the roundups ended, the survivors were supposed to march to prisons in Versailles, but first they had to pass through the Bois de Boulogne, where General Gallifet had established a kind of gauntlet where he checked all prisoners and summarily executed anyone who aroused his displeasure. "I am Gallifet," the general announced to his victims as they arrived on their way to prison. "You people of Montmartre may think me cruel, but I am even crueler than you can imagine."

And Goncourt, as usual, was watching. Near the Passy railroad station, he saw a collection of prisoners standing in the rain and heard one officer tell another: "Four hundred and seven, of whom sixty-six are women."

"The men have been put in rows of eight and are tied to each other with a cord around their wrists," he wrote. "They are as they were when caught, most without hats or caps, their hair plastered on their foreheads and faces by the fine rain which has been falling since morning. There are men of the common people who have made a covering for their heads with blue-checked handkerchiefs. Others, thoroughly soaked by the rain, draw thin overcoats around their chests under which a piece of bread makes a hump. It is a crowd from every social level, workmen with hard faces, artisans in loose-fitting jackets, bourgeois with socialist hats.... Among the women there is the same variety. Some women in silk dresses are next to a woman with a kerchief on her head. You see middle-class women, working women, streetwalkers, one of whom wears a National Guards uniform. Among all these faces there stands out the bestial head of a creature, half of whose face is one big bruise. None of these women have the apathetic resignation of the men. There is anger and irony on their faces. Many of them have the eyes of madwomen. Among these women there is one who is especially beautiful, beautiful with the implacable fury of a young Fate. She is a brunette with wiry hair that sticks out, with eyes of steel, with cheeks reddened by dried tears. She is *planted* in an attitude of defiance, spewing out insults at the officers from a throat and lips so contracted by anger that they cannot form sounds and words. Her furious,

mute mouth chews the insults without being able to make them heard."

Thiers's government forces lost less than 1,000 men killed during the suppression of the Commune, the Communards about twice that many. But during the slaughter known as *la semaine sanglante* (the bloody week), the government troops massacred something like 20,000 citizens, perhaps 25,000, far more than died throughout all of France during the celebrated yearlong "terror" of 1793. "The laws of war!" protested the *Times* of London. "They are mild and Christian compared with the inhuman laws of revenge under which the Versailles troops have been shooting, bayonetting, ripping up prisoners, women, and children during the last six days. So far as we can recollect there has been nothing like it in history...."

And then came the tortuous ritual of prosecuting the survivors. First, of course, came the flood of accusations by neighbor against neighbor, more than 350,000 denunciations within the first month after the fall of the Commune. Twenty-six courts-martial began operations in August to render judgment on some 40,000 prisoners. Only twenty-three were actually executed, about 10,000 sentenced to various terms of prison or deportation (among these latter was Louise Michel, shipped in a cage to eight years of exile in New Caledonia, where she promptly began helping to organize a revolt among the Kanakas). Perhaps the strangest of all these prosecutions (which lasted until 1875) was that of Gustave Courbet, who had served as president of the Commune's Art Commission. Held for three months in jail, where he was required to make felt slippers, Courbet was first sentenced that autumn to another six months and fined 500 francs. When Marshal MacMahon replaced Thiers in 1873 as president of the Third Republic, the legislature passed a new bill requiring Courbet to pay for the reconstruction of the Vendôme pillar. Courbet shrewdly moved himself and most of his paintings to Switzerland, where he instructed his lawyers to fight on and consoled himself with ten quarts of Swiss white wine per day. The government, repeatedly supported by the courts, demanded first 286,549 francs, then 323,091 francs, and finally signed an agreement in 1877 to accept payment of 10,000 francs a year for thirty-two years. By now suffering from cirrhosis and a dropsy so severe that he had to be tapped several times of more than sixteen quarts of fluid, the exiled Courbet lived only long enough to enjoy the defeat and resignation of President MacMahon at the end of 1877.

But what of Manet—where was he during the brief life of the Commune, the last months of what Victor Hugo called "the terrible year"? For him, these were apparently months of migration and anger and uncertainty. Not until a fortnight after the end of the siege was he able to leave Paris, on February 12, and rejoin his family in the Pyrenees. Planning to return to Paris on April 1, he first took them to spend a month on the Atlantic coast, just west of Bordeaux, and there, rather like Berthe Morisot at Cherbourg, he restored himself by working on landscapes, seascapes, calm interior scenes inhabited by Suzanne and Léon. The outbreak of street fighting in Paris made a return there seem unwise, so Manet wandered restlessly up the coast to Royan, to Rochefort, La Rochelle, and Nantes, then rented another house for another month in Pouliguen, just outside Saint-Nazaire, then headed toward Paris but stopped at Tours.

The exact date of his return to the capital, and the details of what he saw on his return, remain uncertain. Adolphe Tabarant has suggested that he got back to Paris as early as May 18, just before the government forces broke into the city (Paris was never fully encircled during the Commune), but other experts are doubtful. Madame Morisot wrote to Berthe on June 5 that Berthe's brother Tiburce, who was now an officer in MacMahon's invading army, "ran into two 'Communards' just at the time they were all being shot—Manet and Degas! Even now they continue to condemn the drastic means of repression. I think they are mad, don't you?" Manet himself wrote to Berthe on June 10 that "we have been in Paris for several days now." From this, Juliet Wilson Bareau deduces in the Manet catalogue that "it seems unlikely that by 'several days' he could have meant more than two weeks, the time elapsed since the end of the *'semaine sanglante.'*" It also seems possible, however, that in this period of denunciations and prosecutions, ex-Guardsman Manet might have become cautious about what he said in the presence of the Morisots, who had become ardent supporters of the Thiers regime.

Henri Perruchot offers no exact dates but suggests that the painter "wandered through the city in increasing horror, stopping every now and again to sketch some street scene: Communards being shot down by soldiers of the regular army, or a corpse lying...under a breached barricade," that Manet "emerged broken from these appalling days," that he was "too shocked to start painting again just yet," that he became "irritable and aggressive," that he suffered "sudden depressions which could

bring him near to tears," and that "at the end of August, he collapsed. His overwrought nerves had given way." That his doctor urged him to seek peace and quiet, and that he found it that autumn by the seashore in Boulogne. There he painted, among other things, a game of croquet being played at the home of the Belgian painter Albert Stevens. The players included Stevens's mistress, Victorine Meurent, newly back from a stay in America.

We can trace some of Manet's response to the terrible year, but only some, in a few of his works. He did do a lithograph, entitled *Civil War*, of a soldier lying dead before a barricade, and his friend Théodore Duret recalled that he had seen a corpse "at the corner of the Rue de l'Arcade and the Boulevard Malesherbes; he made a sketch of it on the spot." But the skeptical Ms. Bareau suggests that "this statement should neverthe-less be regarded with some suspicion," since the dead soldier bears a remarkable resemblance to *The Dead Toreador*, which Manet had shown at the Salon of 1864, and "the monumental composition is cast in a hero-ic mold...whose symbolic or allegorical character transcends the realism of the actual events portrayed."

The same kind of ambiguity surrounds Manet's most important pic-ture on the crushing of the Commune, a colored drawing entitled *The Barricade*. It shows a squad of government troops shooting some prison-ers near a captured barricade. And it looks, in its hurried energy, like a street scene witnessed that same day. Yet the most remarkable fact about *The Barricade* is that it is a reworking of the picture that Manet had done three years earlier on the execution of the Emperor Maximilian. The central figures are virtually identical, three uniformed riflemen, seen from behind, firing at three prisoners to their left, and the three prisoners starting to crumple into the cloud of smoke that obscures their faces.

The technical explanation of what Manet did can best be provided by the Bareau account in the Manet catalogue. "He either reused an origi-nal working drawing made for the Maximilian lithograph," she writes, "or made a tracing from the lithograph, then transferred it, by pressure, onto a sheet of strong wove paper about the same size as the print. Clear traces of the indented outlines of the figures from *The Execution of Max-imilian* appear on one side of the drawing. The composition appears in reverse, and the figures of the three victims and one of the soldiers have been redrawn in outline over the indented contours with black chalk or

lithographic crayon. On the other side of the sheet, all the 'Maximilian' figures appear in pencil and are visible to the naked eye...beneath the wash and gouache of *The Barricade* composition."

The only major change in the new version of the Maximilian picture was that Manet literally glued another piece of paper onto the top of his copy and then sketched onto that a series of buildings. That converted the rather unspecifically located Mexican shooting into a clearly Parisian event. But why did Manet engage in such sleight-of-hand? Why did he pretend to record a dramatic event of recent history by simply refurbishing another pretended record of a quite different event in almost equally recent history? And if one event was the killing of Napoleon's protégé and the other was the killing of his enemies, how could either of these politically contradictory pictures be a statement of any significance?

The answer probably lies partly in that odd phenomenon of creative parsimony. Just as some artists can be extravagantly prodigal, like Verdi discarding the beautiful opening scene of *Don Carlo,* others feel entitled to use their own inventions over and over again, like a Bach recasting a theme from a cantata into the slow movement of a violin concerto, or a Stravinsky reworking some rejected movie music to fulfill a commission from the Boston Symphony. Since the Maximilian lithograph had been suppressed, barred from publication, it did not, in a sense, exist. To Manet, it was still an incomplete conception, waiting for some new way of being brought to life. And just as the young Manet had invoked the authority of the past by visually quoting Goya and Titian, the mature Manet now invoked a different kind of authority by quoting himself.

Another kind of answer, though, may lie in the possibility that Manet never did see the scene that he seems to be recording, any more than he saw the execution of Maximilian, and that the two scenes were therefore not expressions of personal experiences but simply of emotional reactions toward the brutalities of civil war. If one has any strong feelings about the commandment that thou shalt not kill, then the details or circumstances of any killing are relatively unimportant. All killing is horrible.

This is not just a matter of political ambiguity either. Just as Victorine Meurent and Berthe Morisot looked quite different every time Manet painted them, so two quite different scenes of violence could look, to Manet's strange eye, very much the same. He not only did not see what other people saw, he had little interest in what other people saw. "For you, a picture is but an opportunity for analysis," as Zola had written

about *Olympia.* "You wanted a nude, and you took Olympia.... What does all this mean? You hardly know, nor do I."

One thing it may mean is that we attach too much importance to Manet's finished work and not enough to the work undone, the dreams and possibilities never brought to completion. "I will have every opportunity of doing some interesting things," Manet had written to Suzanne at the start of the siege, but he had not done them. When he returned to Paris, he found his studio in the Rue Guyot so badly damaged during the fighting that he had to reestablish himself in another location near his apartment on the Rue Saint-Pétersbourg. He anxiously attended a number of the prosecutions in Versailles, including that of Courbet, whom he perversely criticized for having "behaved like a coward at the court-martial." He wanted to paint a portrait of Léon Gambetta, the liberal leader who had escaped from besieged Paris to raise new troops against the Prussians, but Gambetta kept evading his requests for sittings. And the enigmatic picture of the execution at the barricade may actually have been only a sketch for something far more ambitious. "He sought," Ms. Bareau suggests, "to express his anger and sense of outrage in a monumental composition based on an already fully worked-out idea that he may have made in preparation for a large new Salon painting."

Something intervened. Perhaps it was nerves and depression that intervened. Perhaps it was the calm autumn in Boulogne that intervened. Perhaps it was simply the passage of time that intervened. Manet's vision of the terrible year never emerged from inside his head.

BERTHE MORISOT (II)

*I don't think there has ever been a man who treated
a woman as an equal, and that's all I would have asked,
for I know I'm worth as much as they.*
—BERTHE MORISOT

It would be difficult to imagine a more beautiful and loving portrait than Manet's image of Berthe Morisot sitting on his sofa in her long white dress, the painting titled *Repose,* but he was nonetheless determined to try again. He "finds me not too ugly and would like to have me back as a model," she wrote. "I'm so bored I might even suggest it to him myself." And so we have *Berthe Morisot with a Veil, Berthe Morisot with a Pink Shoe, Berthe Morisot with a Fan,* all done in 1872, and above all, in that same year, *Berthe Morisot with a Bouquet of Violets.*

It is simply a portrait, head-on, but it glows. Listen to Paul Valéry attempt to describe it: "Against the light neutral background of a gray curtain, the face is painted slightly smaller than life. Before all else, the *Black,* the absolute black, the black of a mourning hat, and the little hat's ribbons mingling with the chestnut locks and their rosy highlights, the black that is Manet's alone, affected me. It is held by a broad black band, passing behind the left ear, encircling and confining the neck; and the black cape over the shoulders reveals a glimpse of fair skin at the parting of a white linen collar.

"These luminous deep black areas frame and present a face with eyes black and too large, and expression rather distant and abstracted. The paintwork is fluid, easy, obedient to the supple handling of the brush; and the shadows of this face are so transparent, the light so delicate, that the tender, precious substance of Vermeer's head of a young woman, in

the museum at The Hague, comes to mind. But here the execution seems more ready, more free, more immediate.... By the strange harmony of colors, the dissonance of their force; by the contradiction between frivolous detail now outmoded and the hint of timeless tragedy in the face, Manet creates a resonance, compounds the solidity of his art with mystery...firmly stating the distinctive and essential charm of Berthe Morisot."

Berthe loved this portrait, just as she loved the man who had created it, but she had to see it sold to Manet's friend Théodore Duret, the critic and collector. Manet had another reward for her, however. He repainted the corsage of violets that she had worn in the portrait, and combined it with the red fan that she had once carried in *The Balcony,* plus a written note on which both their names are faintly legible. He thus created a still-life that was both a declaration and a confession. And this he gave to her as a souvenir.

A decade after Manet died in 1883, his friend Duret became engulfed in financial difficulties, so he had to auction off his collection of pictures, which included *Repose* as well as *Berthe Morisot with a Bouquet of Violets.* Berthe, by now a white-haired matron, commissioned an agent to bid for her, and he somehow failed to acquire *Repose,* which is why it now hangs in the Rhode Island School of Design in Providence. But Berthe did succeed in retrieving the portrait of herself with the bouquet of violets. And she kept it for the rest of her life in her new house on the Rue de Villejust (now the Rue Paul Valéry), built in the year of Manet's death.

Her daughter, Julie, later remembered making a copy of this portrait by "Oncle Édouard" in 1895, when she was seventeen. "It is hanging in my bedroom and I can see it from my bed," Julie wrote in her journal. "It's marvelous and magnificently executed, one would hardly believe that he did it in one or at the most two sittings. Maman told me she had sat for it during the day before one of the Thursday dinners that used to be held at Bonne-Maman's [Madame Morisot]. That day Oncle Édouard told Maman that she ought to marry Papa and they talked about it for a very long time." Berthe bequeathed Oncle Édouard's portrait to Julie, who kept it all her life, too. To an interviewer from *Life,* many years later, Julie recalled that Manet had, as usual, taken liberties. "Manet darkened her eyes, which were really green. Perhaps he saw her as a bit Spanish." And today this marvelous portrait still hangs in the

same house, which is now occupied by Julie's son and grandsons.

After *Berthe Morisot with a Bouquet of Violets* in 1872 came *Berthe Morisot Reclining* (1873) and *Berthe Morisot with a Mourning Hat* (1874, after the death of her father), and then, the final picture in the series, *Berthe Morisot in Three-quarter View* (also 1874). In this last portrait, Berthe looks very cool and determined, and she holds high a left hand ornamented with her wedding ring. Being unable to marry Manet, she had done the next best thing and married his younger brother, Eugène. She thus bound herself to her portraitist with the strongest bonds of the nineteenth-century bourgeoisie, those of the family. She acquired the Manet name, and though she still signed her paintings Berthe Morisot, her daughter was born Julie Manet.

Eugène Manet, who had appeared in both *Le Déjeuner sur l'herbe* and *Music in the Tuileries,* remains a somewhat shadowy figure, quiet, considerate, deferential. He is often described as "nervous" or "high-strung," which seems to imply some sort of psychological problem. "I think Eugène Manet is three-quarters crazy," Madame Morisot wrote at the time of the Commune. There is no real evidence of this, however. Eugéne never had any job or profession, which Madame Morisot held against him as a kind of moral shortcoming, but he had enough money to live well without any salary. In the church register where he was married, he identified himself as a "man of property." Berthe Morisot, who had sold a number of paintings by now, described herself in the same church register as having "no profession."

Eugène had been a shy suitor at least since the days of the Commune, but Berthe didn't take him too seriously, and her mother kept hoping that she would accept one of the self-important businessmen whom the mother kept introducing into the house. "I would prefer someone else," she grandly said of Eugène, who she claimed never looked her in the eye, "even if he were less intelligent and from a less congenial background." But Berthe, by nineteenth-century standards, was getting old, and acutely aware of it. "I'm reading Darwin," she wrote in 1873, at the age of thirty-two. "It's hardly subject matter for a woman, even less for an unmarried woman; what I do see clearly is that my situation is unbearable from every point of view."

Eugène, though not the ideal husband, was always there (so, of course, was his distracting brother Édouard). The two families vacationed together, in the summer of 1874, in the Normandy resort of

Fécamp. Eugène, who was enough of an amateur artist to appreciate Berthe's talent, liked going out into the country with her to paint together. On one such expedition they finally agreed to get married. Édouard apparently approved loudly. One can't help suspecting that he regarded it as a marvelous joke to acquire the fascinating Berthe Morisot as a sister-in-law. And one can't help noting that Berthe decided to get married very soon after the death of her stern father, just as Manet had married Suzanne only after the death of the equally stern Judge Manet. Degas gave the couple as a wedding present a portrait of the bearded and bowler-hatted Eugène sitting on a hillside, looking vague.

The marriage took place on December 22, 1874, first at the local *mairie* in Passy, as required by law, and then at the nearby church of Notre Dame de Grâce, as required by tradition. Neither Eugène nor Berthe was religious, but their families believed in tradition. Manet was one of his brother's two witnesses. "I went through this ceremony without the least pomp, in a plain dress and hat, like the old woman that I am and with no guests," Berthe wrote to her brother Tiburce. She was then thirty-three.

Whatever his shortcomings, Eugène seems to have been a good choice. Intensely loyal, he devoted the remaining eighteen years of his life to helping and supporting and admiring the strange woman whom he loved. It was a happier marriage than either of them had any right to expect.

<center>⊕</center>

The year of Berthe's marriage, 1874, was also very important to her artistic career. It marked the opening of a historic art exhibition which had been organized in the previous year, mainly by Claude Monet, but it was Degas who characteristically wrote not to Berthe but to her mother, to ask that Berthe join what was to become the Impressionist movement. She was one of the youngest people to be invited, and the only woman. "We think," Degas wrote in all simplicity "that Mlle. Berthe Morisot's name and talent are too important for us to do without."

Just as Beethoven didn't know that he had written the "Moonlight" Sonata until a minor critic named Rellstab bestowed its name upon it, just as Zola didn't know that he had written "*J'Accuse*" until the editor of *L'Aurore* put that headline on the diatribe that Zola had called "Letter to M. Felix Fauré, President of the Republic," so the impressionists didn't

know that they were the Impressionists. They modestly announced that their show represented the Société Anonyme° des Artistes, Peintres, Sculpteurs, Graveurs, etc.

The word had actually been in use for about ten years, notably by Manet, who had said at the time of his solo exhibition in 1867 that his goal was "to convey his impression." Critics occasionally applied the term to the landscapes of Corot, Jongkind and Daubigny, and one of them specifically praised Manet for his skill in capturing "the first impression of nature," but the full significance of the term emerged only from the storms that surrounded the exhibition of 1874. The catalogue was late, as usual, and there were arguments about the titles of various pictures. Renoir's brother Edmond, who was trying to edit the catalogue, complained that Monet's landscapes all seemed to have similar designations, *Morning in a Village, Evening in a Village*...Monet himself later recalled that the dispute centered on a misty view of the harbor of Le Havre. "I couldn't very well call it a view of Le Havre. So I said: 'Put *Impression*.'" The picture actually was listed as *Impression, Sunrise*. It was only one of 165 pictures by thirty artists—among them Degas, Monet, Renoir, Pissarro, Cézanne, Sisley, and Berthe Morisot, but not Manet—but it inspired the malicious hostility of the critic Louis Leroy in the satirical magazine *Charivari*, who entitled his review "Exhibition of the Impressionists."

Leroy took with him to the exhibition an academic landscape painter named Joseph Vincent, winner of various official medals and prizes, and he wrote his review as a kind of mocking dialogue between the indignant voice of scholastic authority and himself as the innocently inquiring interviewer. Vincent's first shock came on seeing the beautiful Degas *Dancer* that is now in Washington's National Gallery of Art. "What a pity," said Vincent, "that the painter, who has a certain understanding of color, doesn't draw better; his dancer's legs are as cottony as the gauze of her skirts." Next came Pissarro's *Ploughed Field*: "Those furrows?... But they are palette scrapings placed uniformly on a dirty canvas. It has neither head nor tail, top nor bottom, front nor back."

"Perhaps...but the impression is there," Leroy offered.

"Well, it's a funny impression!" snapped Vincent.

Then came Monet's marvelous scene of crowds strolling on the snowy

°*Société anonyme* (S.A.) is the French term for a corporation.

Boulevard des Capucines. "'Ah-hah!' he sneered....'Is that brilliant enough, now! There's impression, or I don't know what it means. Only be so good as to tell me what those innumerable black tongue-lickings in the lower part of the picture represent?'.

"'Why, those are people walking along,' I replied.

"'Then do I look like that when I'm walking along the Boulevard des Capucines? Blood and thunder! So you're making fun of me at last!'"

And then, inevitably, the two nay-sayers arrived in front of Berthe Morisot's exquisite portrait of Edma admiring her new baby in *The Cradle*. Vincent was outraged by the delicate image of Edma's hand on the cradle. "Now take Mlle. Morisot," he protested. "That young lady is not interested in producing trifling details. When she has a hand to paint, she makes exactly as many brushstrokes lengthwise as there are fingers, and the business is done. Stupid people who are finicky about the drawing of a hand don't understand a thing about impressionism, and the great Manet would chase them out of his republic."

Leroy had been so unerringly accurate in singling out the most gifted of his contemporaries to be excoriated as "Impressionists" that the painters of the "Société Anonyme des Artistes" could hardly help accepting their new name. Like the "wild beasts" who later took pride in having been denounced as *"les fauves,"* the impressionists remained the Impressionists.

They did not suddenly appear out of nowhere as a "school," of course. As often happens when the younger generation suddenly becomes famous, they were already approaching middle age at the time of their first exhibition in 1874. Monet, Cézanne, Renoir, and Berthe Morisot were all in their mid-thirties, Degas already forty, Pissarro forty-four (and Manet forty-two). But this emergence of the Impressionist group had been more than a decade in the coming. These young painters had been attracted from all over to the booming imperial Paris of the early 1860s. Claude Monet, for one, was the son of a prosperous grocer in Le Havre. He ignored his schoolwork, doodled in his notebooks, and soon became locally celebrated as a caricaturist. He inevitably encountered another local celebrity, Eugène Boudin, who devoted himself to the very unfashionable practice of painting seascapes, which the seventeen-year-old Monet regarded "with an intense aversion." Boudin was not to be discouraged, however. "Boudin, with untiring kindness, undertook my education," Monet later recalled. "My eyes were finally opened and I

really understood nature; I learned at the same time to love it." Boudin urged the young apprentice onward to Paris, and so, with the reluctant approval of his parents, Monet headed for the capital. He refused to enroll in the stodgy École des Beaux Arts, however, preferring a simpler institution known as the Académie Suisse, where artists could paint live models or work at whatever they liked, without any examinations. Monet's father promptly cut off his allowance.

Monet soon met a fellow student named Camille Pissarro, son of a storekeeper on the Caribbean island of St. Thomas, who had run away from home to become a painter. The two youths struck up a friendship and went out on painting expeditions together. That camaraderie was interrupted by Monet's being summoned to seven years' conscription in the army. His father offered to buy a substitute, as was common in those days; Monet refused. "The seven years of service that appalled so many were full of attraction to me..." he said. "In Algeria I spent two really charming years. I incessantly saw something new; in my moments of leisure I attempted to render what I saw. You cannot imagine to what extent I increased my knowledge, and how much my vision gained thereby. I did not quite realize it at first. The impressions of light and color that I received there were not to classify themselves until later; they contained the germ of my future researches."

Monet fell ill in Algeria, however, so he had to accede to his father's paying for his discharge. He returned to Paris early in 1862—by now bushy-haired and thickly bearded—and compromised with his father's desire for some professional discipline by enrolling in the studio of Charles Gleyre. An eminent conservative, Gleyre was nonetheless a relatively easygoing teacher whose other pupils included the young Renoir, Whistler, Sisley, and Bazille.

They were all, to some extent, Gleyre's black sheep. "The first week I worked there most conscientiously," Monet later recalled, "and made, with as much application as spirit, a study of the nude from the living model.... The following week, when he [Gleyre] came to me, he sat down and, solidly planted in my chair, looked attentively at my production. Then he turned round and, leaning his grave head to one side with a satisfied air, said to me: 'Not bad! not bad at all, that thing there, but it is too much in the character of the model—you have before you a short thick-set man, you paint him short and thick-set—he has enormous feet, you render them as they are. All that is very ugly. I want you to remem-

ber, young man, that when one draws a figure, one should always think of the antique. Nature, my friend, is all right as an element of study, but it offers no interest. Style, you see, is everything."

Renoir had similar problems. One of five children of a tailor in Limoges, he had started as an apprentice painter of the local porcelain, but he too, now twenty-one, had arrived in Paris in that same year of 1862 to fulfill a higher ambition. He too had copied the model as realistically as he could.

"No doubt it's to amuse yourself that you are dabbling in paint?" inquired the lordly teacher.

"Why, of course," said the ebullient young Renoir, "and if it didn't amuse me, I beg you to believe that I wouldn't do it!"

It is strange and striking how the great composers of the early nineteenth century—Chopin, Liszt, Schumann, Berlioz, Wagner—all recognized each other instantly when they were still in their early twenties. Much the same thing happened among the future Impressionists. Monet was still only twenty-two when he met the twenty-one-year-old Renoir at Gleyre's studio and they began going off to paint landscapes together. Cézanne, the schoolmate of Zola, had met Pissarro the previous year, and Pissarro already knew Monet. Manet and Degas met while copying in the Louvre, and Fantin-Latour introduced Berthe Morisot to Monet there. Most of these painters (not, of course, the ultrarespectable Berthe Morisot) met regularly at the Café de Guerbois, a small and relatively quiet establishment on the Grande Rue des Batignolles (now the Avenue de Clichy), and so the group came to be known as the Batignolles group. When Fantin-Latour painted his splendidly documentary *Studio in the Batignolles Quarter* (1870), he placed Manet before an easel in the center, then surrounded him with such younger admirers as Monet, Renoir, Bazille, and Zola.

The goal of the young painters' training was a showing at the official Salon, but as the students observed the Salon jurors' treatment of Manet, whose work they much admired, they began to think about alternative courses. The year after Monet and Renoir first encountered each other at Gleyre's studio was the year when they saw the Salon jurors reject *Le Déjeuner sur l'herbe* and *Mlle. V...in the Costume of an Espada,* and saw both these paintings of Mlle. Victorine Meurent appear before the mocking visitors to the Salon des Refusés. An even more important breaking point came four years later when both Manet and Courbet

decided separately not to submit anything to the Salon but to build separate pavilions and exhibit their works to visitors to the World's Fair of 1867. After both these private exhibitions closed, both failures in any critical or commercial sense, Courbet hoped to rent out the pavilion he had built, and Monet and his friends hoped to move into it.

"I shan't send anything more to the jury," Bazille wrote to his family. "It is far too ridiculous...to be exposed to these administrative whims.... What I say here, a dozen young people of talent think along with me. We have therefore decided to rent each year a large studio where we'll exhibit as many of our works as we wish. We shall invite painters whom we like to send pictures. Courbet, Corot, Diaz, Daubigny, and many others whom you perhaps do not know, have promised to send us pictures and very much approve of our idea. With these people, and Monet, who is stronger than all of them, we are sure to succeed...." But that time was not yet. Bazille soon wrote again to his family: "I spoke to you of the plan some young people had of making a separate exhibition. Bleeding ourselves as much as possible, we were able to collect the sum of 2,500 francs, which is not sufficient. We are therefore obliged to give up what we wanted to do."

Poverty affects the history of art as much as wealth. Just as Manet and Degas and Berthe Morisot could pursue their experiments without any worries about the next meal, some of the younger painters were severely handicapped by their penury. Renoir was so penniless during the unsuccessful 1867 fund-raising that he had to beg a friend to provide the canvas so that he could paint a portrait of the friend's sister-in-law. The following year, both Renoir and Pissarro were reduced to painting window blinds in order to survive. Perhaps the most afflicted of all was Monet, who had started in 1866 what he called "experimenting with effects of light and color." One of these experiments was to dig a trench in his garden near Saint-Cloud so that he could undertake a large painting entirely out of doors. The following year, he began his first cityscapes. But all through this period, his letters to various friends and acquaintances contain repeated appeals for money. Thus to Bazille, who had a modest allowance, in 1868: "I am writing you a few lines in haste to ask your speedy help. I was certainly born under an unlucky star. I have just been thrown out of the inn, and stark naked at that. My family have no intention of doing anything more for me. I don't even know where I'll have a place to sleep tomorrow.... I was so upset yesterday that I had the stu-

pidity to throw myself into the water. Fortunately, no harm came of it."

Monet's finances were never much better than disastrous, but now they became worse than before because he had become involved with a nineteen-year-old girl named Camille Doncieux. She was not a great beauty but handsome, and a personality of considerable patience and character, as anyone would have to be to survive life with Monet. Just a few days after he met her, he quickly painted a full-length portrait for the Salon of 1866. It attracted considerable attention, for it is a remarkable portrait, the face barely visible, turned away to one side, the eyes closed, so that Monet the colorist could devote great attention to his beloved's flowing green-striped dress. He then had her pose—again with her dress, this time white-flowered, more important than her face—for a huge (eight-foot-high) painting called *Women in the Garden.* The practical problem was that Camille was now pregnant, and Monet could not even support himself, much less a family. Out of a mixture of admiration and charity, Bazille bought *Women in the Garden* on the installment plan, fifty francs a month. Monet then fled from the Paris suburb of Ville d'Avray to his native Le Havre to escape his creditors. In an effort to hide his unsold paintings from the creditors, he slit some 200 canvases from their frames and stored them away; the creditors found them and sold them off at the now-incredible price of thirty francs for each lot of fifty paintings.

Monet's only recourse was to beg his father for help, but he could not bring himself to that final humiliation. So it was Bazille who wrote the letter, describing not only Monet's poverty but explaining that his first child was soon to be born. The elder Monet's answer was chilling. He said that he had a sister living in the Le Havre suburb of Saint-Adresse, who would be kind enough to offer her scapegrace nephew his room and board, but no money. As for the pregnant Camille, the elder Monet disapproved of her and showed no interest in his prospective grandchild. He said that young Claude should abandon them both.

And Monet did. He went to live with his aunt, leaving Camille in Paris without a sou. The baby was born that July of 1867 and named Jean. Monet claimed that he could not raise the train fare to visit them. Later that summer, while working at his easel alongside Sisley at Honfleur, Monet mysteriously suffered a temporary blindness. Cézanne once said that Monet was "nothing but an eye, but what an eye," and we are too far away in space and time to do more than wonder at the frequency

with which these Impressionist painters, so obsessed with their visions of light and color, suffered serious eye trouble. Degas spent much of his life struggling with a progressive blindness that finally forced him to shift from painting to sculpture. His highly gifted protégé Mary Cassatt endured the last ten years of her life blind. Renoir, Pissarro, Cézanne, they all saw their vision falter and fail. Monet, too, went blind near the end but was saved by a delicate eye operation.

He somehow recovered from this early crisis and got himself back to Paris, where he and Renoir shared Bazille's studio on the Rue Visconti. "Monet has fallen upon me from the skies with a collection of magnificent canvases," the ever-generous Bazille wrote to his sisters. And Camille took him back, so Monet painted a charming picture of her presiding over the young Jean's cradle. And the struggle went on. "My painting doesn't go, and I definitely do not count any more on fame," Monet wrote to Bazille in 1868. "I'm getting very sunk.... As soon as I make up my mind to work, I see everything black. In addition, money is always lacking. Disappointments, insults, hopes, new disappointments...." At least Camille believed in him. They were finally married in June of 1870, less than two months before the war against Prussia suddenly broke out.

They were remarkably different people, these young Impressionists—Monet the passionate visionary, Renoir the carefree hedonist, Pissarro the idealistic socialist, Berthe Morisot the acerbic aristocrat—and yet they were bound together by their deep belief in a series of radical propositions. One was the conviction commonly held by ambitious young artists, that the gates of the establishment must be broken open. Let the new generation be heard. Another, more important, was that the tradition of historical painting must give way to scenes of contemporary life, *la vie moderne.* And that the tradition of studio composition must give way to a new process of painting out of doors, *en plein air.* And that a painting need not be "finished," in the sense that every detail must be fully shown by nearly invisible brushwork. "The grand manner and subject painting began to go obviously out of date," Valéry wrote. "Filling the walls left bare of Greeks, Turks, Knights, and Cupids, landscape came and demolished the problems of *subject,* and in a few years reduced the whole intellectual side of art to a few questions about *materials* and the coloring of shadows. The brain became nothing but retina; there could no longer be any question of trying to express in paint the feelings of a group of old men before a beautiful Susanna...."

In that phrase about "the coloring of shadows," Valéry merely suggests what is perhaps the most important innovation among the Impressionists, a new sense of light and of how to convey light in pictures. In his authoritative *History of Impressionism,* John Rewald offers a succinct analysis: "Manet liked to maintain that for him 'light appeared with such unity that a single tone was sufficient to convey it and that it was preferable, even though apparently crude, to move abruptly from light to shadow than to accumulate things which the eye doesn't see and which not only weaken the strength of the light but enfeeble the color scheme of the shadows, which it is important to concentrate on.' But those among Manet's companions who had already worked out-of-doors, that is, all the landscapists in the group, must have objected to his manner of dividing a subject merely into lighted and shadowed areas. Their experience with nature had taught them otherwise. Little by little they were abandoning the usual method of suggesting the third dimension by letting the so-called local color of each object become more somber as the object itself seemed further away from the source of light and deeper in the shadow. Their own observations had taught them that the parts in the shadow were not devoid of color nor merely darker than the rest. Being to a lesser degree penetrated by the light, the shaded areas did not, of course, show the same color values as those exposed to the sun, but they were just as rich in color, among which complimentaries and especially blue seemed to dominate. By observing and reproducing these colors, it became possible to indicate depth without resorting to any of the bitumens customarily reserved for shadows. At the same time the general aspect of the work became automatically brighter. In order to study these questions further Monet, Sisley, and Pissarro began to devote themselves especially to winter landscapes...."

"White does not exist in nature," Renoir explained long afterward in examining a young student's snow scene. "You admit that you have a sky above that snow. Your sky is blue. That blue must show up in the snow. In the morning there is green and yellow in the sky. These colors also must show up in the snow when you say that you painted your picture in the morning. Had you done it in the evening red and yellow would have to appear in the snow. And look at the shadows. They are much too dark. That tree, for example, has the *same* local color on the side where the sun shines as on the side where the shadow is. But you paint it as if it were two different objects, one light and one dark. Yet the color of the

object is the same, only with a veil thrown over it. Sometimes that veil is thin, somethimes thick, but always it remains a veil....Shadows are not black; no shadow is black. It always has a color. Nature knows only colors.... White and black are not colors."

More generally, Pissarro told another young student, also many years later, how these perceptions of light should be applied: "Look for the kind of nature that suits your temperament. The motif should be observed more for shape and color than for drawing.... Do not define too closely the outline of things; it is the brush stroke of the right value and color which should produce the drawing. In a mass, the greatest difficulty is not to give the contour in detail, but to paint what is within. Paint the essential character of things, try to convey it by any means, without bothering about technique.... Don't work bit by bit, but paint everything at once by placing tones everywhere.... Use small brush strokes and try to put down your perceptions immediately. The eye should not be fixed on one point, but should take in everything, while observing the reflections which the colors produce on their surroundings. Work at the same time upon sky, water, branches, ground, keeping everything going on an equal basis and unceasingly rework until you have got it. Cover the canvas at the first go, then work at it until you can see nothing more to add. Observe the aerial perspective well, from the foreground to the horizon, the reflections of sky, of foliage. Don't be afraid of putting on color, refine the work little by little. Don't proceed according to rules and principles but paint what you observe and feel. Paint generously and unhesitatingly, for it is best not to lose the first impression. Don't be timid in front of nature; one must be bold, at the risk of being deceived and making mistakes."

If the Impressionists' first effort to join forces in 1867 was thwarted by their poverty, their growing sense of community toward the end of the 1860s was shattered by the sudden outbreak of the Franco-Prussian War. While Manet and Degas joined the armed forces defending Paris, and Berthe Morisot remained in the besieged city, many painters were more interested in painting than in taking up arms for the dissolute emperor or his patchwork successors. Pissarro fled to London, leaving fifteen years' accumulated work behind him in Louveciennes. Monet, too, decided to go to London, once again leaving the indomitable Camille to fend for herself.

Monet and Pissarro soon found each other, through the good offices

of the refugee art dealer Paul Durand-Ruel, the future sponsor of the whole Impressionist movement, who included new works by both of his new discoveries in a London exhibition of French artists. Monet and Pissarro then went off painting and museum-visiting together, just as though nothing were happening back in France. "The water colors and paintings of Turner and Constable...have certainly had influence upon us," Pissarro recalled. "We admired Gainsborough, Lawrence, Reynolds, etc., but we were struck chiefly by the landscape painters, who shared more in our aim with regard to *plein air,* light, and fugitive effects.... Turner and Constable, while they taught us something, showed us in their works that they had no understanding of the *analysis of shadow,* which in Turner's painting is simply used as an effect, a mere absence of light...."

For such disdain, Pissarro got his reward. "Here there is no art; everything is a question of business..." he wrote to a friend. "One gathers only contempt, indifference, even rudeness." And the owner of his house in Louveciennes wrote him that the Prussians had occupied the place and vandalized his paintings: "There are a few which these gentlemen, for fear of dirtying their feet, put on the ground in the garden to serve them as a carpet." All in all, Pissarro estimated, "about forty pictures are left to me out of 1,500." As for Monet, he returned from London only after a leisurely detour through Holland, then picked up the faithful Camille again, moved her to the riverside suburb of Argenteuil, and started painting new portraits of her. She was no longer the handsome girl of the prewar years. Posed next to a mass of bright red flowers in *Mme. Monet on a Garden Bench* (1872–73), she now has a mournful look in her dark-circled eyes.

The young Impressionists liked to go out in pairs—Monet and Renoir, Pissarro and Cézanne—and to paint the same scenes from the same vantage point, all learning from each other's gifts and perceptions. Yet the doors of the official Salon still remained largely closed to them. Renoir submitted two canvases for the Salon of 1873, and both were rejected; Monet, Pissarro, and Sisley didn't even bother to try. So the scene was set for one of Zola's friends, Paul Alexis, apparently prodded by the painters of the Café Guerbois. He published an article in *L'Avenir National* in May of 1873 calling on the young painters to forget about the Salon and organize a showing of their own works.

Monet immediately responded to the cue. "A group of painters

assembled in my home has read with pleasure the article which you have published in *L'Avenir National*," he wrote to Alexis. "We are happy to see you defend ideas which are ours too, and we hope that, as you say, *L'Avenir National* will kindly give us assistance when the society which we are about to form will be completely constituted." Alexis in turn picked up Monet's cue, published his letter, and announced that "several artists of great merit"—including Pissarro, Sisley, and Jongkind—had already joined Monet's nascent "society." "These painters, most of whom have previously exhibited, belong to that group of naturalists which has the right ambition of painting nature and life in their large reality," Alexis wrote. "Their association, however, will not be just a small clique. They intend to represent interests, not tendencies, and hope for the adhesion of all serious artists."

As happens every time that some young people start a new movement appealing to "all serious artists," the first question was, who would pay the bills? A rich participant? Someone's mistress? A social-climbing merchant? One person who could not pay was Durand-Ruel, the art dealer who had by now acquired the largest collection of the young painters' works. The postwar boom had ended abruptly in 1873, and Durand-Ruel had to cut back drastically on his investments. The most logical solution was for the painters to sponsor themselves, with each participant putting up an advance of sixty francs. Those who signed the founding charter on December 27, 1873, included Monet, Degas, Renoir, Pissarro, and Berthe Morisot. The main trouble with this system was that it gave everyone the right to argue about every detail.

The most fundamental disagreement, which was to haunt the movement throughout its existence, was whether the exhibit should be large or small, and if it was to be limited, who should decide on the limits? This was the same problem that had plagued the Salon ever since the beginning, for the despised jury was there to make just such decisions. But the new movement rejected the whole idea of a jury; the painters were to make their own selections, of their own works, and therefore the founders had to decide which painters to admit. To such natural leaders as Monet and Pissarro, it seemed obvious that the exhibition should concentrate on the new tendencies, the new concern with landscapes and light. But Degas felt very strongly that the exhibition should not appear radical, not a movement, simply independent of the official system.

One thing that almost all of the founding members of the group

agreed on was that they wanted to include Manet, their pioneering hero who had fought all the battles of the 1860s. They could hardly believe it when Manet repeatedly refused their invitations. But he was not really an Impressionist; he painted entirely in his studio, he had little interest in landscapes, and though he did engage in radical experiments with light and color, they were experiments all his own. No less important, Manet rejected the Impressionists precisely because they rejected the Salon. Always the reluctant revolutionary, Manet believed strongly that the Salon was the battlefield where the artistic wars could and should be fought. Independent exhibitions, as he knew all too well, amounted to very little in comparison to the Salon. And furthermore, he also believed—a recurrent delusion of his—that victory was finally in sight. At the Salon of 1873, he had won high praises for *Le bon Bock,* his rather conventional, comfortable portrait, in the manner of Franz Hals, of a bearded man contentedly sipping his beer and puffing his long pipe. Better yet, he had sold it for 6,000 francs, his highest price yet. For that matter, the watchful Durand-Ruel had come to visit his studio in 1872 and bought almost everything there—some two dozen paintings—for 49,000 francs.

"Why don't you stay with me?" Manet urged Monet and Renoir. "You can see very well that I am on the right track!" "Exhibit with us; you'll receive an honorable mention," he said to Degas. He strenuously urged the same views on Berthe Morisot, who stubbornly defied him, though Éva Gonzalès remained the loyal pupil. The Impressionists, for their part, continued the argument too. "Manet seems to become obstinate in his decision to remain apart; he may very well regret it..." Degas wrote to a friend in London. "The realist movement...has to *show itself separately*. There has to *be a realist Salon*. Manet doesn't understand that. I definitely believe him to be much more vain than intelligent." That was unjust, but Manet was indeed difficult (though certainly no more so than Degas). Pissarro insisted that his temperamental friend Cézanne join the group, and Manet reacted by saying: "I'll never commit myself with M. Cézanne." And he probably did not yet know that one of Cézanne's three submissions to the new exhibition was *A Modern Olympia,* a slapdash burlesque of Manet's masterpiece. Degas, who wanted a broad variety of participants, kept arguing. To Félix Braquemond, the last of the thirty to join, he wrote: "We are gaining a famous recruit in you. Be assured of the pleasure and good you are doing us. (Manet, stirred up by Fantin-

Latour and confused by himself, is still holding out, but nothing seems to be final in that direction.)"

They finally had a bitter confrontation, a few years later, about this continuing controversy. One of Degas's friends won the Legion of Honor, a decoration for which Manet hungered. Degas scorned it and him.

"All that contempt, my boy, is nonsense..." Manet said. "If there were no rewards, I wouldn't invent them; but they exist.... It is another weapon. In this beastly life of ours, which is wholly struggle, one is never too well armed. I haven't been decorated? But it is not my fault, and I assure you that I shall be if I can and that I shall do everything necessary to that end."

"Naturally," said Degas, the banker's son, "I've always known how much of a bourgeois you are."

Somehow, the arguments did get settled. Pissarro, who had had experience in various Socialist enterprises, suggested a joint stock company, with each stockholder signing the official regulations. Each participant would give the group one-tenth of any sales. Manet's friend Nadar, the photographer who had organized the balloon service during the war, loaned the group his studio, rent-free, on the second floor of a building at the corner of the Rue d'Aunou and the Boulevard des Capucines, just a bit south of the new opera house. That address inspired Degas, who was still trying to avoid any suggestion of a rebellious new faction, to propose that the group adopt the neutral name of La Capucine (nasturtium); the others preferred the even more neutral name of Société Anonyme des Artistes, Peintres, Sculpteurs, Graveurs, etc. As for the touchy question of how the assembled works should be hung, Pissarro won approval for an elaborate system whereby pictures would first be classified according to size and then arranged by a drawing of lots.

The official opening took place on April 15, 1874—two weeks before the official Salon, to make it clear that this was no collection of castoffs, no new Salon des Refusés. Looking back, we can only marvel that such a magnificent collection of pictures could be assembled, all new, in one time and place. Degas's *Carriage at the Races,* for example, in which the serene expanse of a pale green meadow all comes into focus on a tiny baby being fed under a white parasol, watched by a man in a top hat and a large black dog. Or Renoir's *The Loge,* in which a handsome woman in a black-and-white-striped dress, with a pink flower in her red hair, gazes

reflectively out at the theater audience while her escort surveys the balcony through his binoculars. And from Berthe Morisot not only the unforgettable *Cradle* but also the delicious *Hide and Seek,* a mother and her young daughter, both fully outfitted in beribboned hats, pretending to find and be found behind a transparent shrub.

The critics played their predictable roles as blind and ignorant buffoons, with Leroy leading the way in *Charivari.* The condemnation and derision caused Madame Morisot to worry that even though her difficult daughter was now at least engaged, her association with such controversial artists might bring disgrace upon the family. She asked Berthe's one-time teacher, Guichard, that prophet who had warned that Berthe's determination to become a painter would be "a disaster," to visit the exhibition and give her his judgment. "When I entered I became anguished upon seeing the works of your daughter in those pernicious surroundings," Guichard wrote back. "I said to myself: 'One doesn't live with impunity among madmen. Manet was right in opposing her participation.' After examining and analyzing conscientiously, one certainly finds here and there some excellent fragments, but they all have more or less *cross-eyed minds.*"

If the first Impressionist exhibition had relatively little effect on critics and other artists, it had even less on the public or the market. The number of visitors on opening day amounted to only 175—and many of them came only to jeer—as compared to a daily average of nearly 10,000 at the Salon. All in all, some 3,500 came to the Impressionists' month-long exhibit, 400,000 to the Salon. A few Impressionist paintings were sold, but the sales receipts no longer record which ones, and the sums involved were derisory. Total sales figures, derived from the 10 percent commission collected by the group, amounted to only 3,600 francs. Sisley earned 1,000 francs, Monet 200, Renoir 180, Degas and Berthe Morisot nothing, and this at a time when a popular hack like Ernest Meissonier, Manet's commander during the war, charged 100,000 francs for a commissioned painting.

The exhibition seemed for a time to have broken even on its entrance fees, catalogue sales, and commissions, but at the end of the year, Renoir summoned all available stockholders to his studio on the Rue Saint-Georges and told them that they still owed 3,435 francs, or 184.50 apiece. He therefore proposed liquidating the Société Anonyme des Artistes, Peintres, Sculpteurs, Graveurs, etc., and his proposal was

approved unanimously. So the first exhibition of the group now known as Impressionists (though Degas still adamantly rejected the term) both was a historic event and was not a historic event. It was an almost total failure, and yet it established a landmark, created a new sense of common dedication and commitment. But the real history of the Impressionist movement, with its rending conflicts and controversies, was yet to come.

<p style="text-align:center">⊙⊙</p>

Having rejected the Impressionists so that he could pursue his seemingly successful struggle in the Salon, Manet proudly submitted three new paintings to the jury for the Salon of 1874. The jury promptly rejected two of them, *Masked Ball at the Opera* and *The Swallows,* the first time Manet had been rejected in seven years. The only survivor was *The Railroad,* a strange image of a rather plump red-haired woman sitting in front of a barred railway fence and looking up from a book in her lap. Next to her, ignoring and ignored, stands a young girl of about ten, staring out through the fence into a steam-filled background.

The new railroads provided, in these times, a mesmerizing symbol of industrial (and implicitly sexual) power. Dickens conjured up a speeding locomotive to kill off the villainous John Carker in *Dombey and Son,* and Trollope used the same instrument to crush the threatening Ferdinand Lopez in *The Prime Minister.* Frank Norris portrayed the railroad as a kind of monster ravaging the California wheat fields in *The Octopus.* When Zola decided to create *la bête humaine,* he was almost inevitably a railroad worker, and almost inevitably killed by a locomotive, "found headless, without feet. ..." Tolstoy spared us such details, but the fate of Anna Karenina was much the same.

Yet if there was something sinister about the thrusting power of a railroad train, there was also a beauty in its shining steel engine spouting clouds of smoke and steam. Walt Whitman was shamelessly admiring, in "To a Locomotive in Winter": "Fierce-throated beauty!/Roll through my chant with all thy lawless music, thy swinging lamps at night,/Thy madly-whistled laughter, echoing, rumbling like an earthquake, rousing all—" Gautier called railroad stations "the new cathedrals of humanity," and Manet's teacher, Thomas Couture, urged painters to portray "that strange and mysterious power which hides a volcano in its flanks; that monster in bronze carapace and snout of fire which devours space."

J. W. Turner had already painted *Rain, Steam and Speed: The Great Western Railway*. Monet would soon take his easel into the glass-topped new Gare Saint-Lazare, a scene that nobody had ever painted before, and create twenty different versions of smoky locomotives pushing in and out.

Manet felt the attraction. Railroads were among the public activities to which he hoped to devote a series of murals in the new Hôtel de Ville (*"Paris—Halles, Paris—chemins de fer, Paris—bon port, Paris souterrain..."**). And not long before his death, he applied for official permission to go to the Gare Saint-Lazare and watch a railroad crew at work. "What a magnificent spectacle, those two men!" he said. "When I am well again I'll take them as a subject for a painting." But in creating *The Railroad,* he characteristically left all that to the imagination. One of the most striking things about *The Railroad* is that it has no railroad train in it. And although this picture is also known as *The Gare Saint-Lazare,* it has virtually no trace of the Gare Saint-Lazare either, only the imprisoning iron fence and the cloud of blinding white steam. "The steam is the hero—the modern hero—of this painting...." Peter Gay has written in *Art and Act. "The Railroad* is a poem about speed contemplated in tranquillity. I know of no nineteenth-century painting that celebrates modernity more unreservedly than this."

It is also, of course, about a number of other things. Like many of Manet's greatest paintings, it is about separation and alienation, the woman looking out at us, the girl with her back turned. It is about youth and aging, the woman passing her prime, the girl not yet there. But even to list such possibilities is to emphasize the quality of mystery that Manet was so fond of injecting into his pictures. We don't really know who these people are, or the relationship between them. Mother and daughter? A nurse and her charge? Casual acquaintances? We don't know what has disturbed the woman's reading and made her look up at the viewer (or why she is reading next to a railroad track), or why the child ignores the interruption. Such mysteries inevitably inspire scholarly divination. Harry Rand of the Smithsonian Institution, for one, has written a whole book on this painting, entitled *Manet's Contemplation at the Gare Saint-Lazare.*

Technically, this was the first *plein air* painting to be accepted by the

*"Paris—markets, Paris—railroads, Paris—docks, Paris—underground."

Salon, and only the second that Manet had ever done. (The first was *In the Garden* (1870), which showed Berthe Morisot's brother and sister on the back lawn of the Morisot house in Passy.) It thus represents Manet's semi-conversion to the Impressionists, of whom he was already regarded as the leader, but Manet was characteristically less interested in the impressionistic setting of the railroad station than in the enigmatic figures in the foreground. The girl was Suzanne Hirsch, daughter of the painter Alphonse Hirsch, whose garden near the station Manet used as his site. The woman with the book we might or might not recognize, for a decade has passed since we last saw her as a street singer and a matador and Olympia. This was Manet's last painting of Victorine Meurent, and she still wears, like Olympia, a black ribbon around her neck. But the decade has changed her, inevitably, made her heavier, fleshier, more rubicund. Those eyes that used to be so bold and defiant are now just sad.

Shortly after posing for *Olympia,* Victorine had become the mistress of Alfred Stevens, a Belgian painter of considerable talent and even more considerable commercial success, who made his fortune by portraying beautiful women of fashion. Stevens, rather oddly, made virtually no use of her as a model. After a time, she broke up with him and went to America. We do not know exactly when or where or why, but Manet's most knowledgeable biographer, Adolphe Tabarant, has suggested that her trip involved a romantic attachment.°

She seems to have returned to Paris in 1872 and resumed her affair with Stevens. Manet painted her the following year as a minor figure in a croquet party at Stevens's house. But the idea of *The Railroad* was already germinating in his mind. "The swallows are gone. The artists return...." Philippe Burty wrote in the autumn of 1872. "[Manet] has in his studio, not quite finished, a double portrait, sketched outdoors in the sun. A young woman, wearing the blue twill that was in fashion until the

°Tabarant's account is shadowy. In an article published in 1932 in a Paris newspaper called *L'Oeuvre* under the heading "The Unhappy End of She Who Was Olympia" Tabarant put her trip in the late 1870s. "Then she had adventures," he wrote. "She left for America. When she returned in 1883, Manet had just died." In the Morgan Library in New York, however, there is a large collection of Manet papers, Tabarant papers, and related items. Many of these come from Mina Curtiss, who did extensive research on Manet, and who wrote an eight-page summary of a much longer but apparently lost article by Tabarant on Victorine's later years. This states that Victorine returned from America not in 1883 but in 1872. Her travels would, of course, account for her long absence from Manet's works.

autumn...." Not quite finished? Another visitor wrote a year later of seeing the same picture in Manet's studio: "A pure and gentle light, always equal, penetrates the room from the windows which look out on the Place de l'Europe. The trains pass close by, sending up their agitated clouds of white steam. The ground, constantly agitated, trembles under our feet and shakes like a fast-moving boat."

The critical reaction to *The Railroad* was once again remarkably vituperative. Though Stéphane Mallarmé wrote a perceptive article praising not only *The Railroad* but the two paintings that the jury had rejected, Duvergier de Hauranne was more typical when he wrote in *La Revue des Deux Mondes* that Manet "belongs to a school which, failing to recognize beauty and unable to feel it, has made a new ideal of triviality and platitude." And the supposedly satiric periodicals were as witless as ever. *Le Journal Amusant* described Manet's picture as a scene in which "two madwomen, attacked by incurable Manetmania, watch the passing train through the bars of their padded cell." *Charivari* declared: "These unfortunate creatures, finding themselves painted in this fashion, wanted to flee! But the artist foreseeing this, put up a grating which cut off all retreat."

At about this time, Victorine Meurent began to try drawing and painting herself. Perhaps Stevens opposed her ambitions, perhaps mocked or simply ignored them. He was the rich and successful painter, after all, and she was just a woman who sometimes modeled. They broke up again. She became the pupil of a rather obscure portrait painter named Étienne Leroy. In 1876, two years after *The Railroad,* she finished a portrait that she liked, of herself. She even went so far as to submit it to the jury for the Salon of 1876. That same year, Manet submitted two of his paintings. One was a rather dark portrait of a bohemian artist named Marcellin Desboutin (the same chubby figure whom Degas featured in his famous picture, *The Absinthe Drinker*); the other was a charming open-air scene, *The Laundress*, in which a woman hangs up the wash in her garden while a little girl plays nearby.

The jury summarily rejected both of Manet's offerings. But it accepted Victorine Meurent's self-portrait. Manet gave a private exhibit of his rejected paintings; Victorine came to see them. What must Manet have thought of this transformation of the young woman he had painted so often, whom he had seen and known so well? What must she have

thought of her own achievement? What had she seen, she who had once been Olympia, in the mirror next to her own easel? What had she captured of those courageous eyes? All we know is that in an auction at the Hôtel Druot in 1930, a painting entitled *Portrait of a Young Woman,* signed by Victorine Meurent, was sold to an unknown purchaser for the sum of 290 francs.

Though Manet never once exhibited with the Impressionists, his destiny was inextricably intertwined with theirs, partly because of Monet's endless importuning. After the ruinous conclusion of the 1874 exhibition, Monet once again found himself unable to pay his rent, so Manet found him a house in Argenteuil, just a few miles down the Seine from Paris. Since Manet himself had some family property at Gennevilliers, just across the Seine, he decided to spend several weeks there that summer. Renoir, too, came to visit and to paint. And so in the first summer of the Impressionists' collective failure, there blossomed a most beautiful array of paintings all set in this one enchanted place and time. Manet's *The Monet Family in Their Garden in Argenteuil,* for example, and, in the identical pose in the identical white dress and hat under the identical tree, Renoir's *Mme. Monet and Her Son in Their Garden at Argenteuil,* and then, from a slightly different vantage point, Monet's *Manet Painting in Monet's Garden in Argenteuil.* And then Monet's *Boats at Argenteuil* and, against the same background, Manet's *Monet Working on His Boat in Argenteuil.* (Berthe Morisot also visited Argenteuil and painted several pictures there, notably *The Child in the Wheat Field.*)

Manet would not have been Manet if these intimate relationships had not influenced his style, particularly when the three artists not only painted the same scenes but painted them with easels set side by side. Monet later recalled that Manet once began to watch Renoir at work "out of the corner of his eye and from time to time would approach the canvas. Then, with a kind of grimace, he passed discreetly close to me to whisper in my ear, indicating Renoir: 'He has no talent at all, that boy! You, who are his friend, tell him please to give up painting.'" Some critics have taken this as an unfortunate display of rivalry and jealousy, but it seems much more likely an example of Manet's caustic wit, a whisper not intended to be the least bit "discreet." And though Manet never did really

become one of the Impressionists, he did pay them the compliment of not only moving his easel into the outdoors alongside theirs but also experimenting with smaller brushstrokes and brighter colors.

After a carefree summer of painting at Argenteuil, though, the Impressionists once again confronted the specter of their own poverty. Renoir convinced his friends that they should try to organize an auction at the Hôtel Druot, the Paris auction center that operated under government control. Monet and Renoir each provided twenty pictures, Sisley twenty-one, and Berthe Morisot twelve. Manet once again declined to contribute any of his paintings, but he did make the notable gesture of writing a letter to Albert Wolff, the powerful and dangerous art critic for *Le Figaro,* to solicit his support for the auction. A vain gesture. "Perhaps there is here some good business for those who are speculating upon art in the future," *Le Figaro* observed. "The impression which the Impressionists achieve is that of a cat walking on the keyboard of a piano or of a monkey who might have got hold of a box of paints."

On that ominous note, the auction was held on March 24, 1875, and proved quite as unsuccessful as the previous year's exhibition. Indeed, many of the supposed bidders came not to bid but to hoot and jeer at every bid that was actually made. The auctioneer finally called in the police to prevent the shouts from turning into fistfights. The seventy-three pictures received a total of only 11,500 francs in bids, and that total included a certain amount provided by the painters themselves to retrieve underpriced pictures. Berthe Morisot won the highest price, 480 francs for *Interior,* and also the second highest, 320 francs for *On the Grass;* Renoir did worst, with bids averaging only 112 francs. One of his earliest cityscapes, *The Pont des Arts* (1867), now treasured at the Norton Simon Museum in Pasadena, California, went for seventy francs. "We had good fun," *Le Paris-Journal* concluded, "with the purple landscapes, red flowers, black rivers, yellow and green women, and blue children which the pontiffs of the new school presented to the admiration of the public."

Logically, the Impressionists should now have disbanded and gone their separate ways, but logic was not their passion. They kept struggling on. Monet to Manet in June of 1875: "It's getting more and more difficult. Since the day before yesterday, not a cent left and no more credit, neither at the butcher nor the baker. Although I have faith in the future, you see that the present is very painful.... Could you possibly send me

by return mail a twenty-franc note? That would help me for the moment." And again: "I want to beg you not to abandon me.... I have run around all day looking for someone to lend me money.... I am afraid, really afraid, of not finding one." Monet propositioned virtually everyone he knew, Zola, Duret, a newly recruited Impressionist named Gustave Caillebotte. To a Romanian aristocrat who had bought one of his paintings, Monet offered twenty-five more for a paltry total of 500 francs.

The collective urge toward a second group show, temporarily diverted by the unsuccessful auction of 1875, revived once again in 1876. Manet, as always, refused to participate, but the others rejoined each other that April at Durand-Ruel's gallery on the Rue Le Peletier. This exhibit was somewhat more concentrated than the first one—instead of 165 pictures by thirty artists, there were now 252 by twenty. Degas showed twenty-four works, Monet eighteen, Berthe Morisot seventeen. Renoir's fifteen included his portrait of his friend Bazille, killed during the Franco-Prussian War.

Wolff of *Le Figaro* returned ferociously to the attack. "The Rue Le Peletier has bad luck," he wrote. "After the Opéra fire, [the old opera house, now replaced by the grandiose Palais Garnier, had burned down in 1873], here is a new disaster overwhelming the district. At Durand-Ruel's there has just opened an exhibition of so-called painting.... Five or six lunatics—among them a woman—a group of unfortunate creatures stricken with the mania of ambition have met there to exhibit their works. Some people burst out laughing in front of these things—my heart is oppressed by them. Those self-styled artists give themselves the title of noncompromisers, impressionists; they take up canvas, paint, and brush, throw on a few tones haphazardly and sign the whole thing.... It is a frightening spectacle of human vanity gone astray to the point of madness. Try to make M. Pissarro understand that trees are not violet, that the sky is not the color of fresh butter....! Try indeed to make M. Degas see reason; tell him that in art there are certain qualities called drawing, color, execution, control...." And finally, Wolff noted, "There's also a woman in the group, as in most notorious gangs; she's called Berthe Morisot and is curious to note. In her case, a feminine grace is maintained amid the outpourings of a delirious mind."

Even Henry James, who was then writing Paris letters for the *New York Tribune,* offered a few patronizing observations. "I have found it

decidedly interesting," he wrote of the Impressionists' second exhibition. "But the effect of it was to make me think better than ever of all the good old rules which decree that beauty is beauty and ugliness ugliness, and warn us off from the sophistications of satiety. The young contributors to the exhibition of which I speak are partisans of unadorned reality and absolute foes to arrangement, embellishment, selection...." James compared the Impressionists to the English pre-Raphaelites, and myopically judged the latter superior. "This little band is on all grounds less interesting than the group out of which Millais and Holman Hunt rose to fame. None of its members shows signs of possessing first-rate talent, and indeed the 'impressionist' doctrines strike me as incompatible, in an artist's mind, with the existence of first-rate talent."

James's reflections carried little weight in Paris, of course, but Manet did make another misguided attempt to win the good will of Le Figaro's Wolff. He invited the dyspeptic critic to sit for his portrait. This would have been a risky maneuver in the best of circumstances, but it was particularly risky in this case because Wolff was quite ugly and quite vain. If Manet had been willing and able to portray him as a Byronic hero, his attempt might have had some benevolent effect, but Manet seems to have thought that an honest portrait would serve some historic purpose. The illusion did not last long. After a few sittings, Wolff declared that he was tired of posing for Manet, who was notoriously demanding of his models' time and patience; the portrait was never finished.

And so the struggle went on. Monet to Zola, in the winter of 1876–77: "If I haven't paid tomorrow night, Tuesday, the sum of 600 francs, our furniture and all I own will be sold and we'll be out on the street. I haven't a single sou of this amount. None of the transactions on which I had counted can be concluded for the moment. It would pain me deeply to reveal the situation to my poor wife. I am making a last attempt and am turning to you in the hope that you may possibly lend me 200 francs.... Please send me word and, in any case, don't speak about this, for it is always a fault to be in need."

In addition to their hardships, the Impressionists were beginning to split apart, both on the organization of their shows and on the basic principles of the movement. As early as 1875, Pissarro joined with another painter named Alfred Meyer in creating a new group named L'Union, which was supposed to replace the original and disbanded Société Anonyme. L'Union included Cézanne and several lesser

Impressionists but never amounted to a major force. On a more fundamental level, Degas refused almost as adamantly as Manet to take part in anything called Impressionism; he insisted on being considered a realist, or simply an independent. Though he remained linked to the others by his contempt for the Salon, he seemed linked by little else. "I always tried," he said later, "to urge my colleagues to seek for new combinations along the path of draftsmanship, which I consider a more fruitful field than that of color. But they wouldn't listen to me, and have gone the other way."

In opposition to these centrifugal forces, however, the movement had acquired a new organizer in Gustave Caillebotte. A prosperous engineer who specialized in shipbuilding and who painted only as a hobby, Caillebotte was living a quiet bachelor life in Argenteuil when Manet and Monet and Renoir suddenly appeared out of nowhere and set up their easels along the Seine. Caillebotte was overwhelmed. He took his new friends sailing, he tried to paint like them, he bought their pictures, particularly those of Monet. Indeed, he made a new will in 1876, when he was still only twenty-seven, bequeathing to the French nation all the still-unpainted Impressionist paintings that he hoped to buy. His only condition, which was eventually to cause a great uproar, was that they must all be hung together in the Louvre. Even before that, though, some false premonition of early death inspired him to allot part of his estate to arrange in 1878 "an exhibition of the painters who are called Les Intransigeants or Les Impressionistes." He accurately named the important ones: "The painters to take part in this exhibition are Degas, Monet, Pissarro, Renoir, Cézanne, Sisley, Berthe Morisot. I name these not to the exclusion of others."

It was Caillebotte who became the driving force behind the third Impressionist exhibition in the spring of 1877. He wrote the letters, rounded up the pictures, settled the arguments, searched for a location. "We are having some trouble about our exhibition..." he wrote to Pissarro after learning that Durand-Ruel's gallery would be unavailable. "Let's not get discouraged; even now several arrangements offer possibilities. The exhibition will take place; it must." Caillebotte soon found a large and empty apartment down the street from the Durand-Ruel Gallery; he himself advanced the rent.

Degas kept making new difficulties. At a meeting to discuss organizational problems, he argued strenuously against the show being called an

exhibition of Impressionists, but he was overruled, and so the group for the first time adopted the name that had originally been applied to it in derision. Degas argued no less strenuously that all participants must agree to boycott the official Salon, a complete contradiction of his view just three years earlier, when he had tried to make the membership as broad as possible. On this matter, though, he got his way. "Politics *à la Degas*," as Valéry wrote in another context, "were inevitably as high-minded, violent, and impossible as he was."

So the third exhibition opened on April 1, 1877, with, once again, more pictures from fewer artists, this time 230 works by eighteen partic-ipants. Monet alone provided thirty paintings, including eight in his new series on the Gare Saint-Lazare; Degas sent twenty-five pictures, includ-ing many reflecting his new obsession with dancers and women bathing; Renoir sent twenty-one, including the joyous *Bal au Moulin de la Galette,* and Berthe Morisot sent nineteen of her unique domestic scenes. "The proof that the Impressionists constitute a movement," Zola wrote, "is that the public, though laughing, throngs to their exhibition. One counts more than 500 visitors a day. That is success...." Not really. The press remained largely hostile, and the paintings remained largely unsold.

And so the struggle went on. Monet to his friend Duret in the fall of 1877: "Be good enough to take one or two daubs which I'll let you have at any price you may make: fifty francs, forty francs, whatever you are able to pay, because I can't wait any longer." Monet was particularly fran-tic now because Camille was pregnant again, and not in the best of health. "I went to see Monet yesterday," Manet wrote to Duret. "I found him quite broken down and in despair. He asked me to find him some-one who would take ten or twenty of his pictures at one hundred francs each, the purchaser to choose which he liked. Shall we arrange the mat-ter between us, say 500 francs each? Of course nobody, he least of all, must know that the offer comes from us. I had thought of some dealer or collector, but I foresaw the possibility of a refusal. It is unhappily neces-sary to be as well informed as we are in order to bring off—in spite of the repugnance we may feel—an excellent business transaction and, at the same time, to do a good turn to a man of talent."

Duret declined Manet's generous proposal, so Manet even more gen-erously went ahead on his own. He promised Monet in January to pay 1,000 francs "against merchandise," and he seems to have paid that

money without actually taking any "merchandise." Manet's advance enabled Monet to move out of Argenteuil and rent a cheaper house in Vétheuil, but the crisis never ended. Monet to Zola, newly wealthy from *Nana,* in April: "Can you help me? We haven't a single sou in the house, not even anything to keep the pot boiling today. On top of this my wife is ailing and needs care, for, as you perhaps know, she has given birth to a superb boy. Could you lend me two or three louis, or even only one?"

The art market was troubled, the market for Impressionists disastrous. Ernest Hoschedé, the director of a Paris department store, had been collecting the new painters for several years, and when he went bankrupt in the summer of 1878, he had to put his pictures on the block, including sixteen by Monet, thirteen by Sisley, nine by Pissarro, five by Manet, three by Renoir. The results were appalling. The Manets went for an average of less than 600 francs, the Monets 150; one Renoir sold for thirty-one francs, one Pissarro for seven.

Monet was therefore not the only Impressionist to reach a state of desperation. Thus Pissarro: "I am going through a frightful crisis, and I don't see a way to get out of it.... My work is done without gaiety, as a result of the idea that I shall have to give up art and try to do something else, if it is possible for me to begin over again. Depressing!" And Sisley, in asking Duret whether he knew anybody who could advance him 500 francs a month for six months: "It is a question of not letting the summer pass without working seriously, free of worry, to be able to do good things, convinced that in the fall things will be better."

Renoir was the first to break Degas's rule that none of the Impressionists could exhibit at the Salon. "There are in Paris scarcely fifteen art-lovers capable of liking a painting without Salon approval..." he said to Durand-Ruel. "My submitting to the Salon is entirely a business matter." Sisley came to the same decision; so did Cézanne. Since Degas insisted on his rule, the three defectors dropped out of the fourth Impressionist exhibition planned for April of 1879. So did Berthe Morisot, though only because she was pregnant with Julie. So did even Monet, who now felt quite crushed by his personal situation. Alice Hoschedé had abandoned her husband during the summer of his bankruptcy and taken her six children to live in the Monet household, supposedly to help care for the ailing Camille Monet. "I am completely disgusted and demoralized by the existence I have been leading for so long," Monet wrote to a friend. "If that's all one has achieved at my age

[he was forty], there is no hope left.... Each day brings its torments and each day new difficulties arise from which we will never escape. That's why I am giving up the struggle as well as all hope; I don't have the strength to work any more under these conditions. I hear that my friends prepare a new exhibition this year; I renounce taking part in it, not having done anything that's worth being shown."

Caillebotte once again provided the necessary energy. He borrowed enough Monet paintings to make him a participant in the fourth exhibit, which opened on April 10 at 28 Avenue de l'Opéra. The other organizing hand was that of Degas, who now won his argument that the exhibitors must not be called Impressionists. This time, they were only a "Group of Independent Artists." An Impressionist exhibit without Renoir, Cézanne, Sisley, and Berthe Morisot was something of an absurdity, of course, but the sixteen survivors included two important newcomers, Degas's friend Mary Cassatt, the expatriate daughter of a wealthy Pittsburgh banker, and one of Pissarro's discoveries, a successful young stockbroker named Paul Gauguin. And the press was somewhat more sympathetic, and so was the public. "We are saved," Caillebotte wrote to the absent Monet on opening day. "By five o'clock this afternoon the receipts were more than 400 francs. Two years ago on the opening day—which is the worst—we had less than 350..." And three weeks later: "The receipts continue good. We have now about 10,500 francs. As for the public—always in a gay mood. People have a good time with us." He could not resist adding that the absent Manet "is starting to see that he is taking the wrong route." When the show was all over, it had earned a profit of more than 6,000 francs, not a large sum but the first profit the group had ever made. Each of the painters who had taken part collected 439 francs.

And so the struggle went on. Poor Camille Monet did not long survive the arrival of Mme. Hoschedé. She died that September, leaving Monet with a new reason to beg for money. "I come to ask you for another favor," he wrote to a friend. "This would be to retrieve from the pawnshop the locket for which I am sending you the ticket. It is the only souvenir that my wife had been able to keep and I should like to tie it around her neck before she leaves forever." Before she left forever, Monet also wanted to paint the last of the many portraits he did during their thirteen years together. There is a scene in some novel—is it somewhere in Tolstoy?—in which a grief-stricken writer sits by the deathbed

of his wife and realizes to his dismay that he is making mental notes of his own thoughts so that he can use them in some future book. So it happened to Monet, as he later confessed to Georges Clemenceau. As he looked down at the dead face of his Camille, he suddenly realized that he was seeing different tones of blues and yellows, just as though Camille had become another landscape at Argenteuil. And in due time, he married Mme. Hoschedé.

As Monet's endless pleas for money show, he was also the most practical of men, and despite Caillebotte's inclusion of borrowed Monet paintings in the fourth exhibition, Monet now decided to make the break permanent. He offered two canvases to the Salon jury; he also sold three paintings (for 800 francs) to Durand-Ruel's chief competitor, Georges Petit. Degas accused him of "frantic intrigues" and never spoke to him again.

The fifth exhibition of "independent painters," at 10 Rue des Pyramides in April of 1880, virtually demonstrated the end of the Impressionist movement. Pissarro was still loyally there, the only painter who appeared in every one of these exhibitions, and Berthe Morisot was back at work after Julie's birth, but most of the participants were Degas's friends and admirers, half-forgotten figures like Raffaëlli, Vidal, Levert, Tillot, and Zandomeneghi. And the false dawn of success at the 1879 exhibit proved to be just that. "Next to some very interesting sketches," the relentless Wolff wrote in *Le Figaro,* "one finds only canvases without the slightest value, works by madmen who mistake pebbles for pearls. I make an exception of M. Degas and Mme. Berthe Morisot. The rest is not worth viewing...."

And so the struggle went on. "I intend always to be an Impressionist..." Monet bitterly told a newspaper interviewer, "but I see only very rarely the men and women who are my colleagues. The little clique has become a great club which opens its doors to the first-come dauber." It was Caillebotte, however, who finally drew the almost inevitable conclusion: Degas and his friends must go.

"What is to become of our exhibitions?" Caillebotte wrote in a long and unhappy letter to Pissarro. "This is my well-considered opinion: we ought to continue, and continue only in an artistic direction...that is of interest to us all. I ask, therefore, that a show should be composed of all those who have contributed real interest to the subject, that is, you, Monet, Renoir, Sisley, Mme. Morisot, Mlle. Cassatt, Cézanne, Guillau-

min; if you wish, Gauguin, perhaps Cordey, and myself. That's all, since Degas refuses a show on such a basis....

"Degas introduced disunity into our midst," Caillebotte continued. "It is unfortunate for him that he has such an unsatisfactory character. He spends his time haranguing at the [Café] Nouvelle-Athènes.... No, this man has gone sour. He doesn't hold the big place that he ought according to his talent and, although he will never admit it, he bears the whole world a grudge.... All this depresses me deeply. If there had been only one subject of discussion among us, that of art, we would always have been in agreement. The person who shifted the question to another level is Degas, and we would be very stupid to suffer from his follies. He has tremendous talent, it is true. I'm the first to proclaim myself his great admirer. But let's stop there...."

Caillebotte was too logical, and a little ahead of his time. Pissarro could not bear to break with Degas (or anyone else). "He is a terrible man, but frank and loyal," he said. So Caillebotte's brief revolt collapsed. "I don't know what I shall do," he wrote to Pissarro. "I don't believe that an exhibition is possible this year. But I certainly shan't repeat the one held last year." So Caillebotte was among the other defectors when the triumphant Degas organized the sixth exhibit in April of 1881 on the Boulevard des Capucines, near where the first show had been held seven long years earlier. It was perhaps a symbol of Degas's victory over the Impressionists that the most striking work in the exhibit was his superbly realistic statue, *Young Dancer,* a thirty-nine-inch high figure of fierce determination, created out of wax and dressed in a real gauze skirt. Wolff noted the Impressionist defections and remained totally unimpressed. "Who has seen one picture by an Independent has seen the works of all of them..." he wrote.

And so the struggle went on. Caillebotte refused to give up his campaign against Degas's friends and protégés. He wrote a letter of complaint to Pissarro, who reported it to Gauguin, who went and argued with Degas about his sponsorship of Raffaëlli. Gauguin then wrote back angrily to Pissarro: "In spite of all my good will I cannot continue to serve as buffoon for M. Raffaëlli and company. I beg you to accept my resignation."

Gaugin's defection finally persuaded Pissarro, as Caillebotte's defection had not, that he would have to do something. He went to call on Berthe Morisot, his only remaining ally from the old days, but found that

she was away in Nice; he talked instead with Manet. "I have just had a visit from that difficult fellow Pissarro who talked to me about your next exhibition," Manet wrote to Berthe. "Those gentlemen do not give the impression of being of one mind. Gauguin plays the dictator; Sisley, whom I also saw, would like to know what Monet is to do. As for Renoir, he hasn't yet returned to Paris."

Caillebotte was trying again to see whether the other Impressionists would agree to a new exhibition without Degas's friends. Monet answered ambiguously from Dieppe. Renoir wrote that he was sick. Durand-Ruel now stepped in and urged Monet and Renoir to join in a new Impressionist show at his gallery. Renoir sulkily answered that he would do whatever Durand-Ruel wanted, but that he would not deal with the other Impressionists who had been engaged in negotiations without him. He made a bitter reference to "the Jew Pissarro." Monet also equivocated, balking at the fact that Pissarro wanted to invite Gauguin and two other friends of his. Pissarro then wrote directly to Monet and Monet answered that he would join only if Renoir did. Pissarro also tried once again, again in vain, to get Manet to join. Degas naturally heard about all these maneuverings and angrily boycotted the exhibit. He made a point of remaining a paid member of the group but refusing to send any pictures to the seventh show, which opened on the Rue Saint-Honoré on March 1, 1882.

But all the others were happily reunited. "This is the first time that we do not have any too strong stains to deplore," Pissarro wrote to a friend. "Monet has a magnificent group: admirable seascapes, landscapes with a new accent, the execution more baffling than ever. Renoir, though ill in Marseilles, is admirably represented by portraits of children, young girls.... As to Mme. Berthe Morisot...you know her great talent well enough, no need to attempt a description which would be impossible...." Berthe actually was still in the South, so Eugène handled all the details for her and then wrote to her: "Duret, who knows what he is talking about, says that this year's exhibition is the best your group has ever had. This is also my opinion."

In this moment of seeming reunification and victory, though, the Impressionists suddenly found themselves more divided and dissatisfied than ever. The ailing Renoir, for example, was deeply disturbed by his recent studies of Raphael. "Around 1883, a sort of break occurred in my works," he later wrote. "I had gone to the end of Impressionism, and I

was reaching the conclusion that I didn't know how either to paint or to draw. In a word, I was at a dead end." And Monet: "I have more and more trouble in satisfying myself and have come to a point of wondering whether I am going crazy or whether what I do is neither better nor worse than before, but the fact is simply that I have more difficulty now in doing what I formerly did with ease." And Pissarro: "I am much disturbed by my unpolished and rough execution; I should like to develop a smoother technique while retaining the old fierceness." And Degas, describing his feelings on turning fifty: "One closes, like a door, and not only upon friends. One cuts off everything around one and, when quite alone, extinguishes, in a word, kills oneself, out of disgust. I was so full of projects; here I am blocked, powerless. And furthermore, I've lost the thread.... I hoarded all my plans in a cupboard of which I always carried the key with me, and I've lost that key."

In such an atmosphere, there could hardly be much talk of further group shows, and so there were none. Durand-Ruel, in financial trouble again because of the crash of 1882, staged a series of one-man shows for Monet, Renoir, Pissarro, and Sisley, but none of them did very well. And so the old friends went their separate ways, Monet to Giverny, where he began the gardens that included luxurious beds of water lilies, Pissarro to Eragny, Sisley to Saint-Mammès, Gauguin to Copenhagen. They promised to meet at "Impressionist dinners" in Paris once a month, but many of them never came.

The one Impressionist who remained on friendly terms with all the embittered rivals was Berthe Morisot, and so she began trying in 1886 to see if they might not still be reunited once again. Everyone wished her well, but everyone also seemed to insist on new conditions. Degas had more or less reconciled himself to the fact that most of his protégés—other than Mary Cassatt—were not highly regarded. But Pissarro had become strongly influenced by the new pointillist technique of Georges Seurat and Paul Signac, and he very much wanted them included. "I had a violent run-in with M. Eugène Manet on the subject of Seurat and Signac... Pissarro wrote to his son. "M. Manet was beside himself! I didn't calm down. They are all underhanded, but I don't give in. Degas is a hundred times more loyal." The antagonists finally decided to install the works of Pissarro and his two young friends—including Seurat's magnificent La grande Jatte—in a separate room.

But now Gauguin introduced a friend named Émile Schuffenecker,

whom he had known at his bank and who also wanted to become a painter. Berthe Morisot and her husband wearily agreed to take him in. The advent of these newcomers suddenly irritated Monet, who huffily withdrew from the exhibition. So did Caillebotte, and then Renoir and Sisley. Monet and Renoir added insult to injury by deciding to show their new works at Petit's competing Exposition Internationale. So the show that was supposed to represent Berthe Morisot's new reunification of the Impressionists broke apart along the same old fissures. Degas was once again present with a series of nudes bathing, but Monet was once again missing. Berthe Morisot was there, as usual, but Renoir was gone. And when that exhibition closed on June 15—the participants "disband-ed like real cowards," said Seurat, maintaining the group's tradition of personal invective—the Impressionist movement came to its end. Many of its members lived on for many years—Degas until 1917, Renoir until 1919, Monet until 1926—but they never again met as a group except when they came, as they still occasionally did, to Berthe Morisot's draw-ing room.

The man who could and should have written an impassioned history of the Impressionists was Émile Zola, the schoolmate of Cézanne, the first major defender of Manet, the enthusiastic advocate of all that was new and adventurous. But Zola was more interested in advancing his own fortunes, so when he finally decided to exploit his long familiarity with this group of painters, he shoehorned many of his old friends into a melodrama that he called *L'Oeuvre*.

Zola was then at the height of his powers, and of his celebrity. With *L'Assommoir* and *Nana* well behind him, he had just finished *Germinal*, probably his best novel, when he announced early in 1885 what his next project would be: "First of all, I shall probably do a short work, with very few characters, which is set in an artists' milieu." His hero was to be Claude Lantier, the gifted leader of what Zola called "the *plein air* school." "Claude...is a Manet, a Cézanne, more of a Cézanne..." he wrote in his notes.

That is *L'Oeuvre's* reputation, but it is a misleading one. *L'Oeuvre* is a *roman à clef,* and like most specimens of that hybrid form, it is essentially false. An author pretends to portray a famous personality and then fabri-cates events, usually scandalous, that never occurred outside the author's

imagination. Thus Claude Lantier is first shown painting a picture that obviously resembles Manet's *Le Déjeuner sur l'herbe*—Zola avidly describes the naked woman, the clothed men, the still-life picnic in the wooded landscape—and he even describes in considerable detail the jeering crowds at the 1863 Salon des Refusés. But Lantier has none of Manet's personality or gifts, none of his elegance and charm, none of his unflagging determination to achieve his goals. In the violence and ferocity of his personality, he more nearly resembles Cézanne, who had originally taken Zola to see Manet's masterpiece, who had explained to him the new theories of the new art. But Lantier also lacks Cézanne's inner confidence, his real genius. He is, in short, neither "a Manet" nor "a Cézanne."

What he really is, is a Rougon-Macquart—actually the illegitimate son of Gervaise, of *L'Assommoir,* and thus the half-brother of Nana. Zola was by now more than halfway through his twenty-volume chronicle of the Rougon-Macquart family, and nothing could be allowed to go to waste. If he wanted to write a novel about the artists he had known in his youth, then the chief among them, whether based on Manet or anyone else, would have to be a Rougon-Macquart, and thus doomed to the family traditions of alcoholism, violence, madness. How such a man, Nana's half-brother, could ever have become a great painter remains mysterious, and Zola makes no attempt to explain it. Lantier simply appears as a full-fledged artist, aged about twenty, and proclaims what Zola imagined to be an artistic view of things: "Ah! Life, life! To feel it and to paint it as it really is, to love it for its own sake, to see in it the only real beauty...[that] is the only way of being God!"

But if Lantier expressed what Zola regarded as the artistic temperament, *L'Oeuvre* also included another major character, a journalist named Sandoz, who represented Zola's view of a more orderly artistic process, his own. Starting with marriage. Sandoz scorns the romantic idea of getting involved with "a devastating woman who kills the artist." Instead, he seeks "an affection that will safeguard his tranquility...so that he can dedicate his whole life to the enormous work that he is dreaming of." He believes that he has found what he has been looking for, "an orphan, a simple girl, the daughter of some shopkeepers, penniless but good-looking and intelligent." Thus cared for, Sandoz can devote himself to writing a series of novels about, in effect, the Rougon-Macquarts. "I am going to take a family and study its members, one by one, where

they come from, where they're going, how they react to one another; finally, all of humanity in miniature...."

Claude Lantier's life is the standard melodrama of the doomed artist. Though his painting of the nude is ridiculed at the Salon des Refusés, he starts living with Christine, the innocent beauty whom he had persuaded to act as his model; they move to a country house, where he paints beautiful pictures that are scorned by the Paris establishment; a boy is born, though neither the painter nor his model takes much interest in it. After several years, they all move back to Paris so that Lantier can concentrate on creating a masterpiece, which, implausibly, is to be a cityscape of the Île de la Cité, with three large nudes bathing in the Seine. For mysterious reasons, he can't get it right. He works at it for months, years, scraping away each new failure. He not only compels his belatedly married Christine to model for hours but humiliates her with heartless criticisms. "Your legs are still very good," he casually remarks. "That's the last thing to go in a woman. But the stomach and the breasts, damn! Those get spoiled. Look at yourself in the mirror. There, near the armpits, there are pouches that are not beautiful at all." And a little later, after some new disappointment: "No, definitely, I can't do anything with that. Ah, you see, if you want to pose, you shouldn't have a baby."

Christine becomes desperately jealous of the painted version of herself, the object of Lantier's misguided obsession. "You see where we are," she cries, "stretched out side by side every night without so much as touching one another. It's been eight months and seven days—I've counted them!—eight months and seven days that we haven't done anything together." Zola seems to have shared the Lantier illusion of a relationship between chastity and creativity; indeed there are suggestions that he succumbed to the same illusion himself. "Her jealousy was not mistaken in accusing the painting," he writes, "for the virility that he refused her, he saved and gave to her rival.... Basically, she rediscovered the theory repeated a hundred times before her: genius must be chaste, it must sleep only with its work." From such a foolish theory, the likeliest consequence is folly. So the increasingly impoverished Lantier keeps repainting his supposed masterpiece; his abused wife keeps submitting to any humiliation to placate him, and the neglected baby begins to fall ill, ignored.

While Lantier sinks into misery and madness, Sandoz is getting increasingly rich and successful, but Zola wants his readers to know that

he, too, is suffering. "Listen," Sandoz tells Lantier, "my work has taken over my whole existence. Little by little, it has robbed me of my mother, my wife, everything that I love. It's a germ inside the skull, which eats the brain, which invades the torso, the arms and legs, which ranges over the whole body...." Zola feels he must add, however, that "the great work of his life was advancing, this series of novels that landed blow by blow from an obstinate and methodical hand, marching toward the goal that he had given himself, without letting himself be conquered by anything, obstacles, insults, weariness."

As Zola keeps "landing blow by blow," his novels almost always get overdone, repetitious, exaggerated, and *L'Oeuvre* is hardly an exception. Just as Lantier is once again ruining his picture, his son dies, almost unnoticed. Lantier feels strangely inspired to paint a portrait of the dead child and to submit it to the next Salon. The jury, whose machinations Zola describes with great journalistic skill, detests Lantier's picture and accepts it only as an act of charity at the insistence of one of Lantier's former friends. He then goes to see the opening of the Salon—another sharply described scene—and finds his picture hung in obscurity near the ceiling. Returning to work once again on his main painting, he finally realizes that he cannot finish it, and so he hangs himself.

Sandoz is the only one of Lantier's former friends who takes the body to the graveyard (Christine has suffered a crippling brain fever). This is an act of kindness, but Zola uses the opportunity to have Sandoz pronounce a profoundly patronizing verdict on the dead man: "A heroic worker, a passionate observer with a head packed with knowledge, the temperament of a great and gifted painter—and he leaves nothing." And worse: "No, he was not the man to carry out his own system. I mean that he did not have a genius that was clear enough to stand upright and impose itself on a definitive body of work. And look at the artists around him, after him, how all the efforts are squandered. Everyone remains involved in sketches, hasty impressions. Not one of them seems to have the strength to be the awaited master." By contrast, Sandoz took comfort in the idea that he was "marching ahead with the beat of reason and the solidity of science." As he speaks, a brand new railroad train goes chuffing along in the distance.

The misguided idea that a great artist needs to be the leader of a school, that such leadership both confirms and increases the importance of his art, was an idea that was dear to Zola. He cherished the fancy that

he himself was the leader of a "naturalist" school of fiction, and that admiring visitors to his country estate—Goncourt, Daudet, and de Maupassant, for example—went into battle as his literary vassals. He seems to have believed that Manet should have felt a similar ambition, and he held it against the painter that he had very little interest in any such role. Zola remained quite unaware that Manet's isolated achievements were superior to his own, and that most great artists, like Manet, work alone.

Zola published these criticisms as early as 1879, when he wrote briefly about the fourth Impressionist exhibition for a St. Petersburg publication called *Le Messager de l'Europe*. "All the Impressionists are poor technicians," Zola declared in a passage that was gleefully reprinted in *Le Figaro* under the headline "M. Zola Has Just Broken with Manet." "In order to be a man of talent, a man must bring out what is alive in him; otherwise he is nothing but a pioneer. The Impressionists, in my view, are precisely pioneers. For a time, they put great hopes in Manet, but Manet appears exhausted by hasty production; he is satisfied with approximations; he doesn't study nature with the passion of true creators. All these artists are too easily contented.... It is to be feared that they are merely preparing the path for the great artist of the future expected by the world."

As soon as *Le Figaro* publicized this condemnation, Zola hastened to apologize. "I...am anxious to send you a cordial handshake," he wrote to Manet. "The translation of the quotation is not exact. I spoke of you in Russia as I have spoken in France, for thirteen years, with solid sympathy for your talent and your person." Manet insisted that *Le Figaro* print Zola's letter, but on checking further, the newspaper found that the translation, which it had cribbed from another newspaper, was perfectly correct except for a typographical error—Zola had been writing about Monet, not Manet. Why he didn't say so remains mysterious— perhaps he was so careless that he didn't think anyone would check up on his denial, perhaps because his views on Manet elsewhere in the article were no less condescending. "His hand does not equal his eye," Zola had written. "He has not learned how to create a technique; he remains an enthusiastic pupil who always sees distinctly what is happening in nature but who is not certain of being able to convey his impressions in a complete and definitive manner. That is why, when he starts out, one never knows how he will reach the end or even whether he will reach it at all...."

As for his new novel, Zola was so insensitive to the implications of *L'Oeuvre* that he sent copies to all his onetime friends and then sat back to await their compliments. They were not forthcoming. "I have always had great pleasure in reading your books," Monet cautiously wrote him, "and this one interests me doubly because it raises questions of art for which we have been fighting for such a long time. I have read it, and I remain troubled, disturbed, I must admit. You took care, intentionally, that not one of your characters should resemble any of us, but in spite of that, I am afraid that the press and the public, our enemies, may use the name of Manet, or at least our names, to prove us to be failures...." Cézanne, who knew perfectly well that the unbalanced Lantier resembled him rather more than Manet, wrote Zola a cool letter of farewell and never saw him again.

Zola still could not see that he had done anything wrong. At a dinner given in honor of *L'Oeuvre* by Zola's publisher, Georges Charpentier, the publisher's wife irked Zola by suggesting that Claude Lantier was not really a great painter at all. "Seeing that all were siding with Madame Charpentier," recalled George Moore, one of the guests, "Zola plunged like a bull into the thick of the fray and did not hesitate to affirm that he had gifted Claude Lantier with infinitely larger qualities than those which nature had bestowed upon Édouard Manet. This statement was received in mute anger by those present, all of whom had been personal friends and warm admirers of Manet's genius.... It must be observed that M. Zola intended no disparagement of M. Manet, but he was concerned to defend the theory of his book—namely, that no painter working in the modern movement had achieved a result equivalent to that which had been achieved by at least three or four writers.... And, in reply to one who was anxiously urging Degas's claim to the highest consideration, he said, 'I cannot accept a man who shuts himself up all his life to draw a ballet girl as ranking coequal in dignity and power with Flaubert, Daudet, and Goncourt.'" Degas, who, mercifully, was not present at this dinner, reciprocated Zola's judgments. He told a friend that Zola's work in general "has on me the effect of a giant putting together a postal directory," and he declared that *L'Oeuvre* had been written "simply to prove the great superiority of the man of letters over the painter."

That seems to demonstrate Degas's customary malice, but an odd confirmation came a few years later. In April 1900, when Zola had become a figure of international renown, the author of *J'Accuse* and the

hero of the campaign that rescued Captain Alfred Dreyfus from Devil's Island, he received a visit from a Symbolist poet, Adolphe Retté, who remarked, by way of conversation, how much he admired Manet's portrait of the novelist.

"Yes, that portrait isn't bad," Zola answered grandly, "yet Manet wasn't a very great painter. He had an incomplete talent."

Retté was surprised by this dismissal because he remembered the occasions on which Zola had so ardently championed Manet as "the most original painter of his time."

"Ah, I was young," said Zola. "I was looking everywhere for weapons to defend the doctrine on which I based my books. Manet took care to choose contemporary subjects, and his attempt at realism seemed to me worth supporting. But, to tell the truth, his painting has always rather disconcerted me."

Retté worried that his account of Zola's casual confession "may displease some people," but he insisted that Zola had said every word.

"Besides," Zola went on. "I cannot grow enthusiastic about painting. It's like music, when I listen to it I soon become distracted and think of something else.... In fact, I have never felt, I never feel, really passionate except about literature."

<p style="text-align:center">❦</p>

Berthe Morisot was thirty-seven, an almost scandalously advanced age, when she gave birth to Julie in 1878, and it was predictably a difficult birth. Berthe's reaction was just as predictably one of devotion and wonderment. Her life had changed, in every way. "Oh, well! I'm just like everybody else!" she wrote to Yves. "I regret that Bibi isn't a boy; first of all because she looks like one, secondly because she would carry on an illustrious name, and, basically, quite simply, because we all, men and women, love the male sex...." That illustrious name, of which Berthe was so conscious, was only illustrious because of her brother-in-law. Her baby, she wrote to Edma, "is a Manet to the tips of her fingers; she's already like her uncles, not a bit like me."

But Berthe would change all that by taking charge of the child's education. "We were always together, mother and I," Julie recalled many years later. Girls received little formal schooling in those days. It was Berthe who taught Julie to read, partly by creating a series of watercolors to illustrate each letter in an alphabet book. She saw to it that the child

began drawing pictures with colored crayons; they crayoned pictures together. They went for long walks; they went to the zoo; they talked about everything. "Stroll with Julie...down the Rue Bonaparte," Berthe wrote in her diary when Julie was six. "At the photographer's on the corner of the Rue de Beaune, looked at reproductions of Botticelli's *Spring*, a picture which I saw once in Florence, and which didn't give me the same pleasure then.... We wander along the quais, the little one questioning me about everything; we looked for a long time at the sun and planets at a map dealer's; then farther on, Debucourt's *Compliment*.... Julie asks for explanations.... Then in the Tuileries, she recites Théophile Gautier's poetry for me.... I'm thinking about my painting of the garden, studying the shadows and the light, she sees pink in the light, violet in the shadows."

And from the very beginning, Berthe painted Julie, Julie at play, Julie at her studies, Julie steadily growing older. "With the pictures Morisot displayed in 1881," Anne Higonnet writes in her perceptive biography, "begins the most extensive and profound visual exploration we have of a mother-daughter relationship. In the eyes of this mother, the relationship is both intimate and respectful, one in which mother and daughter respond to each other but learn from their differences, one in which a daughter does grow up.... As Morisot relinquished the joys of physical union with her child, she discovered new and more durable ones: the pleasures of intellectual communion and shared values."

Eugène Manet helped as much as he could, but just as he and Berthe acquired their new house on the Rue de Villejust, near the Étoile, Eugène's frail health began to crumble. "My husband is coughing badly, almost never leaves his room," Berthe wrote in the winter of 1887–88. "Just picture to yourself a sick man, sitting on all the furniture, greatly to be pitied and no less high-strung." It was partly because of Eugène's confinement, partly because of the new house, partly because of her sense of herself as a figure of some eminence, that Berthe now began her regular Thursday dinner parties. The guests included not only all her feuding artistic colleagues, Monet and Degas, Renoir and Caillebotte, but also musicians like Chabrier, writers like Mallarmé, politicians like Émile Ollivier.

Eugène kept himself busy. He planted the trees and flowers that gave the Rue de Villejust what Julie called "a real country garden." He even wrote in 1889 a novel called *Victims!*, which derived from the early days

of Napoleon's coup d'état, when local rebellions flared up and were harshly repressed all over France. One of the thousands arrested was a local official in the Nièvre who also bore the name of Eugène—Eugène Millelot. Known as a Republican, he was convicted on false charges of murder and shipped off to a life term in the prison colony of Cayenne in French Guiana. For some reason, Eugène Manet felt inspired to use this obscure case as the basis for a semiautobiographical novel. His hero is blessed with a fiancée named Jeanne, a gifted pianist, daughter of a man who "had neglected nothing to make his daughter a strong woman, immune to the thousand weaknesses of her sex." When her father dies, Jeanne is raised by a Royalist uncle and aunt who try to lead her into the ways of conformity, but Jeanne remains a Republican, an agnostic, and the faithful fiancée of her exiled lover. She eventually follows him to the South American jungle, but only in time for him to die in her arms, while she, having taken poison, dies in his. Like some Verdi couple, they perish while gasping each other's names, and that of France.

Eugène's own days were clearly numbered. He and Berthe bought a new country home in Mézy, northwest of Paris, which was supposed to benefit Eugène's health, but the move had little effect. "Eugène still looks woefully ill," Berthe wrote to Edma. "He coughs, he continues to lose weight, he gets cross. I often ask myself if I fulfill all my duties to him as a wife; in any case I can't manage to distract him. It's a heavy burden to live with a sick person who suffers as much mentally as physically. I sometimes seem to hear my mother telling me at Fécamp that the end of my life would be like hers, bound to an invalid.... Well, let's not stir up all that lies at the bottom of my heart, which during these winter days is gloomy."

She kept on painting, but everything that she painted dissatisfied her. "The end of a season—sadness, despondency—I hate everything I've done and its prelude of desolation!!!" And again: "With what resignation one arrives at the end of life, resigned to all the failures of this life, to all the uncertainties of the next.... It's been a long time since I hoped for anything."

· 8 ·

OLYMPIA (II)

I was young and carefree in those days....
—VICTORINE MEURENT

One of the few elements in modern life that Manet almost never painted was himself. Back in the mid-1850s, he had done one small self-portrait, which he mysteriously inscribed as "a friend!!" and which he kept all his life. After that, the sharp-eyed portraitist of Berthe Morisot and Mallarmé and Zola never again worked from a mirror, until now, in about 1878, he suddenly did two self-portraits. One, *Self-Portrait with a Skullcap,* is a full-length image, notable for the stiff stance, the right leg thrust forward as if unable to bear any weight. The other, *Self-Portrait with a Palette,* extends downward only to the waist, eliminating the legs altogether. (Also eliminated was a portrait of Suzanne Manet, which X-rays have shown to exist underneath the self-portrait.)

Here is what looks like the painter as dandy, or the dandy as painter. He holds the palette in his right hand and flourishes a brush in his left, but he is hardly a professional at work. He wears a black bowler, and his elegant tan jacket has its top button buttoned. Some critics have seen both the pose and the creation of the picture itself as an assertion of Manet's growing success. Theodore Reff cites Duret's early biography: "'Manet, at the height of his career, had achieved the kind of renown that rightfully belonged to him during his lifetime. He was one of those who were most in the public eye in Paris.' He had, in effect, been recognized at last as the Parisian painter par excellence." Perhaps, but

there is a strange look in Manet's eyes in this self-portrait, a look that can best be described simply as fear.

He had been worrying about his health, specifically about an inflammation in his legs, worrying and denying his worries. He felt chronically weak and tired, which was perhaps to be expected at the age of forty-six, but being forty-six was hardly a reason for decrepitude. He felt strange pains in his left foot, numbness, tingling. He went to his doctor, a man named Siredey, and the doctor was slightly evasive. Many things were possible. Perhaps it was simply a matter of rheumatism, Manet told his friends. A number of his relatives had suffered from rheumatism. But when Manet emerged from his studio late one afternoon in 1878, he suddenly felt a stabbing pain in his back and fell to the ground. Dr. Siredey was summoned and Manet had to confront a fearful reality.

What afflicted him was locomotor ataxia, a form of tabes dorsalis, which is a progressive deterioration of the spinal column and central nervous system. Locomotor ataxia can come from a variety of causes, childhood meningitis, vitamin deficiency, a tumor. But the most common cause, which is generally assumed in Manet's case, is the tertiary phase of syphilis. This connection had only been discovered in 1875, and was to be disputed for many years, so it is possible that Manet was misdiagnosed from the start. Tabes dorsalis attacks everywhere, but slowly, over the course of many years. Among its most common symptoms are a loss of coordination in the arms and legs, sexual impotence, inability to urinate, sudden abdominal pains, attacks of vomiting, deafness, increasing paralysis of various muscles, including those in the eyes, and hence double vision, blurring, and eventually blindness. And finally, madness, paralysis, and death. Like so many afflictions, it was, at least in Manet's day, incurable.

Syphilis is still a powerful and mysterious disease. It is widely thought to have been brought back to Europe by Columbus's seamen—the Caribbean Indians' gift to their conquerors—though there is a rival theory that it existed in ancient times and then went into a kind of dormancy. Three years after Columbus's first voyage, in any case, it suddenly erupted during the French occupation of Naples, where the French called it the Neapolitan disease, and the Neapolitans called it the French disease. Mercenaries returning from the Italian wars soon spread it all over Europe. It reached Paris as early as 1495, when the Parlement issued a

decree that all alien victims of the pox must quit the city, and all natives confine themselves to their houses, or they would be hanged. The canons of the cathedral of Notre Dame ordered public processions with the relics of St. Marcel and St. Geneviève to seek protection from "this dangerous and contagious sickness, against which doctors...can offer no remedy."

It seems to have been far more virulent in these first years than later, and far more painful. The highly infectious chancres and lesions and pustules covered not only the genital areas but the whole body; victims' noses disintegrated, leading many people to think this was a new form of leprosy. Others thought it a return of the bubonic plague, the Black Death. The best doctors understood from the start that the disease spread through sexual contact, and that the Arabs treated similar skin diseases with mercury ointment. But the effects of mercury could be fearful, palsy and paralysis. "The throat becomes ulcerated," one doctor wrote of this treatment, "the tongue, palate, and gums swell; the teeth become loose; saliva runs constantly from the mouth, unimaginably fetid...." "Oh, we have seen them so many times when they were thoroughly oiled and covered with ointment," Rabelais wrote in his prologue to *Pantagruel,* "and their faces shone like the key plate of a charnel house, and their teeth quivered like the keys on an organ...and they foamed at the mouth like a wild boar driven into the toils by hounds."

While the disease swept through Europe in less than five years, the age of exploration carried it to Asia. Victims in Calcutta knew it as phiranga, or the Franks' disease; Chinese pirates carried it to isolated Japan, where it was known as Chinese ulcer. It acquired its modern name in 1530 from an Italian physician named Giovanni Fracastoro, who wrote a popular poem about an iconoclastic Greek shepherd named Syphilis. This shepherd offended the sun god by overturning his altars and rededicating them to his own king, Alcithoüs. The sun god retaliated by afflicting Syphilis with painful and repulsive sores all over his body. Erasmus was the first writer to use syphilis as a name for the disease. "What contagion takes such a hold of the entire body," he wrote, "is so resistant to the art of medicine, infects the sufferer, and tortures him so cruelly?.... It alone combines all that is dreadful in the other contagions: pains, infection, danger of death, and painful and repugnant treatment which, moreover, does not lead to complete recovery?" Despite this baptism, however, the disease was long known simply as the pox. It was the nine-

teenth-century's love of romance and euphemism that renamed this pestilence after the stricken shepherd.

The main treatment remained mercury. By the eighteenth century, it was being administered internally, either by pills or enemas, but the side effects were so harrowing that some doctors began experimenting with another poison, arsenic. Others tried potassium iodide. And yet the disease kept spreading. "Oh, my dear Candide!" said the worthy Dr. Pangloss, that believer in the best of all possible worlds, after he became infected by a pretty servant girl named Paquette. "In her arms I tasted the delights of paradise, and they have led me to the torments of hell, which, as you see, have devoured me; she was infected with this thing, and perhaps she had died of it. Paquette had this present from a very learned Franciscan who had traced it right back to its source, for he had caught it from an old countess who had got it from a cavalry captain, who had it from a marquess, who had got it from a page, who had got it from a Jesuit, who, as a novice, had got it in a direct line from one of the companions of Christopher Columbus. As for me, I shall give it to no one, for I am dying."

By the end of the nineteenth century, French experts estimated that as many as 20 percent of the entire population of Paris was infected. Since the disease infected heterosexuals and homosexuals alike, and since there were no rubber condoms to promise "safe sex" (though the English had invented a protective device made of sheepskin), syphilis spread the fear of madness and death on a scale far beyond today's agitations about AIDS. Henrik Ibsen shocked all of Europe in 1881 by dramatizing the problem in *Ghosts,* and even now, there is something haunting about that final scene in which the stricken and suddenly demented Oswald Alving says, "Mother, give me the sun.... The sun—the sun."

Not until 1905, in Berlin, did Fritz Schaudinn first spot in his microscope the syphilis spirochete, which he named *Treponema pallidum;* not until 1910 did Paul Ehrlich finally discover an arsenic compound that could kill it. He named his "magic bullet" Salvarsan, or 606, since he had unsuccessfully tested 605 chemicals before discovering the one that worked. Yet even as late as World War II, three decades after a syphilis "cure" had been found, more than 45,000 of the first million young men tested under the U.S. Selective Service suffered from the disease and the national death rate from it ran at about 20,000 per year, a figure

higher than that for infantile paralysis, spinal meningitis, diphtheria, typhoid, and dysentery combined. The introduction of penicillin in 1943 seemed finally to end the threat, but syphilis has a strange resilience. New York health officials reported in 1987 that new cases of syphilis had more than doubled in the previous year, and some researchers now suspect that the disease is somehow connected with AIDS.

But it was in Manet's time that syphilis seemed like a new Black Death, threatening every household with its hideous consequences. Many people who are thought to have died romantically young—Franz Schubert, for example, or John Keats—were actually victims of syphilis. So were Nietzsche, Donizetti, Schumann, de Maupassant, all raving in their various insane asylums. Flaubert had it, too, though it was apparently a stroke that killed him. (In his last novel, *Bouvard et Pécuchet,* the latter finds that he has caught "an intimate disease" from the housemaid. "But why did she do that to me?" he asks. "She liked you," Bouvard replies. They both decide then that women are "hell beneath a skirt.")

And now Manet, the suave and debonair Manet, with his *"bel air de gentilhomme,"* how did he get himself infected with this curse? It is conceivable that he inherited it from his father, that stern and disapproving jurist whom he had painted two decades earlier. The elder Manet seems to have suffered from syphilis for most of his life and to have died of the tertiary-stage paralysis. His wife outlived both him and their son, but she, too, was paralyzed at the time of her death in 1885, so she may have also have suffered from the same affliction. Ordinarily, however, inherited syphilis affects the baby from birth onward, which seems to rule out that possibility in the case of Manet, leaving only the conclusion that he was infected by one of the women in his life.

Henri Perruchot, Manet's rather fanciful biographer, blames his illness on nocturnal revelries during his youthful voyage to Rio de Janeiro. "There could be no doubt," he writes, "that his ataxia had its origin in that wild night at the carnival in Rio." There is probably an element of racism in this easy accusation of a Brazilian infection, but Perruchot is just as cavalier in suggesting that Victorine Meurent "satisfied not only the painter in Manet, but also the man." Others have stated that Manet had a more than passing affair with Méry Laurent, but the fact is that we really know nothing whatever about his private life. It is quite possible that he made advances to every attractive woman he met, and he met a great many; it is also quite possible, since we remember that he lived

with his mother all his life, that he did not. If we attribute to the Parisian bourgeoisie of the nineteenth century the fang-and-claw morality of contemporary New York or Los Angeles, then it is also quite possible that Manet seduced even Berthe Morisot, and her sisters as well, not to mention Éva Gonzalès, but all we really seem to know is that some woman probably had infected him. The secret of her identity he took to the grave, if, indeed, he knew the answer himself.

Like most people, he first denied his illness, denied its gravity, denied its implications. He would overcome it by hard work, by carrying on his life as usual. Doctor Siredey finally persuaded him, however, to undergo hydrotherapy. This system of prolonged immersion was once prescribed for a number of afflictions, including insanity. It was thought to reduce fevers and inflammations; it can probably be commended mainly for doing no major harm. Manet went for a time to Dr. Béni-Barde's hydrotherapy clinic on the Rue de Miromesnil, then spent the summer of 1879 in the suburb of Bellevue in order to go to a more advanced hydrotherapy establishment there. He had to be submerged and massaged three times a day, an hour and a half each time. "As you say so well, time is a great healer," he wrote to Zacharie Astruc. "Consequently, I'm counting heavily on it, living like a clam in the sun when there is any, and as much as possible in the open air; but even so, the country has charms only for those who are not obliged to stay there." And to Mallarmé: "I feel fine from the stay in Bellevue—air excellent—I hope in three or four months to benefit by it—besides, I am prepared to undergo any discomfort in order to regain my health. ..." And to Méry Laurent: "As for penance, my dear Méry, I am constantly doing it, and as never before in my life! However, if it all comes to something, there will be no reason for regret. ... I hope, dear Méry, that you'll write me all your news soon. ..."

One effect that Manet's syphilitic ataxia did not have on him was to poison him with an onrushing sense of misogyny. On the contrary, he seemed more than ever to enjoy meeting and painting and flirting with attractive women. In Bellevue, he made friends with a neighbor, the opera singer Émilie Ambre, who posed for him as Carmen and who took his *Execution of Maximilian* on her tour of America. Back in Paris, he was charmed by Isabelle Lemonnier, a jeweler's daughter who graced the salon of her older sister, Madame Georges Charpentier, wife of the celebrated publisher. So we have *Portrait of Isabelle Lemonnier, Portrait*

of *Isabelle Lemonnier in a White Scarf,* and *Isabelle Lemonnier with a Muff* (all 1879), and *Isabelle Diving, Isabelle with Bonnet,* and *Isabelle with Umbrella* (all 1880). Manet even wrote her a little poem, under a water color of a plum:

> *À Isabelle,*
> *Cette mirabelle.*
> *Et la plus belle,*
> *C'est Isabelle.**

"Manet couldn't draw," she complained regally to her grandson many years later. "He was forever starting my portraits over again. He destroyed I don't know how many studies before my eyes. I'm sure he would have given them to me if I had asked. But I already had so many portraits."

And then there was Jeanne de Marsy, a beautiful young actress whom he painted in profile in *On the Bench* (1879) and then portrayed in a gaily flowered hat as the incarnation of *Spring* (1882). And Marguerite Guillemet, who repeatedly appears only as "young girl," as in *Young Girl in the Garden in Bellevue* and *Young Girl and Child in the Garden in Bellevue* and *Young Girl at the Entrance of the Garden in Bellevue* and *Young Girl in the Middle of the Garden in Bellevue* (all 1880).

Although the Parisian authorities had never answered Manet's proposal to paint a series of murals in the rebuilt, postrevolutionary Hôtel de Ville, the public rewards that he had yearned for all his life finally began to arrive. Not because the academic establishment welcomed him but because almost any artist who lives long enough begins to have friends in power. At the end of 1880, the government decided to abandon its control over the Salon; it turned over full control to all artists who had ever exhibited there. This meant that the people elected to the all-powerful Hanging Committee included fewer aged academicians, more young and independent painters. These latter wanted to give Manet a medal at the coming Salon, not a first-class medal—that would be too violent a change—but perhaps second-class. The old guard still resisted. When Manet's latest submissions were brought out for inspection, the conservatives sneered at his portrait of the left-wing journalist Henri

*"To Isabelle,/this plum./And the most beautiful,/Is Isabelle."

Rochefort as political propaganda and his portrait of the big-game hunter Eugène Pertuiset as incompetent. Manet received unexpected support from the committee chairman, Cabanel, who had painted that luscious *Birth of Venus* that the Emperor Napoleon had bought at the same Salon that had rejected Manet's *Déjeuner sur l'herbe.* "Gentlemen," said Cabanel as he pointed at the head of Pertuiset, "there are probably not four among us who could paint a head like that."

Cabanel's support helped get the two portraits accepted, but Cabanel would not go so far as to vote for even a second-class prize. The first ballot gave Manet only fifteen votes, two short of a majority. More arguments, shouts, threats, and finally Manet's supporters won over the two votes. Some considered it a rather trivial award. "M. Manet is frankly above such minor distinctions," wrote one critic. "A second-class medal for having so greatly influenced his period! Is this not rather shabby?" But Manet was immensely pleased, not only because of the official recognition but because the medal entitled him to show whatever he pleased at future Salons. No more rejections, ever. "One day, my canvases will be covered in gold," Manet said to his family. "Unfortunately, you won't see it. ... Success will come late, but it is certain to come. I shall be hung in the Louvre."

No less officially exalted was the title of chevalier in the Legion of Honor, which often went to the Salon's prizewinners but only after an elaborate ritual of government approval. Manet's time had come. In November of 1881, the liberal Gambetta became premier, and his cabinet included Manet's old friend Proust as minister of fine arts. He promptly placed Manet's name on the honors list for the coming year. When Gambetta took the list to the president of the republic, Jules Grévy, the president of the republic was shocked. "Manet!" he protested. "Oh, no! Not on your life!" Gambetta was still the man who had escaped from besieged Paris by balloon to help organize resistance against the Prussians. "It is a well-established precedent, *M. le Président,*" he said, "that each minister has the authority to award decorations within his own department." The president of the republic grumblingly gave in and signed.

"To consent to be decorated is to recognize that the State or the Prince has the right to judge you," Manet's friend Baudelaire had once said, but Manet was happy to concede that right, happy that the Gambetta government, which remained in office for only two months, had

granted him permission to wear a red ribbon in his lapel. But underneath that happiness there was a kind of rage that only a dying man could feel about the belated arrival of official honors. Among the messages on his becoming a chevalier in the Legion of Honor came secondhand congratulations from Count Nieuwerkerke, the lover whom Princess Mathilde had installed as minister of fine arts under the empire. "When you write to him," Manet told the intermediary, "you may tell him that I am touched by his remembering me, but that he could have decorated me himself. He would have made my fortune and it is now too late to repair twenty years of lack of success."

The same kind of rage animates a remarkable series of drafts of a letter that Manet wanted to write early in 1883 to Jules Ferry, then the minister of fine arts. "The triennial exposition that will take place at the Champs-Élysées Palace from September 15 to October 31 will be open to the most remarkable works by French and foreign artists created since May 1, 1878," he rather solemnly began (these drafts are all scribbled in a household notebook at the Morgan Library in New York). "That is the first chapter in the regulations. We ask what these remarkable works are since the jury has rejected everything that did not come from the studios of Bouguereau, Lefebvre, Cabanel, Gérôme. We therefore think that it would be good to remind these aged painters that we are in 1883, and although their ideas have not progressed at all, the young painters are following the modern market. We can fearlessly say that painting is only done at a certain age; that it is good to see clearly; if their vision is enfeebled, so much the worse for them; they have had their hour of renown—and that the public is tired—."

The equally enfeebled Manet, who apparently still considered himself a leader of "the young" at fifty-one, crossed out the last two words and started again, from the beginning. "The triennial exposition that will take place at the Champs-Élysées Palace from September 15 to October 31 will not be a step forward for modern art," he wrote. Then he again crossed out his last words and continued: "will hardly be interesting if one judges by the rejection of all our young painters. It is an exhibition of academicians. ..." More words crossed out, and then, after several pages of household accounts, a third beginning:

"It has been announced that the triennial Exhibition of the Fine Arts, which will open at the Champs-Élysées Palace from September 15 to October 31 will be very brilliant. We know that there will be beautiful

tapestries, but what we know even better is that there will be bad paintings. The jury has been composed of members of the Academy. Will the crowds form in front of academic painting as they have in front of modern painting... ?" More words crossed out, more household accounts, and then a fourth attempt: "It has been announced that the triennial Exhibition of Fine Arts, which will open at the Champs-Élysées Palace from September 15 to October 31, will be brilliant. We know that there will be beautiful tapestries, that the luxury spread forth by M. Paul Mantz will surpass anything since that of Count Nieuwerkerke, but what they have forgotten to announce, as we now can judge after the rejection of everything that didn't come from the academies, is that there will be bad painting. The public is not as stupid as you think, M. Ferry..." And then a last try: "...the public is not as stupid as that. It has brought success to exhibitions of modern art but it has completely abstained from going to see pictures by the bewigged figures of the Academy. The Academy of Fine Arts is stuffed with bald heads, just like the Senate. The progress of modern art has been stopped—."

There the drafts break off. It is unclear whether Manet ever managed to finish his angry letter, or to send it, or whether anyone at the Ministry of Fine Arts ever paid any attention, but the inarticulate rage in all those drafts still resounds across the years.

The hydrotherapy didn't work. Or rather, it did some good but brought no permanent improvement. Occasionally, Manet suffered stabbing pains so severe that he cried out, but mostly he felt simple weariness, exhaustion. In the spring of 1881, he balked at any further hydrotherapy, and so the unassertive Dr. Siredey simply advised relaxation in the country. Manet rented a villa in Versailles and went for long walks in Le Nôtre's royal gardens, planning future pictures. Even that soon became too much of an effort, and so he stayed home, sometimes sitting disconsolate in his garden. Mallarmé, whose translation of Poe's *Raven* Manet had illustrated in 1875, wrote to suggest that he illustrate some new translations of Poe; Manet regretfully declined. "Dear Captain," he wrote. "You know how much I should like to embark with you on any voyage at all. But today it's beyond my strength. I don't feel competent to do what you ask. I have no models and above all no imagination. I would produce nothing worthwhile. Please forgive me. I'm not very pleased with my health since I've been in Versailles. I don't know if it's the change of air or the variations in temperature, but it

seems to me I'm not feeling so well as I did in Paris. ..."

To Éva Gonzalès, by now married to an engraver named Henri Guérard, he wrote even more gloomily that September: "Like you, alas, we've been having frightful weather. I believe it's been raining here for a good month and a half. ... I've had to content myself with painting only my garden, which is the most dreadful of gardens." Dreadful or not, rainy or not, Manet did finish here the beautiful picture known as *The Bench* (1881), which he painted very much in the Impressionist style, all sunshine and red roses and tranquillity.

Back in Paris that fall, Manet attempted a great show of making the rounds at his old haunts, the Café de la Nouvelle-Athènes, Tortoni's. And he began work on what was to be his last full-scale painting. It was, almost inevitably, a mysteriously grand portrait of a young woman. Her name was Suzon, and she worked as a barmaid at the Folies-Bergère, that newly fashionable vaudeville theater that, as Huysmans wrote, "stinks so sweetly of the *maquillage* of purchased favors and the extremes of jaded corruption." Manet brought her to his studio to pose for him; he also acquired a marble-topped counter for her to stand behind. This was to be a complex and difficult work, and Manet kept changing things as he progressed, but he could work only for brief periods before exhaustion overcame him.

A young painter named Georges Jeanniot went to visit Manet and left a clear description of the chaotic scene. "He was then painting *A Bar at the Folies-Bergère,*" Jeanniot recalled, "and the model, a pretty girl, was posing behind a table laden with bottles and comestibles. He recognized me at once, offered me his hand, and said, 'It's a nuisance, excuse me, I have to remain seated, I have a bad foot. Sit down over there.' I took a chair behind him and watched him at work. Manet, though painting from life, was in no way copying nature; I noticed his masterly simplifications; the woman's head was being formed, but the image was not produced by the means that nature showed him. All was condensed; the tones were lighter, the colors brighter, the values closer, the shades more diverse. The result was a whole of blond, tender harmony. Someone came in. ... More people came, and Manet stopped painting to go sit on the couch against the wall at the right. Then I saw how illness had changed him. ... He was cheerful all the same, and spoke of his early recovery."

A Bar at the Folies-Bergère is full of mysteries and mystifications.

The various bottles that form a remarkable still-life in the foreground, for example, are arrayed in a completely unrealistic way, the champagne next to some Bass ale and some crème de menthe, all at room temperature. Some tiny legs dangling in the upper left are said to represent a trapeze artist, but nobody seems to be paying any attention. Most remarkable of all, one aspect of the perspective is wildly distorted. The mirror that shows us the whole audience, including the recognizable figures of Méry Laurent and Jeanne Demarsy, is directly behind the barmaid, and yet we see her apparent reflection standing off to the right, conversing with a mustachioed patron (posed by the painter Gaston Latouche). There are, as always, a number of theories to explain the distortion. George Heard Hamilton, for example, argues in *Manet and His Critics* that the mirror "must be understood as being at an angle to the bar in order to account for the man's position." But no effort to imagine this angle eliminates the distortion. Another possibility is that the mirror image of the barmaid is not a mirror image at all but rather a second barmaid serving another customer. Orthodox critics generally reject this possibility for the sake of more elaborate explanations. "The city is reflected in a thousand eyes, a thousand lenses," Walter Benjamin wrote about Paris. "The beauty of Parisian women shines forth from mirrors such as these.... The mirrors are the immaterial element of the city, her emblem, within which have been enrolled the emblems of all schools of poetic art."

Finally, it is possible that the distortion of the mirror image was simply another one of Manet's "mistakes," like *The Spanish Singer* back in the Salon of 1860, who played left-handed on a right-handed guitar. In a preliminary version of *A Bar at the Folies-Bergère,* however, the barmaid and her reflection are fairly "correct," almost exactly back-to-back, so it seems obvious that Manet was quite deliberately making the perspective "wrong" when he separated the two figures. That leaves us with an interesting conundrum. If the barmaid is looking directly out at the viewer, as she is, and if her mirror image is conversing with the mustachioed patron, as she is, then doesn't logic insist that the mustachioed patron must be the viewer, you, *hypocrite lecteur, mon semblable, mon frère*? So much for logic.

The final mystery, though, involves not trickery or technique but the expression on the face of the barmaid, with her blond bangs and her creamy pink complexion. Like Olympia, she wears a black ribbon around

her neck, and like Olympia she is in a situation that suggests her availability. To be a barmaid in the Paris of the 1880s was, almost by definition, to be for sale. Unlike Olympia, with her cool boldness, the barmaid looks discontented and bored. Some critics have naturally seen her as an oppressed sex object, and perhaps she is, but her boredom seems more transcendental than that. The Folies-Bergère was and still is rather like Las Vegas, one of those places where people pay handsomely to convince themselves that they are enjoying themselves. Go to one of those supposedly glamorous casinos, where no natural light or air ever penetrates, where grim-faced pleasure-seekers bend over the blackjack tables, and it becomes easy to imagine that hell is a parody of heaven. And on the faces of the waitresses, whose uniforms similarly parody pleasure—strapless black minidresses, net stockings, high heels—you can see the same overwhelming boredom that Manet painted on the face of his barmaid at the Folies-Bergère. It regards the new and the fashionable with an almost sublime ennui.

Manet submitted *A Bar at the Folies-Bergère* and the portrait of Jeanne Demarsy as *Spring* to the Salon of 1882, and the jury no longer had the right to reject anything he offered. The critics seemed similarly acquiescent, rather than approving, as though Manet had become something unpreventable. Huysmans, for example, was reserved and fretful. "The subject is very modern and Manet's idea of thus putting the female figure in its environment is ingenious," he wrote of *A Bar at the Folies-Bergère,* "but what is the meaning of the lighting? Is it gas or electricity? Or is it perhaps an indefinite out-of-doors light, bathed in pale daylight? From this point of view, everything falls apart.... I regret it all the more, for even with the chalky color his *Bar* is full of good qualities." In *La Revue des Deux Mondes,* Henry Houssaye was even more grudging: "If one uses the word masterly only to mean serious painting, Manet is not a master; far from it. But if the word is taken to mean teacher, or rather initiator, the painter of *Olympia* should be hailed as a master. His influence is apparent upon a whole group of contemporary painters. It is he who since 1860 has advocated, preaching by example, the crude effect of diffused lighting, unusually bright coloring, large areas of color taken from Japanese prints, simplified modeling of the flesh...." Houssaye's conclusion was stern: "Is this picture true? No. Is it beautiful? No. Is it attractive? No. But what is it, then?"

Albert Wolff of *Le Figaro* was, as usual, infinitely patronizing. "I shall

never agree with Manet on all counts," he wrote. "His hatred of the perfumed and powdered painting often makes him exceed his intentions. But, in the end, he has an individual temperament. His painting is not for everyone; it is the work of an incomplete artist, but still of an artist.... There is no denying it; Manet's art is entirely his own. He has not borrowed it from the museums, he has taken it from nature." Manet regarded this as Wolff's version of praise, and he could not resist a jab. "My thanks for the pleasant things you said with regard to my exhibition," he wrote. "But I should be sorry not to read, in my lifetime, the splendid article that you will devote to me after my death."

So the idea of his recovery was fading from Manet's mind, being replaced by a sense of the inevitability of death. He spoke of it often, and not with any show of acceptance but with bitterness and anger. To his mother, he once said, "One shouldn't bring children into the world if they're to be like this." He was exasperated at the idea that he would be outlived by a painter like Cabanel. "He's in good health, damn him!" he said to Proust. When Proust told him that he had reached a time when justice would be done him, Manet answered, "Oh, I know all about justice being done one day. It means one begins to live only after one is dead. I know all about that sort of justice."

In the summer of 1882, Manet rented a house in the western suburb of Rueil, not far from the house that Berthe Morisot had rented in Bougival, but there is no evidence that they saw much of each other, only one hasty sketch of Julie. Manet was in almost constant pain now. His left foot hurt badly, and he could hardly take a step without his cane. He had become stooped and emaciated. He slept badly. "What a wretched month!" he wrote to Méry Laurent. "Rain or wind every day—unlikely to make the country agreeable, especially to a sick man—my only amusements consist in carriage rides and reading, since I've hardly been able to work outside at all.... Good-bye, my dear Méry, I send kisses." Unable to work outside in the rain, Manet once again finished a sunny, Impressionistic painting of his own house and garden. It has been observed that Manet's landscapes almost never contain any sky—he was the urban painter par excellence—and here his eye does not even reach beyond the second-floor windows, an admirable sequence of gray shutters, but this serene vista seems full of quiet happiness, not the work of a dying man. "I need to work to feel well," he wrote to Méry Laurent.

The exquisite creations of these last months, when Manet was too

exhausted to finish anything more demanding, were a series of paintings of flowers, more than a dozen in all, roses, lilacs, tulips, clematis, peonies. Some he found in his garden, some were brought by friends; Méry Laurent's maid Élisa brought him a bouquet every day. "I should like to paint them all," Manet said. They are of an extraordinary sweetness, these last flowers, partly because of their ephemerality; already cut, in their fresh beauty, they are already dying. Manet emphasized that in his funereal backgrounds, which seem both threatening and compassionate, particularly those that serve for two clusters of white lilacs. Robert Gordon and Andrew Forge, who published a beautiful collection called *The Last Flowers of Manet,* write eloquently of these two paintings: "Both have dark backgrounds. In one it is actually black, that cold Spanish black that had served Manet like a familiar all his life—the black of Velázquez, the black of top hats and frock coats, the black of cats and velvet ribbons and Berthe Morisot's hair. The white ghostly flowers are stark against the sooty background. Nowhere else is the light of the flowers as sharply contrasted with the brittle light of the glass. For all the innocence of its subject, it is a tragic, pitiless image. The black of the background falls slanting behind the flowers as though it were being drawn against the light like a curtain, threatening the snowy lilacs."

Manet kept limping to his studio and struggling to finish something for the Salon of 1883. He wanted to paint a woman on horseback; he wanted to paint a bugler; he did three studies for a prospective portrait named *The Amazon.* His model was the pretty daughter of a local bookseller named Saguez. Nothing came out right, and every day he felt weaker. One afternoon in February, he received a visit from a painter named Ernest-Pierre Prins, the widower of that Fanny Claus who had once posed next to Berthe Morisot in *The Balcony.* Manet greeted him glumly: "A dying man is no pleasant sight." He sat on his sofa and stared at the latest version of *The Amazon.* "It's not right," he said. "The background bothers me." He got up, took his palette, and began retouching the picture. Suddenly he dropped his brush and staggered. "He seemed to be fumbling like a blind man," Prins later recalled, "turned, tried to move, groaned weakly.... He clutched at the sofa with both hands and collapsed onto it."

Prins pretended that there was nothing wrong. He tried to make conversation. Manet sat on the sofa, rubbing his painful left leg, his eyes glittering. Prins took a preliminary sketch of *The Amazon* down from the

wall as though to examine it more closely. Manet lurched to his feet, seized the canvas he had been working on, and ripped it from top to bottom with his palette knife.

To be incurably ill is an infuriating thing. Constant weakness is infuriating, and so is recurring pain, and fear. Inability to work is infuriating. Since Dr. Siredey's hydrotherapy didn't seem to do any good, Manet had been consulting more unorthodox healers, including a homeopathist named Simon Vincent. We do not know many details of Manet's medical experiments, but we do know that Vincent urged him to try rye flour tainted with ergot (and that another doctor warned him against drug abuse).

Ergot is a rather mysterious fungus, officially *Claviceps purpurea,* which periodically causes wild outbreaks of communal hallucination among people who accidentally eat contaminated bread. Such outbreaks are also known as St. Anthony's fire, and there are some who blame it for the tales of witchcraft in Salem. Ergot also has medicinal qualities, however, for it constricts the blood vessels. It was therefore used as early as the seventeenth century to stop excessive bleeding during childbirth. It also has occasionally been used as an anesthetic, and this might be what inspired Vincent to try it on Manet. Even today, a synthetic ergot derivative called ergotamine tartrate is used to treat migraine headaches, nervous tension, and menopausal disorders. But because it constricts the blood vessels, ergot can be very dangerous. Reduced blood circulation in the feet can lead to gangrene, and gangrene kills.

On March 24, 1883, the Saturday before Easter, Manet did a pastel sketch of Méry Laurent's maid Élisa, who brought him a daily bouquet of flowers. He had promised to paint her portrait, but this was as far as he got. That night, his left foot turned black. "All night long," Léon Koëlla later recalled, "he suffered such pain in his left foot that his groans could be heard throughout the building. It was only by going on my own to see Siredey that I knew it was gangrene that had begun. His foot was completely black. ..."

Amputation is the standard treatment, but Siredey and two other surgeons were afraid that Manet was too weak to survive the shock. The homeopathist Vincent insisted that surgery would kill him, and so did another doctor whom he brought in. Manet kept to his bed but still dreamed of new paintings for the Salon. In mid-April, according to an account in *Le Figaro,* "Manet having regained some strength in the last

few days, his doctors determined to attempt the amputation, provided their patient was willing to undergo it. On Wednesday one of Manet's friends came to see him and reported that a man he knew, in a similar situation, had permitted such an amputation, and that subsequently he was well on the way to recovery.

"'Well, then,' Manet said, 'if there is nothing else to do, take off the leg and let's be done with it.'"

This may be at least partly fiction. Proust recalled having visited Manet the day before the operation. "We talked rather a long time," he later wrote. "Nobody had told him anything about the surgeons' opinion [that the foot must be amputated], and he was thinking about future projects. The Salon that was about to open preoccupied him. ..."

The news of the calamity had already spread far. "Manet is desperately ill," Pissarro wrote to his son Lucien. "Manet is done for," Degas told a friend. "That doctor...is said to have poisoned him with too much diseased rye seed. Some papers, they say, have already taken care to announce his approaching end to him. His family will, I hope, have read them before he did. He is not in the least aware of his dangerous condition and he has a gangrenous foot." Questioned long afterwards on whether Manet knew what was happening to him, Léon Koëlla was rather evasive. "I did everything I could so that my godfather [Koëlla's standard term for the father who never acknowledged him] would not know that his foot had been cut off. But I cannot certify that he did not know. ... He knew about the operation. Dr. Siredey had spoken to him about it, but as to what words he had used, I know nothing."

At 10:00 A.M. on April 19, Manet was carried into the salon of his apartment and set down on a large table. By now, the gangrene had blackened Manet's leg up to the knee. His toenails dropped off at a touch. "Siredey came in first," Koëlla recalled, "and passed a flask of ether under my godfather's nose and said to me, 'You're going to get out of here, for a start.' So I kissed my godfather and went out of the room."

Paul Tillaux, a famous surgeon whom Siredey had brought into the case, performed the actual operation, amputating Manet's leg above the knee. Another doctor named Marjolin also attended, along with two nurses and Manet's brother Gustave. "My mother and I waited in the dining room," Koëlla recalled, "where Gustave came every instant to give us news of the operation."

The surgeons pronounced the operation a success, and Manet was

carted off to bed. It was only a week later, when Koëlla went to light a fire in the fireplace, "because it was not very warm," that he found Manet's amputated leg lying behind an andiron.

Even then, it was not certain what Manet knew. Claude Monet went to visit him several days after the operation and started to put his cap on Manet's bed. "He was horrified," Monet said later. "He said, 'Look out! You're going to hurt my foot!!'" But Koëlla remembered a very different scene. "One day, he lifted up the sheets from his bed, but without saying a word, as though to make me see that he didn't have a foot anymore. Or was it a pain in his leg? I can't be certain, because of the state of weakness he was in. He hardly spoke anymore."

For more than a week, Manet lingered in a rather dazed state, nursed by his mother and wife. He said he still felt pain in his lost leg. Despite a continuing fever, other friends came to visit him, Berthe Morisot, Mallarmé, Chabrier. Sometimes he spoke with them, even joked, sometimes he just stared. They couldn't be certain whether he recognized them or not. Sometimes he seemed delirious. Koëlla barred the door to anyone but close friends. A health bulletin signed by Doctor Marjolin appeared daily on the concierge's door, reporting that the fever was still there.

"Death came slowly, but it came," said Gaston Latouche, the mirrored customer at the bar of the Folies-Bergère. "The last time I saw poor Manet, he had undergone the painful operation on his leg.... I can still see his fine head silhouetted against the white pillow that emphasized the ashen color his face had already assumed, already invaded by the shadows of death. I stayed with him only a few moments; he was supposed to avoid fatigue. We said little—I tried to keep a smile on my lips for his sake, and I felt the sobs tightening my throat. Yet Manet managed to laugh—I who had promised to cheer up this dear companion.... I left without finding a word to say...."

Manet suffered great pain throughout his last Sunday, and the next day he finally expired in the arms of his unacknowledged son. At 7 P.M. on April 30, 1883. "Poor Édouard suffered atrociously," Berthe Morisot wrote to Edma. "His agony was horrible. In a word, it was death in one of its most appalling forms that I once again witnessed at very close range. If you add to these almost physical emotions my old bonds of friendship with Édouard, an entire past of youth and work suddenly ending, you will understand that I am crushed."

"The hearse stands in front of the door—the center of a vast black

patch—friends of Manet, who have come to pay their final homage...."
Jules-Camille de Polignac wrote in the newspaper *Paris* on May 5. "On
the opposite sidewalk, passersby, girls buying their lunch, people who
have come to have a look, standing on tiptoe to watch, open-mouthed,
voyeurs of death.... No sky, no sun; bright clouds spread a gentle gray
light over the 'picture of a street.'

"The hearse jolts and slowly starts on its way, making a charcoal
stroke across the light of day.... This hearse, however, is a feast of
color—against the black pall, lilacs, violets, cornflowers, pansies, and
roses explode like laughter in the glory of wreaths and the intoxication of
flowers.

"Behind the crowd follows—a long ribbon of mourning unwound for
Death. Friends—Clemenceau, Antonin Proust, who will presently
speak, Zola, who is one of the pallbearers, Aurélien Scholl, Puvis de Cha-
vannes, who, seen from behind, looks as though he were cut out of one
of his own pictures; Degas, Pissarro, Renoir—'three Impressionists'—
Mallarmé, Jean Marras...etc., men who have already achieved success,
men to whom success will come tomorrow—all are there to follow the
body of their valiant friend. And they are five hundred strong....

"The procession stops at the portal of Saint-Louis d'Antin, where a
catafalque has been set up in front of the high altar glittering with can-
dles. Manet's body is brought in, followed by his family and a small num-
ber of friends, and immediately the choirs burst into song, followed by
the mournful solos of the service for the dead...."

After the funeral ceremony, the procession set out along the Boule-
vard Hausssmann toward the Étoile, then southward toward the Tro-
cadéro. Here lay the Passy Cemetery, where Eugène Manet and Berthe
Morisot had acquired a plot for themselves; here they put Manet.

"Here the sky was washed clean, and the route seemed charming,"
Polignac's account continued. "After the long monotony of the streets,
we were happy, in spite of our tiredness and sorrow, to see suddenly,
through some gap, Paris, luminous under clear skies, extended before
us, and to see in this Avenue du Trocadéro the two green lines of orderly
trees silhouetted against the blue sky...."

<center>۞</center>

Éva Gonzalès was horrified by Manet's death, for she had admired him
intensely, perhaps loved him, too. She could not go to his funeral

because she had just given birth to her first child, a boy, born on the day of Manet's amputation. Two days after the funeral, she lay in bed, braiding flowers into a funeral wreath for Manet. Suddenly she called out to her sister, who was keeping watch in the same room. "Something to drink!" she cried. "Cold water! I feel I'm dying!" Before anything could be done, she was dead of an embolism. She was thirty-two.

<div align="center">⊙⊙⊙</div>

Eugène Manet finally died, slowly, on April 13, 1892, and Berthe Morisot, who thought she was resigned to everything, was not resigned to everything. Her parents dead, Manet dead, now Eugène dead, she wrote in her notebook: "I don't want to live anymore. I want to go down into the depths of pain because it seems to me it must be possible to rise from there; but now for three nights I've wept: mercy—mercy." But there was an incredible strength and resilience in Berthe Morisot. She read Montaigne. She reflected. She wrote in her notebook: "I say 'I want to die' but it's not true at all; *I want to become younger.*" And again: "I would like to relive my life and comment on it, tell of my weaknesses; no, that's useless; I've sinned, I've suffered, I've atoned, and I could never produce anything but a bad novel by telling what has been told a thousand times [Was she recalling Eugène's *Victims*!?] What I would like would be to recapture the moments when I had strength and vigor, a line of conduct, a rule, a faith; but that's beyond my powers."

Many of those moments were now captured on canvas, and Eugène, before he died, had organized her first one-woman exhibition, at the Boussot & Valadon gallery. It opened just a month after his death, and it was a considerable success. Monet, no longer penniless, bought one offering for 1,500 francs; others paid even more; Renoir wrote to "send you my compliments." Berthe was pleased. "It all seems less bad than I had anticipated."

Caillebotte died in 1894, bequeathing to the French government his extraordinary collection of sixty-six paintings, which he offered on condition that they all be exhibited as a group. The Ministry of Fine Arts balked; critics complained that the Vandals were at the gates; Renoir, as executor, had to engage in tortuous negotiations. Meanwhile, the Duret bankruptcy brought the auction that enabled Berthe to retrieve Manet's *Berthe Morisot with a Bouquet of Violets.* Duret also owned one of Berthe's paintings, *Woman at a Ball,* which she had shown at the

Impressionist exhibition of 1880. Since several of Berthe's friends knew that Caillebotte had never bought any of her pictures, and therefore she would be absent from the eventual triumphant entry of the Caillebotte collection into the Louvre, Mallarmé brought several museum officials to the Duret auction and they agreed to buy *Woman at a Ball* for the state for a handsome 4,500 francs. And since it took Renoir more than a year to negotiate the government's acceptance of thirty-eight of Caillebotte's sixty-six paintings (including Manet's *The Balcony* and *Angelina*), it was Berthe Morisot who led the Impressionists' entry into the official Valhalla.

She was still only fifty-three, but by now she looked regally venerable. Renoir painted a double portrait of her and her adolescent daughter, Julie all in bloom, Berthe all stoical resignation, her thick white hair knotted in a matronly bun. Mallarmé wrote of "her hair whitened by the abstract purification of the beautiful rather than the aged, with a length of veil, a serene discernment, whose judgment, under the circumstances, had no need of death's perspective...."

But death did give a perspective. "How many silent dead behind us!" she wrote in her notebook. "All those ancestors, of whom we know nothing, who lived, ate, drank, slept, without leaving anything to us, their descendants." And as she reflected on her own art, and that of her friends, she found herself unable to analyze it in any systematic way. "Explaining how painting is done might perhaps interest the idly curious because they'll never understand anything..." she wrote in her notebook. "Real painters understand with a brush in their hand.... Besides, is this vulgarization of artistic matters really necessary?" And of her life as a whole: "We all die with our secret."

She nursed Julie through a bad attack of flu in February of 1895 and then fell ill of the same disease. It went on and on, then turned into pneumonia. Edma came to nurse her; doctors inspected her daily. She was very weak. "My little Julie, I love you as I die," she wrote in a farewell letter to her daughter on February 28; "I will love you when I'm dead; please, don't cry; this separation was inevitable; I would have liked to survive till your wedding.... Work and be good as you have always been; you haven't made me sad once in your little life. You have beauty and wealth; use them well...."

The next day, she was in great pain and had difficulty in swallowing.

She spoke to Julie for the last time at about three in the afternoon. At about ten that evening, she died. She was buried next to Édouard and Eugène Manet in the Passy cemetery.

Méry Laurent remained faithful to Manet's memory. Every year, in the spring, she went and placed lilacs on his grave. When she died in 1900, she bequeathed to the museum in her hometown of Nancy the portrait that he had painted of her as the spirit of Autumn.

Suzanne Manet lived on the profits of the estate. Manet had asked in his will that all the unsold pictures in his studio be auctioned off, for the benefit of his wife and godson, and so it was done, at the Hôtel Druot, on February 4 and 5, 1884. The auction included ninety-three oil paintings, thirty pastels, fourteen watercolors, twenty-three drawings, and nine etchings and lithographs, and it brought in a total of 116,637 francs. Renoir considered that "far better than anyone had dared to hope," though Suzanne had apparently dreamed of 200,000.

She lived her remaining years with her son, Koëlla, whom she continued to refer to as her brother, and to call Leenhoff. This son cherished the illusion that he had a talent for commerce. Two years before Manet's death, he had started a bank, under the name Leenhoff, but this establishment almost inevitably went bankrupt. He then opened a curious business that involved mainly the breeding and selling of rabbits and chickens, but also chicken incubators, rabbit hutches, fishing gear and worms. He published and mailed out thousands of catalogues for his enterprise, and somehow he survived.

In the house above this business, Suzanne died in 1906. Only then, at the age of fifty-four, did "Leenhoff" adopt his legal but equally questionable name of Koëlla—he seems to have feared until then that the name of Koëlla would publicize his illegitimacy—and only then did he get married, to a woman named Fanfillon, who had invented a powder that was alleged to make hens lay more eggs. He eventually retired and went with a senile cousin named Vibert to live out his last years in a village in Normandy. He died there in 1927, childless.

Victorine Meurent exhibited another painting entitled *A Bourgeois Woman of Nuremberg in the Sixteenth Century* at the Salon of 1879, but by now she was falling victim to alcohol, and her looks were fading. She lived with another model named Marie Pellegrin, who seems to have been a lesbian, and there are indications that both of them engaged in prostitution. George Moore, the Irish writer, was rather enamored of Marie Pellegrin and vividly recalled meeting her at a demimondaine establishment called Alphonsine's. "Marie asked me if I played cards," he wrote in *Memoirs of My Dead Life,* "but I excused myself, saying that I would prefer to sit and look at her; and just then a thin woman with red hair, who had arrived at the same time as Marie and who had sat next to her at dinner, was introduced to me, and I was told that she was Marie's intimate friend, and that the two lived together whenever Marie returned to Montmartre. She was known as 'La Glu,'° her real name was Victorine, she had sat for Manet's picture of *Olympia,* but that was years ago. The face was thinner, but I recognized the red hair and the brown eyes, small eyes set closely, reminding one of *des petits verres de cognac.†* Her sketch book was being passed around, and as it came into my hands, I noticed that she did not wear stays and was dressed in old gray woollen. She lit cigarette after cigarette, and leaned over Marie with her arm about her shoulder, advising her what cards to play. The game was baccarat, and in a little while I saw that Marie was losing a great deal of money, and a little later, I saw La Glu trying to persuade her away from the card table.

"'One more deal.' That deal lost her the last louis she had placed on the table. 'Someone will have to pay my cab,' she said.

"We were going to the Élysée Montmartre, and Alphonsine lent her a couple of louis, *pour passer sa soirée,‡* and we all went away in carriages, the little horses straining up the steep streets...."

This was Marie's last night in Paris, because some Russian prince had offered her 500,000 francs to go to Russia with him for three years. So she went to Russia with the prince, but after what Moore described only as "many months," she fell ill, and homesickness brought her back to Montmartre. Moore got her new address from Alphonsine and went to

°Miss Glue, possibly implying sticky fingers.
†Little glasses of cognac.
‡"To spend on her evening."

see her. "As I went upstairs I thought of La Glu," he wrote, "of her untidy dress and her red hair, and it was she who answered the bell and asked me into an unfurnished drawing room, and we stood by the chimneypiece. 'She's talking of going to the Élysée tonight. Won't you come in? She'd like to see you. There are three or four of us here....'"

"*Comme les Anglais son gentils,*" Marie greeted him. "*Dès qu'on est malade—*"°

Moore was talking with the ailing Marie when he suddenly heard a quarrel break out at the card table between Victorine and another woman named Clementine. "The women threw their cards aside, and La Glu told Clementine that she was not wanted.... I heard further accusations, and among them the plaintive voice of Marie begging me not to believe what they said. The women caught each other by the hair, and tore at each other's faces, and Marie raised herself up in bed and implored them to cease, and then she fell back crying. For a moment, it seemed as if they were going to sit down to cards again, but suddenly everybody snatched her own money and then everybody snatched at the money within her reach; and, calling each other thieves, they struggled through the door, and I heard them quarreling all the way down the staircase."

Marie promised to meet Moore at the Élysée at eleven that night, but she never came. When he went to inquire why, he found that she had died that same evening.

After Marie Pellegrin's death, Victorine tried to earn a living by painting portraits of various Montmartre shopkeepers, she tried modeling, she tried giving guitar lessons, all without success. The last time she saw Manet was in 1881, when she went to his new establishment on the Rue d'Amsterdam and asked him for money. He gave her some.

The following year, she was evicted from her room for being unable to pay the rent. She went to stay with her mother, a sick old woman who eked out a living by washing clothes in the Seine in the industrial suburb of Asnières. It was a four-mile walk back to Montmartre, but she came several times to Koëlla's bank during the winter of 1882–83 to beg for money. "She was unrecognizable, looked embalmed," Koëlla recalled later. "Only her breasts seemed unchanged." It is not known whether he gave her any money; one suspects not.

°"How nice the English are. As soon as one is sick—"

Victorine did not go to Manet's funeral that April. Perhaps she did not hear of his death until too late. Perhaps it was just too far to walk. In July, she wrote a touching letter to Suzanne Manet, just about the only letter by her that still survives. "Excuse me, I beg you," she wrote, "if I come today to revive your sorrow by speaking to you of that excellent and much regretted Monsieur Manet. You doubtless know that I posed for a large number of his paintings, notably for *Olympia,* his masterpiece. M. Manet showed much interest in me and often said that if he sold these paintings, he would save a reward for me. I was young and carefree in those days—I left for America. When I came back, M. Manet, who had sold a large number of his pictures...said that he would give me something; I refused, thanking him profusely and saying that when I was no longer able to pose, I would remind him of his promise. That time has come much sooner than I expected. The last time that I saw M. Manet, he promised to take care of me, to get me a job as an attendant in a theater, adding that he would stand security for me. You know the rest, the sickness that tore him from your affection. Of course, I decided never to importune you by reminding you of this promise, but misery has befallen me. I cannot pose any more, I am completely responsible for my aged mother, who is completely incapable of working, and finally I have had an accident with my right hand (a finger broken), which has deprived me for several months of any hope of working. It is this desperate situation, Madame, that has convinced me to remind you of M. Manet's kind promise.... If, in my misery, and in memory of him, you have the kindness to take an interest in my fate and to do something for me, you will have, Madame, my profound gratitude...." Suzanne Manet did not take an interest in Victorine's fate; she never answered the letter.

A year later, Victorine found a savior. She reappeared in Montmartre with a handsome new wardrobe and enough money to pay all her debts. She let it be known that she was being kept by a married man. She even made one last appearance at the Salon of 1885 with a painting entitled *Palm Sunday,* which showed a young woman holding an armful of boxwood cuttings. The wealthy admirer was no longer supporting her, however, and Victorine soon drifted into fairly open prostitution. The owner of the Élysée-Montmartre allowed her to circulate among his customers, offering her drawings for sale. "'Here comes La Glu,' people would say," recalled Suzanne Valadon, who had served as a model for Renoir and

Toulouse-Lautrec before taking up painting herself. "I can still see her, very straight and slender, and dressed in light-colored but never gaudy clothes. She was considered very conceited and not very talkative."

Unable to get work painting portraits, she made copies of her own painting *A Bourgeois Woman of Nuremberg* and did her best to sell those. She even made copies of *Olympia* and announced herself as the model. Suzanne Valadon remembered other streetwalkers laughing at such claims. They persuaded the owner of the Élysées-Montmartre to forbid her soliciting there. She appeared in nearby bars like Le Rat Mort, cadging drinks. She got a job as a dancer at the Bal des Frères Corlieu. She dropped out of sight in the summer of 1888, and there were reports that she was sick in a hospital, but in the fall somebody spotted her near the Odéon, "a broken, wizened, dried-up old woman," according to one account, "wearing espadrilles and playing the guitar."

In 1889, the authorities staged a huge exhibit celebrating a century of French art since the storming of the Bastille. They displayed fourteen of Manet's paintings, including, naturally, *Olympia.* Outside the exhibition hall in the Champs de Mars, Victorine Meurent sat begging. One of the people who recognized her was Louis Lathuille, the restaurateur's son who had once posed as the young seducer in Manet's *Chez le Père La-thuille* (1879). "In July, one afternoon, I saw her on the Avenue Suffren," he told Tabarant. "She was sitting on the ground, leaning against a wall, strumming a guitar. I had heard nothing about her for a long time and couldn't believe my eyes. She was dressed in rags, her hair was white, she looked very old." After the exhibition closed, she acquired a small monkey and began carrying it on her back when she sang and played her guitar in the streets. She became known as "La vieille au singe."* Degas saw her once in the Place Pigalle, drunk. Lautrec saw her once in the Rue Tourlaque, clinging to a street lamp.

Lautrec went to visit her at about this time. He had some friends named Dihaut with whom he liked to eat dinner. "Coming out of the Dihauts' place," according to another friend named Maurice Joyant, "we had to climb up to the sixth floor of the house across the street in order to pay a visit to a shapeless old lady who as a young girl had posed for Manet and Puvis de Chavannes; she kept a drawing of her head, of a purity and simplicity worthy of Ingres: a melancholy pilgrimage, if it

*"The old woman with the monkey."

actually happened." Though there is some uncertainty about Victorine's exact age, this "shapeless old lady" was probably still less than fifty years old.

The last time she posed for anyone was in 1890, when a thirty-six-year-old Impressionist named Norbert Goeneutte painted a bleakly accusatory portrait of her in her degradation. Seen in profile, she sits hunched over next to a table, head bent, her hair disheveled, her eyes nearly closed, her expression one of pain, misery, and exhaustion. Her gnarled right hand holds a guitar, but her left rests atop a bottle, and to emphasize the message, two more bottles stand nearby. Next to them, outfitted in a child's dress, a small monkey regards her with an expression somewhere between dislike and dismay.

According to Tabarant, 1892 was the last year she was seen, "but how or where she died is unknown." The archives of the Musée d'Orsay in Paris, however, contain a document from the Society of French Artists listing the pictures that Victorine showed in various salons, and it includes without any details a fourth entry in the Salon of 1904, *Study of a Cat*. On this list, someone has made a handwritten notation that mysteriously says "Deceased 1928." It would seem astonishing that a rather well-known woman who was considered alcoholic and decrepit in the 1880s could somehow have survived in total obscurity for another forty years. "There is a tradition that she lived to be very old," another investigator named Jacques Goedorp has written. "We have searched in vain through the municipal records until rather recent times. We have interrogated nursing homes and hospices throughout the Prefecture of the Seine. All trace of Olympia seems to be lost in the sands."

Victorine was not, of course, Olympia. The two had coexisted for a brief time in Manet's atelier, but as Victorine sank into alcoholic degradation, Olympia remained in Suzanne Manet's home, still unsold, still as beautiful as ever. She had been offered at the auction after Manet's death, and Suzanne halved Manet's asking price from 20,000 to 10,000. Nobody was willing to pay that much—at a time when a Meissonier had recently sold for 850,000 francs and a Millet for 750,000—and so Suzanne kept the picture.

Late in 1888, John Singer Sargent told his friend Claude Monet that Suzanne Manet needed money so badly that she was about to sell *Olympia* to some American, never subsequently identified, who would carry off this masterpiece to the New World. Some mixture of admira-

tion and chauvinism, perhaps combined with a recollection of the good turns that Manet had done him in his penniless youth, inspired Monet to promise Suzanne 20,000 francs and then to start a subscription drive so that *Olympia* could be bought and presented to the Louvre. Monet and Sargent both pledged their shares, of course, and so did Degas and Renoir and Pissarro and Fantin-Latour and Chabrier and Caillebotte and Huysmans and Mallarmé and Puvis de Chavannes and Anonymous and Double Incognito and a variety of others. One notable nay-sayer was Zola, who offered a characteristically pompous excuse: "I have championed Manet with my pen enough not to fear criticism now for grudging him his glory. Manet will go to the Louvre, but he must do it by himself, with full national recognition of his talent and not in the roundabout manner of this gift, which smells of the coterie and of publicity-seeking."

Monet's "publicity-seeking" couldn't quite reach the promised 20,000 francs, so Suzanne settled for 19,415. "I have the honor," Monet wrote to the Ministry of Public Instruction and Fine Arts early in 1890, "of offering to the state Édouard Manet's *Olympia*.... Not only did he play an important individual part, he was also the representative of a great and fruitful evolution. It thus appears impossible to us that such a work does not belong in our national collections, that the master is denied entrance where his pupils have already been admitted."

The ministry duly accepted the gift, but not for the Louvre. Politics has all kinds of rules, and one of them decreed that an artist had to be dead for ten years before any of his works could be hung in the national mausoleum, and Manet had only been dead for seven. So Olympia was consigned to a kind of second-class immortality in the Musée du Luxembourg. There she remained for three years more, until the ten-year milestone had been reached. Then the national cultural authorities convened in 1893 and decided that Olympia was eligible but not worthy of the Louvre. It was possible that the Louvre should contain some paintings by Manet, now a respectable ten years dead, but not *Olympia,* not that beautiful naked woman on her white pillows.

Years passed—fourteen years, to be exact—and then a political twist of fortune made Georges Clemenceau the premier of France. Clemenceau had known Manet back in the 1870s, when he and Manet's brother Gustave both served on the Paris Municipal Council, and Manet had painted two splendid but unfinished portraits of the young radical, not yet the ferocious Tiger of World War I and the Versailles Confer-

ence. Now that Clemenceau had become premier, Monet intervened once again to ask him to rescue Olympia from the limbo of the Luxembourg and finally install her in the Louvre.

And so it was done, by Clemenceau's personal order, but still with a certain amount of discreet secrecy. A taxi was hired to carry *Olympia,* early one morning in 1907, from the Luxembourg across the Seine to the Louvre. There she was hung in a place of honor, next to Ingres's *Great Odalisque* in the Salle des États. There were complaints and protests, as usual, and even Oriane de Guermantes was heard to say that this wonderful picture "doesn't perhaps quite belong in the Louvre." But the battle was over. What Victorine had lost—her deathless beauty—now belonged only to Olympia.

A NOTE ON SOURCES

"We know little of his private life," Françoise Cachin wrote in her introduction to the monumental catalogue that she produced, together with Charles S. Moffett and Juliet Wilson Bareau, for the hardly less monumental Manet exhibition of 1983, which commemorated the hundredth anniversary of his death. "For example, who were his friends?... Correspondence, by and large, adds nothing essential to our knowledge of Manet.... Very few revealing letters, then, no journal, and Manet died too young to be formally interviewed, as was Cézanne in his old age."

One result of this scarcity of personal information is that there is no really overwhelming biography of Manet. The numerous books about him all tend to be organized in much the same way, a chronological account of his professional life, painting after painting, Salon failure after Salon failure, with appropriate scraps of biographical detail mortised in wherever they fit. In a way, this is commendable, a fulfillment of that conventional assertion that an artist should be known and judged by his works, not by his private life. Still, after reading the tenth or twelfth analysis of how Manet's sense of color or perspective resembles that of some other painter, one does sometimes feel something lacking.

For a painting-by-painting analysis, with the relevant biographical and historical information, the best and most thorough source is the Cachin-Moffett-Bareau catalogue, though "catalogue" seems hardly an adequate term for this sumptuous and authoritative work, published in 1983 by New York's Metropolitan Museum of Art and Harry N. Abrams.

Historically, though, one must go back to the beginnings. The first biography of Manet was by Edmond Bazire (*Manet,* 1884), which was duly superseded by the work of Manet's good friend, Théodore Duret (*Histoire d'Édouard Manet,* 1902), and then by that of his better friend, Antonin Proust (*Édouard Manet, Souvenirs,* 1913). These are all primarily anecdotal rather than analytical, but all subsequent writers are much in debt to them, and particularly to Proust. Somewhat more ambitious, and somewhat less successful, is *Manet Raconté par lui-même,* by Étienne Moreau-Nelaton (2 vols., 1926). Moreau-Nelaton was a major collector of Manet's works, which he donated to the Louvre, and his book combines official biography with a sort of anthology of contemporary views. A similar approach underlies *Portrait of Manet, by Himself and His Contemporaries,* edited by Pierre Courthion and Pierre Cailles (1953; edited and translated by Michael Ross, 1960).

The contemporary who wrote most vigorously and temperamentally about Manet was, of course, Émile Zola, and his works still have a historical interest though not many would agree with all his judgments. His various essays and articles on art, to be found in Volumes 10 and 12 of his collected works, are available in a paperback edition, *Mon Salon/Manet, Écrits sur l'art,* published by Flamarion in 1970. For a detailed analysis, see *Zola, Cézanne and Manet: A study of "L'Oeuvre,"* by Robert J. Niess (1968).

The dean of all modern scholars on Manet, though, is the late Adolphe Tabarant, who not only pursued every trace of Victorine Meurent but actually interviewed the aged Léon Koëlla and insisted on being told in detail whether Manet actually knew that his leg had been amputated. Tabarant's major work was *Manet et Ses Oeuvres* (Gallimard, 1947), which not only describes each painting but even provides its measurements and sales history.

The standard biography, in the French manner, is *La Vie de Manet,* by Henry Perruchot, published by Hachette in 1959. There is an English translation by Humphrey Hare (World). As I have complained in the text, I find Perruchot too willing to make inferences from insufficient evidence. For more recent biographies of the standard sort, see *La Vie de peintre d'Édouard Manet,* by Pierre Daix (1983), and *Manet,* by Éric Darragon (1989).

There has been a good deal of what might be called social analysis of Manet in recent years. Much of it is highly instructive. See, in particular,

The Painting of Modern Life: Paris in the Art of Manet and His Follow-ers, by T. J. Clark (1985); *Manet and the Modern Tradition,* by Anne Coffin Hanson (1977–79); and *Manet and Modern Paris,* by Theodore Reff (1982), which served as the catalogue for an exhibit of one hundred pictures by Manet and his contemporaries at the National Gallery of Art in Washington.

There is another very useful category of books on Manet, and that consists of what are essentially picturebooks. This is reasonable enough, since pictures are what Manet left to us. These pictures, generally much the same from one oversized book to another, are all arrayed in a series of full-page color plates. The accompanying texts, usually a dexterous combination of the biographical and the analytical, nonetheless remain primarily accompanying texts. One of the best and most recent of these is *Manet,* by Kathleen Adler (1986). For earlier examples, see *Manet,* by Georges Bataille (1955; 1983); *Manet,* by Pierre Courthion (undated); *The World of Manet,* by Pierre Schneider (1968); and *Manet,* by Richard Shone (1978).

Rather in a class by itself is *Manet; A Retrospective,* edited by T. A. Gronberg (1988), which is also very large—378 pages nearly the size of a tabloid newspaper—and includes all the usual color plates. Its specialty, however, is historic texts, ranging from a letter by Manet to his mother from Rio de Janeiro to an essay by Clement Greenberg.

Also rather in a class by itself is André Malraux's redoubtable *The Voices of Silence,* translated by Stuart Gilbert (1949–50; 1978).

1. OLYMPIA

Much of this chapter, like much of this book, is derived from wandering around Paris and returning repeatedly to admire *Olympia* and other Manet paintings now exhibited at the Musée d'Orsay. But there is also, of course, much to read. In addition to the general works on Manet, the process of specialization now begins. Perhaps the most notable study of *Olympia* is, quite simply, *Manet: Olympia,* by Theodore Reff (1976), which thoroughly and expertly explores all of Manet's literary and artistic "sources" for his painting, as well as all literary and artistic reactions to it. I suppose it is typical of the scholarly approach that this 132-page analysis of a painting of Victorine Meurent contains only two brief references to Victorine herself.

If Reff's detailed study of *Olympia* seems an exemplar of specialization, what are we to make of *Le Ruban au cou d'Olympia (The Ribbon on Olympia's Neck),* by Michel Leiris (1981)? Not very much, apparently, for the late M. Leiris was a Surrealist in his younger days, and his book on Olympia begins with a declaration to his readers that he prefers speaking to saying something. He immediately follows this odd assertion with an imaginary protest from his imaginary reader about speaking without saying anything, to which he promptly replies that this was only a manner of speaking. And so on.

Many experts have used single paintings by Manet, or single aspects of his painting, as a method of writing about his work as a whole. One of the best of these is *Manet and His Critics,* by George Heard Hamilton (1954), in which the eminent Yale scholar undertakes to view Manet through the distorted perspective of that contemporary hostility, which, as he puts it, "in constancy and bitterness surpassed that directed against any of his nineteenth-century predecessors." On the other side of the quarrel, incidentally, see *The Academy and French Painting in the Nineteenth Century,* by Albert Boime (1971; 1986).

Particularly germane to the critical barrages against Manet and his favorite models is *Manet and the Nude: A Study of Iconography in the Second Empire,* by Beatrice Farwell (1973), a perceptive work that reaches far beyond its far-reaching title. Originally a doctoral thesis at U.C.L.A., and thus available through the University of Michigan program for Xeroxing theses, Dr. Farwell's work was subsequently published by the Garland Press. In the spring of 1985, Dr. Farwell also edited an interesting special issue of *Art Journal* devoted entirely to Manet; I have taken from this some of Sharon Flescher's speculations about the origins of the name "Olympia." For a detailed study of some preliminary versions of *Olympia, Maximilian,* and several other key paintings, see *The Hidden Face of Manet,* by Juliet Wilson Bareau (1986).

The famous lines from Baudelaire on modernity, as well as his views on Wagner, can be found in a paperback edition, *The Painter of Modern Life, and Other Essays,* edited and translated by Jonathan Mayne (1986). For more on Manet's turbulent friend, see *Baudelaire,* by Jean-Paul Sartre, translated by Martin Turnell (1950); *Baudelaire,* by Enid Starkie (1958); and *Baudelaire,* by Claude Pichois, translated by Graham Robb (1989).

The details of Victorine Meurent's early life come mainly from

Tabarant, but also from a two-part article, *"L'Olympia" n'était pas Mont-martroise* ("Olympia Was Not from Montmartre"), by Jacques Goedorp, in the Paris newspaper, *Journal de l'Amateur de l'Art* for February and March, 1967. In quoting the Goncourt *Journals,* I have used the excellent version edited and translated by George J. Becker (1969). The lines by E. E. Cummings are in the section titled "Is 5" in his *Collected Poems.*

2. EMPRESS EUGÉNIE

I know of no major scholarly studies on Napoleon III and Empress Eugénie, but there are a number of good popular histories that are full of interesting detail. I have relied a good deal on two rather iconoclastic accounts, *Napoleon and His Carnival Empire,* by John Bierman (1988), and *Eugénie and Napoleon III,* by David Duff (1978).

The older school of chronicling royalty is fairly well represented by *The Tragic Empress: A Record of Intimate Talks with the Empress Eugénie,* by Maurice Paleologue, translated by Hamish Miles (1928), in which the former ambassador asks the exiled ex-empress respectful questions about how she devoted herself to her people and how her efforts were misunderstood by unprincipled critics. A similar tone of adulation pervades *Memoirs of Empress Eugénie,* by Comte Fleury (1920). Still respectful but much more comprehensive is *The Empress Eugénie,* by Harold Kurz (1964). Probably the best portrait of Napoleon, though somewhat too admiring, is *Napoleon III: A Great Life in Brief,* by Albert Guérard (1955). See also *Napoleon III,* by W. H. C. Smith (1972). Roger L. Williams had the interesting idea, in *The World of Napoleon III* (1957), of leaving out the emperor himself and portraying his "world" in a series of tangential figures, both political (the Duke de Morny) and cultural (Offenbach and Sainte-Beuve)—and not omitting such ornaments as the Countess of Castiglione.

For more purely political works, see *The Second Empire,* an admirably lucid account by G. P. Gooch (1960), and *The Political System of Napoleon III,* by Theodore Zeldin (1958). Dr. Zeldin's most interesting contribution to this field, however, is his magisterial survey, *France 1848–1945* (1973). Its first volume, devoted to "ambition, love and politics" starts with chapters on the bourgeoisie, doctors, notaries, and bankers, then through children and women to opportunism and socialism. For a more orthodox approach to such matters, see *An Economic*

History of Modern France (1981) and *A Social History of Nineteenth-Century France* (1987), both by Roger Price.

Probably the best biography of Princess Mathilde is still *The Princess Mathilde Bonaparte,* by Philip W. Sergeant (1914), though there is a newer account by Joanna Richardson, *Princess Mathilde* (1969). Indeed, Ms. Richardson has portrayed a number of personalities of this period, notably *Théophile Gautier* (1959), *Judith Gautier* (1987), *Verlaine* (1971), and *Zola* (1978). As for Napoleon's other great love, she is well presented in *Miss Howard and the Emperor: The Story of Napoleon III and His Mistress,* by Simone André Maurois (1957).

Dr. Evans tells his own story at great length in *The Memoirs of Dr. Thomas W. Evans: Recollections of the Second French Empire* (2 vols.; 1905), but while one can respect his constant gallantry toward Empress Eugénie, he carries chivalry to the point of not even mentioning his rather public mistress, Méry Laurent. Such omissions are remedied in a sprightly little account, *The Dentist and the Empress: The Adventures of Dr. Tom Evans in Gaslit Paris,* by Gerald Carson (1983).

There are many editions and many translations of the many works of Victor Hugo. For *History of a Crime,* I used an undated translation published by P. F. Collier. For *L'Année Terrible,* I translated from the original edition published by Michel Lévy Frères in 1874.

Manet's series on the execution of Maximilian has been the subject of intense critical scrutiny. See, for example, *Édouard Manet and the Execution of Maximilian* (1981), the catalogue of an exhibition focused on this subject at Brown University; this contains interesting essays by Pamela M. Jones, Marianne Ruggiero, Kathryn L. Brush, and others. Much can also be learned from Nils Gosta Sandblad's *Manet: Three Studies in Artistic Conception* (1954), which concentrates on *Olympia,* *Music in the Tuileries,* and *Maximilian.*

Ambroise Vollard's highly entertaining memoirs were published in 1978 as *Recollections of a Picture Dealer,* translated by Violet M. Mac-Donald.

3. BERTHE MORISOT

There is not a great deal of documentation on the very private life of Berthe Morisot, but what there is can mostly be found in *The Correspondence of Berthe Morisot,* edited by Denis Rouart, translated by

Betty W. Hubbard (1959), which also includes many letters by her mother and sisters. The best biography is *Berthe Morisot,* by Anne Higonnet (1990), who gained access to a good number of private family papers. For earlier studies, see *Berthe Morisot,* by Kathleen Adler and Tamar Garb (1987); *Berthe Morisot, Impressionist,* by Charles F. Stuckey and William P. Scott (1987); and *Berthe Morisot,* by Dominique Rey (1985).

Julie Manet's recollections are well told in *Growing Up with the Impressionists: The Diary of Julie Manet,* translated and edited by Rosalind de Boland Roberts and Jane Roberts (1987), though most of it deals with the years after Berthe Morisot's death. Paul Valéry's penetrating observations on Berthe Morisot and her friends can be found in *Degas Manet Morisot,* translated by David Paul (1960), which is Volume 12 in the Bollingen Foundation's set of Valéry's complete works.

Here and elsewhere, I am greatly indebted to John Rewald's excellent survey, *The History of Impressionism* (1946; revised 1955, 1961, 1973, 1987).

George Moore, the Irish poet and novelist, wanders in and out of this period and later wrote extensive memoirs of his young years in Paris. I have quoted from *Memoirs of a Dead Life* (1905) and *Hail and Farewell* (3 vols., 1911–14).

The indispensable guide to Flaubert, once one has acquired all the novels either in Gallimard's Pléiade edition or in the Penguin paperback translations, is Francis Steegmuller. His biography, *Flaubert and Madame Bovary: A Double Portrait* (1939; 1966; 1977), is a model of its kind. His translation and editing of the two-volume *Letters of Gustave Flaubert* (1980; 1982) is a revelation. And his compilation of the fragments that make up *Flaubert in Egypt* (1972) is a work of art in itself.

Further studies of Flaubert are numerous. For the indefatigable, see the two-volume biography by the indefatigable Enid Starkie (not quite finished at her death in 1971) and the three-volume analysis by the even more indefatigable Jean-Paul Sartre (also unfinished at his death in 1980). Flaubert has attracted some unusual admirers. See, for example, *The Perpetual Orgy: Flaubert and Madame Bovary,* the first nonfiction work by the novelist Mario Vargas Llosa, translated by Helen Lane (1986). And no catalogue on this subject should omit the brilliant extravaganza by Julian Barnes, *Flaubert's Parrot* (1984).

As for Louise Colet, let it be noted that her version of things has been

translated by Marilyn Gaddis Rose and published, in 1986, under the marvelous, semitranslated title, *Lui: A View of Him.*

4. THE GRAND DUCHESS OF GEROLSTEIN

Music in the Tuileries is one of the three works closely analyzed in Sandblad's work, cited above, and it deserves to be cited again.

The best book on Offenbach is probably *Orpheus in Paris: Offenbach and the Paris of His Time,* by S. Kracauer (1972), which is rather shaggy but richly entertaining. See also *Jacques Offenbach,* by Alexander Faris (1980).

The mother lode of legends, lies, and boasts on the life of Richard Wagner is still his own authoritative but thoroughly unreliable autobiography, *My Life,* translated by Andrew Gray (1983), to be supplemented, *ad lib.,* by *Selected Letters of Richard Wagner,* translated and edited by Stewart Spencer and Barry Millington (1987). The standard biography is still Ernest Newman's admirable four-volume monument, *The Life of Richard Wagner* (originally published in 1933). The literature on this troublesome genius is enormous, but I want to single out as particularly helpful Robert W. Gutman's somewhat iconoclastic *Richard Wagner: The Man, His Mind, and His Music* (1968) and Bryan Magee's *Aspects of Wagner* (1969). I found various fragments like "Judaism in Music" and "An End in Paris" in a collection called *Stories and Essays,* by Richard Wagner, edited by Charles Osborne (1973). The account of Wagner's conversation with Rossini is drawn from a charming little book originally published by Edmond Michotte in 1906, then edited, translated, and brought back to life by Herbert Weinstock in 1968 as *Richard Wagner's Visit to Rossini and an Evening at Rossini's in Beau-Sejour.* For everything connected with Berlioz, see Jacques Barzun's *Berlioz and His Century* (1949; 1956).

The best biography of Baron Haussmann, so far as I know, is *The Life and Times of Baron Haussmann: Paris in the Second Empire,* by J. M. (for Joan Margaret) and Brian Chapman (1957). For an excellent study of the baron's accomplishments, though, I have relied on *Napoleon III and the Rebuilding of Paris,* by David H. Pinkney (1958). See also *Haussmann: Paris Transformed,* by Howard Saalman (1971), and *Space, Time and Architecture: The Growth of a New Tradition,* by S. Gideon (1941).

The tale of Lillie Moulton and Blind Tom comes from *In the Courts*

of Memory (1858–1875), by Lillie G. Hegermann-Lindencrone (1912).

The most detailed account of Manet's views on the Exposition of 1867 is Patricia Mainardi's admirable *Art and Politics of the Second Empire: The Universal Expositions of 1855 and 1867* (1987).

5. NANA

Stories of *Les Grandes Horizontales* are everywhere—in Tabarant, in Kracauer, in Bierman, in Perrochot, and so on.

Zola is sometimes a difficult writer to translate, because he relies a good deal on contemporary slang. English translators—which seems to be what most translators are—rely, in turn, on English slang, which sounds inauthentic at best, and which dates rapidly. I have followed mainly the Penguin versions, meaning, in this chapter, Leonard Tancock on *L'Assommoir* and George Holden on *Nana,* but with many comparative glances at other versions and at the original French. For background, I have used *Émile Zola: A Biography,* by Alan Schom (1987).

On the general topic of prostitution in Paris, which is considerably less glamorous than often thought, the standard text is Alain Corbin's *Women for Hire: Prostitution and Sexuality in France After 1850,* translated by Alan Sheridan (1990; originally, *Les Filles de Noce* [1978]). I think the best account of the subject, however, is *Policing Prostitution in Nineteenth-Century Paris,* by Jill Harsin (1985). For a more detailed analysis of the artistic implications of the traffic, see *Figures of Ill Repute: Representing Prostitution in Nineteenth-Century France,* by Charles Bernheimer.

The best biography I have found on Degas is Roy McMullen's *Degas: His Life, Times, and Work,* though there are many interesting studies of his art. *Degas by Himself: Drawings, Prints, Paintings, Writings,* edited by Richard Kendall (1987), is a valuable collection of autobiographical fragments. A helpful overview can be found in the catalogue, edited by Jean Sutherland Boggs *et al.,* for the great retrospective exhibition of 1988. For more detailed perspectives, see *Degas: The Artist's Mind,* by Theodore Reff (1987); *Looking into Degas: Uneasy Images of Women and Modern Life,* by Eunice Lipton (1986); *Degas: The Nudes,* by Richard Thomson (1988); *Edgar Degas: Life and Work,* by Denys Sutton (1986); and let us not forget Paul Valéry's invaluable *Degas Manet Morisot.*

6. EMPRESS EUGÉNIE (II)

Manet's letters to his wife during the siege of Paris have been widely quoted in part; the complete text was published by Mercure de France in 1935 as *Une Correspondance Inédite d'Édouard Manet.* The letters to Éva Gonzalès can be found in Moreau-Nelaton.

The Prussian invasion (through the siege of Paris) is excellently told by Michael Howard in *The Franco-Prussian War* (1961). That forms a kind of overture to Alistair Horne's equally excellent continuation of the story in *The Fall of Paris: The Siege and the Commune, 1870–71* (1965), and *The Terrible Year: The Paris Commune, 1871* (1971). Zola wanders over the whole battlefield in *The Debacle,* translated by Leonard Tancock (1972).

The Becker edition of the Goncourt *Journals* has been cited before, and here must be cited again, with admiration and gratitude.

My main source on the Commune remains Horne, but in working my way through the large literature on the subject, I have been helped by *Revolution and Reaction: The Paris Commune,* edited by John Hicks and Robert Tucker (undated but about 1971), which includes contributions by Henri Peyre, Wallace Fowlie, *et al.,* not to mention "The Days of the Commune," by Bertolt Brecht (translated by Leonard Lehrman). I also found here an interesting article, "The Women of the Commune," by Edith Thomas, who has published in France a biography of the heroic Louise Michel. That pioneer's own recollections may be found in a book with a deplorable title, *The Red Virgin: Memoirs of Louise Michel,* edited and translated by Bullitt Lowry and Elizabeth Ellington Gunter (1981). For a useful collection of documents of this period, see *The Communards of Paris, 1871,* edited by Stewart Edwards (1973). On Victor Hugo's activities during the Prussian siege, I have used *Victor Hugo: A Tumultuous Life,* by Samuel Edwards (1971). For a good short account of actions on the Prussian side, I recommend *Bismarck,* by Edward Crankshaw (1981).

7. BERTHE MORISOT (II)

I have relied heavily throughout this chapter on Rewald's invaluable *History of Impressionism.* Rewald seems the best of sources, erudite, shrewd, interesting, balanced, and I can only express my gratitude. For

more of the same, see Rewald's *Studies in Impressionism* (1985) and *Studies in Post-Impressionism* (1986), both edited by Irene Gordon and Frances Weitzenhoffer.

Other analyses of this popular movement keep appearing, of course. One of the most acclaimed in recent years has been *Impressionism: Art, Leisure, and Parisian Society*, by Robert L. Herbert, who, despite decades of technical studies, undertakes to demonstrate "that impressionist paintings cannot be separated from the history of the events, places, persons, and social institutions they represent," that, for example, "the floating planes of Monet's *Garden of the Princess* are inconceivable without the cleared-out perspectives of Haussmann's new Paris...." This commendable approach dates back at least (and beyond) to *The Social History of Art*, by Arnold Hauser, translated by Stanley Goodman (1951).

I have taken the references to the railroad in Whitman, Gautier, and Couture from Peter Gay's *Art and Act: On Causes in History—Manet, Gropius, Mondrian* (1976). See also Gay's *The Tender Passion* (1986). Harry Rand's exhaustive contemplation of *The Railroad*, which contemplates even the contemplations of the puppy sleeping in Victorine's arms, is in *Manet's Contemplation at the Gare Saint-Lazare* (1987).

The translations from Zola's *L'Oeuvre* are mostly my own, with a little help from the version by Thomas Walton, titled *The Masterpiece* (1950). Some of the reactions to it I owe to Joanna Richardson's *Zola*.

Apart from Rewald, my main sources on the later years of Berthe Morisot are, as in Chapter 3, Anne Higonnet's admirable biography, the Valéry memoir, and the Morisot family correspondence.

8. OLYMPIA (II)

A really comprehensive history of the cultural consequences of syphilis remains to be written. The best study I have found is *History of Syphilis*, by Claude Quétel, translated by Judith Braddock and Brian Pike (1990). For the rest, I have made do with Paul de Kruif's somewhat romanticized *Men Against Death* (1939), Corbin on prostitution, the *Encyclopaedia Britannica*, and such. On the recent increase in syphilis and its possible connection to AIDS, see *AIDS and Syphilis*, by Katie Leishman in the *Atlantic Monthly*, January 1988; an interview with William McNeill, author of *Plagues and Peoples*, in *People* magazine,

October 12, 1987; and *The New York Times* for October 10, December 5, and December 12, 1989.

Tabarant, Perruchot, Hamilton, and the Cachin-Moffett-Bareau catalogue are all useful for the details of Manet's last years. Tabarant's interview with Koëlla about the details of Manet's death is at the Morgan Library in New York. Polignac's long account of the funeral is typical of what is valuable in T. A. Gronberg's previously mentioned documentary collection, *Manet: A Retrospective*. Victorine's letter to Suzanne Manet is preserved at the Morgan Library, as are Mina Curtiss's notes on Tabarant's research on Victorine's last years, including a photograph of Norbert Goeneutte's dreadful painting of the onetime Olympia as an aging alcoholic.

A final word of praise for the beautiful little book entitled *The Last Flowers of Manet*, by Robert Gordon and Andrew Forge (1986).

No matter how hard one tries to fit all one's research into neat categories, there always remain some valuable works that elude categorization. Like *Romanticism and Realism: The Mythology of Nineteenth-Century Art*, by Charles Rosen and Henri Zerner (1984). Or *Romanticism*, by Hugh Honour (1979). Or *Moving Pictures*, by Anne Hollander (1991). Or the researches of Linda Nochlin, notably *The Politics of Vision: Essays on Nineteenth-Century Art and Society* (1989). Or, even more, those of Roger Shattuck, notably *The Banquet Years* (1968) and *The Innocent Eye* (1984).

INDEX

Index

Index